ROUND TOWERS
OF
ATLANTIS

Henry O'Brien

1834

The **Atlantis Reprint Series:**
- RIDDLE OF THE PACIFIC by John MacMillan Brown (1924)
- THE HISTORY OF ATLANTIS by Lewis Spence (1926)
- ATLANTIS IN SPAIN by Elena Whishaw (1929)
- THE SHADOW OF ATLANTIS by Col. A. Braghine (1940)
- SECRET CITIES OF OLD SOUTH AMERICA by H. Wilkins (1952)
- MYSTERIES OF ANCIENT SOUTH AMERICA by H. Wilkins (1947)
- ATLANTIS: MOTHER OF EMPIRES by R. Stacy-Judd (1939)

The **Mystic Traveller Series:**
- IN SECRET TIBET by Theodore Illion (1937)
- DARKNESS OVER TIBET by Theodore Illion (1938)
- IN SECRET MONGOLIA by Henning Haslund (1934)
- MEN AND GODS IN MONGOLIA by Henning Haslund (1935)
- MYSTERY CITIES OF THE MAYA by Thomas Gann (1925)
- IN QUEST OF LOST WORLDS by Byron de Prorok (1937)

The **Lost Cities Series:**
- LOST CITIES OF ATLANTIS, ANCIENT EUROPE & THE MEDITERRANEAN
- LOST CITIES OF NORTH & CENTRAL AMERICA
- LOST CITIES & ANCIENT MYSTERIES OF SOUTH AMERICA
- LOST CITIES OF ANCIENT LEMURIA & THE PACIFIC
- LOST CITIES & ANCIENT MYSTERIES OF AFRICA & ARABIA
- LOST CITIES OF CHINA, CENTRAL ASIA & INDIA

The **New Science Series:**
- THE ANTI-GRAVITY HANDBOOK
- ANTI-GRAVITY & THE WORLD GRID
- ANTI-GRAVITY & THE UNIFIED FIELD
- THE FREE ENERGY DEVICE HANDBOOK
- THE TIME TRAVEL HANDBOOK
- THE FANTASTIC INVENTIONS OF NIKOLA TESLA
- UFOS & ANTI-GRAVITY: PIECE FOR A JIGSAW
- THE COSMIC MATRIX: PIECE FOR A JIGSAW PART 2
- THE A.T. FACTOR: PIECE FOR A JIGSAW PART 3
- MAN-MADE UFOS: 1944-1994
- THE BRIDGE TO INFINITY
- THE ENERGY GRID
- THE HARMONIC CONQUEST OF SPACE
- ETHER TECHNOLOGY
- THE TESLA PAPERS
- TAPPING THE ZERO-POINT ENERGY
- QUEST FOR ZERO-POINT ENERGY
- HARNESSING THE WHEELWORK OF NATURE
- THE GIZA DEATH STAR
- THE GIZA DEATH STAR DEPLOYED
- ATLANTIS AND THE POWER SYSTEM OF THE GODS

Write for our free catalog of unusual science, history, and archaeology books.
Visit us online at:
www.adventuresunlimitedpress.com
www.adventuresunlimited.nl
www.wexclub.com/aup

THE
ROUND TOWERS
OF
ATLANTIS

**ATLANTIS
REPRINT
SERIES**

ADVENTURES UNLIMITED PRESS

The Round Towers of Atlantis
©Copyright 2002
Adventures Unlimited Press

Originally published 1834
as *The Round Towers of Ireland*

This edition published
August, 2002

ISBN 1-931882-01-0

Printed in the United States of America

Published by
Adventures Unlimited Press
One Adventure Place
Kempton, Illinois 60946 USA

www.adventuresunlimitedpress.com
www.adventuresunlimited.nl
www.wexclub.com

THE
ROUND TOWERS
OF
ATLANTIS

Henry O'Brien

1834

INTRODUCTION

by David Hatcher Childress

The Deathless Ones will waft you instead to the world's end, the Elysian Fields, where yellow-haired Rhadamanthus is. There indeed men live unlaborious days. Snow and tempest and thunderstorms never enter there, but for men's refreshment Ocean sends out continually the high-singing breezes of the west.
—Homer, The *Odyssey*

This fascinating book, first published in 1834 as *The Round Towers of Ireland,* was an instant sensation at the time, and was one of the first modern studies of Atlantis, round towers, pre-Christian megalithic architecture and secret societies. In addition to being a sourcebook on Atlantis research, Druidic culture and origins of modern Celtic Christianity, the book is a treasurehouse of ancient esoteric lore and arcane knowledge of the past.

The book includes amazing information on a variety of subjects relating to Ireland's fascinating past: the history of the Tuatha de Danaan, the mysterious ancient people said to have been led to Ireland from the Holy Land by Queen Scota; the pre-Christian origin of the round towers and megalithic crosses of Ireland; Ireland's strange connections with ancient India, Persia and China; ancient secret societies and Ireland; pre-Christian Messiahs, Mithraism and Ireland; and the connections between Atlantis and Ireland.

O'Brien's book caused a sensation in its day, as O'Brien was arguing very successfully that the strange round towers found throughout Ireland were pre-Christian, as were the megalithic crosses often found near the round towers. It has generally been assumed that the crosses and towers had been built some hundreds of years after Christ by early missionaries. Some believe that the towers were built even later than that.

O'Brien claims in his book that Irish tradition holds that the towers were built by the Tuatha de Danann. The towers "were specifically constructed for the twofold purpose of worshiping the Sun and Moon, as the authors of generation and vegetable heat..." The linking of the towers to the Tuatha de Danann is important, and in his 1894 book *Irish Druids and Old Irish Religions* James Bonwick mentions that the great battle between the ancient tribes of the Tuatha de Danann and the Firbolgs took place on a battlefield that became known as the "Field of the Towers."

The fact is, we have no idea who built the towers, or why. Bonwick relates, "One has affirmed that a celebrated tower was built by the devil in one night. To this, Latocnaye says, 'If the devil built it, he is a good mason.' Others may still ask 'Who erected the rest?' While over a hundred are known to us now, their number must have been much greater formerly, if, as that ancient *Chronicler Annals,* declares, 75 fell in the great Irish earthquake of 448 A.D."

Bonwick goes on to say that the towers have been variously described as "fire-towers, belfries, watch-towers, granaries, sepulchers, forts, hermit dwellings, purgatorial pillars, phallic objects of worship, astronomical marks, depositories of Buddhist relics, Baal fire-places, observatories, sanctuaries of the sacred fire, Freemason lodges, etc, etc. They were Pagan and Christian, built long before Christ, or a thousand years after."

One early authority on Irish round towers was Dr. G. Petrie who wrote the mid-1800s book, *Ecclesiastical Architecture of Ireland.* Dr. Petrie makes the conservative statement that the towers "are of Christian ecclesiastical origin, and were erected at various periods between the fifth and thirteenth centuries."

Basically, Dr. Petrie says that the towers were built by the Norman conquerors as belfries, starting around 400 A.D. Yet, in the great earthquake of 448 A.D., 75 of the towers fell down. Says Bonwick, "Petrie and others point to the fact of skeletons being found in some, and these lying east and west, as a proof of Christian origin. Yet, as is replied, all this existed under paganism. Christian emblems, found only in three out of 63, have been regarded as modern alterations. The silence about the Towers in Irish hagiography [writings on the saints], as the *Acta Sanctorum,* etc., would seem to indicate a non-Christian origin, as early monkish authors forbore reference to paganism."

Bonwick and others ask, if these are Christian monuments, then where are the prototypes for such

buildings and why are they only found in Ireland? Bonwick goes on to say, "If an Irish style of Christian building, why did it not appear in countries known to have been under Irish missionary influence—as in Cornwall, Isle of Man, Scotland, France, Germany, etc.? Why did not Culdees leave such memorials in the Hebrides, in Lindisfarne, and other localities?"

Bonwick quotes the Irish historian Gradwell who says, "There are weighty authorities on both sides, but there are sufficiently high names who maintain they were already in existence when the Saint was brought to Ireland. If they belong to a later period, when Ireland was Christian, it seems strange that the architects of those times should have displayed such surpassing skill in the construction of these Towers, for which it is difficult to assign any adequate purpose; and yet, on the other hand, have left us no monuments whatever of more useful kind."

Indeed, it is a good point to make that in many cases, the amazing towers stand by themselves, the churches having long passed into rubble. Why were not the churches constructed in the same indestructible manner as these towers? The early Irish churches were constructed of wood, not stone. Says Bonwick, "St. Patrick and his followers almost invariably selected the sacred sites of paganism, and built their wooden churches under the shadow of the round towers, then as mysterious and inscrutable as they are today."

Another Irish authority, Kenrick, believes that the towers have a Phoenician origin, which is the same as saying the Tuatha de Danann were the builders. Bonwick indicates a Phoenician origin as well when he likens the round towers to similar towers in the Mediterranean: "...they may be likened to the Nurhaghs or Giants' Towers of Sardinia, Gozo Island, Balearic Isles, etc., though these towers are much more complicated in structure, and rather conical. Like our Towers, they are splendid specimens of masonry."

Some writers on the round towers ascribe them to Buddhism, and it is said that the closest structures resembling Irish round towers are to be found in India. Says Anna Wilkes in *Ireland, Ur of the Chaldees* (quoted by Bonwick), "There can be no doubt the Towers in the interior of Hindustan bear more than a striking likeness to those remaining in Ireland. These resemblances are to be found in such great quantities in the latter place, that it is impossible but to believe that Ireland was the centre from which a great deal of the religion of Budh developed."

Bonwick tells us of the Irish Tree of Life or Aithair Faodha, or Tree of Budh. "In Irish we read of the Danann King Budh the Red; of the Hill of Budh, Cnox Buidhbh, in Tyrone; of other Budh hills in Mayo and Roscommon; and in the Book of Ballymote, of Fergus of the Fire of Budh."

The idea of ancient Ireland being a Phoenician state as well as influenced in early times by Buddhism is fascinating. Perhaps here lies an explanation for the discovery in the mid-1800s of a cache of Chinese seals and coins, as reported by Charles Fort in his first collection of anomalous material, *The Book of the Damned.*

Fort quotes from the *Proceedings of the Royal Irish Academy* (1852, 1-381) that a paper by Mr. J. Huband Smith describes a dozen ancient Chinese seals discovered in various places in Ireland, all cubes with an animal carving and "inscriptions upon them of a very ancient class of Chinese characters." Fort goes on to say that many more seals have been found in Ireland. "In 1852, about 60 had been found. Of all the archaeological finds in Ireland, none is enveloped in greater mystery."

The seals had been discovered in various places around Ireland: three in Tipperary, six in Cork, three in Down, four in Waterford, and one or two in other counties. Comments Fort dryly, "(There is) agreement among archaeologists that there were no relations, in the remote past, between China and Ireland."

The evidence says, however, that there was indeed a connection between ancient Ireland and China. Were special ambassadors and consultants from an ancient court in China sent to Ireland on some important mission? How would a group, or several groups of Chinese visitors have arrived in Ireland and why would they have wanted to go? Buddhism came to China circa 200 BC and mixed strongly with the new Taoist religion.

The Chinese had a large and sophisticated navy and might have arrived in Ireland by several different ways. We know that the Chinese traded via large sailing vessels into the Indian Ocean area. There is evidence that Chinese explorers reached Madagascar and East Africa. Chinese vessels may have sailed around the African Cape and arrived in Europe via West Africa but it would have been easier, and presumably safer, for them to have sailed the familiar Indian Ocean around Arabia into the Red Sea. A short land crossing from either Eilat or Port Said to a Phoenician port on the eastern Mediterranean coast would have brought them from one common transportation network to another.

If the theories of a close connection between the eastern Mediterranean and Ireland are correct, it would have been easy for several ships to have been hired to take our Chinese ambassadors to Ireland. In light of this theory, it is interesting to note some curious facts that have surfaced in the past few decades,

such as Chinese characters discovered in some of the Dead Sea Scrolls, written by the Essenes. The Essenes were a secret sect with centers in Israel, Egypt, southern France and possibly Ireland and Britain. It is believed by some Biblical scholars that Joseph, Mary, Jesus and their relatives, like John the Baptist, were all members of the Essenes. They are similarly associated with Queen Scota and the Tuatha de Danaan and the Phoenician voyagers of the Mediterranean and Atlantic.

Ancient Ireland was a special world of learning, with an idyllic lifestyle, and the round towers were apparently an important part of that world. But why were they built? According to researchers like Christopher Bird and Philip S. Callahan, they are antennae for receiving electromagnetic rays from the sun and transmitting them into the ground.

Callahan in his fascinating 1984 book *Ancient Mysteries, Modern Visions* maintains that the Irish round towers are agricultural antennae for helping to energize the soil. He claims that the round towers are all built of paramagnetic rocks which help channel natural earth energies into the soil and energize it for greater fertility.

Callahan spent a great deal of time in Ireland and studied many of the towers. He draws a distinction between the round towers and the square towers scattered about Ireland. The square towers were built by the Normans in the 12th century, a time often ascribed to the building of round towers. But the round towers, according to Calahan, were built in the 7th century as mainstream archeologists typically contend.

Callahan says that every single round tower he tested (fifteen in number) was made of a paramagnetic stone, such as the Glendalough tower, which is built of mica schist, one of the most paramagnetic varieties of stone. Farmhouses and other later structures were usually made of diamagnetic stone.

Despite the popular belief that the towers were either fortresses or bell towers, Callahan believes they are neither. He says, "I have always considered both explanations to border on the ludicrous. Large bells were not cast until the Middle Ages (except in China), and the Viking attacks began long after the tower-building seventh century. ...According to Professor G.L. Barrow, in his book *The Round Towers of Ireland*, the Irish themselves attacked the monasteries more often than Vikings did in the later centuries. The round towers are like huge smokestacks. A few fire spears or arrows through the lower door or windows would burn the wooden floors and smoke the monks out in no time at all. The towers were not built over springs and could not possibly hold enough food for a long siege. Starvation was the main siege technique in warfare, and we may be assured neither the Vikings nor the Irish attackers were too impatient that they would not camp in place for a couple of weeks until the hungry monks crawled out."

Callahan's theory is that each tower is a resonant cavity that is tuned by piling up soil inside. This is the reason for the door being partially up the tower, to allow a portion of the base to be filled in with dirt, as many were.

Further, he believes that a paramagnetic, crystalline rock outcrop would serve as a "lens" or antenna to focus and direct the sun's "monopole" signal into the ground where the roots of plants pick up this energy and grow faster.

Callahan does not seem to question the date of the towers, and, as mentioned above, believes them to have been built in the 7th century. He does, however, ultimately attribute the concept and technology to

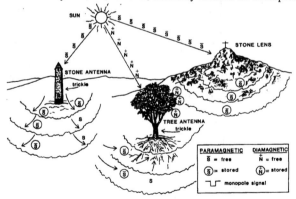

According to Philip S. Callahan's research published in his book *Ancient Secrets, Modern Visions* (1984, Acres USA, Kansas City), the round towers functioned to channel the sun's energy into the earth, nurturing plant growth.

the Egyptians. In Egypt, Callahan points to the crystalline antennae (obelisks) and antenna headdresses worn by the Pharaohs. He also likens these antennae, including round towers, to the antennae of insects. Insects have specialized antennae in different shapes for communication. Though the towers are almost certainly much older than the 7th century

The whole subject seems to indicate that Ireland was a special center for esoteric sciences and agricultural work. The round towers may be from before the Christian era and may have their origins in Egypt, the round towers being a version of a solid stone obelisk. This is basically what Callahan is implying. Until some sort of accurate dating is done on the towers themselves, and not on charcoal or bones found within the tower (which may be hundreds or thousands of years younger), the round towers of Ireland will remain a mystery of the past.

We can thank Henry O'Brien for shedding some early light on this fascinating archeological subject. O'Brien's life was mysterious in itself. He was born in County Kerry, Ireland in 1808 and graduated from Trinity College, Dublin. His linguistic ability and his interest in archeological studies are reflected in his translation of Villaneuvas's *Phoenician Island* for which he wrote a lengthy introduction and extensive scholarly notes, which was published in 1833. The following year his major achievement, *The Round Towers of Ireland* was published. He began work on a new book, entitled *The Pyramids of Egypt for the First Time Unveiled,* but unfortunately died suddenly at a friend's home at Hanwell, Middlesex on June 28, 1835. He was only 27 years of age.

Why he died at such an early age is a mystery to later researchers. Apparently he was a healthy young man, full of energy to write such a lengthy book and planning others besides. Was O'Brien the victim of an early conspiracy to silence someone who was disclosing the hidden knowledge of some secret society? Or perhaps he was killed by agents of the traditional churches such as the Vatican or Church of England who were upset with O'Brien's revolutionary thesis. Sadly, we will probably never know what happened to Henry O'Brien that kept him from writing a sequel, but we have this book, a significant life achievement for any scholar.

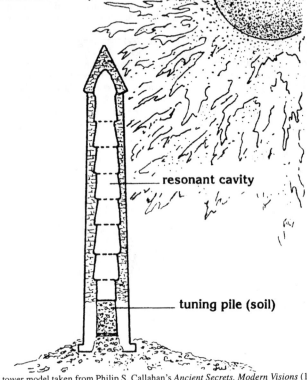

A round tower model taken from Philip S. Callahan's *Ancient Secrets, Modern Visions* (1984, Acres USA, Kansas City), showing how the tower's resonance was tuned by filling to a certain level with soil.

iv Round Towers of Atlantis

ROUND TOWERS,

&c.

CHAPTER I.

" A lively desire of knowing and recording our ancestors so generally
prevails, that it must depend on the influence of some common prin-
ciple in the minds of men. We seem to have lived in the persons of
our forefathers ; our calmer judgment will rather tend to moderate
than suppress the pride of an ancient and worthy race. The satirist
may laugh ; the philosopher may preach ; but reason herself will
respect the prejudices and habits which have been consecrated by the
experience of mankind *."

OF all nations on the globe, the Irish, as a people,
are universally admitted to possess, in a pre-eminent
degree, those finer sensibilities of the human heart,
which, were they but wisely controlled, would exalt
man above the level of ordinary humanity, and make
him, as it were, a being of another species. The
numerous instances adduced in all periods of their
history, of ardent and enterprising zeal, in every case
wherein personal honour or national glory may be
involved, are in themselves sufficient to establish this
assertion. But while granting their pre-eminence as
to the possession of those feelings, and the capability
of the feelings themselves to be refined and sub-
limated to the very acmé of cultivation, we may still
doubt whether the *mere possession* of them be not
less a blessing than a curse—whether, in fact, their

* Gibbon's Memoirs.

quick perception of disquietudes and pains be not more than a counterpoise to their keen enjoyment of delight or pleasure.

Foremost, however, in the train of the *many virtues* which flow therefrom, is that " amor patriæ," or love of country, which, unsubdued often by the most galling miseries and the most hopeless wants, throws a halo round the loneliness of their present despair in the proud retrospection of their former buoyancy. This spirit it is which, despite of obvious advantages to be derived from emigration, has riveted the Irish peasant so immutably to his home, that any effort on his part to dissolve those local fetters would be equivalent to the disruption of all the ties and attachments which nature or habit had implanted within him.

> " The lofty scenes around their sires recall,
> Fierce in the field and generous in the hall ;
> The mountain crag, the stream and waving tree,
> Breathe forth some proud and glorious history—
> Urges their steps where patriot virtue leads,
> And fires the kindred souls to kindred deeds.
> They tread elate the soil their fathers trod,
> The same their country, and the same their God."

But it may be said, that this is a day-dream of youth—the hereditary vanity of one of Iran's sons, arrogating antiquity and renown for an inconsiderable little island, without a particle of proof to substantiate their assumption, or a shadow of authority to give colour to their claims. Why, sir, cast your eye over the fair face of the land itself, and does not the scene abound with the superfluity of its evidences? What are those high aspiring edifices which rise with towering elevation towards the canopy of the " *Most High?* " * What are those stu-

* The Budhist temples.

pendous and awful structures of another form—the
study at once and admiration of the antiquarian and
the philosopher, to be found on the summits of our
various hills * as well as in the bowels † of the earth
itself?—what are they but the historical monuments
of splendour departed—surviving the ravages of time
and decay, not as London's column, to " lift their
heads and lie," but to give the lie and discomfiture
to those, who, from the interested suggestions of an
illiberal policy, or the more pardonable delusions of a
beclouded judgment, would deny the authenticity of
our historic records, and question the truth of our
primeval civilisation ?

It is true, the magnificence, which those memo-
rials demonstrate, is but the unenviable grandeur of
druidical, as it is called, idolatry and unenlightened
paganism,—when man, relinquishing that supremacy,
consigned to him at his creation, or rather divested
thereof in punishment for the transgression of his dege-
nerate disposition, lost sight of that Being to whom
he owed his safety and his life, and bent himself in
homage before perishable creatures that crawl their
ephemeral pilgrimage through the same scene with
himself: granted ; yet that cannot well be objected
to *us* as a disgrace, which, co-extensive in its adoption
with the amplitude of the earth's extension, equally
characterised the illiterate and the sage; and if, amidst
this lamentable prostration of the human understand-
ing, any thing like redemption, or feature of supe-
riority may be allowed, it must be, unquestionably, to
the adherents of that system, which, excluding the
objects of matter and clay, recognised, in its worship
of the bright luminaries of the firmament, the purity

* The Cromleachs. † The Mithratic Caves.

and omnipotence of that Spirit who brought all into existence, and who guides and preserves them in their respective spheres;—and when I shall have *proved* that the intent and application of those *Sabian* * *Towers*,—or, to speak more correctly, those *primitive Budhist Temples*,—which decorate our landscape and commemorate our past renown, appertained to this species of purified idolatry, which worshipped only the host of heaven, the moon and the solar body, which gives *vigour* to all things, I shall, methinks, have removed one obstacle from the elucidation of our antiquities, and facilitated the road to further adventure in this interesting inquiry.

Let me not be supposed, however, by the preceding remarks to restrict their destination to one single purpose. All I require of my readers is a patient perusal of my details; and I deceive myself very much, and overrate my powers of enunciation, else I shall establish in their minds as thorough a conviction of the development of the " Towers," as I am myself satisfied with the accuracy of my conclusions. I shall only entreat, then, of their courtesy that I be not anticipated in my course, or definitively judged of by isolated scraps, but that, as my notice for this competition has been limited and recent, allowing but little time, for the observance of *tactique* or rules, in the utterance of the novel views which I now venture to put forward, the proofs of which, however, have been long registered in my thoughts, and additionally confirmed by every new research, the merits of the production may not be estimated by parcels, but by the combined tendency of the parts all together.

To begin therefore. The origins I have heard

* Job i.

assigned to those records of antiquity,—however invidious it may appear, at this the outset of my labours, to assume so self-sufficient a tone, yet can I not avoid saying that, whether I consider their multiplicity or their extravagance, they have not more frequently excited my ridicule than my commiseration. That specimens of architecture, so costly and so elegant, should be designed for the paltry purposes of purgatorial columns or penitential heights, to which criminals should be elevated for the ablution of their enormities—while the honest citizen, virtuous and unstained, should be content to grovel amongst lowly terrestrials 'mid the dense exhalations of forests and bogs, in a mud-wall hut, or at best a conglomeration of wattles and hurdles—is, I conceive, an outrage upon human reason too palpable to be listened to.

Not less ridiculous is the idea of their having been intended for beacons; for, were such their destination, a hill or rising ground would have been the proper site for their erection, and not a valley or low land, where it happens that we generally meet them.

The belfry theory alone, unfounded in one sense though it really be, and when confined to that application equally contemptible with the others, is, notwithstanding, free from the objection that would lie against the *place*, as it is well known that the sound of bells, which hang in plains and valleys, is heard much farther than that of such as hang upon elevations or hills: for, air being the medium of sound, the higher the sonorous body is placed, the more rarefied is that medium, and consequently the less proper vehicle to convey the sound to a distance. The objection of situation, therefore, does not apply to this theory; and, accordingly, we shall find that the exer-

cising of bells—though in a way and for an object little contemplated by our theorists—constituted part of the machinery of the complicated ceremonial of those mysterious edifices.

The truth is, the " Round Towers" of Ireland were not all intended for one and the same use, nor any one of them limited to one single purpose : and this, I presume, will account for the variety in their construction, not less perceptible in their diameters and altitudes than in other characteristic bearings. For, I am not to be told that those varieties we observe were nothing more than the capriciousness of *taste*, when I find that the indulgence of that caprice, in one way, would defeat the very object to which one party would ascribe them, whilst its extension, in a different way, would frustrate the hopes of another set of speculators.

But what must strike the most cursory as irresistibly convincing that they were not erected *all* with *one* view, is the fact of our sometimes finding two of them together in one and the same locality.

Now, if they were intended as beacons or belfries, would it not be the most wasteful expenditure of time and wealth to erect two of them together on almost the same spot? And when I mention expenditure, perhaps I may be allowed, incidentally, to observe, that, of all species of architecture, *this* particular form, as it is the most durable, so is it also the most difficult and the most costly.

Need I name the sum of money which Nelson's monument has cost in modern times? or that imperfect testimonial in the Phœnix Park which commemorates the glories of the hero of Waterloo? No; but I will mention what Herodotus tells us was the

purport of an inscription upon one of the pyramids of Egypt, the form of some of which, be it known, was not very dissimilar to our Irish pyramids, while their intent and object were more congenial; viz., that no less a sum than 1600 talents of silver, or about 400,000*l.* of our money, had been expended upon radishes, onions and garlic alone, for 360,000 men, occupied for twenty years in bringing that stupendous fabric, that combined instrument of religion and science, to completion !

Our " Round Towers," we may well conceive, must have been attended, at the early period of their erection, with comparatively similar expense: and assuredly the *motive*, which could suggest such an outlay, must have been one of corresponding import, of the most vital, paramount, and absorbing consideration.

Would the receptacles for a bell be of such moment? And that too, whilst the churches, to which, of course, they must have appertained, were thought worthy of no better materials than temporary hurdles, and, so, leave behind them no vestiges of their local site,—no evidence or trace of their ever having existed ! And, indeed, how could they ?—for existence they never had, except in the creative imagination of our hypothetical antiquaries.

Ruins, it is true, of chapels and dilapidated cathedrals are frequently found in the vicinity of our ' Round Towers;' but these betray in their *materials* and architecture the stamp of a later age, having been founded by missionaries of the early Christian church, and purposely thus collocated—contiguous to edifices long before hallowed by a religious use,—to, at once, conciliate the prejudices of those whom they

would fain persuade, and divert their adoration to a more purified worship.

And yet, upon this single circumstance of proximity to ecclesiastical dilapidations—coupled with the bas-relief of a crucifix which presents itself over the door of the Budhist temple of Donoghmore in Ireland, and that of Brechin in Scotland—have the deniers of the antiquity of those venerable memorials raised that superstructure of historical imposture, which, please God, I promise them, will soon crumble round their ears, before the indignant effulgence of regenerated veracity.

It might be sufficient for this purpose, perhaps, to tell them, that similar ruins of early Christian churches are to be met with, abundantly, in the neighbourhood of Cromleachs and Mithratic caves, all through the island; and that they might as well, from this vicinity, infer, that those two other vestiges of heathenish adoration were contrived by our early Christians as appendages to the chapels, as they would fain make out—by precisely the same mode of inference—that the "Round Towers" had been!

But this would not suit; they could find no ascription, associated with Christianity, which cave or cromleach could subserve; and, thus, have the poor missionaries escaped the cumbrous imputation of having those colossal pagan slabs, and those astounding gentile excavations, affiliated upon them.

Not so fortunate the "Towers." After ransacking the whole catalogue of available applications, appertaining to the order of monastic institutions, with which to *Siamise* those temples, Montmorency has, at last, hit upon the noble and dignified department of a "dungeon-keep" or "lock-up!" as the sole use and intention of their original erection!

As I intend, however, to unravel this fallacy in its proper quarter, I shall resume, for the present, the thread of my discourse.

Besides the absurdity, then, of bestowing such magnificence upon so really inconsiderable a thing as a belfry, while the supposed churches were doomed to dwindle and moulder in decay, is it not astonishing that we find no vestiges of the like fashion, or structures of the like form, in any of those countries where the people, to whom the advocates of this theory ascribe their erection, have since and before exercised sway?

The Danes had dominion in Britain longer and more extensively than they ever had in *this* island; and yet, in the whole compass of England, from one extremity to the other, is there not one fragment of architecture remaining to sanction the idea of identity or resemblance!

Nay, in all Denmark and Scandinavia, the original residence of the Ostmen and Danes, there is not a single parallel to be found to those columnar edifices!

Ireland, on the contrary, exhibits them in every quarter; in districts and baronies where Danish authority was never felt; and surely our forefathers were not so much in love with the usages and habits of their barbarian intruders, as to multiply the number of those stately piles, solely in imitation of such detested taskmasters.

But what renders it *demonstrative* that those professional pirates had no manner of connexion with the Irish 'Round Towers,' is the glaring fact, that in the two cities of Wexford and Waterford—where their power was absolute, their influence uncontrolled—

there is not a solitary structure that could possibly be ascribed to the class of those which we now discuss!

In Scotland alone, of all European countries besides Ireland, do we meet with two of them :—one at Brechin, and the other at Abernethy ;—but they are smaller than the Irish, and, with other characteristics, seem to have been built, after their model, at a comparatively recent period, by a colony from this country, " as if marking the fact," to use Dalton's *accidentally* * appropriate phrase, " of that colonization having taken place when the rites, for which the ' Round Towers' were erected, in the mother-country, were on the decline."

But, forsooth, they are called " cloghachd " by the peasantry, and that, without further dispute, fixes their destination as belfries! Oh! seri studiorum quîne difficile putetis?

That some of them had been appropriated in latter times, nay and still are, to this purpose, I very readily concede ; but, " toto cœlo," I deny that such had ever entered into the contemplation of their constructors, as I do, also, the universality of the very name, which I myself know, by popular converse, to be but partial in its adoption, extending only to such as had been converted by the moderns to the purpose described, or such as may, originally, have had a clogh, or bell, of which I admit there were some, as part of their apparatus.

The first bells of which we have any mention, are those described by Moses, as attached to the gar-

* I say *accidentally*, because he foundered as well upon the *actual colony*, who erected those temples, as upon the *nature* of the *rites* for which they were erected.

ments of the high-priest. From these, the Gentiles, as they affected to rival the Israelites in all their ceremonies, borrowed the idea, and introduced its exercise into the celebration of their own ritual. By "Israelites," however, I deem it necessary to explain that I do not understand those who, in strictness of speech, are so denominated as the descendants of Israel, *i. e.*, Jacob, who, in fact, were a comparatively modern people; but I particularize that old stock of patriarchal believers which existed from the Creation, and upon which the Israelites, rigidly so called, were afterwards engrafted.

Our Irish history abounds with proofs of the " ceol," and " ceolan," the bell and the little bell, having been used by the pagan priests in the ministry of their religious ordinances; and to the fictitious sanctity which they attributed to this instrument may we ascribe that superstitious regard, which the illiterate and uneducated still continue to entertain for the music of its sound.

From the Sabian ceremonial—succeeded by the Druidical—it unquestionably was that the Christian missionaries in Ireland first adopted the use of bells, wishing, wisely, therein to conform as much as possible to the prejudices of the natives, when they did not essentially interfere with the spirit of their divine mission. I shall hereafter relate the astonishment excited in England, at the appearance of one of those bells, brought there in the beginning of the sixth century by Gildas, who had just returned after finishing his education in Ireland; and this, in itself, should satisfy the most incredulous, that the Britons, as well pagan as Christian, were ever before strangers to such a sight; and no wonder, for they were strangers

also to such things as " Round Towers," to which I
shall prove those implements properly and exclu-
sively belonged.

" Clogad" is the name, and which literally signifies
a " pyramid," that has led people into this " belfry"
mistake. To conclude, therefore, this portion of our
investigation, I shall observe, in Dr. Milner's words,
" that none of these towers are large enough for a
single bell, of a moderate size, to swing about in it ;
that, from the whole of their form and dimensions,
and from the smallness of the apertures in them, they
are rather calculated to stifle than to transmit to a
distance any sound that is made *in* them : lastly, that
though, possibly, a small bell may have been acciden-
tally put up in one or two of them at some late period,
yet we constantly find other belfries, or contrivances
for hanging bells, in the churches adjoining to them."

I fear greatly I may have bestowed too much pains
in dispelling the delusion of this preposterous opinion.
But as it had been put forward with so much confi-
dence by a much-celebrated " antiquarian,"—though
how he merited the designation I confess myself at a
loss to know,—I thought it my duty not to content
myself with the mere exposure of the fallacy, without
following it up with proofs, which must evermore, I
trust, encumber its advocates with *shame :* and the
rather, as this great champion of *Danish civilisation*
and proclaimer of his *country's barbarism,* is at no
ordinary trouble to affect ridicule and contempt for
a most enlightened and meritorious English officer,
who, from the sole suggestion of truth, promoted by
observation and antiquarian research, stood forward
as the advocate of our ancestral renown, to make
amends, as it were, for the aspersions of domestic
calumniators.

Both parties are, however, now appreciated as they ought; and though Vallancey, certainly, did not understand the purport of our " Round Towers," his view of them, after all, was not far from being correct; and the laborious industry with which he prosecuted his inquiries, and the disinterested warmth with which he ushered them into light, should shield his memory from every ill natured sneer, and make every child of Iran feel his grateful debtor.

Having given Milner a little while ago the opportunity of tolling the death-knell of the belfry hypothesis, I think I could not do better now than give Ledwich, in return, a triumph, by demolishing the symmetry of the anchorite vagary.

" It must require a warm imagination," says this writer,—after quoting the account given by Evagrius, of Simeon Stylite's pillar, upon which Richardson, Harris, and Milner after them, had founded the anchorite vagary,—" to point out the similarity between this pillar and our ' tower :' the one was solid, and the other hollow—the one square, and the other circular : the ascetic *there* was placed without *on* the pillar ; with *us* inclosed *in* the tower. He adds, these habitations of anchorites were called *inclusoria*, or *arcti inclusorii ergastula*, but these were very different from our round towers ; for he mistakes Raderus, on whom he depends, and who says, ' The house of the recluse ought to be of stone, the length and breadth twelve feet, with three windows, one facing the choir, the other opposite, through which food is conveyed to him, and the third for the admission of light—the latter to be always covered with glass or horn.'

" Harris, speaking of Donchad O'Brien, Abbot of

Clonmacnois, who shut himself up in one of these cells, adds, 'I will not take upon me to affirm that it was in one of these towers of Clonmacnois he was inclosed.' It must have been the strangest perversion of words and ideas to have attempted it. Is it not astonishing that a reverie thus destitute of truth, and founded on wilful mistakes of the plainest passages, should have been attended to, and even be, for some time, believed?"

Thus have I allowed him to retaliate in his own words; but in order to render his victory complete, by involving a greater number within his closing denunciation, he should have waited until he had seen a note appended to the fourteenth of Dr. Milner's Letters, which, unquestionably, would deserve a similar rebuke for its gross perversion of a "cell" into a "tower."

It is this:—"We learn from St. Bernard, that St. Malachy, afterwards Archbishop of Armagh, in the twelfth century, applied for religious instruction, when a youth, to a holy solitary by name Imarus, who was shut up in a 'cell,' near the cathedral of the said city, *probably in a Round Tower.*" Risum teneatis?

But I am tired of fencing with shadows and special pleading with casuists. And yet, as I would wish to render this Essay systematically complete, I am forced, however reluctant, to notice the conjecture, which others have hazarded, of those "Round Towers" having been places of retreat and security in the event of invasion from an enemy; or depositories and reservoirs for the records of state, the church utensils and national treasures!

To the *former*, I shall reply, that Stanihurst's description of the "excubias in castelli vertice," upon

which it would seem to have been founded, does not, at all, apply to the case; because, while the " castella" have vanished, the "Round Towers,"—which never belonged to them,—do, many of them still firmly, maintain their post; and as to the *latter*, the boldness with which it has been put forward, by its author before named,* requires a more lengthened examination than its utter instability could otherwise justify.

* Colonel Montmorency.

CHAPTER II.

THIS chivalrous son of Mars, more conversant, I
should hope, with tactics than with literary disquisi-
tions, has started with a position, which he is himself,
shortly after, the most industrious to contradict;
namely, " that the gods, to punish so much vanity
and presumption, had consigned to everlasting obli-
vion the founders, names, dates, periods, and all
records relating to them *."

Surely, if they were intended for the despicable
dungeons, which the colonel would persuade us was
their origin, there existed neither " vanity " nor " pre-
sumption " in *that humble design;* and when to this
we add the *nature* of that security, which he tells us
they were to establish, one would think that *this*
should be a ground for the perpetuity of their regis-
tration, rather than for consigning their history to
" everlasting oblivion."

But secure in the consciousness of the whole history
of those structures, and satisfied that *truth* will never
suffer any thing by condescending to investigation,
I will, to put the reader in full possession of *this*
adversary's statement, here capitulate his arguments
with all the fidelity of an honourable rival.

His object, then, being to affix the " Round Towers "
to the Christian era, he begins by insisting that, as

* Pliny, Lib. lxvi. cap. 12.

" the architects of those buildings were consummate masters in masonic art," it follows, that " a people so admirably skilled in masonry, never could have experienced any impediments in building substantial dwellings, strong castles, palaces, or any other structures of public or private conveniency, some fragments of which, however partial and insignificant, would still be likely to appear, in despite of the corroding breath of time or the torch of devastation."

His next argument is, " that the *busy* and *fantastic bard*,—whose occupation led him to interfere in private and public concerns,—who, in truth, (he adds,) is our oldest and most circumstantial annalist,—on the subject of the Pillar Tower, is dumb and silent as the dead ;" whence he infers the " non-existence of those Towers during the remote ages of bardic influence,"—" and of their being utterly unknown to them, and to our ancestors, anterior to the reception of the Christian faith."

His third proposition is, that as " Strabo, Pomponius Mela, Solinus, Diodorus Siculus, and other writers of antiquity, have represented the condition of Ireland and its inhabitants to be barbarous in *their* days,—in common with their neighbours the Britons, Gauls, and Germans, to whom the art systematically to manufacture stone had been unknown,—*ergo*, those *barbarians* could not be set up as the authors of the Pillar Tower."

His fourth premise is, that " wherever we chance to light upon a cromleach, we seldom fail to find near it one of those miserable caves"—and which he has described before as " surpassing in dreariness everything in the imagination of man ;"—whereas in the vicinity of the Pillar Tower no such thing is seen, *unless some natural* or *accidental excavation* may hap-

pen to exist *unaccountably* in that direction." His
inference from which is, that " although the cromleach
and the cave do claim, the first a Celtic, the second a
Phœnician origin, and happen *here* to be united, the
Pillar Tower, nevertheless, disavows even the most
distant connexion with either of them."

His fifth is a continuation of the foregoing, with an
erroneous parallelism, viz., " at Bael Heremon, in
India, not far from Mount Lebanon, there stood a temple
dedicated to Bael, near to which were many caves, of
which one was roomy enough to admit into it four
thousand persons." " The size of those temples," he
adds, " was regulated according to the extent or
amount of the local population, being spacious and
magnificent in large cities, and small and simple in
the inferior towns and villages ; but nowhere, nor
in any case, do we meet an example of a lofty spiral
tower, *internally too confined* to admit *into it at once a
dozen bulky persons*, denominated a temple."

" An edifice," he resumes, " like the Pillar Tower,
might easily serve for a belfry ; and there are in-
stances where it has been converted, in modern times,
to that use ; on the other hand a temple, properly
speaking, gives an idea of a spacious edifice, or of one
calculated to accommodate, withinside its walls, a cer-
tain congregation of devout people, met to pray.
Should the building, to answer any partial or private
use, be constructed upon a diminutive scale, like the
little round temple at Athens*, called Demosthenes'

* This incomparably beautiful object, constructed of white marble, in
the days of Demosthenes, in the second year of the one hundred and
eleventh Olympiad, 335 years before Christ, and in the year 418 of Rome,
was erected in honour of some young men of the tribe of Archamantide,
victors at the public games, and dedicated, it is supposed, to Hercules.

the edifice," he continues, " in that case, obtains its appropriate shape, yet differing in plan, size, and elevation, from the Irish Pillar Tower, to which it cannot, in any one respect, be assimilated."

" Moreover," he says, " the ancients had *hardly* any round temples. Vitruvius barely speaks of two kinds, neither of which bears the slightest resemblance to a tower. Upon the whole," concludes he, " if we will but bestow a moment's reflection on the geographical and political condition of primitive Ireland, and the avowed *tardy* progress towards civilization, and an acquaintance with the fine arts, then common to those nations not *conveniently* placed within the enlightened and enlivening pale of Attic and Roman instruction, it will be impossible not to pronounce *Vallancey's* conjectures respecting the Pillar Tower, as receptacles for the sacred fire, altogether chimerical and fabulous."

Before I proceed to demolish, *seriatim*, this tissue of cobwebs, I wish it to be emphatically laid down that *I* do not tread in General Vallancey's footsteps. To his undoubted services, when temperately guarded, I have already paid the tribute of my national gratitude; but, pitying his mistakes, while sick of his contradictions, I have taken the liberty to *chalk out my own road.*

Now for Montmorency. As to the first, then, of those objections against the antiquity of our Round Towers, it is readily repelled by explaining that, in the early ages of the world, masonic edifices, of architectural precision, were exclusively appropriated, as a mark of deferential homage, to the worship of the *Great Architect* of the universe ; and with this view it was that the science was, at *first*, studied as a sort of

religious mystery, of which there can be required
no greater possible corroboration than the circum-
stance of that *ancient* and *mysterious* society who
date the existence of their institution from Noah him-
self, and it is incomparably older, still retaining—
amid the thousand changes which the world has since
undergone, and the thousand attempts that have been
made to explore and explode their secrets—the
mystic denominational ligature of " *Free and Accepted
Masons* *."

The absence, therefore, of any vestiges of other
coeval structures, for private abode or public exhibi-
tion, should excite in us no surprise ; more especially
when we recollect that in the East also,—whence all
our early customs have been derived,—their mud-built
houses present the greatest possible contrast between
the simplicity of their domestic residences, and the
magnificence and grandeur of their religious con-
venticles—Verum illi delubra deorum pietate, domos
suâ gloriâ decorabant †.

But though this my reply is triumphantly subver-
sive of the Colonel's first position, I shall dwell upon
it a little longer, to hold forth, with merited retalia-
tion, either his disingenuousness or his forgetfulness ;
because the same inference which he deduced from
the non-appearance of coeval architecture of any *other*
class, would apply as well to the period which *he*
wishes to establish as the era of the erection of the

* The first name ever given to this body was *Saer*, which has three
significations—firstly, *free ;* secondly, *mason ;* and thirdly, *Son of God.*
In no language could those several imports be united but in the
original one, viz., the Irish. The Hebrews express only one branch of
it by *aliben ;* while the English join together the other two.

† Sallust, Cat. Con.

Towers,—and of which era, he admits, no other archi-
tectural monuments do remain,—as to that which I
shall incontrovertibly prove was their proper epoch.

Then, without having recourse to the *impossibility*—
of which all travellers complain—to ascertain even the
situation of those gigantic cities which in other parts
of the globe, at equally remote periods of time, were
cried up as the wonders of the age—the master-
pieces of human genius, making their domes almost
kiss the stars—without betaking myself, I say, to
those, the only memorials of which are now to be
found in that of the *echo*, which, to your affrighted
fancy, asking inquisitively and incredulously, " Where
are they ?" only repeats responsively, " Where are
they ?"—passing over this, I tell him that, more highly
favoured than other countries, we possess, in Ireland,
ample evidences of those remnants which he so vaunt-
ingly challenges. Traverse the isle in its inviting
richness, over its romantic mountains and its fertile
valleys, and there is scarcely an old wall you meet, or
an old hedge you encounter, that you will not find—
imbedded among the mass,—some solitary specimens of
chiselled execution, which, in their proud, aristocratic
bearing, afford ocular and eloquent demonstration of
their having *once* occupied a more respectable post.

Not less futile than the foregoing is his second
objection, arising from what he represents as the
silence of " the busy and fantastic bard." Doubtless
he reckoned upon *this* as his most impregnable bat-
tery ; and I readily believe that most of his readers
anticipate the same result ; but this little book will
soon shiver the fallacy of such calculations, and ad-
duce, in its proper place,—from the very head and
principal of the *bardic order*, no less a personage than

Amergin himself,—its *towering* refutation ; as well as the *final,* incontrovertible appropriation of those structures to their *actual* founders.

In the interim, I must not let the opportunity pass of vindicating our ancient bards from the false imputations of " busy and fantastic."

If pride of descent be a weakness of Irishmen, it is one in which they are countenanced by all the nations of the globe who have had anything like pretensions to support the claim ;—and I fearlessly affirm, that the more sensitive a people prove themselves of their national renown, their hereditary honour, and ancestral splendour, the more tenacious will they show themselves, in support of that repute,—whether as individuals or a community,—in every cause involving the far higher interests of moral rectitude, of virtue, and of religion. In the legitimate indulgence of this honourable emotion, the Irish have ever stood conspicuously high. No nation ever attended with more religious zeal to their acts and genealogies, their wars, alliances, and migrations, than they did : and while no people ever excelled them in enterprise or heroism, or the wisdom and administration of their legislative code, so were they surpassed by none in the number and capability of those who could delineate such events, and impart to reality the *additional charm* of imagery and verse.

The Bards were a set of men exclusively devoted, like the tribe of Levi amongst the Israelites, to the superintendence of those subjects. Their agency in this department was a legitimately recognized and graduate faculty ; and, in accuracy of speech, the only one which merited the designation of *learned ;* being attainable only after the most severe novitiate of preliminary study, and rigid exercise of all the mental powers.

The industry and patience bestowed on such a course were not, however, without their reward. In a classical point of view *this* exhibited itself in the high estimation in which they were held, — both amongst foreigners and natives,—as poets, as prophets, and as philosophers ; while the dignity and emolument attached to their situation, and the distinguished rank assigned them, at the general triennial assemblies of the state, at Tara,—with the endowments conferred upon them by the monarch and the several provincial kings,—were sure to render it, at all times, an object of ambition and pursuit, to members of the noblest families throughout the various parts of the realm.

The moral deportment and personal correctness of those literary sages contributed still further to add to their esteem ; and, probably, I could not succeed better, in depicting the almost *sanctity* of their general behaviour, than by transcribing a stanza, descriptive of the qualities which won to them, as a society, the mingled sentiments of veneration and of awe. It is taken from a very ancient Irish poem, and runs thus :—

> Iod na laimh lith gan ghuin,
> Iod na beorl gan ean neamhuib,
> Iod na foghlama gan ean ghes,
> Is iod na lanamh nas.

That is,—

> Theirs were the hands free from violence,
> Theirs the mouths free from calumny,
> Theirs the learning without pride,
> And theirs the love free from venery.

In later times, I admit there was a lamentable degeneracy in the bardic class ;—or rather the innumerable pretenders to the assumption of the name, and the " fescennine licentiousness " with which they vio-

lated the sanctity of domestic seclusion,—in exposing
the objects of their private spleen,—tended not a little
to bring their body into disrepute, and subject them
additionally to the salutary restrictions of legisla-
tive severity.　They were not less extravagant in the
lavishment of their fulsome commendations ; so that
one can hardly avoid drawing a parallel between them
and those poetasters, formerly, of Italy, whom Horace
so happily describes in those remarkable hexameters,
viz.—

> " Fescennina per hunc invecta licentia morem,
> Versibus alternis opprobria rustica fudit,
> *　　　*　　　*　　　quin etiam lex
> Pœnaque lata malo quæ mallet carmine quenquam,
> Describi *."

You would imagine the Roman poet was speaking
of the Irish bards in the *night* of their decline ; but
the description by no means applies to the original
institution,—whose object it was to perpetuate the
history and records of the nation, and preserve its
history from the intrusions of barbarism.　To this end
it was, that they met for revision at the senatorial
synod ; and the importance of this trust, it was, that
procured to their body the many dignities before de-
scribed,—giving them precedence above the aggregate
of the community at large, and investing them with
an authority little short of royalty.

Rhyme was the vehicle in which their lucubrations
were presented ; verse the medium selected for their
thoughts.　To gain perfection in this accomplishment,
their fancies were ever on the stretch ; while the
varieties of metre which they invented for the purpose,
and the facility with which they bent them to each

* Lib. xi. Epist. 11.

application and use, were not the least astonishing part of their arduous avocations, and leave the catalogue of modern measures far away in the shade.

Music is the sister of poetry, and it is natural to suppose that they went hand in hand *here*. In all countries, the voice was the original organ of musical sounds. With this they accompanied their extemporaneous hymns ; with this they chanted the honours of their heroes. The battle-shout and the solemnity of the hour of sacrifice were the usual scenes for the concerts of our ancestors. Singing the glory of former warriors, the combatant was *himself* inspired ; and while the victim expired on the altar of immolation, the priest sung the praise of the deity he invoked.

The introduction of the Christian truths gave a new and elevated scope to the genius of the bards. A new enthusiasm kindled up their ardour—a new vitality invigorated their frames ; and they who, but the moment before, were most conspicuous in upholding the dogmas of the pagan creed, became now the most distinguished in proclaiming the blessings of the Christian dispensation. Fiech, Amergin, Columba, Finan, &c., are glorious examples of this transmuted zeal.

About the twelfth or thirteenth centuries, however, a change burst forth for the destinies of this order. Verse ceased to be used in their historical announcements. Prose succeeded, as a more simple narrative ; and from that moment the respectability of the bards progressively evaporated.

The jealousy of the English government at the martial feeling excited by their effusions, and the intrepid acts of heroism inculcated by their example, if not the actual cause of this national declension, pre-

ponderated very largely amongst its component ingredients.

In the height of the battle, when the war-cry was most loud, and the carnage most severe, those poetic enthusiasts would fling themselves amongst the ranks of the enraged contenders, and determine the victory to whatever party they chose to befriend.

When, too, under the pressure of an untoward fate, and the disheartening yoke of—what they deemed—a treacherous subjugation, the nobles would seem dispirited at the aspect of circumstances, and all but subscribe to the thraldom of slavery, the bards would rouse the energies of their slumbering patriotism, and, as Tyrtæus used the Spartans, enkindle in their bosoms a passion for war. We must not be surprised, therefore, to find in the preamble to some of the acts passed in those times for the suppression of this body of men, the following harsh and depreciating allusions; viz., " That those rymors do, by their ditties and rymes made to divers lords and gentlemen in Ireland, in the commendacyon and high praise of extortion, rebellyon, rape, raven, and outhere injustice, encourage those lords and gentlemen rather to follow those vices than to leave them."

For two centuries after the invasion of Henry II., the voice of the Muse was but faintly heard in Ireland. The arms of Cromwell and William III. completely swept away her feudal reminiscences. As it was their country's lustre that inspired the enthusiasm of the bards, so, on the tarnishing of *its* honour, did they become mute and spiritless. They fell with its fall; and, like the captive Israelites, hanging their untuned harps on the willows, they may be supposed to exclaim, in all the vehemence of the royal psalmist,—

> " Now while our harps were hanged soe,
> The men whose captives there we lay
> Did on our griefs insulting goe,
> And more to grieve us thus did say :
> You that of musique make such show,
> Come, sing us now a Zion lay.—
> Oh ! no, we have nor voice nor hand
> For such a song in such a land."

Montmorency's *third* objection against the antiquity of the " Round Towers,"—founded on the statements of those Greek and Latin writers above named, respecting the " barbarous " condition of the *then* Irish, —I thus dissipate into thin air.

The inhabitants of Ireland, at the time in which those authors flourished, had nothing to do with the erection of the Round Towers. Those edifices were hoary with antiquity at that moment. They belonged to an æra and to a dynasty, not only of a more ancient but of a more exalted character in every sense of the word, and whose religious ceremonials, for the celebration of which the Round Towers were constructed, the *then* inhabitants did not only abhor, but did all in their power to efface and obliterate. Nor was it the religion alone, of this inoffensive and sacred tribe, that this new and devastating race of militants laboured to extirpate ; but, what was far more to be deplored, they, for a season, extinguished their literature also ; until at length, fired by the moral ether which the lessons of their now slaves had inspired, their souls got attuned to the sublimity of such studies, and they sat themselves down accordingly to emulate their instructors.

As to the puny detractions, therefore, of either Greece or Rome, they might well have been spared, as they knew *less* than *nothing* of our real history.

When they were lowly and obscure, and immersed in the darkness of circumambient benightment, our high careering name, *synonymous* with civilization, was wafted by the four winds of heaven to all the quarters of the world which that heaven irradiates. The commerce of the whole east pressed tumultuously to our shores—the courts of the polished universe (not including Greece or Rome amongst the number) sent us embassies of congratulation ; while the indomitable ardour and public-spirited zeal of the " islanders" themselves launched them abroad over the bosom of the wide watery circumference ; exploring in every region the gradations of civil institutes, as well as the master productions of Nature herself ; civilizing life with the results of their discoveries, and garnishing their houses, like so many museums, with the fruits of their research, for the benefit, at once, and entertainment of their less favoured, though not less ambitious brethren at home.

Think you that the testimony of Festus Avienus, who wrote before the Christian light, and who, avowedly, only compiled his treatise from other more ancient authorities—think you, I say, that *his* designation of this island as " sacred,"—and which he says was the appropriate denomination by which the still greater ancients used to call it,—was an idle sobriquet or an arbitrary adjective ? Amongst the many discoveries which will develop themselves in succession, before I shall have done with this little book, I pledge myself to the public incontrovertibly to prove, that the word " *Hibernian*,"—so grossly abused and so malignantly vilified, and which Avienus has recorded as the name of the *islanders* at the period in which he wrote, as it is still to this day—signifies—in its *com-*

ponent essence, and according to the nicest scrutiny of etymological analysis, independently *altogether* of historical corroboration—*an inhabitant of the sacred isle ;* and has *nothing* on earth to do with *Heber* or *Heremon ;* or *hiar,* the west ; or *iberin,* extremes ; or any other such outlandish nonsense !

Now comes the Colonel's *fifth* and *last* objection ; viz., that because there existed at Baal Heremon, in India, a temple sacred to Baal, the capacity of which was sufficient to accommodate four thousand persons, therefore the Round Towers, which are " internally too confined to admit into them, at once, a dozen bulky persons, could not be denominated a temple."

Does not the Colonel know that there existed a plurality of those Baals? that, in fact, they were as innumerable as the stars in the firmament, resolving themselves—according to the character of every distinct country, and of every minor subdivision and canton in that country—into the specific and gentile classifications of Baal Shamaim, Baal Pheor or Phearagh, Baal Meon, Baal Zephon, Baal Hemon, &c. ; while under the *veil* of all, the learned ever understood to have been solely personated, the sun and moon. " Howbeit every nation made gods of their own, and the men of Babylon made Succoth-Benoth *."

In accordance with the *different* views under which each people considered the *bounties* of those luminaries, so did their temples assume a corresponding shape ; and it shall be my lot, in the progress of this litigated research, to show why the followers of one of those Baals, namely, Baal Phearagh, gave their temples this *erect, narrow,* and *elevated roundness.*

I have thus annihilated those visionary ramparts,

* 2 Kings xvii. 29, 30.

which my opponent had flattered himself he had raised
against the intrusion of long-suppressed truth ; and
by the help of which, as a military bastion, he had
fondly hoped he might link together the church and
the sword in one *cemented* bond of anachronism. Let
us see, however, how he would bring about the match,
with the articles of intermarriage, and so forth.

His assumption is, that " the founders of those
Towers were primitive Cœnobites and Bishops, *muni-
ficently* supported in the undertaking by the newly-
converted kings and toparchs; the builders and
architects being those monks and pilgrims who, from
Greece and Rome, either preceded or accompanied
our early missionaries in the fifth and sixth cen-
turies ;" which he pretends to substantiate in the
following manner.

Having discovered, by a most miraculous effort of
penetration, that one hundred and fifty Greek and
Roman religionists had accompanied St. Abhan on
his return from imperial Rome,—whither he had gone
to complete his theological studies, towards the end of
the fifth century,—and not knowing how to occupy
those strangers in this *then pagan* land, the Colonel,
with his industrious habits, well aware that " idleness
is the mother of mischief," sets them, at once, about
building the Towers.

But as it would be too lavish a display of knight-
errantry to waste their time and strength without some
ostensible purpose, he must, of course, find out for
them a pretext, at least, for such ; and so, in the eager-
ness of his milito-monastic zeal, he flies off, at a tangent,
to the top of mount Colzoum, near the desert of Gebel,
—"a short day's journey from the Red Sea,"—where he
thinks he has got, in the monasteries of the Egyptian

monks, a direct, immediate, and indubitable proto-
type.

Reader, you shall be the judge. Here is his own
translation of Bonnani's description of the place, viz.

" There are three churches, of which St. Anthony's,
which is small and very old, is the most distinguished;
the second is dedicated to the apostles Peter and
Paul; and the third church is raised in honour of St.
Macaire, who has been a lay brother in this convent.
All of the cells stand separately from each other; they
are *ill built*, the walls being composed of clay, covered
in with flat roofs, and diminutive windows only one
foot square. Close to the refectory, which is dark
and dirty, the monks have added a rather decent apart-
ment, in their wonted hospitality, destined to the
reception of visiters.

" Within the central court-yard, an isolated *square
tower* of masonry, which is approached by a drawbridge,
holds a formidable station. Here the Cophtes preserve
whatever wealth or precious objects they possess;
and if assailed by the plundering Arabs, defend them-
selves with stones. There are four more celebrated
monasteries in the desert of St. Macaire, distant about
three days' journey from Grand Cairo. The first is
the convent of St. Macaire, which is ancient and in a
ruinous state—the bones of the founder are enshrined
in a stone coffin, placed behind an iron gate, en-
veloped in a chafe or pluvial (a sort of church orna-
ment), formed into a canopy. A *square tower* of
stone, which you enter by a drawbridge, is the only
solid building belonging to the Abbey that remains.
The friars store their books and their provisions, and
obstinately defend themselves in this *hold*, whenever
the wild Arabs come to pay them a predatory visit.

" There are *similar* (square) towers attached to the
three other monasteries in the desert, the doors of
which, and of the convent of St. Macaire, are alike
covered with iron plates," &c. &c.

To the candid and dispassionate reader,—who has
gone through this extract, and who is told that *this* is
the *basis* upon which Colonel de Montmorency builds
his superstructure of monastic appropriation,—to such
I fearlessly appeal whether he will not scout the in-
dignity with *intellectual* scorn.

Here are edifices spread, *in numbers*, over our
island, in unity of design and elegance of execution,
admitted by this writer himself as " the most imposing
objects of antiquity in all Christendom," and " placed
by an almost supernatural power to brave the stormy
winds and the wrath of time ;" yet, in the same breath,
made the counterparts of a *few trumpery*, *temporary*, and
crazy old piles, which were originally erected as mili-
tary stations, totally distinct from religion or religious
uses—similar to those erected by Helena, mother to
Constantine the Great, on the coast of Syria, against
piratical incursions, and analogous to what we find
in India, viz., a whole fortress converted into a con-
ventual establishment. The thing is absurd,—it is
revolting to *common sense*,—and bears on its forehead
its own discomfiture.

CHAPTER III.

OBSERVE, then, the structures which he compares are altogether different; one being *square*, and the other round. Nor, in the whole *compass* of *possible analogies*, is there a single feature in which the two *classes* of edifices could be *said* to correspond, but that they both have their doors—which, by the way, are different in their form—at a distance from the ground. The *Pyramids* of Egypt bear the same correspondence, —their entrance being one-third of the height from the surface—and why does not the Colonel bestow *them* also upon the monks? No; those poor, denuded, inoffensive, exemplary, *unearthly* victims of maceration, were incapable of, either the masonic acmé, or,—at the era which Montmorency particularises,—of the corporate influence and pecuniary or equivalent supplies, indispensable for the erection of either " pyramid " or " tower ; "—contenting themselves rather with their *lowly cells*, whence they issued out, at all seasons, to diffuse the word of " life," than in raising *maypoles* of stone, within which to garrison their *inexpressible* treasures.

But to reconcile this discrepancy in exterior outfit, he has recourse to a miracle, which he thus conjures up. " Doubtless, in the *beginning*, when first those Cœnobites settled in the desert, the convent-tower was round ;" then, by a single word, *præsto*,—or

" doubtless "—right-about face, takes place a meta-
morphosis, from round to square !—the more miracu-
lous, in that the *former round* ones left behind them
no vestiges ! Upon which, again, a counter miracle
is effected ;—" The square ones having subsequently
fallen into disuse, the round tower, in after ages,"—he
says,—"appears to have acquired a degree of increased
celebrity, especially in *Europe*, during the preponder-
ance of the feudal system, when every baronial castle
in Great Britain, Ireland, Germany, France, &c., was
furnished with one or more." Now, has he not before
told us, and told us *truly, by chance,* that the Pillar
Tower *scorns* all kind of affinity with those " *barba-
rians ;"* whereupon I shall merely observe with the
poet, that—

> " If people contradict themselves, can *I*
> Help contradicting them * ?"

But, if intended as a place of shelter for either
person or *property,* why build them of such an alti-
tude ? Above all things, why not build them of such
internal capacity as to accommodate the *whole* number
of inmates in each convent, in case of an attack,—as, in
fact, those *square* towers in the desert used ; whereas,
" a *dozen bulky persons"* could not squeeze together
into one of our Round Towers ; and accordingly, with
the inconsistency inseparable from error, our author
himself proclaims, that " it has frequently occurred
that the *barbarian,* on finding that he had been foiled
in his search after treasures, though he burned the
abbey, and perpetrated all the mischief he was able,
sooner than retire empty-handed, the *pirate* seized on
the abbot, or most prominent member he found be-

* Byron.

longing to the community, and hurried away the un-
fortunate individual on board his ship, holding him in
durance, till, overcome by ill-usage, he besought his
brethren to come to his relief with a heavy ransom for
his freedom." "It has also often happened," he adds,
"that, unable to comply with the tyrant's exorbitant
demands, the monks resigned the captive to his fate."

Surely, if they had those *keeps* to fly to, the "un-
fortunate" abbot need not allow himself to be seized
at all : and surely, also, if they had all those treasures
upon which the Colonel insists, they would not leave
the father of their "community" unredeemed from so
excruciating a degradation. And hence we may con-
clude with Dr. Lanigan, "What little credit is due
to the stories of some hagiologists, who talk of great
estates granted to our monasteries and churches in
those and even earlier times *." Indeed, for the two
first centuries subsequent to the arrival of St. Patrick,
such a thing was incompatible with the nature of the
"political compact" in Ireland.

I do not deny, however, but that the ecclesiastics of
this time did possess some articles of value appertain-
ing to the altar, and that these were objects of unholy
cupidity to the Danes : nay further, I admit that, to
escape from the insatiability of those virulent marau-
ders, they used to fly to the belfries, which—from that
mistaken regard attached to these edifices, as the re-
ceptacles of those sonorous organs to which super-
stition has ever clung †—they had hoped would prove

* Vol. iii. p. 78—Note.

† The tolling of a bell was supposed to have had miraculous effects—
to keep the spirits of darkness from assaulting believers—to dispel thun-
der, and prevent the devil from molesting either the church or congre-
gation ; and hence they were always rung, in time of storm or other

an asylum from their pursuits,—but in vain—neither religion nor superstition opposed a barrier to the North-men, while the frail materials whereof those belfries were constructed afforded a ready gratification to their appetite for destruction.

The Ulster Annals, year 949, furnish us with the following fact : " Cloicteach Slane do loscadh do Gall Athacliath. Bacall ind Erlamha, 7 cloc badec do cloccaibh, Caenechair Ferleghinn, 7 sochaide mor inbi do loscadh." That is, The belfry at Slane was set fire to by the foreigners (the Danes) of Dublin. The pastor's staff or crozier, adorned with precious stones, besides the principal *bells*, and Canecar the lecturer, with a *multitude* of other persons, were burned in the flames. The Annals of the Four Masters, noticing the same event, use nearly similar words :—" Cloicteach Slaine do loscadh can a lan do mhionnaibh 7 deghdh aoninibh, im Chæinechair Fearleighinn Slaine, Bachall an Eramha 7 *clocc* ba deach do chloccaibh." That is, The belfry at Slane was *burned to the ground*, along with several articles of value which were therein, and *numbers* of *individuals*, besides the Slane prælector, the patron's staff, and all the bells, which were there of *most* worth.

Now take notice that within those " belfries " a " *multitude* of persons " used to have been collected,

attack, to paralyze the fiend, whether the elements or mortal man, by the hallowed intonation. Each was dedicated to a particular saint,—duly baptized and consecrated ; and the inscriptions which still remain on the old ones that have come down to us proclaim the virtue of their capabilities. The following distich will be found to sum them up, viz. :—

" Laudo Deum verum, plebem voco, congrego clerum,
 Defunctos plero, *pestem fugo*, festa decoro.'

And the very syllables of this which follows form a sort of *tuneful* galloping, viz. :—

" Sabbata pango, funera plango, solemnia clango."

whereas the Round Towers could not accommodate above " a dozen " at one time. The belfries also are represented to have been reduced to ashes by the conflagration, which accords with the description given by both Ware and Colgan, of the *wooden* substance whereof they were composed; whereas the Round Towers are made of *stone,* and cemented by a bond of such indurated tenacity, that nothing short of lightning or earthquake has been known to disturb them :— and even though other violence may succeed in their overthrow, yet could it not be said with any accuracy that they were reduced by *fire* to cinders. But, above all, those very Annals which I have above quoted, when recording a greater and national calamity, place the belfries and the Round Towers in the same sentence, *contradistinguished* from one another,—the former characterized by their appropriate name of *Cloicteach,* as exhibited before, and the latter under the still more apposite denomination of *Fidh-nemeadh,* as we shall explain elsewhere.

Again, if designed as fortresses for the monks, and receptacles for their riches, is it not strange, that in the isle of Hy,—which was literally a nest of ecclesiastics, and which Columb Kill himself evangelized at the time when Montmorency was,—in a *dream,*—employing him and his coadjutors at the erection of the Round Towers,—is it not strange, I say, that this little isle, the most defenceless, as it is, and forlorn, of all lands that ever projected above the bosom of the sea, should yet, in the allotment of monastic artillery, be left totally destitute of an *aërial* garrison ?

And yet, notwithstanding the absence of such defences, the monks still continued to make it their favourite abode ; of which we have but too cogent an

evidence in the record of the Four Masters, under the year 985, stating that the abbot and fifteen of his brethren were slain by the Northmen on Christmas-day, just as they were preparing to celebrate the nativity of their Redeemer.

But those monks spread themselves, in *shoals*, over England also ; and we know that *that* country was even more infested than our own with both Northmen and Danes. Is it not astonishing, therefore, that the English convents were not protected against the sacrilege of those savages by telescopic steeples of *Babylonish cement ?*

This, it may be said, is applying a steam-engine to crush a flapwing; yet, as that flapwing has been somewhat troublesome, and has contrived to blindfold some searchers after antiquarian *truth,* I may be excused if, to frustrate any efforts at impotent revivals, I shall continue decapitating the hydra, until he disappears in his own sinuosities.

He tells us, then, with all the calculation of an engineer, and the gravity of a physician, that a stone let fall from the top of one of those towers would crush the " barbarian " to atoms. True, it would, and the *civilian* also. A little pebble let fall from an eagle's beak, as he cuts his aërial passage through the cloudy regions, or soars aloft into the empyreal of interminable space, would have a similar effect ; but it would puzzle the shrewdest engineer in Christendom to place a ballast-man, with a big stone on his lap, on either the top or the sloping sides of the conical " caubeen " which graces the summit of our careering cylinders. This, to use the Colonel's own words, " will be admitted to be contrary to all that is admissible in the rules of architectural proportions."

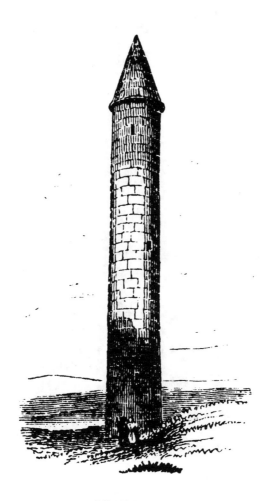

DEVENISH.

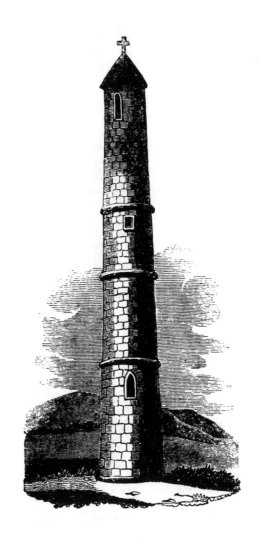

ARDMORE.

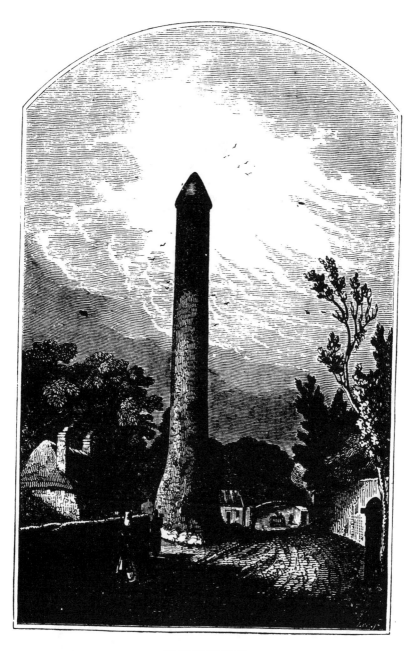

CLONDALKIN.

FROM THE RUINS OF THE PALENCIAN CITY.

Next, remark that the Colonel keeps those 150 " volunteers" at work upon the " Round Towers," in the midst of a raging war;—after he had before affirmed that they could only be erected in a season of profound peace—for a complete century. During this whole time they must, of course, have availed themselves of the assistance of the inhabitants; and is it not marvellous that, during that long time, " the ancient Irishman,"—and " Pat's nae stupid fellow," as the Colonel himself avows,—should not have been able to pick up a single insight into the arcana of the masonic art?—but that, soon as ever the dear externs expired,—who at the period of their arrival must have been, at least, over twenty years of age, each, and who, to accomplish Montmorency's miracle, must have, every one of them, lived just one hundred years more, and then died, all in one day!—is it not *petrifying*, I say, that soon as ever this appalling catastrophe occurred, every vestige of those " fairy" masons should have vanished along with them?—and the country, in a *paralysis*, have forgotten to associate them with the " Towers," as if stupified with the incantation of a wizard or a talisman!

And yet this was not the greatest injustice of which the poor Cœnobites got reason to complain; but it *is* that, when the people had recovered from the delirium of their late trance, and began to look abroad for some " authors" on whom to *father* those edifices, they unanimously, though unaccountably, agreed to lay them at the door of the " O'Rorkes" and the " Mac Carthy Mores!"

It so happens that the last of the Mac Carthy Mores was my *own* maternal grandfather; and he, venerable and venerated old gentleman, apt as he was, in the

evening of his faded life, to revert to the mutability of worldly possessions, never, for a moment, bestowed a solitary thought upon the alienation of the property of those columnar masonries. Often used he to mention the castles of Palace and of Blarney : Castlemain and Glenflesk used still oftener to grace his talk ; but oftener still, and with more apparent delectation, would he dilate on the *Castle* of Macroom and the *Abbey* of Mucruss,—all, as the creation of *immediate* or *collateral* branches of his family ; but never, in the catalogue of his patrimonial spoliations, did he enumerate a " *Round Tower*," or lay a shadow of claim to their construction.

To the point, however.—The great miracle, after all, is, that after the decease of those " fairy " masters, no one of their native helpmates could be found able to join together, with mechanical skill, two pieces of hewn stone with the intermediate amalgam of adhesive mortar ! The thing is so absurd as to make the Colonel himself, in his honesty, to exclaim, " Is this simple process that mighty piece of necromancy which, according to some authors (forgetting that he was one of those himself), that *lively* people were unable to comprehend ? " It is amusing to see how encomiastic and commendatory he is of the " Hibernians," when it answers his views ; and how vituperative and condemnatory, when it is equally to his purpose.

The last assumption of this writer, and which I have purposely reserved until now, is an affected parallel of the Irish Culdees with the Egyptian Cophtes. " Their great piety, austerity, and hospitality announce," he says, " the existence of one kind of discipline, and of kindred religions, between the

Cophtes and the Irish Cœnobites." That is, because they are both *pious, austere,* and *hospitable,* they must both necessarily correspond in *religious opinions* and in *Church forms!* The Indian Brahmins, say I, are also *pious, austere,* and *hospitable ;* and why are they not incorporated in this holy identification? No, Colonel, it will not do; I see what you are at. You want to insinuate our obligation to the Greeks for the blessings of the Gospel. A false zeal for mental emancipation,—subsequent to the dislodgment of spiritual encroachment,—has forced into mushroom existence this spurious abortion. Aloof from the thraldom of Roman or other yoke, the Irish, within themselves, cultivated the principles of the Christian verity; but it is, in the extreme, erroneous to say, that they derived their *faith* in that verity through emissaries of the Grecian church, from whom they differed as substantially as light does from darkness.

I think it very probable indeed, that the glad tidings of revelation were first imparted to Ireland by the lips of St. Paul himself*. We have the names of many Christians existing amongst us before the arrival of either Pelagius or Patrick. The very terms of the commission, which pope Celestine gave to the *former,* being addressed " ad Scotos in Christum credentes," to the *Irish who believe in Christ,*—prove the good seed had been laid in the soil before *his* pontificate. The nation, however, was yet too much immersed in its

* υπερ τον Ωκεανον παρελθειν επι τας καλουμενας Βρετανικας νησους.

Euseb. in Præp. Ev. l. 3.

Egyptum et Libyam sortitus est alius Apostolorum, extremas vero oceani regiones, et *Insulas Britannicas* alius obtinuit.

Nicephor., l. 2, c. 40.

old idolatries—and the fascinations of their former
creed had so spell-bound the inhabitants, as a com-
munity—that those who singled themselves out as
converts to the new faith were obliged, from persecu-
tion, to betake themselves to other countries. And
yet *this* is the moment, when paganism was omnipotent
throughout this island, that Colonel de Montmorency
has the modesty to tell us that the " Round Towers "
were erected as magazines for the monks !

To the *Patrician Apostle*, the beloved patriarch of
Ireland, was reserved the glory of maturing the fruit
which his predecessors had planted. His constitu-
tional zeal and absorbing devotion, in the service of
his Creator, were but the secondary qualifications
which pre-eminently marked him out for so hazardous
an enterprise. The primary and grand facility which
this *true hero* possessed for the attainment of his great
design, was his intimate converse with the manners
and language of the natives,—obtained during his cap-
tivity not long before,—which making way at once to
the *hearts* of his auditory, was an irresistible passport
to their heads and their understandings.

In the sequel of this volume it will be fully shown,
that when St. Patrick entered upon his prescribed task,
—towards the close of the fifth century,—the monarch
and his court were celebrating their pagan festival, or
preparing for it, on the hill of Tara. Can a nation be
called Christian where the sovereign and court are
Pagan ? Or will a few exceptions from the mass of
the population be indulged with fortresses of im-
perishable architecture, while the nation at large took
shelter within *wattles* and walls of clay ?—and that, too,
at a moment when Christianity was considered a name

of reproach, and its few solitary abettors constrained to exile or to degradation !

No sooner, however, were the simplicities of Christianity expounded to the natives through the medium of their native tongue, than the refined organism of the Irish constitution, habituated by discipline to sublime pursuits, took fire from the blaze of the sacred scintilla, and enlisted them as its heralds, not only at home but throughout Europe.

Precisely at this instant it was that all the *ancient* names of places in the island—recorded by Ptolemy from other foreign geographers,—were changed and new-modelled—the converts—"*ut in nova deditione*,"—not thinking it sufficient to abandon the forms of their previous belief, and adopt the more pure one, if they did not obliterate every vestige of nominal association, which could tend to recall their fancies to the religion which they relinquished. Accordingly from the names of Juernis, Macollicon, Rhigia, Nagnata, Rheba, &c , sprung up the names of Killkenny, Killmalloch, and the thousand other names, commencing with " Kill," to be met with in every district and subdivision throughout the country.

Every corner was now the scene of Christian zeal ; and every neophyte strove to surpass his neighbour in evincing devotion to the newly-revealed religion. " Kills," or little churches—from the Latin *cella*, now for the first time introduced—were built in the vicinity of every spot which had before been the theatre of pagan adoration—whether as cromleachs, as mithratic caves, or as Round Towers. These were the memorials of *three distinct species* of paganism, and were, therefore, now singled out as appropriate sites for the erection of Christian " Kills," the ruins of

which are still to be traced, contiguous to *each* of those idolatrous reminiscences,—disputing with the false divinities the very ground of their worship, and diverting the zeal of the worshippers from the creature to the Creator.

Nay, to such a pitch did the crusaders, in their conflict, carry the principle of their enthusiasm, that many of them adopted the names of their late idols, and intertwined *those* again,—now christianly appropriated,—with the *old* favourite denominations of many of the localities. For instance, St. Shannon assumed *that* name from the *river* Shannon, which was an object of deification some time before ; and St. Malloch adopted *this* name from the city of Malloch, that is, the Sun, or Apollo,—the supreme idol of pagan Ireland's adoration,—from which again, with the prefix " Kill," he made the name Kill-*malloch*,—the latter alone having been the ancient name of the place, converted by Ptolemy into " Macollicon ;" which is only giving his Greek termination, *icon*, to the Irish word, *Malloch*, and transposing, for sound sake, the two middle syllables.

Chaildee was the pious but appropriate epithet by which those patriarchs of Christianity thought fit to distinguish themselves. The word means *associate of God*. Having obtained the gospel from the see of Rome, they adhered implicitly,—yet without conceding any *superiority*,—to the Roman connexion— agreeing in all the grand essentials of vital belief, and differing only as to some minor points of ecclesiastical discipline.

This variance, however, has afforded handle to some lovers of controversial doubt, to maintain that Ireland was never beholden to Rome for the gospel. The fallacy is disproved by the fact of all our early neo-

phytes betaking themselves, for perfection in the mysteries of revelation, to the Roman capital. On one of which occasions it was that Montmorency himself brought over his hundred and fifty volunteers, to accompany back one of those converted students, who had gone there to learn the very minuteness of the doctrine which the Romans inculcated.

It was not, remember, for ordinary or secular education that they betook themselves to Rome. The academies of Ireland far surpassed it in splendour. It was solely and exclusively to learn the particulars of their faith; and having once obtained this insight, they continued in spiritual unison with the tenets of that church, as to all fundamental points of doctrine : never surrendering, however, the independence of their judgment, nor bowing before the " *ipse dixit*" of any tribunal,—where *reason* was to be the guide,—until forced by the conspiracy of Pope Adrian IV. and his countryman Henry II.

How contemptible, therefore, is the effort, in the teeth of this exposure, to identify the Irish Chaildees with the Egyptian Cophtes ! There was no one point in which they may be compared, except their mutual *poverty ;* which, however, Montmorency overlooks, or rather contradicts, making them both wealthy, and have *banks* even for their riches. As, however, I look upon Dr. Hurd * as somewhat a better authority, you shall have what he says upon the subject :—

" Among the Ethiopians, there are still to be found some monks, called Coptics, who first flourished in Egypt, but, by no difficult sort of gradation, made their way into Ethiopia. They profess the utmost

* Religious Rites and Ceremonies, published under his name.

contempt for all *worldly things*, and look upon them-
selves as a sort of terrestrial angels. They are obliged
to *part with all their possessions before they can enter
upon a monastic life.*"

Their discrepancy in doctrine is even still more
notorious, agreeing with the Chaildees only in a *single*
instance also ; namely, in *both* denying the supre-
macy of the Pope. Here are the Doctor's words :—
" They deny the papal supremacy, and, indeed, *most
parts* of the popish doctrine, particularly transubstan-
tiation, purgatory, *auricular confession*, *celibacy* of the
clergy, and *extreme unction ;*" all which, save the first,
the Irish Chaildees maintained in *common with the see
of Rome.*

And now, on the point of education, I will content
myself with Montmorency's own testimony, which is
to this effect, viz. :—" Only on the score of erudition,
it must be acknowledged that the *Irish theologian*, as
history asserts, did not only *excel* the modern Greek
and Egyptian, but his profound acquaintance with the
sciences, arts, and *laws of his country*, gave him an
unrivalled superiority in the *literary* and civilized
world."

What, Colonel ! are those the " barbarians ?" Is
this what you mean by not being *conveniently situated*
within the *enlightened* and *enlivening* influence of
Greek and Roman refinement ? Alas ! you knew but
little of the real statement of the case :—whilst the
illustrious Fenelon, himself a descendant of this
boasted Rome, thus more accurately avows, " that,
notwithstanding all the *pretended politeness* of the
Greeks and Romans, yet, as to moral virtue and reli-
gious obligations, they were no better than the savages
of America."

I have been thus hurried on by the train of my thoughts, without observing much of order or methodical arrangement. As my object is, however, the elucidation of truth,—not idle display, or vain-glorious exhibition,—I am sure my readers will scarce murmur at the course by which I shall have led them to that end; in a question, moreover, where so many adventurers have so miserably miscarried.

So much the rather, thou celestial light,
Shine inward, and the mind through all her powers
Irradiate. There plant eyes ; all mist from thence
Purge and disperse ; that I may see and tell
Of things invisible to mortal sight *.

* Milton.

CHAPTER IV.

HAVING thus disposed of the word " Cloic-teach,"
which Dr. Ledwich so relied upon, as determining
the character of these antique remains, I take leave,
evermore, to discard the misnomer, and draw atten-
tion to a name which I have never seen noticed, as
applied to any of those pyramidal edifices. That
which I allude to is " Cathoir ghall," which means the
" Cathedral or temple of brightness" (" and *delight**;")
not, I must premise, from any external daubing, with
which modern Vandalism may have thought proper to
incrust it,—as happened to that at Swords,—but in
evident reference to the solar and lunar light,—the
sources of life and generation,—therein contemplated,
at once, and interchangeably venerated.

The particular Tower to which this epithet had
been assigned—and which it obtained, by way of
eminence, for its colossal superiority—is not now
standing †. It rose about half a mile distant from
the old castle of Bally Carbery, in the barony of
Iveragh, and county of Kerry; a place where one
would hope that the true designation of such phe-
nomena would be preserved most pure, being aloof
from the influence of exotic refinements, and, thus

* This latter to be explained hereafter.
† The ruins, to the height of ten feet, still remain.

far, free from that maudlin *scepticism* and laboured
doubt which a " little learning" too frequently super-
induces.

> Dear, lovely bowers of innocence and ease,—
> Seats of my youth, when ev'ry sport could please,—
> How often have I loiter'd o'er thy green,
> When humble happiness endear'd each scene !
> How often have I paused on every charm,—
> The shelter'd cot, the cultivated farm !
> While all the village train, from labour free,
> Led up their sports beneath the spreading tree *.

No combination of letters could possibly approach
closer, or convey to a discerning mind greater affinity
of meaning to anything, than does the above name to
the description given of them in the 12th century by
Giraldus Cambrensis, who calls them " *turres eccle-*
siasticas, quæ, more patriæ, arctæ sunt et altæ, nec non
et rotundæ." This definition, vague as it may seem,
affords ample illumination, when compared with the
epithet which I have above adduced, to penetrate the
darkness of this literary nebula. The word " *turres* "
points out their constructional symmetry, and " *eccle-*
siasticas " their appropriation to a religious use ; and
what can possibly be in stricter consonance with the
tenour of this idea than " Cathaoir ghall," or the
Temple of Brightness, which I have instanced above
as the *vernacular* appellation of one of those sanctu-
aries ?

Should it be asked, why did not Cambrensis, at
the time, enter more fully into the minutiæ of their
detail ? I shall unhesitatingly answer, it was because
he knew nothing more about them. The Irish had at
that moment most lamentably dwindled into a de-

* Goldsmith.

generate race. The noble spirit of their heroic an-
cestors, which had called forth those pyramids, for the
twofold and *mingled* purpose of *religion* and *science,*
had already evaporated; and all the historian could
glean, in prosecuting his inquiries, as to their era and
cause, was, that their antiquity was so remote, that
some of them may be even seen immersed beneath the
waters of Lough Neagh *, which had been occasioned
many ages before by the overflowing of a fountain†.

Let us now turn to the annals of the " Four Mas-
ters," which record the destruction of Armagh, A.D.
995, by a flash of lightning, and see under what name
they include the " Round Towers" in the general
catastrophe. Here is the passage at full length, as
given by O'Connor : — " *Ardmaeha do losc do tene
saighnein, ettir tighib,* 7 ‡ *Domhuliacc,* 7 *Cloic teacha,*
7 *Fiadh-Neimhedh :*"—that is, Armagh having been
set on fire by lightning, its houses, its cathedrals, its
belfries, and its *Fiadh-Neimhedh,* were all destroyed.

The Ulster Annals have registered the same event
in the following words :—" *Tene diait do gabail Aird-
maeha conafarcaibh Dertach, na Damliacc, na h Erdam,
na Fidh-Nemead ann cen loscadh :*"—that is, Lightning
seized upon Armagh, to so violent a degree, as to
leave neither mansion, nor cathedral, nor belfry, nor
Fidh-Nemead, undemolished.

Here we find *Fiadh-Nemeadh* to occur in both
accounts, while the belfries are represented in one
place as *Cloic teacha,* and in the other as *Erdam,*—and
in both are opposed to, and contradistinguished from,

* Top. Dist. ii. c. 9, p. 720.

† In the reign of Txiacha Labhruine, A.M. 3177 ; B.C. 827.

‡ This mark (7), in the Irish language, is an abbreviation for *agus,*
i.e. *and.*

the *Fiadh-Nemeadh.* Our business now is to investigate what this latter word conveys; and though I do not mean, for a while, to develop its *true interpretation,* —of which I am the sole and exclusive depositary,— yet must I make it apparent, that by it,—whatever way it must be rendered,—all before me have understood, were emphatically designated our Sabian Towers. Thus Colgan in his " Acts," page 297, referring to these words of the Four Masters, says, " Anno 995, Ardmaeha cum *Basilicis, Turribus, aliisque omnibus edificiis,* incendio ex fulmine generato, tota vastatur."

O'Connor also, wishing to wrest its import to his favourite theory of their having been *gnomons,* while ignorant of its proper force, indulges in a conjecture of the most lunatic *ostentation,* and translates *Fiadh-Nemeadh* by *celestial indexes.*

But though the word does not *literally* signify either " Towers,"—as Colgan, for want of a better exposition, has set forth,—or " celestial indexes,"— as O'Connor, equally at a loss for its proper meaning, has ventured to promulgate,—yet is it indisputable that it stood as the representative of those *enigmatical* edifices, as well as that both writers had the same structures in view as comprehended under the tenor of this *mysterious* denomination *.

These annals I look upon, in three different lights, as invaluable documents :—firstly, as they prove the existence of those edifices at the date above assigned ; secondly, as they show that they were distinct things from the belfries—whether cloicteach or erdam— which shared their disaster ; and, thirdly, because that, even admitting of O'Connor's mistranslation, it

* The Annals of Inisfallen, also, page 148, call them by the same name of *Fiadh-Nemeadh.*

gives us an insight into their character more for-
tuitous than he had anticipated. *Celestial indexes* * *!*
Could any one be so silly as for a moment to suppose
that this was a mere allusion to the circumstance of
their height? No; it was no such casual epithet,
or witty effort of hyperbole; but it was, what Sallust
has so truly said of the Syrtes, " *nomen ex re inditum.*"

The identity between this island and the " Insula
Hyperboreorum" of Hecatæus being to be completely
established in an ensuing chapter,—the *bungling* of
natives and the *claims* of externs notwithstanding,—
I shall not hesitate to assume as *proved*, that ours was
the " island" described.

Allow me then to draw your attention to an extract
from Diodorus's *report* thereof:—" They affirm also,"
says he, " that *the moon* is so seen from this island,
that it *appears not so distant* from the *earth*, and *seems
to present on its disk certain projections like the moun-
tains of our world.* Likewise that the *God Apollo* in
person visits this island once in *nineteen* years, in
which the *stars* complete their *revolutions,* and return
into their old positions; and hence this *cycle of nine-
teen years* is called, by the Greeks, the great year."

Who is it that collates this description with the
" celestial indexes †" above produced, that is not, at
once, struck with the felicity of the coincidence?
On earth, what could *celestial indexes* mean but such
as were appropriated to the contemplation of the
heavenly bodies?—just as the name of " Zoroaster,"
—which, in the Persian language, signifies " cœlorum
observator," that is star-gazer, or observer of the

* Rer. Hib. Scrip. Vet. iii. p. 527.
† *Fidh-Nemeadh* certainly admits of this interpretation, but in a very
different sense from what its author had supposed.

heavens,—was given to Zerdust, the great patriarch of the Magi, from his eminence and delight in astronomical pursuits.

Now, " the moon being so seen from this island that it appears not so distant from the earth," is so obvious a reference to the study of astronomy that it would be almost an insult to go about to prove it; but when it is said that " it presents on its disk certain *projections* like the mountains of our world," it not only puts that question beyond the possibility of dispute, but argues furthermore a proficiency in that department, which it is the fashion *now-a-days* to attribute only to *modern* discoveries.

But have we any evidence of having ever had amongst us, in those " olden times," men who by their talents could support this character? Hear what Strabo says of *Abaris*, whom " Hecatæus and others mention" as having been sent by his fraternity from the " *island* of the Hyperboreans" to Delos, in Greece, in the capacity of a sacred ambassador, where he was equally admired for his knowledge, politeness, justice, and integrity. " He came," says Strabo, " to Athens, not clad in skins like a *Scythian*, but with a bow in his hand, a quiver hanging on his shoulders, a plaid wrapt about his body, a gilded belt encircling his loins, and trowsers reaching from the waist down to the soles of his feet. He was easy in his address, agreeable in his conversation, active in his despatch, and secret in his management of great affairs; quick in judging of present occurrences, and ready to take his part in any sudden emergency; provident withal in guarding against futurity; diligent in the quest of wisdom; fond of friendship; trusting *very little* to *fortune*, yet having the entire confidence of others,

and trusted with everything for his prudence. He spake Greek with a fluency, that you would have thought he had been bred up in the Lyceum, and conversed all his life with the Academy of Athens *."

This embassy is ascertained to have taken place B.C. 600; and from what shall be elsewhere said of the " island of the Hyperboreans,"—coupled with the circumstance of the orator Himerius having called this individual a Scythian, which Strabo would seem to have insinuated also,—we can be at no loss in tracing him to his proper home.

> " Far westward lies an isle of ancient fame,
> By nature blessed, and Scotia is her name ;
> An island rich—exhaustless is her store
> Of veiny silver and of golden ore ;
> Her verdant fields with milk and honey flow,
> Her woolly fleeces vie with virgin snow,
> Her waving furrows float with verdant corn,
> And *Arms* and *Arts* her envied sons adorn."

Such is the description of Ireland given by Donatus, bishop of Etruria, in 802 ; and I have selected it among a thousand other authorities of similar import, to show that Scotia or Scythia was one, and the *last,* of the *ancient* names of this country † ;

* A German writer, contemporary with the Emperor Charles the Great, says of another Irishman, named Clement, at a much later period, " That through his instructions the French might vie with the Romans and the Athenians. John Erigena, whose sirname denoted his country, (Eri or Erina being the proper name of Ireland,) became soon (in the ninth century) after famous for his learning and good parts, both in England and France. Thus did most of the lights, which, in those times of thick darkness, cast their beams over Europe, proceed out of Ireland. The loss of the manuscripts is much bewailed by the Irish who treat of the history and antiquities of their country, and which may well be deemed a misfortune, not only to them, but to the whole learned world."

† Isidore of Seville, in the seventh century, says,—" Scotia eadem et Hibernia," that is, Scotia and Ireland are one and the same—an identity, however, of *locality,* not of *signification.* And Orosius of Tarracona

while the name of "Hyperborean" was the distinctive character assigned thereto, not only as descriptive of its locality towards the north, but as worshipping the wind Boreas.

Did I not apprehend it might be considered irrelevant to the scope of this work, I could easily prove that the amity, said by Hecatæus to have been cemented on the occasion of the visit above alluded to, was not that of a mere return of courteous civilities for a casual intercourse, but one of a far more tender and *familiar* nature, viz., the recognition on both sides of their mutual descent from one common origin; the same people who had settled in this country, and imported the mysteries of their magic priesthood, being akin to the first settlers on the coasts of Greece, which they impregnated with similar initiation. I am anticipated, of course, to have meant the Pelasgi, who, under another name, belonged to the same hive as the Indo-Scythæ, or Chaldean Magi, or Tuath-de-danaan,—*as the head tribe thereof were called* —who, having effected an establishment on *this* happy isle, aloof from the intrusion of external invasion or internal butcheries, were allowed to cultivate the *study* of their *favourite rites*, the fame and eminence of which had obtained for its theatre, of all nations, the designation of " sacred." But I fear it would be encroaching upon the patience of my readers, and

still earlier, in the fifth century, avers, that " In his own time, Ireland was inhabited by the nations of the Scoti." And were further evidence required as to the point, it would be found in the fact of one of our Christian luminaries, whose name was Shane, i. e. John, being called by the Latin historians indifferently by the epithets of Johannes Scotus and Johannes Erigena—the former signifying John the Irishman, and the latter, John the Scotchman.

besides anticipating, in point of order, what may by
and by follow.

An inconsistency, however, appears in the details,
which I cannot here well overlook. It is this. Hi-
merius has called this our ambassador a " Scythian;"
and Strabo has affirmed, that he was " not clad like
a Scythian." How, then, shall I cut this knot?
Thus. Abaris, as his name implies, was one of the
Boreades, or priests of Boreas, belonging to the
Tuath-de-danaan colony in this island, who were sub-
dued, about six hundred years before this event, by
the Scythians, whose dress, as well as manners, dif-
fered in all particulars from those of their religious
and learned predecessors.

But though the Scythians, from state policy, had
suppressed the temple-worship when they deposed
from the throne their antecedent Hyperboreans, they
were but too sensible of their literary value not to
profit by their services in the department of education.
Hence it came to pass, that the Boreades were still
indulged with their favourite costume, while the infe-
rior communities were obliged to conform to the rules
and the fashions of the ascendant dynasty. In a short
time, however, the Scythian Druids superseded the
Danaan Boreades, by the influence of their own in-
struction; and the consequence was, that of that
graceful garb, in the folds of which our ancient high-
priests officiated at the altar, or exhibited in the senate,
not a single vestige is now to be traced, except in the
word God, *Phearagh,* whom I shall, anon, intro-
duce, and in the highlands of Scotland, where a rem-
nant of those Hyperborean or Danaan priests took
shelter from the ruthless Picts, resigning to those

remorseless and intolerant persecutors the ground of the only two temples which they were able there to raise, as the last resort of their hopes, and the solace of their exile*.

Nor is it alone as accounting for the circum-stance of costume that the above explanation deserves the reader's regard. An additional insight is afforded, by its enabling us to account for that boundless supe-riority which the Irish Druids possessed over all other bodies of the same denomination all over the world. Originally, the Druids were an humble set of men, without science, without letters, without pretensions to refinement; but having succeeded here to the fra-ternity of the accomplished Danaan Boreades, who, in the revolution of affairs, were forced to communi-cate their acquirements to the opposite but prevailing priesthood, those latter so far profited by the ennobling opportunity, as to eclipse all other Druids, as well in Europe as in Africa.

Cæsar, in his Commentaries, bears direct testimony to their astronomical research; saying, " Multa præterea de sideribus atque eorum motu, de mundi ac terrarum magnitudine, de rerum naturâ ac deorum immortalium vi ac potestate disputant ac juventuti transdunt."—De Bel. Gal., lib. 1—6. c. xiv. Pom-ponius Mela, also confirming the fact, says, " Hi terræ mundique magnitudinem ac formam, motus cœli ac siderum, ac quid Dii velint scire, profitentur."—De Situ Orbis, lib. 3. c. ii. These two latter authorities, I admit, were more immediately directed to the *Druids* of Britain; but as it is agreed on all hands that *that*

* The Scots first drove them from Ireland to what is now called Scot-land, and the Picts afterwards chased them from the lowlands to the highland fastnesses.

body of religionists had received the seeds of their
instruction from the Irish *Magi,* who were infinitely
their superiors in *all* literary accomplishments, I think
we may be warranted in extending the commendation
to Ireland also, as the writers indubitably *included* it
under the *general name* of *Britain.*

But were all *external* testimonies silent on the
matter, and mercenary vouchers even assert the reverse,
the internal evidence of our language itself—a lan-
guage so truly characterised as " more than three
thousand years old," would afford to the ingenuous
and disinterested inquirer the most convincing proof
of the ground which I have assumed. In that lan-
guage,—and the writer of this essay *ought* to know
something of it,—there is scarcely a single term apper-
taining to time, from *la,* a day, derived from liladh,
to turn round,—in allusion to the diurnal revolution
—up to bleain, a year, compounded of Bel, the sun,
and Ain, a circle,—referring to its annual orbit,—
that does not, in its formation and construction,
associate the idea with the planetary courses, and
thereby evince not only an astronomical taste, but
that astronomy was the " ruling passion " of those
who spoke it.

" The Irish language," says Davies, an intelligent
and respectable Welsh writer, " appears to have
arrived at maturity amongst the Iapetidæ, while they
were yet in contact with Aramæan families, and formed
a powerful tribe in Asia Minor and in Thrace. It
may, therefore, in particular instances, have more
similitude or analogy to the Asiatic dialects than what
appears in those branches of the Celtic that were
matured in the west of Europe. Those who used this
language consisted partly of Titans, of Celto-Scythians,

or of those Iapetidæ who assisted in building the city
of Babel, and must have been habituated, after the
dispersion, to the dialects of the nations through which
they passed, before they joined the society of their
brethren." We thank this learned author for the
flattering notice which he has been pleased to take of
us; and though, in his subsequent remarks, he steers
far wide of our true pedigree, yet a concession so
important as that even here adduced, must command
at least our becoming acknowledgments.

The splendid examples which we have had of
primitive preachers of Christianity in this kingdom,
and whom Ledwich himself, reluctant as he was to
afford ordinary justice to Irish merit, is obliged to
praise,—were not more remarkable for the sanctified
zeal and enthusiastic devotion with which they pro-
pagated the Gospel, than they were for the diversified
range of their literary acquirements, and the moral
sublimity of their ideas and conceptions *. Speaking
of a production belonging to one of these worthies,
Ledwich remarks; "In this tract we can discover
Cumman's acquaintance with the doctrine of time,
and the chronological characters. He is no stranger
to the solar, lunar, and bissextile years, to the epactal
days, and embolismal months, nor to the names of
the Hebrew, Macedonian, and Egyptian months. To
examine the various cyclical systems, and to point out

* Henricus Antisiodrensis, writing to Charles the Bald, says,—" Why
need I mention all Ireland, with her crowd of philosophers?" " The
philosophy and logic," says Mosheim, a German historian, " that were
taught in the European schools in the ninth century, scarcely deserved
such honourable titles, and were little better than an empty jargon.
There were, however, to be found in various places, *particularly among
the Irish*, men of acute parts and extensive knowledge, who were per-
fectly well entitled to the appellation of philosophers."

their construction and errors, required no mean abili-
ties : a large portion of Greek and Latin literature
was also necessary *."

Here I would have it distinctly noticed, that the
above-mentioned individuals who shone in the galaxy
of our early Christian constellations, had been but just
converted from paganism by St. Patrick, and conse-
quently were not indebted for this " learned lore " to
the Romish missionaries, but to the more elevated
genius of their native institutions. This it was that
enabled them to make those astronomical observations
which our annals commemorate ; and who can say,
amidst the decay of time, the ravages of persecution,
and the fury of fanaticism, what *tomes* of such labours
has not the world lost ? Some few, however, remain,
of which we shall adduce some by way of specimen.
Solar eclipses of 495—664—810—884—Lunar of
673—717—733—807—877—Solar and Lunar 864—
A comet 911—are recorded in our annals.

Those of the " Four Masters " additionally record
certain extraordinary celestial phenomena in 743 :—
" Visæ sunt stellæ quasi de cœlo cadere." Again, in
744, they observe, " Hoc anno stellæ item de cœlo
frequentes deciderunt ;" while it cannot be too dili-
gently noted, " that, when the rest of Europe, as
Vallancey so justly remarked, through ignorance or
forgetfulness, had no knowledge of the *true figure* of
the earth, in the eighth century, the rotundity and
true formation of it should have been taught in the
Irish schools," which we shall by and by more
pointedly advert to.

It thus appears manifest that the Irish must, at one

* Antiq., p. 108.

time, have not only possessed, but excelled in, the science of astronomy. How did they acquire it? is the next question. " Ad illa mihi pro se quisque acriter intendat animum." In that passage of Diodorus, to which I have already referred, we find the following appropriate characteristic. " It is affirmed that Latona was born there, and that, therefore, the worship of Apollo is preferred to that of any other God ; and as they daily celebrate this deity with songs of praise, and worship him with the highest honours, they are considered as *peculiarly* the *priests* of Apollo, whose sacred grove and *singular* temple of *round form*, endowed with many gifts, are there."

Now, it is universally known that Apollo, which, " according to the learned Pezron, is no other than Ap-haul, or the son of the Sun," was understood by the ancients only essentially to typify that powerful planet, " which animates and imparts fecundity to the universe, whose divinity has been accordingly honoured in every quarter by temples and by altars, and consecrated in the religious strains of all nations" and all climes.

His being peculiarly worshipped in this island only shows the intimate knowledge it possessed of the mysteries of the *solar system ;* and that near converse which we have been already told it possessed with the moon, is confirmation the most positive of this explanation.

Let me here again recall to the reader's mind the name of *Cathaoir Ghall,* or *temple of brightness,* which I have before adduced, and when we compare *all* with the *celestial indexes* recorded in our annals, the conclusion is inevitable, *that the Round Towers of Ireland were specifically constructed for the twofold purpose*

of worshipping the Sun and Moon,—as the authors of generation and vegetative heat,—*and, from the nearer converse which their elevation afforded, of studying the revolutions and properties of the planetary orbs.* Let me, however, before elucidating the era of their actual erection,—with their *Phallic* form and their further use,—revert to the Mosaic history for the *groundwork* of my development.

> " And chiefly thou, O Spirit! that dost prefer
> Before all temples th' upright heart and pure,
> Instruct me, for thou know'st; thou from the first
> Wast present, and, with mighty wings outspread,
> Dove-like sat'st brooding on the vast abyss,
> And mad'st it pregnant. What in me is dark,
> Illumine! what is low, raise and support!
> That to the height of this great argument
> I may assert eternal Providence,
> And justify the ways of God to man *."
>
> * Milton.

CHAPTER V.

Nimrod, the son of Cush, " the mighty hunter before the Lord," was the first person *, according to Vossius †, who introduced the worship of the *sun* as a deity. Disgusted with the roving character of his previous life, and tired of peregrination, he resolves to build himself a permanent abode, and persuades his followers to embark in the design, " lest they be scattered abroad upon the face of the whole earth ‡." Mankind had already relapsed into the follies of their antediluvian ancestors. The awful lesson of the watery visitation was read to them in vain, and again they verified what God had before that memorable epoch with sorrow declared, " that every imagination of the thoughts of their hearts was only evil continually §."

In Babel, the city thus agreed upon to be built—as the anchor of their stability and the basis of their renown,—we find a " *Tower* " mentioned, " whose top may *reach*,"—says our version, (but should it not rather be—*point ?*)—*towards Heaven.*

What was the object of this architectural elevation ?

* I will show, however, that it was much older.

† De Orig. et Progress. Idolat., ii. 61.

‡ Genesis xi. 4. § Genesis vi. 5.

Not certainly, as some have supposed, as a place of refuge in apprehension of a second deluge; for in that case, it is probable, they would have built it on an eminence, rather than on a *plain, whereas* the bible expressly tells us they had selected the latter.

Much less could it be, what the poets have imagined, for the purpose of scaling the celestial abodes, and disputing with Jehovah the composure of his sovereignty.

What, then, was it intended for?

Undoubtedly as an acknowledgment, however vitiated and depraved, of dependence upon that Being, whose acts shine forth in universal love, but whose spiritual adoration was now partially lost sight of, or *merged* in the homage thus primarily tendered to the *lucid offspring* of his *omnipotent fiat.*

This Tower, so erected by Nimrod, in opposition to the established system of religious belief, and which, therefore,—but from a *nobler* reason than what was generally imagined, *viz.,* his researches in astronomy, and the application thereto of instruments— procured him the appellation of *rebel*, from *nemh,* heaven, and *rodh,* an assault—was, I hesitate not to say, a temple constructed to the celestial host, the sun, moon, and stars, which constituted the substance of the *Sabian idolatry* *.

* * On the top was an observatory, by the benefit of which * it was that the *Babylonians advanced their skill in astronomy so early;* when Alexander took Babylon, Callisthenes the philosopher, who accompanied him there, found they had *observations* for 1903 years backward from that time, which carries up the account as high as the hundred and fifteenth year after the flood, *i. e.,* within fifteen years after the tower of Babel was built.

Shinaar, in Mesopotamia, was the theatre of this dread occurrence—this appalling spectacle at once of man's weakness and God's omnipotence :—Here the Noachidæ had been then fixed; and the name by which this innovation upon their previous usages is transmitted, viz., *Ba-Bel,* corroborates the destination above assigned *.

The word " Baal," in itself an appellative, at first served to denote the true God amongst those who adhered to the pure religion; though, when it became common amongst the idolatrous nations, and applied to idols, He rejected it. " And it shall be in that day that you shall call me Ishi, and shall call me no more Baali †." Another name by which the *Godhead* was recognized was Moloch. The latter, indeed, in accuracy of speech was the name assigned him by the Ammonites and Moabites—both terms, however, corresponded in sense, " Moloch" signifying king, and " Baal" Lord, that is, of the heavens; whence transferring the appellation to the Sun, as the *source* and *dispenser* of all *earthly favours,* he was also called Bolati, i. e., " Baal the *bestower*," as was the moon, Baaltis, from the same consideration : whilst the direct object of their internal regard was not, undoubtedly,

* I stop not to inquire whether or not this may have been the same with that which stood in the midst of the temple of Belus, afterwards built around it by Nebuchadnezzar. The intent I conceive similar in all, whether the scriptural *Tower,* Birs Nimrod, or Mujellibah ; and the rather, as Captain Mignan tells us of the last, that on its summit there are still considerable traces of erect building, and that at the western end is a *circular* mass of solid brick-work *sloping towards the top,* and rising from a confused heap of rubbish; while Niebuhr states that Birs Nimrod is also surmounted by a turret. My object is to show that the same *emblematic design* mingled in all those ancient edifices, though not identical in its details.

† Hosea, ch. ii. v. 16.

that globe of fire which illumines the firmament and vivifies terrestrials, but, physically considered, *nature* at large, the *fructifying germ* of universal *generativeness*.

The Sun, it is true, as the source of light and heat, came in as *representative* for all this adoration, Thus viewed, then, it would appear that the origin of the institution may have been comparatively harmless. God being invisible, or only appearing to mortals through the medium of his acts, it was natural that *man*, left to the workings of unaided reason, should look on yon mysterious luminary with mingled sentiments of gratitude and awe. We have every reason, accordingly, to think, that solar worship at first was only emblematical, recognizing, in the effulgence of the orb of day, the creative power of Him, the

> " Father of all, in every age,
> In every clime adored,
> By saint, by savage, and by sage,
> *Jehovah, Jove*, or *Lord* "—

who sent it forth on its *beneficent* errand.

As such, originally they had no temples dedicated to the occasion; they met in the open air, without the precincts of any earthly shrine : there they poured forth their vows and their thanksgivings, under the aërial canopy of the vaulted expanse; nor can it be denied but that there was something irresistibly impressive in such an assemblage of pious votaries, paying their adoration to the throne of light in the natural temple of his daily splendours *.

The degeneracy of man, however, became manifest in the sequel, and, from the frequency of the act, the

* St. Stephen, the first martyr who suffered death for Christ, said before the Jewish Sanhedrim, " God dwelleth not in temples made with hands." Acts vii. 48.

type was substituted in room of the thing typified. "Solum in cœlis deum putabant solem," says Philobibliensis, in his interpretation of Sanchoniathon. Nor did it stop here, but, proceeding in its progress of melancholy decay, swept before it the barriers of reason and moral light; and, from the bright monarch of the stars, who rules the day, the seasons, and the year, with perpetual change, yet uniform and identical, bowed before the grosser element of *material fire*, as his symbol or corporeal representative.

But the worst and most lamentable is yet untold. The sign again occupied the place of the thing signified, and the human soul was prostrated, and human life often immolated, to propitiate the favour of earthly fire, now by transition esteemed a god. They had, it is true, from a *faint* knowledge of the sacred writings, and a perverted exercise of that inspired authority, something like an excuse for, at least, a decent attention in the ordinary management of that useful article. In Levit. vi. 13, it is said, "the fire upon the altar shall ever be burning, it shall never go out." This injunction given by the Lord to Moses, to remind his people of the constant necessity of sacrifice and prayer, the Gentiles misconstrued into reverence for the fire itself, and "quoniam omnes pravi dociles sumus," hence the ready admission with which the doctrine was embraced, and the general spread of that which was at first but partial and figurative.

Indeed we find that God himself had appeared to Moses in a "flame of fire in the midst of a bush," Exod. iii. 2, and in presence of the whole Israelitish host. Exod. xix. 18. "The Lord descended upon Mount Sinai, as the smoke of a furnace;" while in Exod. xiii. 21, it is declared that "the Lord went

before them by day in a pillar of a cloud, and by
night in a pillar of fire, to give them light." So ac-
cordingly we find Elijah, 1 Kings xviii. 24, when
challenging the priests of the false divinities, propose
a decision by fiery ordeal. "Call you on the name
of your gods," he says, " and I will call upon the
name of the Lord, and the God that answereth by *fire*,
let him be God, and all the people answered, it is well
spoken."

The infidels, therefore, who could not concede any
superiority to the religion of the Hebrews, and yet
could not deny those manifestations of divine support,
thought they best proved their independence by insti-
tuting a rivalship, and got thereby the more confirmed
in their original idolatry. Their bloody sacrifices
themselves originated, we may suppose, in some simi-
lar way. God must, undoubtedly, have prescribed
that rite to Adam, after his fall in Paradise, else how
account for the " skins" with which Eve and he had
covered themselves? The beasts to which they be-
longed could not have been slain for food; for it was
not till a long time after that they were allowed to eat
the flesh of animals. We may, therefore, safely infer
that it was for a sin-offering they had been immo-
lated; and the subsequent reproof given to Cain by
the rejection of his oblation, evidently for the non-
observance of the exact mode of sacrifice prescribed,
coupled with the command issued to Abraham, to try
his obedience, by offering up his own son, are unde-
niable proofs of the truth of this inference.

In " Ur" of the Chaldees, a name which literally
signifies " fire," the worship of that element first
originated. Thence it travelled in its contaminating
course, until all the regions of the earth got impreg-

nated therewith. In Persia, a country with which *this island* had, of old, the most *direct communication,* we also find a city denominated "Ur;" and who does not know that the Persians, having borrowed the custom from the Chaldean priests, regarded fire with the utmost veneration? Numerous as were the deities which that nation worshipped, "fire," on every occasion, in every sacrifice—like the Janus of the Romans—was invoked the first. Their Pyrea, in which they not only preserved it ever burning, but worshipped it as a deity, have been noticed by Brisson—but without the necessary adjunct of their being an innovation.

Even the ordinary fire for culinary or social purposes participated in some measure in this hallowed regard; as they durst not, without violating the most sacred rules, and stifling the scruples of all their previous education, offer it the least mark of impious disregard, or pollute its sanctity by profane contact.

It was, however, only as symbolical of the *sun,* that *they,* like the Chaldeans, paid it this extraordinary reverence—a reverence not limited to mere religious rules, but which exercised control over, and biassed the decisions of, their most important secular transactions. Accordingly we learn from Herodotus, lib. vii., as quoted by Cicero in Verrem, that when Datis, the prefect of Xerxes' fleet, flushed with the result of his victory over Naxos, and the city of Eretria, in Euboea, might easily have made himself master of the island of Delos, he, however, passed it over untouched, in honour of that divinity before whom his country had bowed, having been sacred to Apollo, or the sun, and reputedly his birth-place.

But do I mean to say that the " Round Towers " of Ireland were intended for the preservation of the sacred fire ? Far, very far, indeed, from it. That *some few* of them were therewith connected—I say *connected, not appropriated*—may, I think, be well allowed ; nay, it is my candid belief, so far as belief is compatible with a matter so unauthenticated. But having all through maintained that they were not all intended for one and the same object, I must have been understood, of course, by the numerous supporters of that fashionable proposition, as including fire-worship within the compass of my several views. I put it, however, frankly, to the most *ardent* supporter of that theory, who for a moment considers the different *bearings* and peculiarities of those several structures, comparing them first with one another, and then with the description of fire-receptacles which we read of elsewhere, whether he can dispassionately bring himself to say that all our Round Towers, or indeed above two of those at present remaining, could have been *even calculated* for that purpose ?

Where, let me ask, is it they will suppose the fire to have been placed ? In the bottom ? No ; the intervening floors, of which the GREATER PORTION retain evident traces, would not only endanger the conflagration of the whole edifice, as it is most probable that they were made of wood, but would also prevent the egress of the smoke through the four windows at the top, for which use, they tell you, those apertures were inserted.

But I am answered that the tower of Ardmore, which has within it no vestiges of divisional compartments, could offer no hinderance to the ascent of the smoke, or its consequent discharge through the

four cardinal openings. To which I rejoin, that if there had *ever* been a fire lighted within that edifice, and continued for any length of time, as the sacred fire is known to have been kept perpetually burning, it would have been impossible for the inner surface of that stately structure to preserve the beautiful and white coating which it still displays, through the mystic revolutions of so many ages. The same conclusion applies to the tower of Devenish, which, though it has no inside coating, yet must its elegant polish have been certainly deteriorated, if subjected to the action of a perpetual smoke.

The instance which is adduced of the four temples described by Hanway, in his "Travels into Persia," proves nothing. It certainly corresponds with the architectural character of some of our Round Towers, but leaves us as much in the dark as to the era and use of both, as if he had never made mention of any such occurrence.

To me it is as obvious as the noon-day sun that *they too*, on examination, would be found of a more comprehensive religious tendency than what could possibly relate to the preservation of the sacred fire : for it is well known that when temples were at all appropriated to this consecrated delusion, it was within a small *crypt* or *arched vault*—over which the temple was erected—that it was retained. The Ghebres or Parsees, the direct disciples of Zoroaster, the reputed author of this improved institution, " build their temples," says Richardson *, " over *subterraneous fires.*"

Whenever a deviation from this occurred, it was in favour of a low stone-built structure, all over-arched,

* Asiatic Researches.

such as that which *Hanway met with at Baku,* and
corresponding in every particular with the edifices of
this description to be seen at Smerwick, county
Kerry, and elsewhere throughout Ireland *.

The fire-house which Captain Keppel visited at a
later period at Baku, in 1824, was a small square
building, erected on a platform, with three ascending
steps on each side, having a tall hollow stone column
at every side, through which the flame was seen to
issue, all *in the middle of a pentagonal enclosure*—com-
prising also a large altar, whereon naphtha was kept
continually burning.

Now could anything possibly *correspond more mi-
nutely* with Strabo's description of the Pyratheia,
than does this last account? " They are," he says,
" *immense enclosures,* in the centre of which was
erected an altar, where the Magi used to preserve, as
well a quantity of ashes, as the ever-burning fire it-
self." And could anything possibly be *more opposite*
to our " Round Towers " than all these accounts?

When, therefore, we are told † that at the city of
Zezd, in Persia—which is distinguished by the ap-
pellation of Darub Abadat, or seat of religion—the
Ghebres are permitted to have an Atush Kidi, or fire-
temple, which they assert had the sacred fire in it
since the days of Zoroaster, we must be prepared to
understand it as corresponding in architectural pro-
portion with one or other of the instances just now

* It is most unaccountable how Hanway, after seeing this evidence of
an *actual* fire-temple, should, notwithstanding, commit the egregious
blunder of calling the Round Towers—which differed from it as much
as a *maypole* does from a rabbit-hole—fire-temples also. Yet has he
been most religiously followed by Vallancey, Beauford, Dalton, &c., who
could not open their eyes to the mistake.

† Pottinger's Belochistan.

detailed; and in truth, from recent discovery, I have ascertained—since the above was composed—that it is nothing more than a *sorry hut.*

But Pennant's view of Hindostan is brought forward as at once decisive of the matter. What says Mr. Pennant, however? "All the people of this part of India are Hindoos, and retain the *old religion,* with all its superstition; this makes the Pagodas here much more numerous than in any other part of the peninsula; their form too is different, being chiefly buildings of a *cylindrical* or *round tower* shape, with their tops either pointed or truncated at the top, and ornamented with something eccentrical, but frequently with a round ball stuck on a spike : this ball seems intended to represent the *sun,* an emblem of the deity of the place."

To this ascription of this learned traveller I most fully, most heartily respond. Pagoda is a name invented by the Portuguese, from the Persian " Peutgheda," meaning a temple of idols, in which they supposed them to abound, but which in reality were only so many figures or symbols of the " principle of truth," the " spirit of wisdom," the " supreme essence," and other attributes of the Godhead, which, I believe, they in a great measure spiritually recognized. Those structures, therefore, as the very word implies, had no manner of relation to the sacred fire, but they had to the sun and moon, the supposed authors of *generation* and *nutrition,* of which fire was only the corrupt emblem, and the different forms of their constructural terminations, similar to those elsewhere described by Maundrell, some being *pointed,* and some being *truncated,* harmonizes most aptly with the *radial* and *hemispherical representa-*

tions of the two celestial luminaries, as well as with
that organ of human *procreation* which we shall here-
after more particularly identify.　These are the two
Baals dwelt so largely upon in the Scriptures—Baal
masculine, the sun, and Baal feminine, the moon,
from both of which the Hindoos derive their fabulous
origin.　Indeed it was from their extreme veneration
for the " queen of night " that they obtained their
very name; Hindoo meaning, in the Sanscrit lan-
guage, the moon; and accordingly we find among
them Hindoo-Buns, that is, children of the moon, as
we do Surage-buns, children of the sun, the other
parent of their fanciful extraction.

Here then, methinks, we have at once a clue to
the character of those Round Towers so frequent
throughout the East, of whose history, however, the
Orientals are as ignorant as we are here of our
" rotundities."　Caucasus abounds in those columnar
fanes, and it must not be forgotten that Caucasus has
been claimed as the residence of our ancestors.　On
Teric banks, hard by, there is a very beautiful and
lofty one as like as possible to some of ours.　The
door is described as twelve feet from the ground, level
and rather oblong in its form.　Lord Valentia was
so struck with the extraordinary similitude observable
between some very elegant ones which he noticed in
Hindostan and those in this country, that he could
not avoid at once making the comparison.　The in-
habitants, he observes, paid no sort of regard to those
venerable remains, but pilgrims from afar, and chiefly
from Jynagaur, adhering to *their old religion,* used an-
nually to resort to them as the shrines of their ancient
worship.　Yet in the ceremonies there performed we
see no evidence of their appropriation to the sacred

fire—however *tradition* may have ascribed them as once belonging to the Ghebres! Franklin mentions some he has seen at Nandukan, as do other writers in other sites. In short, all through the East they are to be met with, and yet all about them is obscurity, doubt, and mystery, a proof at once of the antiquity of their date, and of their not being receptacles for fire, which, *if the fact,* could be *there* no secret.

Yes, I verily believe, and I will as substantially establish, that they were, what has already been affirmed, in reference to those in Ireland, viz.,— temples in honour of the sun and moon, the pro-creative causes of general fecundity,—comprising in certain instances, like them, also the additional and blended purposes of funeral cemeteries and astro-nomical observatories. The Septuagint interpreters well understood their nature when rendering the " high place of Baal*" by the Greek στηλη του βααλ, or Pillar of Baal, that is, the pillar conse-crated to the sun; while the ancient Irish themselves, following in the same train, designated those struc-tures Bail-toir, that is, the tower of Baal, or the sun, and the priest who attended them, Aoi Bail-toir, or superintendent of Baal's tower. Neither am I with-out apprehension but that the name " Ardmore," which signifies " the great high place," and where a splendid specimen of those Sabian edifices is still remaining, was in direct reference to that religious column; but this " en passant."

In the *sepulchral* opinion I am not a little fortified by the circumstance of there being found at Benares pyramids corresponding in all respects, save that of size, to those in Egypt, having also subterranean

* Numbers, chap. xxii., ver. 41.

passages beneath them, which are said to extend even
for miles together. A column also, besides a sphinx's
head, which has been discovered not long since in
digging amid the ruins of an ancient and unknown
city, on the banks of the Hypanis, bearing an inscrip-
tion which was found to differ on being compared
with Arabic, Persia, Turkish, Chinese, Tartar, Greek,
and Roman letters; but bore " a manifest and close
similarity with the characters observed by Denon on
several of the mummies of Egypt," gives strength to
the idea of the identity of the Egyptian religion with
that of the Indians, as it does to the identity of desti-
nation of their respective pyramids.

CHAPTER VI.

Now if there be any one point of Irish antiquity which our historians insist upon more than another, it is that of our ancestral connexion with the Egyptian kings. In all their legends Egypt is mixed up—in all their romances Egypt stands prominent, which certainly could not have been so universal without *something* at least like foundation, and must, therefore, remove anything like surprise at the affinity our ancient religion bore, in many respects, to theirs, since they were both derived from the same common origin.

I have already intimated my decided belief of the application of the Egyptian pyramids to the combined purposes of religion and science. The department of science to which I particularly referred was astronomy, the cultivation of which was inseparably involved in all their religious rites ; for despite of the reverence which the Egyptians semed to pay to crocodiles, bulls, and others of the brute creation, in those they only figured forth the several attributes, all infinite, in the divinity ; as their worship, like that of the ancient Irish, was purely planetary, or Sabian.

The Indians too have images of the elephant, horse, and other such animals, chiselled out with the most studious care, and to all intents and purposes appear to pay them homage ; but if questioned on the subject, they will tell you that in the sagacity of the

former, and the strength and swiftness of the latter, they only recognise the superior wisdom and might of the All-good and All-great One, and the rapidity with which his decrees are executed by his messengers.

If questioned more closely, they will tell you that the Brahmin is but reminded by the image of the inscrutable Original, whose pavilion is clouds and darkness; to him he offers the secret prayer of the heart; and if he neglects from inadvertence the external services required, it is because his mind is so fully occupied with the contemplation of uncreated excellence, that he overlooks the grosser object by which his impressions were communicated. Then with respect to their subterranean temples or Mithratic caves, of which we have so many specimens throughout this island, they affirm that the mysterious temple of the caverns is dedicated to services which soar as much above the worship of the plain and uninstructed Hindoo, as Brahma the invisible Creator is above the good and evil genii who inhabit the region of the sky. The world, whose ideas are base and grovelling as the dust upon which they tread, must be led by objects perceptible to the senses to perform the ceremonial of their worship; the chosen offspring of Brahma are destined to nobler and sublimer hopes; their views are bounded alone by the ages of eternity.

These specimens, though brief, will prove that the spirit of the religion of ancient India and Egypt was not that farrago of mental prostration which some have imagined. No, the stars, as the abode or immediate signal of the Deity, were their primary study, and even to this day, depressed and humiliated as the

Indians are, and aliens in their own country, they are not without some attention to their favourite pursuit, or something like an observatory to perpetuate its cultivation. In May, 1777, a letter from Sir Robert Baker to the President of the Royal Society of London, was read before that body, which details a complete astronomical apparatus found at Benares, belonging to the Brahmins.

Such is the remnant of that once enlightened nation, the favourite retreat of civilization and the arts, which sent forth its professors into the most distant quarters of the world, and disseminated knowledge wherever they had arrived. " With the first accounts we have of Hindostan," says Crawford, " a mighty empire opens to our view, which in extent, riches, and the number of its inhabitants, has not yet been equalled by any one nation on the globe. We find salutary laws and an ingenious and refined system of religion established ; sciences and arts known and practised ; and all of these evidently brought to perfection by the accumulated experience of many preceding ages. We see a country abounding in fair and opulent cities ; magnificent temples and palaces ; useful and ingenious artists employing the precious stones and metals in curious workmanship ; manufacturers fabricating cloths, which in the fineness of their texture, and the beauty and duration of some of their dyes, have even yet been but barely imitated by other nations."

" The traveller was enabled to journey through this immense country with ease and safety ; the public roads were shaded with trees to defend him from its scorching sun ; at convenient distances buildings were erected for him to repose in, a friendly

Brahmin attended to supply his wants ; and *hospitality* and the *laws* held out assistance and protection to *all alike*, without prejudice or partiality..... We afterwards see the empire overrun by a fierce race of men, who in the beginning of their furious conquests endeavoured, with their country, to subdue the minds of the Hindoos. They massacred the people, tortured the priests, threw down many of the temples, and, what was still more afflicting, converted some of them into places of worship for their prophet, till at length, tired with the exertion of cruelties which they found to be without effect, and guided by their interest, which led them to wish for tranquillity, they were constrained to let a religion and customs subsist which they found it impossible to destroy. But during these scenes of devastation and bloodshed, the sciences, being in the sole possession of the priests, who had more pressing cares to attend to, were neglected, and are now almost forgotten."

I have dwelt thus long upon the article of India, from my persuasion of the intimate connexion that existed at one time as to religion, language, customs, and mode of life between some of its inhabitants and those of *this* western island. I have had an additional motive, and that was to show that the same cause which effected the *mystification* that overhangs *our* antiquities, has operated similarly with respect to *theirs*, and this brings me back to the subject of the " Round Towers," in the *history*, or rather the *mystery*, of which, in both countries, this result is most exemplified.

As to their appropriation, then, to the *sacred* fire, though I do not deny that *some* of them *may* have been connected with it, yet unquestionably *too much*

importance has been attached to the *vitrified* appearance of Drumboe tower as if necessarily enforcing our acquiescence in the universality of that doctrine. " At some former time," says the surveyor, " *very strong fires have been burned* within this building, and the inside surface towards the bottom has the appearance of vitrification."

I do not at all dispute the *accident*—but while the vitrified aspect which *this tower* exhibits is proof irresistible that *no fire ever entered* those in which *no such* vitrification appears, I cannot but *here too* express more than a surmise that it was not the " *sacred fire*," which, when religiously preserved, was not allowed to break forth in those *volcanos* insinuated ; but in a *lambent, gentle flame*, emblematic of that emanation of the spirit of the Divinity infused, as *light from light*, into the soul of man.

> Hail, holy Light! offspring of heaven first-born !
> Or of th' Eternal co-eternal beam !
> May I express thee unblamed ? Since God is light,
> And never but in unapproached light
> Dwelt from eternity ; dwelt then in thee,
> Bright effluence of bright essence increate !
> Or hear'st thou rather, pure ethereal stream,
> Whose fountain who shall tell ? Before the sun,
> Before the heavens, thou wert, and at the voice
> Of God, as with a mantle, didst invest
> The rising world of waters dark and deep,
> Won from the void and formless infinite *.

But to prove that they were not appropriated to the ritual of fire-worship, *nay, that their history and occupation had been altogether forgotten when that ritual now prevailed*, I turn to the glossary of Cormac, first bishop of Cashel, who after his conversion

* Milton.

to Christianity, in the fifth century, by St. Patrick, thus declares his faith :—

> " Adhram do righ na duile
> Do dagh bhar din ar n' daone
> Leis gach dream, leis gach dine
> Leis gach ceall, leis gach caoimhe."

That is,

> " I worship the King of the Elements,
> Whose fire from the mountain top ascends,
> In whose hands are all mankind,
> All punishment and remuneration."

No allusion here to " *towers*," as connected with that *fire* so pointedly adverted to. And lest there should be any doubt as to the *identity* of this fire with the religious element so frequently referred to, we find the same high authority thus critically explain himself in another place : " dha teinne soinmech do gintis na draoithe con tincet laib moraib foraib, agus do bordis, na ceatra or teamandaib cacha bliadhna ;"—that is, the Druids used to kindle two immense fires, with great incantation, and towards them used to drive the cattle, which they forced to pass between them every year.

Nay, when St. Bridget, who was originally a *pagan vestal,* and consequently well versed in all the solemnities of the sacred fire, wished, upon her conversion to Christianity, A.D. 467, to retain this favourite usage, now sublimated in its nature, and streaming in a more hallowed current, it was not in a " tower " that we find she preserved it, but in a cell or low building " like a vault," " which," says Holinshed, whose curiosity, excited by Cambrensis's report *, had induced him to go and visit the spot, " to this day they call the fire-house." It was a stone-roofed edi-

* Top. Dist. ii. c. 34.

fice about twenty feet square, the ruins of which are
still visible, and recognized by all around as once the
preservative of the sacred element. When Cam-
brensis made mention of this miraculous fire of St.
Bridget, why did he not connect it with the *Round
Towers*, which he mentions elsewhere? He knew
they had no connexion, and should not be associated.

But, forsooth, the Venerable Bede has distinctly
mentioned in the Life of St. Cuthbert, that there were
numerous *fire receptacles*, remnants of ancient pagan-
ism, still remaining in this island!—Admitted. But
does it necessarily follow that they were the *Round
Towers**? No: here is the enigma solved—they
were those *low stone-roofed structures*, similar to what
the Persians call the " Atash-gah," to be met with so
commonly throughout all parts of this country, such
as at Ardmore, Killaloe, Down, Kerry, Kells, &c. &c.
The circumstance of St. Columbe having for a time
taken up his abode in this last-mentioned one, gave
rise to the idea that he must have been its founder:
but the delusion is dispelled by comparing its archi-
tecture with that of the churches which this distin-
guished champion of the early Christian Irish church
had erected in Iona †, whose ruins are still to be seen,
and bear no sort of analogy with those ancient re-
ceptacles. Struck, no doubt, with some apprehensions
like the foregoing, it is manifest that Miss Beaufort

* Had Bede even *asserted* that the Round Towers were fire receptacles,
it would not obtain my assent, as they were as great an enigma in that
venerable writer's day, as they have been ever since, until now that their
secret is about to be unveiled.

† The derivation of this word not being generally known, I may be
allowed to subjoin it. It is the Irish for *dove*, as *columba* is the Latin,
and was assigned to the above place in honour of St. Columbe, who was
surnamed Kille, from the many churches which he had founded.

herself, while combating most strenuously for the
Round Towers as *fire receptacles*, had no small mis-
giving, nay, was evidently divided as to the security
of her position. " From the foregoing statements,"
she observes, " a well-grounded conclusion may be
drawn that these *low fabrics* are seldom found but in
connexion with the towers, and were designed for the
preservation of the sacred fire ; in some cases the lofty
tower may have served for both purposes *." The
lofty tower, I emphatically say, was a distinct edifice.

Again when St. Patrick, in person, went round the
different provinces to attend the pagan solemnities
at the respective periods of their celebration, we find
no mention made of any such thing as a " tower "
occupying any part in the ritual of their religious
exercises. When he first presented himself near the
court of Laogaire, not far from the hill of Tara, on
the eve of the vernal equinox, and lit up a fire before
his tent in defiance of the legal prohibition, the appeal
which we are told his druids addressed to the monarch
on that occasion was couched in the following words :
" This fire which has to-night been kindled in our
presence, before the flame was lit up in your *palace*,
unless extinguished this very night, shall never be
extinguished at all, but shall triumph over all the
fires of our ancient rites, and the lighter of it shall
scatter your kingdom." In this notification, as I
translate it from O'Connor's Prolegomena, i. c. 35,
there occur two terms to which I would fain bespeak
the reader's regard ; one is the word *kindled*, which
implies the lighting up of a fire where there was none
before ; the second is the word *palace*; which is more
applicable to a kingly residence or private abode,

* Trans. Roy. Ir. Acad. vol. xv.

than to a *columnar structure,* which would seem to demand a characteristic denomination.

Another objection more imposing in its character, and to the *local* antiquary offering no small difficulty to surmount, is that those above-mentioned low structures must have been erected by our first Roman missionaries, because that they bear the strongest possible affinity to the finish and perfection of the early Roman cloacæ or vaults. This difficulty, however, I thus remove : no one in this enlightened age can suppose that those stupendous specimens of massive and costly workmanship, which we read of as being constructed by the Romans in the very infancy of their state, could have been the erection of a rude people, unacquainted with the arts. The story of the wolf, the vestal, and the shepherd is no longer credited ; Rome was a flourishing and thriving city long before the son of Rhea was born, and the only credit that he deserves, as connected with its history, is that of uniting together under one common yoke the several neighbouring communities, many of whom, particularly the Etrurians, were advanced in scientific and social civilization, conversant not only with the researches of letters, and the arcana of astronomy, but particularly masters of all manual trades, and with none more profoundly than that of architecture.

But who, let me ask, were those Etrurians ? none others, most undoubtedly, than the Pelasgi or Tyrseni, another branch of our Tuath-de-danaan ancestors, who, as Myrsilus informs us, had erected the ancient wall around the acropolis of Athens, which is therefore styled, by Callimachus, as quoted in the Scholia to the " Birds " of Aristophanes, " the Pelasgic Wall

of the Tyrseni." It is now a point well ascertained by historians that what are termed by ancient writers *Cyclopean walls*—as if intimating the work of a race of giants, while the true exposition of the name is to be found in the fact of their having been constructed by a caste of miners, otherwise called arimaspi, whose lamp, which perhaps they had fastened to their foreheads, may be considered as their *only eye*—were actually the creation of those ancient Pelasgi, and, as will shortly appear, should properly be called Irish *. Mycenæ, Argos, and Tiryns, in Greece, as well as Etruria and other places in Italy, the early residences of this lettered tribe, abound in relics of this ancient masonry. In all respects, in all points, and in all particulars it corresponds with that of those above mentioned *low*, stone-roofed, fire-receptacles, so common in this island ; which must satisfactorily and for ever do away with the doubt as to why such features of similarity should be observed to exist between our antiquities and those of *ancient Greece* and *Rome ;* not less perceptible in the circumstance of those edificial remains than in the collateral evidences of language and manners.

The sacred fire, once observed with such religious awe by every class, and in every quarter of this island, was imported from Greece into Italy by the same people who had introduced it here. Let me not be supposed to insinuate that the people of the latter country, *modernly considered,* adopted the usage from those of the former country, moderns also; no, there was no intercourse between these parties for many years after the foundation of the western capital.

* This adjective is not here applied to our western *Irin*, *i.e.*, Ireland, but to the eastern Iran, *i.e.*, Persia.

Indeed it was not until the time of Pyrrhus that they knew anything of their respective existences, whereas we find that the vestal fire was instituted by Numa, A. U. C. 41. What I meant therefore to say was, that the same early people, viz., the Pelasgi, who had introduced it into Greece, had, upon their expulsion from Thessaly by the Hellenes, betaken themselves to Latium, afterwards so called, and there disseminated their doctrines not less prosperously than their dominion.

Numa was in his day profoundly skilled in all the mysteries of those religious philosophers; and his proffered elevation to the Roman throne was but the merited recompense of his venerable character. His whole reign was accordingly one continued scene of devotion and piety, in which pre-eminently outshone his regard to Vesta*, in whose sanctuary was preserved the Palladium, " the fated pledge of Roman authority," and which too, by the way, ever connected as we see it was with the *worship of fire*, would seem to make the belief respecting it also to be of Oriental origin. This eastern extraction additionally accounts for that dexterous state contrivance of client and patron established in the early ages of the Roman government, corresponding to our ancient clanship—both evidently borrowed from the same Indian castes.

I now address myself to another obstacle which has been advanced by an Irish *lady*, and of the most deserved antiquarian repute, whose classic and elaborate treatise on this identical subject, though somewhat differently moulded, has already won her the applause of that society whose discriminating verdict I now

* Virginesque Vestæ legit, Albâ oriundum sacerdotium, et genti conditoris haud alienum. Livy, lib. i. cap. xx.

respectfully await. But as my object is *truth*, divested as much as possible of worldly considerations, and unshackled by systems or literary codes, I conceive that object will be more effectually attained by setting inquiry on foot, than by tamely acquiescing in dubious asseverations or abiding by verbal ambiguities.

What elicited this sentiment was Miss Beaufort's remark on the enactment at Tara, A.D. 79, for the *erection* of a *palace* in each of the four proportions subtracted by order of Tuathal Teachmar, from each of the four provinces to form the present county of Meath. Her words are as follow : — " Taking the landing of Julius Cæsar in Britain, in the year 55 before Christ, as a fixed point of time, and counting back fifty years from that, we shall be brought to about one hundred years before the Christian era, at which time the introduction of the improvements and innovations of Zoroaster, and that also of fire towers, may, without straining probability, be supposed to have fully taken place. *That it was* not much earlier may be inferred from the before-mentioned ordinance of the year 79 A.D., to increase the number of towers in the different provinces."

With great submission I conceive that the *error* here incurred originated on the lady's part, from mistaking as authority the comment in the Statistical Survey, vol. iii. p. 320, which runs thus :—" It is quite evident from sundry authentic records, that these round towers were appropriated to the preservation of the Baal-thinne, or sacred fire of Baal : first at the solemn convention at Tara, in the year of Christ 79, in the reign of Tuathal Teachmar, it was enacted, that on the 31st of October annually, the sacred fire

should be publicly exhibited from the stately tower of Tlactga, in Munster, from whence all the other repositories of the Baal-thinne were to be re-kindled, in case they were by any accident allowed to go out. It was also enacted, that a particular tower should be erected for that purpose in each of the other four provinces, Meath being then a distinct province. For this purpose the tax called Scraball, of three-pence per head on all adults, was imposed."

Well, for this is quoted " Psalter of Tara, by Comerford," page 51 ; on referring to which I find the text as thus : " He (Tuathal) also erected a stately palace in each of these proportions, viz., in that of Munster, the palace of Tlactga, where the fire of Tlactga was ordained to be kindled on the 31st of October, to summon the priests and augurs to consume the sacrifices offered to their gods ; and it was also ordained that no other fire should be kindled in the kingdom that night, so that the fire to be used in the country was to be derived from this fire ; for which privilege the people were to pay a scraball, which amounts to three-pence every year, as *an acknowledgment to the king of Munster*. The second palace was in that of Connaught, where the inhabitants assembled once a year, upon the first of May, to offer sacrifices to the principal deity of the island under the name of Beul, which was called the convocation of Usneagh ; and on account of this meeting the king of Connaught had from every lord of a manor, or chieftain of lands, a horse and arms. The third was at Tailtean, in the portion of Ulster, where the inhabitants of the kingdom brought their children when of age, and treated with one another about their marriage. From this custom the king of Ulster de-

manded an ounce of silver from every couple married
here. The fourth was the palace of Teamor or Tara,
which originally belonged to the province of Leinster,
and where the states of the kingdom met in a parlia-
mentary way."

I now leave the reader to decide whether the word
" palace" can be well used to represent an " eccle-
siastical tower," or indeed any tower at all; or
whether it is not rather a royal residence for the
several provincial princes, that is meant to be con-
veyed; as is evident to the most superficial, from the
closing allusion to the *palace* of Tara, " where the
states of the kingdom met in a parliamentary way."
The impost of the scraball, I must not omit to observe,
has been equally mis-stated in the survey; for it was
not for the purpose of erecting *any* structures, but as
an acknowledgment of homage and a medium of
revenue that it was enforced, as will appear most
clearly on reverting to the original, and comparing it
with the other means of revenue, which the other
provincial kings were entitled to exact. But what
gives the complete overthrow to the doctrine which
would identify those *palaces* with columnar edifices, is
the fact that there are no vestiges to be found of
Round Towers in any, certainly not in all of those four
localities specially notified. Wells and Donaghmore
are the only Round Towers now in the county Meath,
and these are not included among the places above
designated.

CHAPTER VIII.

To wind up the matter, steadily and unequivocally I do deny that the " Round Towers " of Ireland were fire receptacles. I go farther, and deny that any of those eastern round edifices which travellers speak of, were ever intended for fire receptacles : that they were all pagan structures—and temples too—consecrated to the most *solemn* and *engrossing* objects of *human pursuit,* however errroneously that pursuit may have been directed, I unhesitatingly affirm. What then, I shall be asked, was their design? To this I beg leave to offer a circumlocutory answer. Squeamishness may be shocked, and invidiousness receive a pretext, but, the spirit being pure, the well-regulated mind will always say " Cur nescire pudens prave quam discere malo * ?"

Then be it known that the " *Round Towers* " of *Ireland* were temples constructed by the early Indian colonists of the country, in honour of that *fructifying* principle of nature, emanating, as was supposed, from the sun, under the denomination of Sol, Phœbus, Apollo, Abad or Budh, &c. &c. ; and from the moon, under the epithet of Luna, Diana, Juno, Astarte, Venus, Babia or Butsee, &c. &c. Astronomy was inseparably interwoven with this planetary religion ; while the religion itself was characterized by enforcing almost as strict a regard to the body after

* Horace.

death, as the body was expected to pay to a Supreme Essence before its mortal dissolution. Under this double sense then of *funereal* or posthumous regard, as well as active and living devotion, must I be understood to have used the expression, when previously declaring that our *Sabian rotundities* were erected with the two-fold view of religious *culture* and the *practice* of that *science* with which it was so amalgamated.

To be explicit, I must recall to the reader's mind the destination which the Brahmins assigned to the Egyptian pyramids, on hearing Wilford's description of them—viz., that they were places appropriated to the worship of Padma-devi[*]. Before I proceed, however, I must state that I do not intend to make this the basis of what I shall designate my *disclosures*. It would be very foolish of *me*, if hoping to dislodge a *world* of long-established prejudice, to use, as my *lever*, a ray shot transversely from a volume which has been tarnished by forgery. I need no such aid, as the sequel will show; and yet were it requisite, no objection would be valid, as the " *Pundit* " could have had no motive, either of interest or of vanity, such as influenced his *transcriptions*, here to mislead his victim. It was the mere utterance of a casual opinion, without reference to any deduction. Besides it was not the statement of the knave at all, but that of a number of religious men of letters, who all agreed in the ascription above laid down. They spoke, no doubt, from some traditionary acquaintance with the use of those tall round buildings which so much baffle antiquarians, not more in Ireland than they do in Hindostan; but the explanation of this

[*] Asiatic Researches, Dissert. Up. Egypt and Nile.

their answer will be a happy inlet—and as such only do I mean to employ it—to the *illustration* of what we have been so long labouring at.

The word Padma-devi * means "*the deity of desire*," as instrumental in that principle of *universal* generativeness diffused throughout all nature. Do I mean that gross suggestion of carnal concupiscence?—that mere propensity of animal appetite which is common to man with the brute creation? No; it became redeemed, if not justified, by the religious complexion with which it was intertwined, derived, mayhap, originally from that *paradisiacal* precept which said, "increase and multiply;" while the strain of metaphor under which it was couched, and the spiritual tendency by which the ceremony was inculcated, prevented offence even to the most refined taste—the most susceptible fancy—or the most delicate sensibility.

The love of offspring has ever been a powerful ingredient in man's composition. The fair portion of the human species, as every age and experience can prove, have shown themselves not more exempt from the control of the same emotions or the influence of the same impulses. It was so wisely instituted by the great Regulator of all things, nor is the abuse of the principle any argument against its general utility or sanctified intent. Search the records of all early states, and you will find the legislator and the priest, instead of opposing a principle so universally dominant, used their influence, on the contrary, to bring it more into play, and make its exercise subservient to the increase of our species; the law lent its aid to enforce the theme as national, and religion sanctified it as a moral obligation.

* Literally, " the goddess of the lotos."

In India this *fervor* was particularly encouraged :
for " as the Hindoos depend on their children for per-
forming those ceremonies to their manes, which they
believe tend to mitigate punishment in a *future state*,
they consider the being deprived of them as a severe
misfortune and the sign of an offended God *." They
accordingly had recourse to all the stratagems which
ingenuity could devise to recommend this passion to
the inner senses, and dignify its nature by the studied
imagery of metaphor and grace. In conformity with
this sentiment we are favoured by Sir William Jones
with the copy of a hymn, which they were in the
habit of addressing to the above-mentioned " Padma-
devi," or " Mollium mater sæva cupidinum," which
he thus prefaces with her figurative descent :—

It is Camadeva, that is, the *god* of desire, the oppo-
site sex he speaks of, but the principle is the same.

> " Peor, his other name, when he enticed
> Israel in Sittim, on their march from Nile,
> To do him wanton rites, which cost them sore †."

" According to the Hindu mythology, he was the
son of Maya, or the general attracting power‡; that
he was married to Ritty, or Affection; and that his

* Craufurd's Sketches. † Milton.

‡ Maya also signifies *illusion*, of which as an operation of the Deity,
the following remark, extracted elsewhere from Sir William, may not be
unseasonable :—" The inextricable difficulties," says he, " attending the
vulgar notion of material substances, concerning which ' we know this
only, that we know nothing,' induced many of the wisest among the
ancients, and some of the most enlightened among the moderns, to be-
lieve that the whole creation was rather an *energy* than a work, by which
the Infinite Being who is present at all times and in all places, exhibits
to the minds of his creatures a set of perceptions, like a wonderful
picture or piece of music, always varied, yet always uniform ; so that all
bodies and their qualities exist, indeed, to every wise and useful purpose,
but exist only as far as they are *perceived*—a theory no less pious than
sublime, and as different *from* any principle of atheism, as the brightest
sunshine differs from the blackest midnight."

bosom friend is Vassant, or the Spring: that he is
represented as a beautiful youth, sometimes convers-
ing with his mother, or consort, in the midst of his
gardens and temples: sometimes riding by moon-
light on a parrot, and attended by dancing girls,
or nymphs, the foremost of whom bears his colours,
which are a fish on a red ground: that his favourite
place of resort is a large tract of country round Agra,
and principally the plain of Mathra, where Kreshen
also, and the nine Gopia usually spend the night
with music and dance: that his bow is of sugar-cane
or flowers, the sting of bees, and his five arrows are
each painted with an Indian blossom of an healing
quality." Tedious and diffuse as has been the dis-
sertation already, I cannot resist the inclination of
transcribing the hymn also.

> " What potent god, from Agra's orient bowers,
> Floats through the lucid air; whilst living flowers,
> With sunny twine, the vocal arbours wreathe,
> And gales enamoured heavenly fragrance breathe?
>
> Hail, Power unknown! for at thy beck
> Vales and groves their bosoms deck,
> And every laughing blossom dresses,
> With gems of dew, his musky tresses.
> I feel, I feel thy genial flame divine,
> And hallow thee, and kiss thy *shrine.*
>
> Knowest thou not me?—
> Yes, son of Maya, yes, I know
> Thy bloomy shafts and cany bow,
> Thy scaly standard, thy mysterious arms,
> And all thy pains and all thy charms.
>
> Almighty Cama! or doth Smara bright,
> Or proud Aranga, give thee more delight?
> Whate'er thy seat, whate'er thy name,
> Seas, earth, and air, thy reign proclaim;
> All to thee their tribute bring,
> And hail thee universal king.

Thy consort mild, Affection, ever true,
Graces thy side, her vest of glowing hue,
And in her train twelve blooming maids advance,
Touch golden strings and knit the mirthful dance.
 Thy dreadful implements they bear,
 And wave them in the scented air,
 Each with pearls her neck adorning,
 Brighter than the tears of morning.
Thy crimson ensign which before them flies,
Decks with new stars the sapphire skies.

God of the flowery shafts and flowery bow,
Delight of all above and all below !
Thy loved companion, constant from his birth
In heaven clep'd Vassant, and gay Spring on earth,
 Weaves thy green robe, and flaunting bowers,
 And from the clouds draws balmy showers,
 He with fresh arrows fills thy quiver,
 (Sweet the gift, and sweet the giver,)
And bids the various warbling throng
Burst the pent blossoms with their song.

He bends the luscious cane, and twists the string,
With bees how sweet ! but ah, how keen their sting !
He with fine flowrets tips thy ruthless darts,
Which through five senses pierce enraptured hearts.
 Strong Champa, rich in od'rous gold,
 Warm Amer, nursed in heavenly mould,
 Dry Nagkezer, in silver smiling,
 Hot Kiticum, our sense beguiling,
And last, to kindle fierce the scorching flame,
Loveshaft, which gods bright Bela name.
Can men resist thy power, when Krishen yields,
Krishen, who still in Mathra's holy fields,
Tunes harps immortal, and to strains divine,
Dances by moonlight with the Gopia nine ?
Oh ! thou for ages born, yet ever young,
For ages may thy Bramin's lay be sung ;
And when thy Lory spreads his emerald wings,
To waft thee high above the tower of kings,
 Whilst o'er thy throne the moon's pale light
 Pours her soft radiance through the night,
 And to each floating cloud discovers
 The haunts of blest or joyless lovers,
Thy milder influence to thy bard impart,
To warm, but not consume his heart."

Amongst the fables that are told to account for the origin of this amorous devotion, Sir William tells us, is the following, viz.—

"Certain devotees in a remote time had acquired great renown and respect; but the purity of the art was wanting; nor did their motives and secret thoughts correspond with their professions and exterior conduct. They affected poverty, but were attached to the things of this world, and the princes and nobles were constantly sending them offerings. They seemed to sequester themselves from the world; they lived retired from the towns; but their dwellings were commodious, and their women numerous and handsome. But nothing can be hid from the gods, and Sheevah resolved to expose them to shame. He desired Prakeety* to accompany him; and assumed the appearance of a Pandaram of a graceful form. Prakeety appeared as herself, a damsel of matchless beauty. She went where the devotees were assembled with their disciples, waiting the rising sun, to perform their ablutions† and religious ceremonies. As she advanced, the refreshing breeze moved her flowing robe, showing the exquisite shape which it seemed intended to conceal. With eyes cast down, though sometimes opening with a timid but a tender look, she approached them, and with a low enchanting voice desired to be admitted to the sacrifice. The devotees gazed on her with astonishment. The sun appeared, but the purifications were forgotten; the things of the Poojah‡ lay neglected; nor

* Nature.

† The Hindoos never bathe nor perform their ablutions whilst the sun is below the horizon.

‡ Poojah is properly worship.

was any worship thought of but that to her. Quitting
the gravity of their manners, they gathered round her
as flies round the lamp at night, attracted by its
splendour, but consumed by its flame. They asked
from whence she came; whither she was going?
' Be not offended with us for approaching thee; for-
give us for our importunities. But thou art incapable
of anger, thou who art made to convey bliss; to thee,
who mayest kill by indifference; indignation and re-
sentment are unknown. But whoever thou mayest
be, whatever motive or accident may have brought
thee amongst us, admit us into the number of thy
slaves; let us at least have the comfort to behold
thee.'

" Here the words faltered on the lip; the soul
seemed ready to take its flight; the vow was for-
gotten, and the policy of years destroyed.

" Whilst the devotees were lost in their passions,
and absent from their homes, Sheevah entered their
village with a musical instrument in his hand, playing
and singing like some of those who solicit charity.
At the sound of his voice the women immediately
quitted their occupations; they ran to see from whom
it came. He was beautiful as Krishen on the plains
of Matra*. Some dropped their jewels without
turning to look for them; others let fall their gar-
ments without perceiving that they discovered those
abodes of pleasure which jealousy as well as decency
has ordered to be concealed. All pressed forward
with their offerings; all wished to speak; all wished
to be taken notice of; and bringing flowers and scat-
tering them before him, said—' Askest thou alms !

* Krishen of Matra may be called the Apollo of the Hindoos.

thou who art made to govern hearts! Thou whose
countenance is fresh as the morning! whose voice is
the voice of pleasure; and thy breath like that of
Vassant* in the opening rose! Stay with us and we
will serve thee; nor will we trouble thy repose, but
only be jealous how to please thee.'

"The Pandaram continued to play, and sung the
loves of Kama†, of Krishen, and the Gopia, and
smiling the gentle smiles of fond desire, he led them
to a neighbouring grove that was consecrated to
pleasure and retirement. Sour began to gild the
western mountains, nor were they offended at the
retiring day.

"But the desire of repose succeeds the waste of
pleasure. Sleep closed the eyes and lulled the senses.
In the morning the Pandaram was gone. When
they awoke they looked round with astonishment, and
again cast their eyes on the ground. Some directed
their looks to those who had been formerly remarked
for their scrupulous manners, but their faces were
covered with their veils. After sitting awhile in
silence, they arose, and went back to their houses
with slow and troubled steps. The devotees re-
turned about the same time from their wanderings
after Prakeety. The days that followed were days of
embarrassment and shame. If the women had failed
in their modesty, the devotees had broken their vows.
They were vexed at their weakness; they were sorry
for what they had done; yet the tender sigh some-
times broke forth, and the eye often turned to where
the men first saw the maid, the women the Pandaram.

"But the people began to perceive that what the

* Vassant, the spring.　　　† Kama, the god of love.

devotees foretold came not to pass. Their disciples in consequence neglected to attend them, and the offerings from the princes and the nobles became less frequent than before. They then performed various penances; they sought for secret places among the woods, unfrequented by man; and having at last shut their eyes from the things of this world, retired within themselves in deep meditation, that Sheevah was the author of their misfortunes. Their understanding being imperfect, instead of bowing the head with humility, they were inflamed with anger; instead of contrition for their hypocrisy, they sought for vengeance. They performed new sacrifices and incantations, which were only allowed to have effect in the end, to show the extreme folly of man in not submitting to the will of heaven.

"Their incantations produced a tiger, whose mouth was like a cavern, and his voice like thunder among the mountains. They sent him against Sheevah, who, with Prakeety, was amusing himself in the vale. He smiled at their weakness, and killing the tiger at one blow with his club, he covered himself with his skin. Seeing themselves frustrated in this attempt, the devotees had recourse to another, and sent serpents against him of the most deadly kind; but on approaching him they became harmless, and he twisted them round his neck. They then sent their curses and imprecations against him, but they all recoiled upon themselves. Not yet disheartened by all these disappointments, they collected all their prayers, their penances, their charities, and other good works, the most acceptable of all sacrifices; and demanding in return only vengeance against Sheevah, they sent a consuming fire to destroy his genital parts. Sheevah,

incensed at this attempt, turned the fire with indignation against the human race; and mankind would have been soon destroyed, had not Vishnou, alarmed at the danger, implored him to suspend his wrath. At his entreaties Sheevah relented. But it was ordained that in his temples those *parts* should be *worshipped* which the false devotees had impiously attempted to destroy *."

But what was the form under which this *deity* was recognized? " Look on this picture and on that;" and the answer presents itself †. The eastern votaries, suiting the action to the idea, and that their vivid imagination might be still more enlivened by the very *form* of the *temple* in which they addressed their vows, actually constructed its architecture after the model of the *membrum virile*, which, obscenity apart, is the divinely-formed and indispensable medium selected by God himself for human propagation and sexual prolificacy.

This was the Phallus, of which we read in Lucian ‡, as existing in Syria of such extraordinary height, and which, not less than the Egyptian Pyramids, has heretofore puzzled antiquaries,—little dreaming that it was the counterpart of our Round Towers, and that both were the prototypes of the two "*Pillars*" which Hiram wrought before the temple of Solomon.

Astarte was the divinity with whose worship it was thus associated, and by that being understood

* Translated from the Persic, and read before the Oriental Society in India.

† The reason why the Egyptian Pyramids, though *comprehending* the same idea, did not *exhibit* this form, will be assigned hereafter.

‡ In his treatise " De Deâ Syriâ."

the moon *, it was natural to suppose that the study
of the stars would essentially enter into the ceremo-
nial of her worship. Another name by which this
divinity was recognized, was Rimmon, which, signify-
ing as it does *pomegranate*, was a very happy emblem
of *fecundity*, as apples are known to be the most pro-
lific species of fruit.

Lingam is the name by which the Indians de-
signated this idol †. Those who dedicate themselves
to his service swear to observe inviolable chastity.
" They do not, however," says Craufurd, " like the
priests of Atys, deprive themselves of the means of
breaking their vows ; but were it discovered that they
had in any way departed from them, the punishment
is death. They go naked ; but being considered as
sanctified persons, the women approach them without
scruple, nor is it thought that their modesty should
be offended by it. Husbands, whose wives are bar-
ren, solicit them to come to their houses, or send
their wives to worship Lingam at the temples ; and
it is supposed that *the ceremonies* on this occasion, if
performed with the proper zeal, are usually productive
of the desired effect ‡."

* Astarte, queen of heaven, with crescent horns,
 To whose bright image nightly by the moon,
 Sidonian virgins paid their vows and songs."—MILTON.

† Les Indiens ont le Lingam qui ajoute encore quelque chose a
l'infamie du Phallus des Egyptiens et des Grecs : ils adorent le faux
dieu Isoir sous cette figure monstreuse, et qu'ils exposent en procession
insultant d'une manière horrible à la pudeur et à la crédulité de la
populace.—La Croze, p. 431.

‡ We can now see how it happened that the Irish word *Toradh, i. e.*,
" to go through the tower ceremony," should signify also " to be preg-
nant ;" and we can equally unravel the *mythos* of that elegant little
tale which Sir John Malcolm tells us from Ferdosi, in his History of
Persia. " It is related," says he, " that Gal, when taking the amusement
of the chase, came to the foot of a *tower*, on one of the turrets of which

Such was the origin and design of the most *ancient* Indian pagodas, which had no earthly connexion with fire or fire-worshippers, as generally imagined.—And that such, also, was the use and origin of the Irish pagodas is manifest from the name by which they are critically and accurately designated, viz., *Budh*, which, in the Irish language, signifies not only the *Sun,* as the source of *generative vegetation,* but also the *male organ of procreative generativeness*, consecrated, according to their foolish ideas, to Baal *Phearagh* or Deus-*coitionis*, by and by to be elucidated. This thoroughly explains the word " Cathoir-ghall," or " temple of *delight,*" already mentioned as appropriated to one of those edifices, and is still further confirmed by the name of " Teaumpal na greine," or " temple of the sun," by which another of them is called ; while the ornament, that has been known to exist on the top of many of them, represents the crescent of Sheevah, the matrimonial deity of the Indians, agreeably to what the Heetopades states, viz., " may he on whose diadem is a crescent cause prosperity to the people of the earth."

But you will say that my designating these structures by the name of *Budh* is a *gratuitous assumption,* for which I have no authority other than what *imagination* may afford me ; and that, therefore, however striking may be *appearances,* you will withhold your conviction until you hear my proofs. Sir, I advance nothing that I cannot support by arguments, and

he saw a young *damsel* of the most exquisite beauty. *They mutually gazed and loved,* but there appeared no mode of ascending the battlement. After much embarrassment, an *expedient* occurred to the fair maiden. She loosened her dark and beautiful *tresses,* which fell in ringlets to the *bottom* of the *tower,* and enabled the *enamoured* prince to *ascend.* The lady proved to be Noudabah, the daughter of Merab, king of Cabul, a prince of the race of Zohauk."

should not value your adherence were it not earned
by truth. This is too important an investigation to
allow *fancy* any share therein. It is not the mere
settlement of an antiquarian dispute of *individual* in-
terest or *isolated* locality that is involved in its adjust-
ment,—no, its bearings are as comprehensive as its
interest should be universal; *the opinions of mankind
to a greater extent than you suppose will be affected by
its determination;* and I should despise myself if, by
any silly effort of ingenuity, I should attempt to lead
your reason captive, or pander to your credulity,
rather than storm your judgment.

This being premised, I shall not condescend, here or
elsewhere, to apologize for the freedom with which I
shall express myself in the prosecution of my ideas.
The spirit that breathes over the face of the work will
protect me from the venom of ungenerous imputation.
Freedom is indispensable to the just development
of the subject. Nor do I dread any bad results can
accrue from such a course, knowing that it is the
vicious alone who can extract poison from my page—
and they could do it as well in a museum or picture
gallery—while the *virtuous* will peruse it in the
purity of their own conceptions, and if they rise not
improved, they will, at least, not deteriorated.

My authority for assigning to the Round Towers
the above designation is nothing less than those
annals before adduced *. Where is it *there?* you
reply. I rejoin in *Fidh-Nemphed;* which, as it has
heretofore puzzled all the world to develop, I shall
unfold to the reader with an almost miraculous result.
Fidh, then—as the Ulster Annals, or *Fiadh*, as those
of the Four Masters spell it—is the plural of *Budh*,

* Chapter IV. p. 48.

i. e., Lingam; the initial *F* of the former being only
the aspirate of the initial *B* of the latter, and com-
mutable with it*; and *Nemphed* is an adjective, sig-
nifying *divine* or *consecrated*, from *Nemph*, the heavens:
so that *Fidh-Nemphed*, taken together, will import the
Consecrated Lingams, or the *Budhist Consecrations*.

Celestial INDEXES, cries O'Connor; following which
term—but with a very different acceptation—the reader
must be aware how that, in the early part of our
journey, I ascribed to this *enigma* an astronomical
exposition; but herein I was supported not only by
expediency but by verity, having, all along, not only
connected *Solar* worship, and its concomitant survey
of the stars—which is *Sabianism*—with *Phallic* wor-
ship—beginning with the former in order to prepare
the way for the latter,—but shall proceed in detail
until I establish their identity.

The Egyptian history, then, of the origin of this
deification is what will put this question beyond the
possibility of denial, viz., that "Isis having recovered
the mangled pieces of her husband's body, the *geni-
tals excepted*, which the murderers had thrown into
the sea, resolving to render him all the honour which
his humanity had merited, got made as many waxen
statues as there were mangled pieces of his body.
Each statue contained a piece of the flesh of the dead
monarch. And Isis, after she had summoned in her
presence, one by one, the priests of all the different
deities in her dominions, gave them each a statue,

* Syncellus accordingly spells Budh, even in the singular number, with
an *F*; and Josephus, from the Scriptures, additionally commutes the
final *d* into *t*. We shall see more inflections anon.

Φουδ ιξ ου τρωρλοδιται.—Syncellus, p. 47.

Fut was the founder of the nations in Libya (Africa), and the people
were from him called Futi.—Josephus, Ant. lib. i. c. 7.

intimating that, in so doing, she had preferred them to all the other communities of Egypt; and she bound them by a solemn oath that they would keep secret that mark of her favour, and endeavour to prove their sense of it by establishing a form of worship, and paying divine honours to their prince. But that *part* of the body of Osiris which had *not* been discovered, was treated with more *particular* attention by Isis, and she ordered that *it* should receive *honours more solemn,* and at the same time *more mysterious,* than the other members *."

Now as Isis † and Osiris—two deities, by the way, which comprehended all nature and all the gods of the ancients—only personated the *Sun* and *Moon,* the sources of nutrition and vegetative heat, it is very easy to remove the veil of this affectionate mythology, and see that it means nothing more than the mutual dependence and attraction of the sexes upon, and to, each other; while the fact of the Egyptian "*Osiris*‡," which in *their* language signifies the *Sun,* and the Irish "*Budh,*" which in *our language* signifies the same planet, being *both* represented by the *same emblematic sign*§; and the *name* of that sign in both languages signifying as well *sign* as *thing* signified, gives a stamp to my proof which I defy *ingenuity* to overthrow.

* Vide Plutarch, de Isi et Osiri.

† Eas, in Irish, also means the moon.

‡ Literally the Son of the Sun, and should properly be written O'Siris, like any of our Irish names, such as O'Brien—and meaning *sprung from.*

§ These are the *indexes* for which Mr. O'Connor could find no other use than that of dials!

CHAPTER IX.

Wʜᴀᴛ is it, then, that we see here elucidated? Just conceive. For the last three thousand years and more, the learning of the world has been employed to ascertain the *origin* of the doctrine of Budhism. The savants of France, the indefatigable inquirers of Germany, the affected pedants of Greece and Rome, and the pure and profound philosophers of ancient India and Egypt, have severally and ineffectually puzzled themselves to dive into the secrets of that mystic religion *.

" The conflicting opinions," says Coleman, "which have prevailed among the most intelligent oriental writers, respecting the origin and antiquity of this and the Jaina sects, and the little historical light that has yet been afforded to disperse the darkness that ages have spread over them, leave us, at the end of many learned disquisitions, involved in almost as many doubts as when we commenced upon them."

" There was, then," adds Gentil, " in those parts of India, and principally on the coast of Choromandel and Ceylon, a sort of worship the precepts of which we are quite unacquainted with. The god Baouth, of whom

* Les mystères de l'antiquité nous sont demeurés presqu'interdicts; les vestiges de ses monuments manquent le plus souvent de sens pour nous, parceque, de siècle en siècle, les savants ont voulu leur attribuer un sens.—Dᴇ Sᴀᴄʏ.

at present they know no more in India than the name, was the object of this worship; but it is now *totally* abolished, except that there may possibly yet be found some families of Indians who have remained faithful to Baouth, and do not acknowledge the religion of the Brahmins, and who are on that account separated from and despised by the other castes.... I made various inquiries concerning this singular figure, and the Zamulians one and all assured me that this was the god Baouth, who was now no longer regarded, for that his worship and his festivals had been abolished ever since the Brahmins had made themselves masters of the people's faith."

" The worship of Budha," says Heeren, " concerning the rise and progress of which we at present know so little, still flourishes in Ceylon." Again, " All that we know with certainty of Budha is, that he was the founder of a sect which must formerly have prevailed over a considerable part of India, but whose tenets and forms of worship were in direct opposition to those of the Brahmins, and engendered a deadly hate between the two parties, which terminated in the expulsion of the Budhists from the country *."

* To this declaration of Mr. Heeren, as I cannot *now* bestow upon it a separate inquiry, I must be allowed briefly to intimate that if such be all that he " knows with certainty" on the topic, he had better not know it at all, for, with the exception of that part which avows the general *ignorance* concerning its rise and progress, as well as its expulsion by the Brahmins from the East, *all the rest is inaccurate.* In the first place it does not "*flourish*" at present in Ceylon. It has sunk and degenerated there into an unmeaning tissue of hideous demonology, *if we may judge by a reference to a large work published here some time ago,* by Mr. Upham, which is as opposite from real *Budhism* as truth is from falsehood. In the second place its tenets were *not* " in direct opposition to those of the Brahmins," any more than those of the Catholics are from the tenets of the Protestants; yet have the latter contrived to oust the Ca-

" The real time," say the Asiat. Res., viii. p. 505,
" at which Buddha propagated the doctrines ascribed
to him, is a desideratum which the learned knowledge
and indefatigable research of Sir W. Jones have still
left to be satisfactorily ascertained."

" If the Budhaic religion," says the Westminster
Review of January, 1830, " really arrived at pre-
dominance in India, its *rise* in the first place, and more
especially its *extirpation*, are not merely events of stu-
pendous *magnitude*, but of impenetrable mystery."

It will soon appear, that however *impenetrable* here-
tofore, it is so no longer. Indeed a great deal of the
principle of their *faith* has been at all times under-
stood, but under different associations. It was that
which Job alluded to when he said, " If I gazed upon
Orus (the sun) when he was shining, or upon Järêcha
(the moon) when rising in her glory ; and my heart
went secretly after them, and my hand kissed my
mouth (in worship), I should have denied the God
that is above."

So far all have arrived at the discovery of this
creed ; and accordingly, if you look into any encyclo-
pedia or depository of science for a definition of the
word Budhism, you will be told that " it is the doc-
trine of solar worship as taught by Budha." There
never was such a person as Budha—I mean at the
outset of the religion, when it first shot into life, and
that was almost as early as the creation of man. In
later times, however, several enthusiasts assumed the
name, and personified in themselves the faith they

tholics, their predecessors, as the Brahmins did the still more antecedent
Budhists. And this will be sufficient to neutralize that insinuation
which would imply that Budha was an *innovator* and a *sectarian*, until
I show by and by that the reverse was the fact.

represented. But the origin of the religion was an *abstract thought*, which while Creuzer allows, yet he must acknowledge his ignorance of what that *thought* was.

The sun and moon were the great objects of religious veneration to fallen man in the ancient world. Each country assumed a suitable form to their propensities and peculiarities; but all agreed in centering the essence of their zeal upon those resplendent orbs to whom they were indebted for so many common benefits. Those mysteries of faith to which the "*initiated*" alone had access, and which were disguised in the habiliments of symbols and of veils, were neither more nor less than representative forms of *generation* and *production*. These were the *theme* which made the canopy of the firmament to ring with their songs; and these the *spring* which gave vigour and elasticity to those graceful displays which, under the name of *dances*, typified the circular and semicircular rotations of those bright objects of their regard *.

The Eleusinian † rites themselves were essentially of this kind; for though the benefits of *agriculture* were said to be chiefly there commemorated, this after all resolves itself into the above : for, as the process of the earth's bearing is similar to that of our own species, and indeed of all creatures that rest

* The Jews themselves, so early as the time of Moses, adopted the practice as an act of *thanksgiving*.

" And Miriam the prophetess, the sister of Aaron, took a timbrel in her hand ; and all the women went out after her, with timbrels, and with dances.

" And Miriam answered them, Sing ye to the LORD, for he hath triumphed gloriously; the horse and his rider hath he thrown into the sea."—Exod. xv. 20, 21.

† The origin of this word shall be explained hereafter.

upon her—no seed bringing forth fruit until, as the
Apostle has affirmed*, it first dies—the representa-
tion of this miracle of nature's vicissitudes led the
mind to the contemplation of general fecundity. And
hence the *culture* of the ground, and the *propagation*
of human beings, being both viewed in the same
light, and sometimes even named by the same epithet,
viz., *tillage*, were inculcated no less as beneficial
exercises than as religious ordinances. Did a doubt
remain as to the accuracy of this connexion between
the worship of the ancients and their sexual cor-
respondence, it would be more than removed by
attending to the import of the terms by which they
mystified those celebrations, and which, with the
sanctity attached to the *parts* themselves, will come
consecutively under our review. One of them, how-
ever, is too apposite to be omitted here, and that is
the term by which they designated a certain cere-
mony still practised on the coast of Guinea, and which
neither the *blandishments* of *artifice* nor the *terrors* of
menace could ever prevail upon them to divulge. This
ceremony they call *Belli-Paaro*. The meaning they
assign to it is *regeneration,* or the act of reviving from
death to a new state of existence ; and when we see
that the name itself is but an inflection of the *Baal-
Peor* of the Scriptures, the *Baal-Phearagh* of our
forefathers, and the *Copulative deity* of the amative
universe, it will not be hard to dive into its character,
though so shrouded in types.

But the Budhists, not content with this ordinary
veneration, or with paying homage in *secret* to that

* " Verily, verily, I say unto you, except a *corn* of *wheat* fall into the
ground and *die*, it abideth alone; but if it die, it bringeth forth much
fruit."—John xii. 24.

symbol of production which all other classes of idola-
tors equally, though privately, worshipped—I mean
the Lingam—thought they could never carry their
zeal sufficiently far, unless they erected it into an *idol*
of more than colossal magnitude—*and those idols
were the Round Towers.* Hence the name *Budhism,*
which I thus define, viz., *that species of idolatry which
worshipped Budh* (i. e., the Lingam) *as the emblem*
of *Budh* (i. e., the Sun)—Budh signifying, indiscrimi-
nately, Sun and Lingam.

Such was the whole substance of this philosophical
creed, which was not—as may have been imagined—
a *ritual of sensuality,* but a *manual of devotion,* as
simple in its exercise as it was pious in its intent—a
Sabian veneration and a symbolical gratitude. I shall
now give a summary of their moral code, couched in
the following Pentalogue, as presented by Zarado-
beira, chief Rahan at Ava, to a Catholic bishop, who
expressed a wish, some years ago, to be favoured with
a brief outline of their tenets; it is this :—

1. Thou shalt not kill any animal—from the meanest
insect up to man himself.

2. Thou shalt not steal.

3. Thou shalt not commit adultery.

4. Thou shalt not tell any thing false.

5. Thou shalt not drink any intoxicating liquor.

The extension of this first commandment from the
crime of homicide to the deprivation of life of any
breathing existence, arose from their doctrine of the
transmigration of souls, which they believed should
continue ever in action, and, after release from one
tenement of earthly configuration, enter into some
other of a different species and order.

In this incessant alternation—which was to be one of

ascent or of *descent*, according to the merits of the *body*, which the spirit had *last* animated, and which was all considered as a sort of lustral crucible, for the refining of the vital spark against its reunion with the Godhead, whence it had originally derived — it is manifest that such tenderness for the entire animal creation arose from the apprehension of slaying some relation in that disguise.—Or, did we ascribe it to no higher motive than a sympathy with fellow-creatures, which, if not equally responsible, are at all events susceptible of anguish and of pain, this in itself should teach us to suppress all ebullitions of irreverent sarcasm, and, if we yield not our acquiescence, to extend to it at least our commiseration.

"Pain not the ant that drags the grain along the ground,
It has life, and life is sweet and delightful to all to whom it belongs.*"

The *good works* which they were *additionally* enjoined to perform were classified under the two heads of *Dana* and *Bavana*. By "*Dana*" was meant the *giving of alms*, and hence the whole fraternity were called *Danaans* or *Almoners* †. By "*Bavana*" was

* We are told,—says Sir John Malcolm—in a Persian work of celebrity, the Attash Kuddah,—that a person dreamt he saw Ferdosi composing, and an angel was guiding his pen : he looked near, and discovered that he had just written the above couplet, in which he so emphatically pleads for humanity to the smallest insect of the creation.

† *Another Almoner* was an epithet they assigned to God, which even the Brahmins retained after they had seceded from them, as may be seen in Wilkins' translation of a Sanscrit inscription on a pillar near *Buddal*, published in the first volume of the " Asiatic Researches." This inscription, I must observe, as it escaped that learned orientalist to perceive it, as it equally did the acumen of the president, his annotator, is, with the column on which it appears, nothing else than a record of the triumphs obtained by a hero of the Braminical party in exterminating the Budhists. The frequent allusion to the " lustful ele-

understood the *thoughtfully pronouncing* those three
words, *Anuzza, Docha,* and *Anatta:* of which the
first implies our liability to *vicissitude;* the second
to *misfortune,* and the third our *inability* to exempt
ourselves from either *.

The exposition of the terms *Tuath* and *de,* as pre-
fixes to *Danaans,* forming with it the compound Tuath-
de-danaan, I shall reserve for a more befitting place.

phants,"—such as " whose piles of rocks reek with the juice exuding
from the heads of intoxicated elephants,"—and " Although the prospect
hidden by the dust arising from the multitude of marching force
was rendered clear from the earth being watered by constant and
abundant streams flowing from the heads of lustful elephants of various
breeds,"—and still more that beautiful and pathetic sentiment which
occurs in the original of the preceding paper, omitted by Mr. Wilkins,
but supplied by the president, viz., " by whom having conquered the
earth as far as the *ocean,* it was left as being unprofitably seized—so
he declared ; and his *elephants weeping* saw again *in the forests their
kindred whose eyes were full of tears,*"—make this a demonstration:
yet would the beauty of the image be lost to some of my readers, were I
not to explain that the Budhists treated with a sort of deified reverence
the tribe of *elephants,* which now bewailed their extermination as above
described.

* From Bavana was named the village of Banaven, in Scotland,
whither some of the Tuath-de-danaans had repaired after their retreat
from Ireland—a very appropriate commemoration of their recent sub-
version ; and a particular locality within its district, where St. Patrick
was born, was called *Nemph-Thur,* that is, the *holy tower,* correspond-
ing to *Budh-Nemph,* i. e., the *holy Lingam,* from the circumstance of
there having been erected on it one of those temples which time has
since effaced. *Tor-Boileh* upon the Indus, which means the *Tower of
Baal,* is in exact consonance with *Nemph-Thur* and with *Budh-Nemph ;*
and there can be no question but that *there* also stood one of those edi-
fices, as the ruins even of a city are perceptible in the neighbourhood.
Mr. Wilford, however, would translate this last name, Tor Boileh, by
Black Beilam : and, to keep this *colour* in countenance, he invents a new
name for a place called Peleiam, " which," he says, " *appears* to have
been transposed from Ac Beilam, or the *white Beilam,* sands or shores,
and now called ' Hazren.' " I am not surprised at the *discredit* brought
upon etymology.

Meantime I hasten to redeem my "pledge" as to the elucidation of the import of the name *Hibernian.*

In the wide range of literary disquisition there is no one topic which has so engrossed the investigation of studious individuals as the origin of the word *Hibernia.* The great Bochart, the uncertain Vallancy, the spiteful Macpherson, the pompous O'Flaherty, and the "antiquary of antiquaries," Camden himself,—with a thousand others unworthy of recognition,—have been all consecutively shipwrecked upon its unapproachable sand-banks. But the most miserable failure of all is that of a namesake of my own, *the author of a Dictionary upon the language of his country;* who, in his mad zeal for an outlandish conceit, foists into his book a term, with which our language owns no kindred, and then builds upon that a superstructure which " would make even the angels weep."

This gentleman would fain make out * that, because those islands have been denominated the *Cassiterides,* or *Tin Reservoirs,* therefore Eirin, our own one of them, must have been so called as an *Iron Store!* forgetting that the genius of our vocabulary has never had a term whereby to express that *metal* at all—that by which we now designate it, namely *iarun,* being only a modern *coinage* from the English word,—as the general voice of antiquity speaks trumpet-tongued on the point, and the fragments of our Brehon laws give it insuperable confirmation, that *iron* was the last metal which mankind has turned to profit, or even known to exist, while with us it was an exotic until a very recent period.†

* And this, too, after he had admitted that "the name is certainly of the pure Iberno-Celtic dialect, and must have had some meaning founded in the nature of things in its original and radical formation."

† All our ancient swords were made of brass.

But admitting that *Eirin* or *Erin* did signify *the Land of Iron*, then its Greek formation *Ierne* must convey the same idea, and so must *Hibernia*, their Latin inflection ; and it would afford me a considerable portion of merriment to behold any champion for this *iron-cased* knight buckle on his *etymological* armour, and analyze these two last terms so as to make them indicate the *land of iron*.

Yet pitiable as this appears, for the author of an Irish Dictionary, its ingenuity, at all events, must screen it from contempt. But how will the public estimate the brightness of that man's intellect, who would state that *Erin* is but a *metempsychosis* of the word *Green?* Will it be believed that such is the sober utterance of the author of the " Decline and Fall of the Roman Empire?" But lest I should misrepresent, I shall let him speak for himself : viz. " Ireland, from its luxuriant vegetation, obtained the epithet *Green*, and has preserved, with a slight alteration, the name *Erin*." *

So that a country which piques itself on its *Irishry*, has remained ever without a cognomen, until the *English* language has been *matured ;* and then, in compliment to her sister, Britain,—has borrowed an adjective from her *rainbow*, which, however, she had not the good manners to preserve pure, but allowed to degenerate so far, that the sagacity of a conjurer could not trace any resemblance between this *vitiation* and the *original epithet* which pourtrayed her *verdure !*

Have we not here the solution of that general disbelief which attaches to proofs deduced from etymology ? It is so in all professions, when quacks break into the fold, and usurp the office of the legitimate practitioner.

* Gibbon, vol. ii. p. 527. 4to. 1781.

Etymology, in itself, is an exalted *science*, and an *unerring standard ;* but the mountebanks that have intermeddled with her holy tools, and disjointed the symmetry of her fair proportions, knowing no more of the *foundation* of *languages* than they do of the *origin* of *spirit*, have sunk it into a *pandemonium* of *huckling*, *mangling* and *laceration*, at which " the satirist," perhaps, may laugh, but " the philosopher," who has any regard for the right thinking of society, and the implanting in the tender mind a correct idea of words, at a moment when impressions are so wrought as to be *ineffaceable*, will feel differently on the subject ; and, if he cannot *reform*, do all that he can to *expose* it!

How opposite has been the conduct of the learned Abbé Mac Geoghegan as to the origin of this abstruse word! After reviewing, in his able work *, the opinions offered by the several persons who wrote before him upon the question, and none of them giving him satisfaction, he freely acknowledges, when unable to supply the deficiency, that " the derivation of this name is unknown." He was right : but the spell is at last broken.

As a sequel to this avowal, I must be allowed to quote at full length the extract from Avienus, which has been already referred to.

> " Ast hinc, duobus in *Sacram*—sic *Insulam*
> Dixere *prisci*—solibus cursus rati est ;
> Hæc inter undas multum cespitem jacit ;
> Eamque latè gens *Hibernorum* colit,
> Propinqua rursus insula Albionum patet,"—

that is, two days' sail will take you thence (from the Sorlings) to the *Sacred Island ;* as so denominated by

* Histoire d'Irelande, vol. i. cap. 7.

the *men of old.* A rich gleby soil distinguishes this
favourite of the waters; and the race of the *Hiber-*
nians cultivate it in its wide extent. Close by, again,
is situated the isle of the Albiones.

Without dwelling upon the importance which he
attaches to this " Sacred Island," while he disposes of
England in one single line, I ask any person, at all con-
versant with letters, whether it was as a vernacular
epithet, or not rather in compliance with his *hexame-*
ters, and the rules of metrical versification, which
rendered inconvenient the exhibition of the *name it-*
self, that the poet paraphrased its meaning, and gave
insula sacra as its equivalent?

Is not the country inhabited by the Gauls called
Gallia; that occupied by the Britons, Britannia; that
possessed by the Indians, India; that peopled by the
Germans, Germania; and that tenanted by the Arca-
dians, Arcadia? Consequently, the land inhabited by
the people styled *Hibernians* must, by universal ana-
logy, be denominated *Hibernia.* And if this signifies
" Sacred Island," of course " Hibernian " must mean
" an inhabitant of the Sacred Island."

Avienus wrote about the three hundredth year of
the Christian era, and cites the authorities, whence he
derived his information, to the following purpose, viz.—

" Himilco, the Phœnician, has recorded that he
has himself traversed the ocean, and with his own
eyes and senses verified those facts. From the
remote annals of the Phœnicians, I copy the same,
and present them to you as handed down from anti-
quity."

Himilco, be it remarked, flourished six hundred
years before the name of Christianity was mentioned
in the world; and when his acquaintance with this

isle, and that of his countrymen in general, is thus irrefutably premised, we shall be the more ready to do justice to that observation made by Tacitus, when, in his "Life of Agricola," talking of Ireland relatively to England, he affirmed that "her coasts and harbours were better known, through commerce and mercantile negotiation," than those of the latter country*.

Why do I introduce this notice here? To show that it was not to the Latins Avienus was indebted for his *insight* into that term, which we thus pursue. The Romans knew nothing even of the *situation* of the place that bore it, until their avarice and their rapacity brought their eagles to Britain; and, after effecting the subjugation of that heroic island, it is no small incentive to our vanity, to see their historian constrained to confess, that the exhibition of a similar project against the liberties of Ireland was more with a view to over-awe, than from any hopes of succeeding*; while the ignorance which he evinces in another clause of that very sentence, whence the above extract has been quoted,—placing Ireland *midway* between Spain and England,—is proof incontrovertible of the position which has been assumed.

But it is to me immaterial whether Avienus was aware or otherwise that "Hibernia" and "Sacred Island" were convertible and synonimous. It is not by his authority that I mean to establish the fact; for even admitting his cognizance of the identity of these two terms, he must yet of *necessity* be unacquainted with the *root* whence they *both* had sprung; and, accordingly, I have only put him here in the fore-

* Melius (Hiberniæ quam Britanniæ) aditus—portusque per commercia et negociatores cogniti. Tacit., vit. Agricol. 499.
† Plus in metum quan in spem.

ground—as has been the plan all through—" to break the ice," as it were, for the exordium of the promised *denouement.*

Iran, then, and *Irin,* or, as more correctly spelled, *Eirean* and *Eirin,* with an *e* prefixed to each of the other vowels, as well initial as intermediate, is the characteristic denomination which all our ancient *manuscripts* affix to this country. There is no exception to this admitted rule. From the romance to the annal, the observation holds good; it is an *inalienable* landmark, and of *inviolable* unanimity.

Dionysius of Sicily, who wrote about fifty years before the *Advent,* and who cannot be suspected of much partiality towards our forefathers, calls the land they inhabited by the name of *Irin**. Nor will the circumstance of his applying to it, in another place, the variation *Iris,* detract from this fact; as it is evident that he only manufactured this latter,† having occasion to use a nominative case, which he thought that *Irin* would not well represent, and so, with the lubricity of a Greek, ever sacrificing sense to sound †, he gave birth to a conception which *strangled* the original. ‡

* "ὥσπερ καὶ τῶν Βρεττανῶν τοὺς οἰκοντας τὴν ονομαζομενην Ιριν.
 Diod. Sic. lib. v.

† In proof of this, I aver that I could go through the whole range of their language, and prove that in its fabrication, so punctilious was their regard to *euphony,* they scrupled not to *cancel,* or otherwise *obnebulate* the *essential* and *significant* letters of the primitive words : so that, in a few generations, their descendants were unable to trace the true *roots* of their compounds. Hence that lamentable imperfection which pervades all our Lexicons and Dictionaries, and which can never be rectified but by the revisal of the whole system, and that by a *thorough adept* in the language of the Irish.

‡ I say strangled, because *Irin* is a compound word, embracing within its compass *two distinct parts,* of which Iris could give but the spirit of one.

In the " Life of Gildas," an early and eminent Eng-
lish ecclesiastic, we find it called *Iren*, when the bio-
grapher, talking of the proficiency made by his subject
in literary pursuits, says that he betook himself to
Ireland, which he designates as above, in order to
ascertain, by communion with kindred teachers, the
very utmost recesses of theology and philosophy.*

Ordericus Vitalis, in his " Ecclesiastical History†,"
having occasion to mention the *Irish,* calls them by the
name of *Irenses,* equivalent to *Iranians,* that is, *inha-
bitants* of *Iran, Iren,* or *Irin,* whichever of them you
happen to prefer. And as these are now established
as the *basis* of our general search, I shall address my-
self, without further digression, to their syllabic ana-
lysis.

To do this the more effectually, and at the same time
to comprise within one dissertation what otherwise
might encroach upon two, it is to be noticed that the
country, known in the present day as *Persia,* and whi-
ther our labours will be directed at no distant hour,
was by its *primitive* inhabitants called *Iran* also, and
spelled as ours, with an initial *E.* The prefixing of
this letter, in both instances of its occurrence, whether
we regard the *Eastern* or the *Western* hemisphere, was
neither the result of chance, nor intended as an opera-
tive in the import of the term. It was a mere *dialectal*
distinction, appertaining to the court-language of the
dynasty of the times, and, what is astoundingly mira-
culous, retains the same appellation, with literal pre-
cision, unimpaired, unadulterated, in both countries, up
to the moment in which I write.

* Iren perrexit ut et aliorum Doctorum sententias in philosophicis at-
que divinis litteris investigator curiosus exquireret. Vita Gildæ, cap. 6.
† Lib. x. Anno 1098.

Palahvi * is the appellation of this courtly dialect in *Persia*, and *Palahver* is the epithet assigned to it in *Ireland ;* and such is the softness and mellifluence of its enchanting tones, and its energy also, that to soothe care, to excite sensibility, or to stimulate heroism, it may properly be designated as " the language of the gods."

Thus we see that Ireland and Persia were both called *Iran ;* that both equally admitted of the change of this name to *Eiran ;* and that the *style* of this variation was similarly characterised in both. How, then, will the *empyrics* of etymology recover their confusion : they who would persuade us that Ireland was so denominated from *Iar*, the *West*—unless, indeed, they can substitute *East* for *West*, and show that Persia was denominated from *Iar* also.† Entangled in this dilemma, the amiable old General Vallancy, without intimating, however, that *it* was what extorted his remark—after rigidly maintaining, through a series of volumes, that the word had its origin in the above exploded *Western* Will o' the Wisp—exclaims, in a sentiment of unconscious self-conviction, that " nothing more can be said of this derivation than that the name was common to that part of the globe whence they (who imported it) originally came. ‡"

Arrived, then, at length, at the *fountain-head* of our inquiry, how shall we account for it in " that part of the globe whence we originally came?" I have seen but two efforts to develop the word, as applied to that

* Modern writers upon Persia, who would *refine* upon the matter, have perverted this word to *Pehlivi ;* but look you into the early numbers of the " Asiatic Researches," and there you will find it spelled as above.

† Besides, to speak *accurately*, this is not a *western* country at all, or only so relatively to Britain, Gaul, and that particular line.

‡ Collect. de Reb. Hib. vol. iv.

quarter: one by Professor Heeren, of the Göttingen University; the other by "a learned priest of the Parsees," as recorded by Sir John Malcolm, the late lamented author of a history of the place itself. And as the former of these is rather *humorous,* and as the latter contains in it a small *ingredient of truth,* it is worth while to parade them in the *tail* of our inspection.

"Anciently," says the professor, "they were called by the Orientals themselves by the common term of *Iran,* and the inhabitants, inasmuch as they possessed *fixed* habitations and laws, were styled *Iranians,* in opposition to the *Turanians,* or *wandering* hordes of central Asia*."

I wonder did the German *historian* take his cue from the conjecture of the Irish *lexicographer?* It is literally marvellous if he did not; for, by a most unaccountable coincidence, while tracing the foundation of a name, descriptive of two localities at opposite points of this mundane ball, one boldly asserts, and the other more than insinuates, that its root is to be found in one and the same *English* word!—and this, too, when those countries were blazing in glory, before three words of the English language were broken into train!

A difference, however, breaks out amongst those partners, which seems to sever the prospects of their *metallic* union. It is, that though each would make *iron* to be the substratum of their respective hobbies, yet would *my namesake* have his so called as *abounding* therein; whereas the *professor,* who betrays a respectable insight into geology, and fearing that the womb of *Persia* could not conceive so hard an ore, wishes us, at once, to believe that it acquired its

* Antiq. Research. Pers. vol. i. p. 137.

ancient epithet from the *fixedness* of that metal ; and
thus would one *ex abundantiâ,* and the other *ex simi-
litudine,* have the common name of *Iran* for Ireland
and for Persia be derived from an *English* word, which
was not concocted for many centuries after the *decay*
of those two regions, when the very metal it repre-
sented first grew into use * !

" Moullah Feroze, an excellent Palahvi scholar, tells
me," says Sir John Malcolm, " that *Iran* is the plural of
Eir, and means *the country of believers.*" And again,
when he had occasion to consult his oracle, he states
the answer as follows :—

" I gave this inscription † to Moullah Feroze, a
learned priest of the Parsees, at Bombay, and he
assured me that the translation of De Sacy was cor-
rect. Ferose explained the word *An-Iran* to mean
unbelievers. *Eer,* he informed me was a Pehlivi
word, which signified *believer ; Eeran* was its plural :
in Pehlivi, the *a* or *an* prefixed, is a privative, as in
Greek or Sanscrit ; and consequently, *An-Eeran* meant
unbelievers. The king of *Eeran* and *An-Eeran* he in-

* If I have taken a wrong view of the Professor's phraseology, I shall
feel most happy to be set right ; but I submit to the critic whether I am
not justified in understanding him as I do.

† To be met with at a place called Tauk-e-Bostan. Silvestre de
Sacy, a member of the Institute at Paris, had made the following
translation of it, which is divided into two parts.

The first :—" This figure is that of a worshipper of Hormuzd, or God ;
the excellent Shahpoor ; king of kings ; of *Iran* and *An-Iran ;* a celestial
germ of a heavenly race ; the son of the adorer of God ; the excellent
Hormuzd ; a king of kings ; of *Iran* and *An-Iran ;* a celestial germ of
a heavenly race ; grandson of the excellent Narses ; king of kings."

The second :—" This figure is that of a worshipper of Hormuzd, or
God ; the excellent Varaham ; king of kings ; king of *Iran* and *An-Iran ;*
a celestial germ of a heavenly race ; son of the adorer of God ; the excel-
lent Shapoor ; king of kings ; of *Iran* and *An-Iran ;* a celestial germ of
a heavenly race ; grandson of the excellent Hormuzd ; king of kings."

terpreted to mean king of *believers* and *unbelievers ; of* Persia and other nations. It was, he said, a title like king of the world. This, however," adds Sir John, of himself, " is like all *conjectures* founded on etymology, very uncertain."

It was natural enough that Sir John should express himself slightingly as to a mode of proof, the principle of which he must have seen violated in so many instances ; and, independently of this, it is an infirmity in human nature to affect disregard for any knowledge which we do not ourselves understand. I do not mean, however, to vindicate Feroze's interpretation ; on the contrary, I purpose to show that it is not only *imperfect,* but *incorrect ;* yet while doing so, I am bound to acknowledge, that, if he has not hit off the whole truth, he has a part of it ; and even *this* is such a treat, in the wilderness through which we have been groping for some time back, that I welcome it as an *oasis,* and offer him my thanks thus beforehand.

To prove, however, that he is in error, I need but confine myself to the unravelling of his own words. At first he affirms that *Eeran* is the plural of *Eer,* and means *the country of believers ;* if so, the singular must mean *the country of a believer ;* but he tells us afterwards, that *Eer* signifies *a believer* alone, consequently *Eeran* must *believers* alone, without any consideration of the word *country.* And the same inconsistency, which manifests itself here, applies with equal strictness to *An-Eiran* also.

Should these papers ever reach the observance of this distinguished foreigner, whom I appreciate even for his *approximation* to the precincts of the *thought,* they will, I doubt not, readily disabuse him of a *radical*

misconception. *Eeran* is not a *plural* at all, but a *compound* word : its constituents being *Eer* and *An* *, of which the former signifies *Sacred* and the latter a *Territory.* So that the united import will be the *Sacred Territory ;* and *An-Eeran*, of course, is but its negative.

This exposition I gain from the Irish language, which I take to be the primitive Iranian or Persic language. By it I am furthermore enabled to inform the *German* " professor" that *Turan*, though now inhabited by "Nomad tribes," obtained not its name from that circumstance, but from a widely different one. Tur † means *prolific*, whether as regards *population* or *rural produce ;* and *An*, as before, a territory—the whole betokening a *prolific territory* ‡. And he should remember, what he is not at all unconscious of, that eastern denominations are not varied by recent occupants, but continue in uninterrupted succession, from age to age, as imposed at the outset.

* This *An*, the original name for *country*, was modified afterwards, according to clime and dialect, into *tan*, as in Aqui-*tan*-ia, Brit-*tan*-ia, Mauri-*tan*-ia, &c.; and into *stan*, as in Curdi-*stan*, Fardi-*stan*, Hindu-*stan*, &c.

† From this was formed the English word *tower*, the very idea remaining unchanged.—As was also the English word *bud*, meaning the *first shoot of a plant*, a *germ*, from the Irish *budh*, i. e., the *organ of male energy.*

‡ The present bleak and sterile aspect of this region militates nothing against this view, when we consider the thousand alterations which it has undergone, under the thousand different tribes that have consecutively possessed it.

CHAPTER X.

Thus far have Ireland and Persia kept company together, both equally rejoicing in the common name of *Iran*. But now, when we descend to particulars, this harmony separates. Ireland being an *island*, surrounded on all sides by water—which Persia is not—it was necessary it should obtain a denomination expressive of this accident; or, at all events, when the alteration was so easily formed as by the change of the final *an* into *in*—*an* meaning *land*, and *in island*—the transition was so natural as at once to recommend its propriety.

Hence it is that though we occasionally meet with *Iran*, as applied to this country, yet do we more frequently find *Irin* as its distinctive term; whereas the latter is never, by any chance, assigned to Persia, the former alone being its universal name. And this is all conformable to the closest logical argumentation, which teaches that every species is contained in its genus, but that no genus is contained in its species; *Irin*, therefore, which is the specific term, may also be called *Iran* the generic, while *Iran*—except as in *our* instance, where the *extension* of both is identical, could never be called *Irin*: and so it happens that *Ireland* is indifferently called by the names of *Iran* or *Irin*, the latter alone marking its *insular* characteristic; whereas *Persia*, not being so circumstanced, is mentioned only by the general form of *Iran*.

To simplify this reasoning I must repeat that *Iran* *
signifies the *Sacred Land*, and *Irin*†, the *Sacred Island;*
now every *island* is a *land,* but every *land* is not an
island : Persia, therefore, which is *not an island,* could
not be called *Irin,* whereas Ireland, *which is,* may as
well be called one as the other ‡.

Irin, then, is the *true, appropriate, characteristic* and
specific denomination belonging to this island :—and
the words Ire, Eri, Ere ‡, and Erin, applied also
thereto, are but vicious or dialectal modifications of
this grand, original, and ramifying root.

The import of this appellative having spread itself
over the globe before Rome was ever known, under
that name, as a city, and when Greece was but just
beginning to peep into the light, the Pelasgi—who
were partly Budhists, allied somewhat to them in
religion, and still more akin in birth and endowments
—conveyed, in conjunction with the Phœnician mer-
chants, to the early Greek inhabitants §; and they,
by a very easy process, commuted *Irin* to *Iérne,* which
is but a translation of the word—ιεϱος, signifying
sacred, and νηος an island.

Of this Greek form, Ierne, there were again various
inflections and depraved assimilations, such as Iernis,
Iuernia, Ouvernia, Vernia, &c. And from one ‖ of
those, the Latins, without, perhaps, exactly knowing

* From *Ir* or *Eer,* sacred, and *an* a *land.*
† From *Ir* or *Eer,* sacred, and *in* an *island.*
‡ Iran or Irin, i. e., Eeran or Eerin.
‡ Each of these three preceding words means *religion* or *revelation.*
And from them *Era,* denoting a *period of* time—which with the ancients
was a *sacred* reckoning—has been so denominated ; as well as *Eric,* which,
in law phraseology, indicates a certain penalty attachable to certain
crimes, and equivalent to *Deodand,* or a *religious restitution*—all Irish.
§ I mean the " *Græci vetustissimi,*" not the " *Græculi esurientes.*"
‖ Namely, *Ivernia :—u, v,* and *b* are commutable.

what it meant, conjured up *Hibernia,* but which, how-
ever, with soul-stirring triumph, retains *uninjured* our
original root—the initial *H* being nothing more than
the aspirate of the Greek ἱερος, *sacred;* νηος, *island,*
remaining unaltered ; and the letter *b* only interposed
for sound-sake *.

So that, whether we consider it as *Irin, Ierne,* or
Hibernia, or under the multiplied variations which di-
verge, almost interminably, from those *three originals,*
in the several languages which they *respectively* re-
present, they will be found, each and all, to resolve
themselves into this *one, great, incontrovertible position
of the* " Sacred Island."

Thus, under heaven, have I been made the humble
instrument of redeeming my country from the asper-
sions of calumniators. I have shown to *demonstration*
the real origin of its *sanctified* renown. I have traced
from the *Irish,* through all the variations of *Greek*
and *Latin* capricios, its *delineatory* name ; and have
proved, beyond the possibility of rational contradic-
tion, that in all those different changes regard was
still held to the original epithet.

Where, then, are the sneers—of " hallucination,"
—of " lunacy,"—and of " etymological moonshine ?"
These are very cheap and convenient terms for gen-
tlemen to adopt, as cloaks to their ignorance of the
purport of denominations imposed at a time when
every *word* was a *history.* In the early ages of
the world whimsicality never mingled with the cir-

* Should you hesitate as to this mode of accounting for the letter *b,*
I can show you that the Greeks spelled *Albion* indifferently with or with-
out a *b* ; as they indifferently used *b* or *v* in one of the above names for
Ireland ; for instance—.

　Ἀι Βρετανιδις εισι δυο νησοι, Ουιρνια και Αλουιον, ητοι Βιρνια και Αλβιων.

Eustatb. ad Dion. Perieg.

cumstantial designation of either person or locality.
Every name was the sober consequence of deliberate
circumspection; and was intended to transmit the
memory of events, in the truest colours, as well as in
the most comprehensive form, to the latest generation.

Will this be considered the *vapouring* of conceit?
Is it the *spouting* of self-sufficient inanity? Let
the heartless *utilitarian*, unable to appreciate the
motives which first enlisted me in this inquiry, and
which still fascinate my zeal, at an age when,—did not
my love for *truth* and the rectification of my country's
history *rise superior* to the mortification of *alienated*
honour,—I should have flung from me letters and lite-
rature in disgust, and betaken myself, an adventurer
for distinction as a soldier—let such, I say *conceal
within himself* his despicable worldly-mindedness, and
leave me unmolested, if unrewarded, to posterity.

> " Come, thou, my friend, my genius, come along,
> Thou master of the poet and the song,
> And while the muse now stoops, or now ascends,
> To man's low passions, or his glorious ends,
> Teach me, like thee, in various nature wise,
> To fall with dignity—with temper rise;
> Formed by thy converse happily to steer
> From grave to gay, from lively to severe;
> Correct with spirit, eloquent with ease;
> Intent to reason, or polite to please."

The origin of the term " Sacred Island," being now
for ever adjudicated, the reader will at once see that
it belonged to an era long anterior to Christianity. In
assigning to it this *date* *, I pretend not to be *unique ;*
and, as I should not wish to deprive any brow of the

* It is only the *date*, however, that I will share with any one. The
derivation of the word, and its *true exposition*, are exclusively my own.

laurels which it has earned—more especially, where an undisputed enjoyment has amounted to *prescription*,—I shall register, in express words, my predecessor's own exposé, which is, that " the isle must have been so named *because of its nurturing no venomous reptile** " *! ! !* Who will not smile?

No, sir, the imposers of this name were too sensible of its value, and too jealous of its use, to expose it to ambiguity. It pourtrayed the sanctity of the occupying proprietors; and lest there should be any misconception as to the *species* of worship whence that " sanctity " had emanated, they gave *this scene* of its exercise three other names, viz. *Fuodhla, Fudh Inis,* and *Inis-na-Bhfiodhbhadh* †—which at once associate the " worship" with the *profession* of the worshippers: for *f,* or *ph*, being only the aspirate of *b*, and commutable with it, *Fuodhla*—which is compounded of *Fuodh* and *ila,* this latter signifying *land*—becomes *Buodhla*—that is, Budh*land* ‡. *Fudh Inis,* by the same rule, is reducible to *Budh Inis,* of which the latter means *island,* that is, Budh-*island* §; while *Inis-na-Bhfiodhbhadh* requires no transposition, being clear and obvious in itself, as the *Island of Budhism.*

Now, "to make assurance doubly sure," go to " Keating's History of Ireland," p. 49, and you will there find " the female deities,"—an incorrect expression for the deities worshipped by the females—of

* " Quod nomen ob beati solum ingenium, in quo *nullum animal venenosum vitale,* facile assentior attributum." Ogyg. part i. c. 21. So gratifying, however, has this been to the obsequious wisdom of subsequent *historians* (?), as to be echoed from one to the other with the most commendable fidelity. " *O imitatores, servum pecus !*"

† Pronounced Fiodhvadh—copied *literally* from the old manuscripts.

‡ This corresponds to *Ir-an,* the Sacred *Land.*

§ This answers to *Ir-in,* the Sacred *Island.*

the Tuath-de-danaans, to have been Badhha, Macha,
and Moriagan.* Of these the first needs no exposition;
the second I shall reserve for another place, but the
third I will here develope. He was the military deity
of this " sacred" colony, and a personification of
Budh, under the designation of Farragh †, i. e. *Copu-
lation;* and, accordingly, the Scythians, who incor-
porated with them, after first dethroning them, adopted
this term as their exhilarating war-shout, while under
the veil of the epithet was really meant the *sun,*
whose aid they invoked to give *strength* to their *loins*
and *vigour* to their *arms* ‡.

And yet this is the name which *Spenser* would
derive from that of Fergus king of Scotland! Fifteen
hundred years and more before Fergus was born,
which, by the way, was not until the sixth century
of the Christian era, the Irish basked in the *sun-
shine* of their resplendent war-god, who, under an-
other and equivalent denomination—namely Buodh,
abbreviated into *Boo* §, and thus with the prefix
a, implying *to,* or *under the auspices of*—assumed
by the different septs as their distinctive watch-
words, branched out into the national and spirit-

┌ * The reader will see that, in quoting Dr. Keating, I do so from no
respect for his discrimination or sagacity. Whenever he has attempted
to exert either, in the way of comment or *deduction,* he has *invariably*
erred : fortunately he has offered none in this instance. Yet is his book
a most valuable compilation; and *I* now cull out of it *those three names,*
as one would a casket of jewels from a lumber-room.

† This *Farragh,* otherwise *Phearragh,* is the *Peor* of the Scriptures,
and the *Priapus* of the Greeks.

‡ " Priapus, si *physice* consideretur idem est ac *sol;* ejusque lux primo-
genia unde *vis omnis seminatrix.*" Diod. Sic. lib. i. See also Numb. xxv.
ver. 4., where you will see that " Peor" *remotely* meant the sun.

§ I shall not trouble myself in reciting the absurd *attempts* that have
been heretofore made to expound this word : it is enough to say that
they were all wrong.

stirring acclamations of *O'Brien* a-Boo*! O'Neil a-Boo! &c. &c.; which the early English settlers, who would fain become *Hibernis ipsis Hiberniores*, afterwards imitated: such as Butler a-Boo; Shanet-a-Boo; Grasagh a-Boo; Crom a-Boo, &c.; the last having been that adopted by Fitzgerald, duke of Leinster, and still retained as the motto of his armorial escutcheon.

It is worth while to listen to Spenser's *gratulation*, while chuckling himself with the idea of his fancied discovery: " This observation of yours," he says to himself, " is very *good* and *delightful*, far beyond the *blind conceits* of some, who upon the same word Farragh have made a very *blunt* conjecture." *Oh patria! Oh mores!* how little is known of Ireland! But I am not surprised at *foreigners*, when the very *natives*, the descendants of the *actors* in those glorious scenes, are ignorant of its history!

Take up any document, purporting to give an account of this country, and you will find it to be composed, either of absurd and nauseous *exaggerations* on the one hand, or of gross and calumnious *detractions* on the other. But though the *wildness* of the *former* cannot fail to generate, in the intellectual amongst all readers, an *unfavourable impression;* and in those of a different nation, already prejudiced, or mayhap incapable of separating the gold from the baser metal, *incredulity* and *contempt;* yet the *true Irish searcher*, versed in the antiquities, not only of his own dear " father-land," but of the kindred East, which maintained in the old world a religious and incessant com-

* The *motto*, also, of this family, viz. *Lamh laider a-Boo;* i. e. " The strong arm from Boo," now changed to *Vigueur du dessus*, is in keeping with the same idea.

munication with this " Sacred Isle," will glean in the distortion of those *maniac effusions*, the *glimmerings* of that *truth* whence they originally emanated—while the *injustice* of the *calumniators* must, *of itself*, bring dismay, with the whole train of confusion and dishonour, upon the mercenary instruments of those foul abuses, as well as upon the heartless abettors who could have enlisted their vassalage!

Truth, notwithstanding, obliges me to say that the blame should not altogether be laid upon the historians. They did as much as, under the circumstances, could be expected at their hands. Two successive invasions having passed over, and swept away, in the whirlwind of their desolating fury, all those monuments of learning to which the world had bowed just before—one from *innate antipathy* to the *thing* itself; the other from *apprehension* that the contents of those memorials, acting upon the sensibilities of a high-hearted and proud race, should stimulate their ardour to the recovery of their lost rights, and the consequent ejectment of the party who had usurped them*—the patriot had little more to guide him in supplying the deficiencies thus created, than the rude imaginings of his own brain, or the oral traditions of the village schoolmaster and genealogist.

The rigour, however, of penal observances began, in time, gradually to relax; and the people ventured to confess that they had still in their possession such things as *manuscripts*, illustrative of their lineage and ancestral elevation. This was the signal to some liberal

* This is the *mere utterance* of an historical transaction, without reference to *sect, creed, party,* or *politics*. No feelings of bitterness mingle therein. The author disclaims all such, as much as he would deprecate them in others.

individuals to prosecute an inquiry for additional me-
morials; and the result was, that they rose from the
pursuit, if not with a *connected aggregate of demonstra-
tional evidence*, at least with a *conviction* on their *minds,*
that those treasured visions of primeval lustre, here-
ditary and inborn within the breast of every Irishman,
and impossible to be eradicated, were not yet, *late as
was the hour*, without something like a basis to rest
upon.

I would be unjust did I not furthermore avow, that
it was not their enemies alone that waged this unge-
nerous warfare with the literature of the Irish. St.
Patrick himself was the individual who, in pursuance,
as he conceived, of his apostolic charge, may be said
to have perpetrated the greatest outrage upon our an-
tiquities; having set fire, in a paroxysm of pious zeal,
to no less than *one hundred and eighty volumes*, which
he selected from the great mass of the records of the
nation, as embodying the tenets of *Budhism* and *As-
trology*. The rest, relating to the notification of
national or personal achievements, he left untouched
and secure.

Yet, will it be believed that this was the severest
infliction, so far as *letters* are concerned, which we
have sustained, after all? For as the *religion* of the
ancient Irish was intermingled with their *history*, and
as the wide diffusion of their *celebrity* arose from the
eminence of their *religious creed*, the flames of that
conflagration have inflicted a loss upon the antiquarian
which *fifteen centuries of study* have not been able to
repair!

Despite, however, the united inroads of suspicion
and mistaken piety, the Irish have still materials,
ample and authentic, for the completion of a history,

not only of *insular*, but, if *properly handled*, of almost
universal elucidation * : and of this Toland himself
was, in some measure, aware, when he said that " not-
withstanding the long state of barbarity in which that
nation hath lain, and after all the rebellions and wars
with which the kingdom has been harassed, they (the
Irish) have *imcomparably* more ancient materials of
that kind for their history, to which even their *mytho-
logy is not unserviceable*, than either the English, or
the French, or any other European nation with whose
ancient manuscripts I have any acquaintance."

But though resources most unquestionable thus
notoriously still abounded, yet has it not been the for-
tune of Ireland, hitherto, to meet with any historian
gifted with the widely comprehensive, philosophical

* In the Library of Trinity College, Dublin are several such, collected
in the beginning of last century, by Lhuyd, author of the " Archæ-
ologia," and restored by Sir John Seabright, at the instigation of
Edmund Burke. I am credibly informed also, that there have been
lately discovered in the Library at Copenhagen certain documents re-
lating to our antiquities, taken away by the Danes, after their memor-
able defeat at Clontarf, by King Brian, A. D. 1014. Lombard has
already asserted the same; and that the King of Denmark entreated
Queen Elizabeth to send him some Irishman, who could transcribe them ;
that Donatus O'Daly, a learned antiquarian, was selected for the pur-
pose, but that his appointment was afterwards countermanded, for poli-
tical reasons.

There are, besides, in mostly all the public libraries of Europe—with-
out adverting to those which are detained in the Tower of London—
divers Irish manuscripts, presented by the various emigrants, who from
time to time have been obliged to fly their country, to seek among
strangers that shelter which they were denied at home ; taking with them,
as religious heirlooms, those hereditary relics of their pedigree and race.

One of the most beautiful and pathetic pieces of Irish poetry remaining,
written by Macleog, private secretary to Brian, after the demise of that
monarch, and beginning with this expression of his sorrow : " Oh ! Cen-
coradh (the name of his patron's favourite palace), where is Brian ?" was
picked up in the Netherlands, in 1650, by Fergar O'Garu, an Augustinian
friar, who fled from Ireland in the iron days of Cromwell.

views and suitable education calculated to do her jus-
tice: so that, by the untoward hand of fate, and the
iniquitous operation of the old political stroke, the
knowledge of the character in which those papers are
couched has become already so almost extinct, that
they lie on the shelves, to all intents and purposes a
dead letter*.

I now beg leave to introduce this identical war-god,
in his military costume and hyperborean philebeg,
in which, as before observed, the Scythians never in-
vested themselves; and hope the reader will enjoy a
hearty laugh at the expense of those blunderers, who,
in their *preposterous*, 1 had almost said *repentant*, de-
votion to monastic refinements, would rob the Pagans
of this long-cherished *idol*, and convert his godship
into a *Christian* nonentity!

You will find him—name and all corresponding—
described fully in the " Rites and Ceremonies of all
Nations," as similarly officiating and worshipped in the
East. " There is," says the author, " in the province
of Matambo, an *idol* whose priests are *sorcerers* or *ma-
gicians ;* and this image stands *upright*, directly over
against the temple dedicated to his peculiar service, in
a *basket made in the form of a bee-hive*†."

* I rejoice to state, that the present Administration, under the benign
direction of our patriot King, have resolved, so far as in them lies, to
atone for former depredators. There is now a vigorous revisal of those
documents going on, with a view, as I understand, to their immediate
publication.

† The antiquarian luminaries of the *Royal Irish Academy* would fain
make out that this was a *Christian warrior*. Their *high priest* has
lately proclaimed the fact, in their " collective wisdom." It is astonishing
how fond they have *suddenly* become for the memory of the monks ; they
would now father every thing like culture in the country upon them. It
used not to have been so !

"To this deity in particular they apply themselves for success when they go out a *hunting* or *fishing*, and for the relief of all such as are indisposed*! *Miramba*

* This image was found under the root of a tree dug up in Roscommon. It is about the size of the drawing; is made of brass, once gilt, the gilding, however, now almost worn off; and may be seen in the Museum of Trinity College, Dublin.

always marches at the head of their armies ; and he is presented with the first delicious morsel, and the first glass of wine that is served up at the governor's or king of Matambo's table."

But a *living* traveller, in a very interesting work just launched from the press, and without expecting therein to become my auxiliary, decides this ascription without further pains. " This village," says our author (near Rampore, on the Himalaya range), " instanced the care which the sacerdotal orders in the East take for their comfort and good. It was a neat, clean, and substantial place, in all acceptations of the word. These Brahmin villagers pay no rent of any kind to the state : they live on the granted lands, but are obliged to keep the *temples* in repair, to furnish all the implements, and to take care of the godships within it—these are *small brass images, with nether garments in the shape of petticoats.* They are carried in procession, on certain occasions, and the ceremonies belonging to them are performed twice a-day. Mahadeo is the great god of the mountains *."

But if the advocates of modernism have cause to be annoyed at my depriving them of this specimen of " the Fine Arts in Ireland," which they thought they had appropriated to the prejudice of truth, how much greater must not be their chagrin at my wrenching from their grasp another " exceedingly curious " and " richly-ornamented" " ecclesiastic † ?" Ecclesiastic, indeed ! Yes ; but reverenced and revered, by many a beating heart, as the head of all ecclesiastics, for centuries upon centuries, before the name of monachism, as connected with Christianity, was ever articulated !

* Major Archer's Travels in Upper India, vol. i. pp. 383, 384. Lond. 1833.

† So the " collective wisdom," in the true spirit of Christian restitution and penitential contrition, have lately pronounced him ! It is

delightful to see this solicitous zeal with which, when it suits a private
purpose, they cherish the memory of the monks, being *no longer* in the
way of their *secular* perquisites: but if the poor monks could speak,
or send a voice from the tomb, it would be to say that they did not
choose to be encumbered with such meretricious flattery; and that,
having laid no claim to those *relics*, or to the *towers* which they decorated,
during their *lifetime*, they now in *death* must repudiate the ascription.
" Timeo Danaas et dona ferentes," would be their answer.

This, Sir, is no less a personage than Mr. Budha him-self, or rather the personified abstract, in the possession of one of the last queens of the Tuath-de-danaans, at the moment of the inundation of the Scythian dynasty. I hope that, after so long an obscuration, and the un-courtly treatment he has received during the humi-liating interval of revolving centuries, you will—now that he chooses to reveal his proper character, avow his delegation, and acknowledge the supremacy of that power by which his empire had been overthrown, —treat him as an *Irishman*, with generous cordiality, and impute not to him a crime which belonged only to his followers.

But his dress is like a Christian. So much the better, man : we ought to like him the more for that. But to be serious,—although, as my friend Horace for-merly told me, " what hinders one laughing from speaking truth ?"—all our ecclesiastical ritual, as well of *ceremony* as of *costume*, has been borrowed from the Jewish, and that again from the Pagans, with such alterations only as the allwise Jehovah thought neces-sary to recommend. Besides, we have the authority of Dr. Buchanan for stating that " *Samona* is a title bestowed on the priests of Godama (Budha), and is likewise applied to the *images* of the *divinity*, when *re-presented, as he commonly is,* in the *priestly habit* *."

* Asiatic Researches, vol. vi.; where it will be observed that the Doctor was not writing for me. He did not even *suspect* the existence of this figure. It is, like the preceding one, of bronze.

CHAPTER XI.

PHARAOH*, the titular appellation of the monarchs of Egypt, being but the *local modification* of this our Irish *Phearagh*, the mind is instinctively directed towards that great storehouse of bygone consequence. And as the best authority that we can command in gaining any insight into its reverses is through the medium of its own historians, let us hear what Manetho, a priest of the country, thus transmits :—

" We had formerly," says he, " a king named Timæus, in whose reign, I know not why, but it pleased God to visit us with a blast of his displeasure; when, on a sudden, there came upon this country a large body of *obscure people* from the East, and with great boldness invaded the land, and took it without opposition. Their behaviour to the natives was very barbarous; for they slaughtered the men, and made slaves of their wives and children. The whole body of this people were called *Huksos*, or *Uksos*; that is, Royal Shepherds: for the first syllable, in the *sacred*

* The Egyptian sovereign assumed this *title*, as the highest that *language* and *imagination* could bestow. It signifies literally the *act of copulation*, of which it would represent him as *presiding genius*—the source whence all pleasure and happiness can flow—and is but faintly re-echoed in the Macedo-Syriac regal epithet of Ευεργετης, " Benefactor," or even that by which we designate our king as the *fountain* of *goodness*. There being no such letter as *ph* in the ancient alphabets, all those words —viz. *Pheor, Pharaoh*, and *Pharagh*—should properly be spelled *Feor, Faraoh*, and *Faragh*.

dialect, signifies a ' king,' as the latter, in the popular language, signifies ' a shepherd.' These two compounded together constitute the word Huksos. These people are said to have been Arabians."

The Vedas, or Sanscrit records of Hindustan, furthermore state that these invaders were the " Pali," or shepherds, a powerful, warlike, and enterprising Indian tribe. While the deadly aversion which existed in the minds of the Egyptians against the name and office of a shepherd in Joseph's day, is a lasting memorial of their visit and their severity *.

They did not go, however, without leaving behind them other signs. The pages of Herodotus afford ample evidence of the resemblance between the Egyptian customs and those of the more remote East. By his description of the rites and ceremonies, the mode of life, &c., of the priests of Egypt, they are at once identified with the Brahmins of India. China still celebrates that festival of lamps which was formerly universal throughout the extent of Egypt †; and " we have the most indubitable authority for stating that the sepoys in the British overland army from India, when they beheld in Egypt the ruins of Dendera, prostrated themselves before the remains of the ancient temples, and offered up adoration to them; declaring, upon being asked the reason of this strange conduct,

* Gen. xlvi. 34.

† " On the fifteenth day of the first month every year. Every person is obliged, on the evening of that day, to set out a lantern before his door, and these are of various sizes and prices, according to the different circumstances of those to whom they belong. During this festival, they have all sorts of entertainments, such as plays, balls, assemblies, music, dancing, and the lanterns are filled with a vast number of wax candles, and surrounded with bonfires."

that they *saw sculptured* before them the Gods of their country *."

But the most stupendous and appalling memento of their dominion and science was the three great pyramids of Geeza, the erection of which, Herodotus assures us, (B. ii. § 128), though the *priests* would attribute to Cheops, Cephrenes, and Mycerinus, three Egyptian kings, " yet the *people* ascribed them to a *shepherd* named Philitis, *who at that time fed his cattle* in those places ;" so consonant with the *invasion* above authenticated. This is additionally confirmed by the Sanscrit records already referred to, informing us of *three mountains*, Rucm-adri, " the Mount of Gold," Rajat-adri, " the Mount of Silver," and Retu-adri, " the Mount of Gems ;" having been raised by that Indian colony who had conquered Egypt; which is only a figurative denotation of those *factitious heights*, those astounding monuments of religion and ostentation, which were originally cased with *yellow, white,* and *spotted marbles,* brought from the quarries of Arabia, until stripped by the rapacity of succeeding colonies.

Belzoni's testimony is decisive on this point, as his drawing of the second pyramid represents the upper part of its casing remaining still entire, about a third of the distance from the summit to the base downwards. We meet with other pyramids, it is true, chiefly dispersed about the Libyan deserts, but they are much inferior to the fore-mentioned three, except one near the mummies, whose dimensions and structure are very nearly the same with the largest Gezite

* Barker.—The same is mentioned by Captain Burr, in reference to the Indian followers who had attended him to the temple of Isis.

one. This latter, according to Greaves, is 693 feet square at the base ; its perpendicular height 499 feet ; that is, 62 feet higher than St. Peter's at Rome, and 155 feet higher than St. Paul's in London ; while the inclining height is 693 feet, exactly equal to the breadth of the base ; so that the angles and base make an equilateral triangle *. Belzoni measures them all differently, and gives to the second even greater dimensions than are *usually* assigned to the first or largest ; viz., base, 684 ; perpendicular height, 456 ; central line down front, from apex to base, 568 ; coating,'from top to where it ends, 140.

The variation arises from the circumstance of the latter gentleman's measurement having been taken after the base had been cleared away of all sand and rubbish ; while those of his predecessors applied only as taken from the level of the surrounding heap. The small ones above noticed are some quadrilateral, *some round, terminating like a sugar-loaf,* some rising with a greater and some with a lesser inclination. All commence immediately south of Cairo, but on the opposite side of the Nile, and extend, in an uninterrupted range, for many miles in a southerly direction, parallel with the banks of the river.

After what has been said above, I need scarcely allude to the ridiculous supposition of those having been built by Joseph as granaries for his corn ! Their form and construction, ill adapted to such an occasion, refutes that absurdity, as it does the derivation upon which it has been founded ; viz., the *Greek* words

* Mr. Greaves's diagonal, in proportion to his base of 694 feet, is 991 feet nearly ; the half of which is 495½ feet, for the height of the Pyramid ; for as the radius is to the tangent of 45°, so is half the diameter to half the diagonal, or as 7 to 10, or 706 to 1000. Say, 7 : 10 :: 694 : $\frac{991}{2}$ = 495½. —*Dissertation upon the Pyramids.*

πυρος, wheat, and αμαω, I gather; as if, forsooth, an *Egyptian* structure, erected before the *Greek* language was ever known to exist, should wait for a designation until Greece should be pleased to christen it. Still more disposed must one be to discard with contempt the usual derivation given them, of πυρ, fire; as this not only labours under the weakness of the former, but betrays an ignorance of the correct idea of the Greek word πυργος, of which πυρ, fire, is the true derivation, " quia flammæ instar in *acutum* tendit * ;" intimating its *continually tapering* until it ends in a *point*; whereas the top of the Egyptian *pyramids* never does so end; that of the largest above described ending in a flat of nine stones, besides two wanting at the angles, each side of this platform being about sixteen feet; so that a considerable number of people may stand on it, and have, as from most of ours, one of the most beautiful prospects imaginable.

Wilkins's derivation from *pouro,* a king, and *misi,* a race, would seem plausible enough, being a purely Coptic or Egyptian analysis; but when we consider the general ascription of them by the people to the *shepherd Philitis,* whether as one of the *Pali,*—that is, shepherds—or Uksi, which meant the same,—king-shepherds above adduced; or as *emphatically the shepherd,* the son of Israel †, it argues a disposition on the part of the people to assign the honour—if taken in the latter light—to the workmen employed; if in the former, to a prince of a different dynasty from those whom the Egyptian priests would fain associate with them. This derivation, therefore, will not stand; and we have only to betake ourselves to the ingenious

* Schindl. † Gen. xlvii.

conjecture of Lacroze *, which, perhaps, may give more satisfaction respecting the etymology of the word *pyramid*. Lacroze derives it from the *Sanscrit term* Biroumas, and traces an analogy between Brahma, Birma, (which the Indians of Malabar pronounce Biroumas,) and the word Piromis, which means the same thing, namely, a virtuous and upright character —Piromia meaning, according to him, in the language of Ceylon, man in general.

Herodotus states †, that the priests of Egypt kept in a spacious building large images of wood, representing all their preceding *high priests*, arranged in genealogical order, every high priest placing his image there during his life. They mentioned to Hecatæus, the historian, when they were showing this edifice to him, that each of the images he saw represented a *Piromis*, begotten by another *Piromis*, which word, says Herodotus, signifies, in their language, a *virtuous* and *honest man*. A passage from Synesius, the celebrated bishop of Cyrene, in his treatise " on Providence," at once coincides with, and is illustrative of, this anecdote. " The father of Osiris and Typhon," says he, " was at the same time a *king*, a *priest*, and a *philosopher*. The Egyptian histories also rank him among the gods; for the Egyptians are disposed to believe that many divinities reigned in their country in succession before it was governed by men, and before their kings were reckoned in a genealogical order by *Peirom* after Peirom."

The Japanese celebrate an annual festival in honour of one *Peirun*, who, they say, was many ages ago king of *Formosa*, and who, being disgusted with the

* Hist. Christ. des Indes, p. 429.
† Lib. ii. p. 4.

abandoned morals of his subjects—wealthy traders
—consigned himself solely to the worship of the
gods. Forewarned in a dream, he took flight from
the impending visitation, and had scarcely sailed ere
the island, with its inhabitants, sunk to the bottom of
the sea. As for the good king, he arrived safe in
China, whence he went over to Japan, where he has
been ever since honoured by the above commemora-
tion.

The true Coptic name for those edifices, is Pire
monc—which signifies a *sunbeam* *—not so much in
allusion to their *form*, as to their appropriation, which
we shall make the subject of a separate inquiry.

It has, I trust, satisfactorily been proved that the
erection and nomination of those wondrous edifices
were not of *native* growth. It has, I trust, additionally
appeared that *both* were essentially Indian. It may
not now be " ungermane to the matter," if we would
for a moment digress, to consider the era of their
probable date, as introductory to the character of
their probable destination.

Josephus expressly informs us, that the Israelites
were employed in the construction of the pyramids. Is
there any reason why we should doubt so respectable
an authority? Oh! yes, it is said the Scriptures are
against it,—the task of the Israelites during their
bondage being exclusively confined to the making of
brick. I deny that the Scriptures either allege or
insinuate any such thing. On the contrary, we may
fairly infer, from Exod. ix. 8, 10, that they were en-
gaged in other servile offices ; as also from Psalm
lxxxi. 6, where it is said, " I removed his shoulder

* πυϱ, generally rendered *fire*, is not so, however, in the true import of
the word, but the *Sun*; fire is only a secondary sense of it.

from the *burden*, and his hands were delivered from
the *mortar-box*,"—not *pots*, as our translation has it;
and such rendering is supported by the Septuagint,
Vulgate, Symmachus, and others *.

This ascription receives further countenance from a
passage in Diodorus, i. 2, where, referring to those
immense piles, and the ideas of the Egyptians them-
selves respecting them, he adds, " they say the first
was erected by Armæus, the second by Amosis, the
third by Inaron." Who is it that pronounces the last
two names, if only spelled, aMosis and inAron, and
recollects, at the same time, what the Scriptures tell
us of Moses and Aaron, that is not at once struck with
the similarity of the sound ? And as to Armæus, why
it bears so evident an affinity with Aramæus or Ara-
mean, that one cannot avoid connecting it with the
" Aramite ready to perish," the very name given to
Jacob, Deut. xxvi. 5 †. Nothing, then, prevents, so
far as I can see, our concluding *one* of those structures
at least—I say one at least, to *conciliate* the brick-
party ; and I think, besides, I have read somewhere,
that one of the pyramids, the smaller ones no doubt,
was built of such material—to have been the work of
the sons of Israel. And the rather as it was consonant
with the uniform practice of the ancient Oriental na-
tions to employ captive foreigners on servile and labo-
rious works.

The usual time, too, assigned to the slavery of the
Israelites corresponds very nearly with that generally
allotted to the erection of those masses. The stay of
the sons of Israel in the land of Egypt is generally
understood to have been two hundred and fifteen
years—of these Joseph ruled seventy—forty is a fair

* Barker. † Ibid.

average for the generation that succeeded—which,
added to his seventy, leaves one hundred and five
years to the Exodus.　Now, we learn from Herodotus,
that Cheops, the *reputed* founder of the first or greatest
of these pyramids, was the first also of the Egyptian
kings who oppressed, or in any way tyrannized over,
his subjects.　His reign is stated to have been fifty
years.　Cephrenes, who succeeded, showed himself in
every respect his brother, barring, as the other before
him, the approach to every temple, stopping the per-
formance of the usual sacrifices, and keeping his
subjects all the while employed in every species of
oppressive task and laborious drudgery.　The period
of his reign is stated to have been fifty-six years,
which, added to the preceding fifty, make one hundred
and six, exactly answering to the above calculation.

The Exodus, besides, is stated to have occurred B. C.
1791 ; and Herodotus and Diodorus together, while
acknowledging their ignorance of the actual date of
the pyramids, and the impossibility, on their part, to
ascertain it, declare also their conviction, that they
must have been built at least about that period.

I have thus, I trust, done honourable justice to the
testimony of Josephus.　I have done so for many rea-
sons : firstly, because of the importance of the subject
itself ; secondly, from my respect for the merits of the
writer ; and, thirdly, because that I think it very pro-
bable indeed, that the Israelites may have been occu-
pied in the erection of some of the minor and later
pyramids.　But *insuperable* obstacles stand in the way
of our associating them with the structure of them *all ;*
and of these *one* is, the improbability that the victo-
rious invaders would single out the inoffensive Israel-
ites as particular objects of their oppression, when

policy should suggest to them a directly different course in securing their adherence in opposition to the native residents. By Josephus's account, however, it would appear that the Israelites alone were engaged upon those edifices; and the Scriptures themselves confine the intimation of drudgery to the Israelitish race : it therefore is manifest that the Egyptian *natives* were favoured by the *then existing* dynasty, while it is on all hands agreed, that the *new comers* had treated, during the whole period of their dominion, the *entire* Egyptian nation with indiscriminate rigour and chastisement.

Besides this, that deadly animosity existing in the Egyptian mind to the name and profession of shepherds, above alluded to, at once identifies their character with that of the " Uksi," or " King-shepherds," to whom we have before referred, and proves the date of their invasion anterior in point of time to Israel's introduction into the land of Egypt. Joseph was well aware of the particulars of this invasion, and of the sting it left behind it in the mind of the Egyptians ; and accordingly he acquaints his brothers, whose " trade also had been about cattle," that " every shepherd was an abomination to the Egyptians *."

Manetho himself, the Egyptian priest, is my voucher for this deduction, when he says, that " After these— the shepherd-kings—came *another set of people*, who were sojourners in Egypt, in the reign of Amenophis. These chose themselves a leader, one who was a priest of Heliopolis, and whose name was Osarsiph; and after he had listed himself with this body of men, he changed his name to Moses."

* Gen. xlvi. 34.

But this, it will be said, is at variance with Moses'
own account, which states that he obtained his name
on being rescued from a watery cradle by Pharaoh's
daughter. Not in the least, I reply ; for it is more than
probable that, after his slaying the Egyptian, and con-
sequent flight, he dropped this name to ensure conceal-
ment, and only resumed it on being invested with his
divine commission. Or, what is more likely still, and,
perhaps, the truth, that Osarsiph was the name which
his " mother " had given him, and which adhered to
him until " he grew up,"—a term in Scripture which
expresses *mature* age,—until when it was not that the
princess had designated him as Moses.

Strong, too, as my veneration is for Josephus, I
cannot conceal either from myself or from the reader,
that his testimony in *this instance* is rather of a du-
bious character. The idea of interpolation I altoge-
ther waive—it is, at *all times,* a contemptible subter-
fuge. I will take for granted that the text is genuine ;
and, on the very face of it, it bears the impress—in
the first place, of inaccuracy, confounding the period
of his countrymen's *servitude* with that of their actual
sojourn in Egypt ; and, in the second place, of *indis-
tinctness,* attaching a term of obloquy to those edifices,
without condescending to offer therefor any cause.
Here are his own words :—" When time had oblite-
rated the benefits of Joseph, and the kingdom of
Egypt had passed into another family, they inhu-
manely treated the Israelites, and wore them down in
various labours : for they ordered them to divert the
course of the river (Nile) into many ditches, and to
build walls, and raise mounds, by which to confine
the inundations of the river (Nile) ; and, moreover,
vexed our nation in constructing FOOLISH PYRAMIDS,

forced them to learn various arts, and inured them to undergo great labours ; and after this manner did they, for *four hundred years,* endure bondage ; the Egyptians doing that to destroy the Israelites by overmuch labour, whilst we ourselves endeavoured to struggle against all our difficulties."

Now, it is not a little remarkable, as connecting the erection of the pyramids with the " royal shepherd race," the former occupants of the above fertile territory, that those immense edifices happen to be situated in the very vicinity of Goshen. Geeza, where the three *great ones* stand, is universally allowed to have been the site whereon Memphis once stood ; and as a west wind took away the locusts, and cast them into the Red Sea (Exodus x. 19), Goshen, which we find, by Genesis xlv. 10, cannot have been far from Joseph's own residence, will be more aptly fixed in the vicinity of this spot, within the Heliopolitan nome, than within any other nome or præfecture, particularly the Tanitic, " where the same wind," as has been justly remarked by Dr. Shaw, " would not have blown those insects into the Red Sea, but into the Mediterranean, or else into the land of the Philistines." Goshen, then, was that part of " the land of Rameses," " the best of the land," (Gen. xlvii. 6—11,) which lay in the neighbourhood of Cairo, but on the opposite side of the Nile, where, as already observed, the pyramids are first met with, and whence they proceed in a continued line along the banks of the river, in a southerly direction, for many miles together.

After reading these details, it will be impossible, I conceive, for any dispassionate mind to remain longer in suspense as to the origin of the pyramids. The doubt, too, and obscurity in which they have been

heretofore enveloped can be explained with similar ease, if we but remember the execration in which their Cushite founders were held by the Egyptians, and their consequent disinclination to associate their name with such splendid memorials. With this view, indeed, it is not at all improbable but that active legislative measures were adopted to cancel and suppress every vestige of proof which could tend to perpetuate the memory of the obnoxious erectors. So that we must not wonder if, after a lapse of years, their history was as great a riddle to the Egyptians themselves as that of *our pyramids* is to the Irish nation.

A collateral cause for this universal ignorance of their use and origin was the probable absence of letters on the part of the Egyptians, until now, for the first time, introduced by those learned Arabians; and though any one who is acquainted with the oriental disquisitions of Wilfrid, and the coincidences he establishes between the ancient history of Egypt and the account given of the customs and dynasties of that kingdom, as drawn from the Hindoo Puranas, will at once admit that "there must have been a period when a Hindoo power had reigned in Egypt by right of conquest," and established therein the peculiar rites of their religion, with the elements of literature and social civilisation, yet is it probable that, during their sojourn, which, we have seen, was a continued series of warfare, they kept themselves aloof from all intercourse with the natives, and checked, as much as possible, the circulation of their science among them.

Some *sparks* of it, however, must inevitably have transpired; and the Egyptian intellect was too finely constituted to be insensible to its value, or allow it to extinguish without food; so that, in the time of

Moses, and long after, their learning and accomplishments were courted by the philosophers of the day, and were so eminently conspicuous, as to become a proverb, (Acts Apost. vii. 22.) Homer, we all know, visited that favoured land—so did Pythagoras—so did Solon, Thales, Plato, and Eudoxus;—in short, all the sages of antiquity, of whom we read so much, and whom we peruse with such *recuperative* pleasure, either finished their education in that favoured school, or conversed with those who had themselves done so.

The Egyptians are said to have been the first who brought the " rules of government," with the art of making " life easy" and " a people happy,"—the *true end* of worldly politics—to a regular system. But much as they excelled other nations in scientific lore, in nothing was their superiority so conspicuous as in that *magic* art which enabled them to cope, for so long a time, and under such trying varieties, even with the prophet and ambassador of God himself.

These exhibitions are too stubbornly authenticated by scriptural proofs, as well in the Old as in the New Testament *, for any one to affect disbelief in them without at the same time disbelieving the authenticity of the Scriptures themselves. Yes, I implicitly subscribe to the truth of the narration ; and as I mean to bring home their *initiation* in the art, as well as in their other several accomplishments, to the Chaldean diviners, or *Aire Coti* shepherds—a branch of the Tuath-de-danaan colonists of this our western isle—from whom, or their relatives, under the designation of Uksi, Indo-Scythæ, or Cushite shepherds—who, if not all one and the same, were at least mixed and incor-

* Exod. vii. 11, &c., and 2 Tim. iii. 8.

porated—the Egyptians had imbibed it—this, I trust, will plead my excuse for obtruding its notice here, as well as for dilating so much at large upon the early history of Egypt *.

* America also has had her ancient pageantry. Antonio de Solís gives the following description of the Mexican shrine:—" The site of that temple devoted to the worship of the Sun, and its altar for human sacrifices, was a large square environed by walls, cloisters, and gates; in the centre was raised a high tower of a pyramidical form, broad at the base, and narrowed towards the top, having four equal sides in a sloping direction; in one of which was a flight of one hundred and fifty steps to the top, covered with the finest marble, with a square marble pavement, guarded with a balustrade : in the centre stood a large black stone, in manner of an altar, placed near the idol. In the front of this tower, and at a convenient distance from its base, stood a high altar of solid masonry, ascended by thirty steps : in the middle of it was placed a large stone, on which they slaughtered the numerous human victims devoted for sacrifice ; the outside being set with stakes and bars, on which were fixed human sculls."

CHAPTER XII.

I COME now, with the same view, to consider the *destination* of their famous " Pyramids*." In this pursuit the first thing that strikes us is the uniform precision and systematic design apparent in their architecture. They all have their sides accurately adapted to the four cardinal points, as the four apertures near the summit of most of ours indicate a similar regard to fidelity to the compass. In six of them which have been opened, the principal passage preserves the same inclination of 26° to the horizon, being directed towards the polar star. And I doubt not, were the ground *within* and *around all* of *ours* sufficiently explored, there would be found, in some at least, regular vistas to correspond with this description. Their obliquity too being so adjusted as to make the north side coincide with the obliquity of the sun's rays at the summer's solstice, has, combined with the former particulars, led some to suppose they

* The regular pyramid is a section of the cube, whose altitude is equal to half the diameter of the base, and is contained within a semicircle. The great pyramid is not of this precise order ; its height or altitude being found more than half the diameter of its base. A second order is that whose altitude is equal to half the diagonal of the base, and is also bounded and contained within a semicircle ; and consequently, if the diagonal be given at 1000, the altitude will be 500 : but the true height of the Egyptian Pyramid being determined at less than half its diagonal, is therefore found to be not exactly of this order, but nearly approaching to it, and probably aimed at in the original design, though failing in the execution.—*Dissertation upon the Pyramids.*

were solely intended for astronomical uses; and certainly, if not altogether true, it bespeaks, at all events, an intimate acquaintance with *astronomical rules*[*], as well as a due regard to the principles of *geometry*[†].

No one, I believe, has ever questioned the latter fact. Some, induced thereby, have thought them to be erected for the purpose of establishing the exact measure of the cubit; of which they happen to contain both in breadth and height a certain number of multiples. But as they were evidently constructed by persons well versed in all the niceties of exact measurement, and who consequently had no occasion for such colossal reference to refresh their memories, like the Lancasterian apparatus, it is ridiculous to suppose them erected with this view, nor should I have alluded to it but to expose its weakness. Others have fancied them intended for sepulchres; and as

[*] Astronomy began very early to be cultivated among the Egyptians; and to them is attributed the discovery of the magnitude of the solar year, or, as it is distinguished, *the Egyptian year* of 365 days; which discovery appears to be noticeable, and memorialized in the construction of their Great Pyramid. The ancient measure of length being the cubit, and that measure being determined common with the Hebrews and Egyptians, as nearly as Dr. Cumberland could determine it, and reduced to English measure, a certain standard is obtained: but we find also another, called the longer cubit, to have obtained, on which we may with equal propriety calculate the measures of the Egyptian Pyramid, on which to infer the number of days contained in the solar year; the measures of the base of the Great Pyramid being found, if not exactly, yet nearly approximating to it.—*Dissertation upon the Pyramids.*

[†] I have not the least doubt but the ancient Egyptians measured by the cubit, whatever it then was; that the number of cubits was designedly fixed upon by them in laying the base of the Pyramid; and that if we divide the ascertained sum of 752 feet by 2, the quotient will be 376, which is a number exceeding 365 by 11: consequently, if we estimate their ancient cubit at 2 feet $\frac{7}{10}$ of an inch, that measure will be ascertained, and found to approximate nearly to the longer Hebrew cubit; and so will the measures of the Pyramid be found to agree with the number of days in the solar year.—*Dissertation upon the Pyramids.*

the Egyptians, *taught by their ancient Chaldean victors,* connected *astronomy* with their *funereal* and *religious ceremonies,* they seem not in this to be far astray, if we but extend the application to their *sacred bulls* and *other animals,* and not merely to their *kings,* as Herodotus would have us suppose.

The immense sarcophagus lying in the interior of the first or Great Pyramid, with the *bone* found by the Earl of Munster * in the second, must put this question beyond the possibility of doubt; as Sir Everard Home, after a laborious examination of the properties of this relic, found it accurately to agree with the lower extremity of the thigh-bone of an ox, while it corresponded with that of no other animal.

In conformity with this conclusion were the discoveries of Belzoni, some time before, in Upper Egypt, which abounds in specimens of the most splendid antiquities, in a catacomb amongst which, called Biban el Moluk," that is " the gates of the king"— meaning thereby the *universal king of the ancients,* the generating principle of vegetation and life, of which *Apis* and *Mnevis, Osiris* and *Typhon,* were but the representatives among the Egyptians, as other nations had adopted equivalent forms and names, according to the genius of their climes and languages —I mean the Sun—well, in one of the numerous chambers of this catacomb, Belzoni discovered an exquisitely beautiful sarcophagus of alabaster, nine feet five inches long, by three feet nine inches wide, and two feet and an inch high, covered within and without with hieroglyphics, and figures in intaglio, nearly in a perfect state, sounding like a bell, and as transparent as glass : from the extraordinary magnificence of

* Then Major Fitzclarence, March 2nd, 1818.

which, he conceives, it must have been the depository
of the remains of Apis; in which idea he is the
more confirmed by having found the carcass of a *bull*
embalmed with asphaltum, in the innermost chamber.

The passage in Herodotus, to which I before re-
ferred, appears to throw some light on the intricate
subject which we are now pursuing. In lib. ii.
p. 124, &c. " the father of historians" tells us that the
two kings, who succeeded each other on the throne of
Egypt, after the happy reign of Rhampsinitus and his
predecessors, and to whom the building of those pyra-
ramids was reputedly ascribed, had shown themselves
indeed *brothers*, not more by affinity of blood than by
the similar outlines of their cruelty and intolerance.
No species of oppression was by them left unattempted;
no extreme of rigour or rapacious plunder by them
unenforced: but what peculiarly characterized the
hardship of their tyranny was the restraint they put
upon the *religion* and pious exercises of their subjects ;
closing the portals of the *temples* where they were
wont to adore, and preventing the oblation of their
usual sacrifices.

Though Herodotus has been justly honoured with
the designation of " Father of Historians," he has also,
perhaps, not so very justly been called " the Father
of Errors ;" and, as he himself admitted his incapability
of obtaining any satisfactory insight into the original
of those structures, may we not fairly conclude that,
in the extract now cited, he either confounds those
princes with the *foreign dynasty* which we have al-
ready established, or else, from the ignorance *superin-
duced* to obliterate their memory, mistakes the erection
of some of the *minor* and *later* ones, which this " par
nobile fratrum " may, indeed, have devised, in imitation

of the *three* " *mountains* " built by the Uksi. What he states, however, is of value, as it points to a *previous form of worship*, and a *system of government* by an alien house. The prohibition of sacrifices, and the closing the temple doors, make this as clear as words can delineate any thing. All we want, then, is to be informed what the particular temples, alluded to, were : and that they were the *pyramids*, will, I think, be conceded by every one, who has carefully perused the arguments here set down, and who has not his judgment warped by favourite plans of literary systems and speculative hypotheses.

This conclusion receives additional force from the conversation which Wilford, in his " Dissertation upon Egypt and the Nile*," tells us he had with several learned Brahmins, when, upon describing to them the form and bearings of the great Egyptian pyramid, one of them asked if *it had not a communication under ground with the river Cali?* Being answered that such communication was spoken of as having once existed, and that a *well* was still to be seen, they unanimously agreed that it was a *temple* appropriated to the worship of *Padma-devi*, and that the supposed *tomb* was a *trough*, which, on certain festivals, her priests used to fill with the sacred water and lotos-flowers.

Mr. Davison, British Consul to Algiers, when accompanying Mr. Wortley Montague to Egypt, in 1763, discovered here a chamber, before unnoticed, and descended, to a depth of 155 feet, the three successive reservoirs. The principal oblique passage has, since then, been traced by the very enterprising master of a merchant vessel, Captain Caviglia, 200 feet far-

* Asiatic Researches.

ther down than by any former explorer, and found to
communicate with the bottom of the well, which is
now filled with rubbish. A circulation of air being
thus procured, he was emboldened to proceed 28 feet
farther, which brought him to a spacious hall, 66 feet
by 27, unequal in altitude, and directly under the
centre of the pyramid. In no instance yet recorded
has any appearance presented itself of human remains
within those apartments, nor indeed was there any
possibility of conveying such thither, unless placed
there before the erection of the pile itself; for the
extremities of the gallery, which leads into the *great
chamber*, are so *narrow* and *circumscribed*, that it is
with difficulty one can effect an *entrance into it, even by
creeping upon his belly.*

The *symbolical anatomy* prefigured in this con-
trivance, and which equally exhibits itself in all the
temples of the ancients, as well *under* as *over ground*,
is such as almost to have tempted me to make *this* the
occasion on which I should uncover another secret of
their mystic code. But a more *concentrated* oppor-
tunity will occur as we advance, and for which this
intimation will answer as a prelude; meanwhile, I
would have the reader soberly to bethink himself, what
possible use could *dead bodies have of wells of water?*
Is not *such* the *type*, as it is also the *accompaniment*, of
life and activity? And does not *this*, of itself, subvert
the absurdity of those temples having been erected as
mere mausoleums for kings?

I have already hinted my confident belief *that if
the ground all, within, and around our pyramids were
sufficiently examined,* there would not be wanting indi-
cations of subterraneous passages. I am the more
confirmed in this my belief from the appearances that

presented themselves on the demolition of *that* at Downpatrick, in 1790, " to make room for the rebuilding of that part of the old cathedral next which it stood, and from which it was distant about 40 feet. When the tower was thrown down," continues Dubourdieu, in his " Statistical Survey " of the county, " and cleared away to the foundation, another foundation was discovered under it, and running directly across the site of the tower, which appeared to be a continuation of the church wall, which, at some period prior to the building of the tower, seemed to have extended considerably beyond it." With great deference, however, to the authority of so respectable a writer, I hesitate not to proclaim that the second foundation so discovered was *not* a " continuation of the church wall," but the remnant of some *pagan* structure, appertaining to the tower itself—in fact a *Vihár*, or college for its priests—or else the vestige of some larger temple, and connected therewith, previously existing on the same locality.

That this announcement is correct will be apparent, from the *superiority of masonic skill* exhibited in this *foundation*, as well as in its having been upon a larger scale and ampler dimensions than what the Christian " Cathedral " had ever occupied ; " in the walls of which," says my authority, " there are many pieces of cut stone that have evidently been used in some former building. The same circumstance may also be observed in several of the ruined churches at Clonmacnoise.* "

Nor ought this relict of an ancient pagan edifice to excite our surprise, when we are told that the temple

* Scientific Tourist through Ireland, p. 33

of the " Syrian goddess," which existed in the days of
Lucian, was not that which was originally erected by
Deucalion, but one built *many ages* after, on the *same
site*, by Attis, Bacchus, or Semiramis.

With the church, therefore, or other Christian edi-
fice, this " foundation " had no relation. St. Patrick
was the first who erected one in that vicinity, to which
he gave the name of Sgibol Phadruig, or Patrick's
Granary ; having been built on the identical spot on
which Dichu, son of Trichem, of the tribe of the Dal-
fiatachs, and lord of the territory of Lecale, had a
granary constructed to preserve his corn, before that
his gratitude for the saint, by whom he was just con-
verted, induced him to consecrate the place where
that event occurred, by raising thereon a house to the
God of nature and of harvests.

Its situation, be it observed, was " two miles from
the city of Down *;" different, therefore, from that of
the cathedral, as was also its *form :* having been built
from north to south, at the solicitation of Dichu him-
self, agreeably to the plan of the former store-house.

This took place in 433-4 ; and though, for conces-
sion sake, I may admit,—*what yet is far from being my
conviction,*—that *some* of our Round Towers may have
been erected *subsequently* to the Christian era, yet
positive I must be that *no one* of them *was after the
successful mission* of the Apostle of Ireland ; and the
explosion of the doctrines with which even the *most
modern of them* may happen to be associated,—while
the majority, and the *real ones*, I shall prove, belong
to an infinitely earlier date.

As a further inducement to explore for cavities be-

* Usher's Primord. c. xvii. p. 846.

neath, and connected with, our Round Towers, I beg
leave to bring under review what Maundrel relates of
two Round Pillars, which he met with in his journey
from Aleppo to Jerusalem, on the sea-coast, a little to
the south of Aradus, in the neighbourhood of Tripoli.
He describes one of them as thirty-three feet high,
composed of a pedestal, ten high and fifteen square,
surmounted with a tall cylindrical stone, and capped
with another in the form of a *pyramid*. The second
was not quite so high—thirty feet two inches—its
pedestal, which was supported by four lions, rudely
carved at each corner, was in height six feet, being
sixteen feet six inches square ; the superstructure
upon which was one single stone cut in the shape of
a *hemisphere*. Each of these pillars, of which he
gives accurate drawings, has under it several cata-
combs or sepulchral chambers, the entrances to which
lie on the south side. He pronounces a third which
he met with, as " a very ancient structure, and pro-
bably a place of sepulchre *."

With the opinion of this judicious traveller I alto-
gether concur, provided only, as said before, in refer-
ence to the pyramids, that the application be extended
to the sacred bulls and crocodiles, serpents, dragons,
and heifers, with the whole train of *bestial* divinities,
which both Indians and Egyptians, and all the other
polished nations of antiquity, thought proper to adopt
as objects of their regard, and treat with the ho-
mage—though only *commemorative,* as they will tell
you—of the One Great Supreme †.

* Journal, pp. 21, 23.

† Neither can I, with him, restrict their object to *Tombs alone;* their
Phallic shape bespeaks another allusion ; as does the style of archi-
tecture indicate an *affinity* of *descent,* though not an *identity* of *design*
with that of our *Towers.*

This extension of the use will at once afford a solution of the otherwise unaccountable and unnecessary *size* of those cavities, and is further supported by Savary's remark, made on occasion of his searching for the Egyptian Labyrinth, viz., that "amidst the ruins of the towns of Caroun, the attention is particularly fixed by several narrow, low, and very long cells, which seem to have had no other use than that of containing the bodies of the sacred crocodiles; these remains can only correspond with the labyrinth." While Herodotus's declaration, of his not being allowed to enter its vaults, on the score of their " containing within them the bodies of the fifteen kings, together with the *sacred crocodiles*," should afford it a determination no longer liable to doubt.

Archer, also, when mentioning a very ancient Hindoo temple, at the south end of the fort of Gualior, resembling in shape those on the Coromandel coast, and decorated with much carving, says that " there was a subterranean communication with the plain at the north end, but the passage has been so long neglected as to be impassable."

Am I not justified, therefore, in the conviction, from what I have already intimated, as to the *complicated* design of those sacred piles, that *our Round Towers* would be found similarly furnished with subterranean chambers? I do respectfully urge that such is my *firm belief,* and that it would be well worth the while of the learned community to investigate the accuracy of the surmise here put forward.

CHAPTER XIII.

ANOTHER characteristic, to which I would fain attract the reader's regard, is the circumstance of their being erected in the vicinity of *water*. At Glendalough, what a magnificent lake salutes the Tower? In Devenish and at Killmalloch, is not the same the case? In other parts of the country, also, we find them similarly located. And even where nature has not been so lavish of her *inland seas*, yet is water, of some shape, always to be seen contiguous to our towers.

What use, it will be asked, do I mean to make of this argument? or how seek support from the accidental propinquity of this element? Remember my remark upon the article, before, in connexion with the Egyptian Pyramids. Captain Mignan, besides, tells us that a tradition, handed down from time immemorial, says that " near the foot of the ruin of El Mujellebah," which he takes to be that of the Tower of Babel, " is a *well*, invisible to mortals ;" and, as all Eastern heathenism, whence ours was deduced, partook in some degree of the same usages and properties, I think it very probable the correspondence will apply in this as well as in other peculiarities ; and the rather as from symptoms of vaults, which have already appeared, and the hollow sounds, or echoes, which invariably accompany, the proposition does not

come unwarranted, however singly put forth, or with-
out something like argument to recommend its trial.

We know that in Hieropolis, or the " Holy city," in
Syria, where a Temple, with a *Tower*, was erected to
Astarte, there stood adjacent a *lake*, were *sacred fishes*
were preserved, in the midst of which was a stone
altar, which was *said*, and really *appeared*, to float ;
whither numbers of persons used to swim every day
to perform their devotions. Under this temple they
showed the cleft where it was said the waters drained
off after Deucalion's flood, and this tradition brought
on the extraordinary ceremony now about to be nar-
rated, something similar to which our ancestors must
formerly have practised *here.*

" I have," says Lucian *, " myself seen this chasm,
and it is a very small one, under the temple. Whether
it was formerly larger and since lessened I cannot
tell, but that which I have seen is small. In com-
memoration of this history they act in this manner :
twice in every year water is brought from the sea to
the temple, and not by the priests only, *but by all
Syria* and Arabia. Many come from the Euphrates
to the sea, and all carry water, which they first pour
out in the temple, and afterwards it sinks into the
chasm, which though small, receives a prodigious
quantity of water, and when they do so, they say,
Deucalion instituted the ceremony as a memorial of
the calamity above named, and of his deliverance from
it."

Twice a year a man went up to the top of the
Priap, and there remained seven days. His mode of
getting up was thus :—He surrounded *it* and *himself*
with a chain, and ascended by the help of that and

* In his treatise " De Deâ Syriâ."

certain pegs, which stuck out of its sides for the purpose, lifting the chain up after him at each resting interval—a method of ascent which will be readily understood by those who have seen men climb up the palm trees of Egypt and Arabia. Having reached the summit he let down the chain, and by means thereof drew up all necessaries in the way of food, and withal prepared himself a seat, or rather nest on his aërial tabernacle.

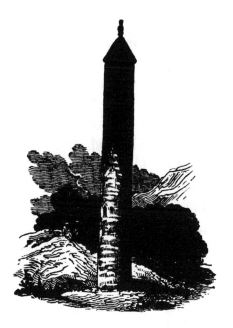

View him now mounted on his sacred tower,
He looks around with conscious sense of power.

On these occasions crowds used to come with offerings, and the custom was for each to declare his name to the priests; upon which one below cried it out to him on the top, who thereupon muttered a prayer, which, in order to arrest the attention of the congregation, and enliven their devotion, he *all the while* accompanied by striking a bell.

One way of their sacrificing was as shocking as it would be otherwise ridiculous. They crowned victims with garlands, then drove them out of the temple-court, on one side whereof was an abrupt steep, where falling they thereby perished. Nay, some tied up their very children in sacks, and then shoved them down, reproaching them as wild beasts, miserably to perish.

This whole proceeding, only under a mythological garb, was in direct harmony with the directions given and the practice pursued by God's own people. The man ascending to the top of the tower had a parallel in that declaration of the Lord recorded in Exodus xxiv. 1, 2, 3, viz., " And he said unto Moses, come up unto the Lord, thou, and Aaron, Nadab, and Abihu, and seventy of the elders of Israel, and worship ye afar off. And Moses alone shall come near the Lord; but they shall not come nigh, neither shall the people go up with him. And Moses came and told the people all the words of the Lord, and all the judgments; and all the people answered with one voice, and said, ' All the words which the Lord hath said, will we do*.' "

His staying there seven days corresponded with Levit. viii. 33, 34, 35—" And ye shall not go out of the door of the tabernacle of the congregation in seven days, until the days of your consecration be at an end: for seven days shall ye consecrate you. As he hath done this day, so the Lord hath commanded to do, to make an atonement for you. There-

* Of this distant adoration we may still see traces in the practice of the Irish peasantry, almost preferring to say their prayers outside the precincts of the chapel, or mass-house, than within it, unconsciously derived from this service of the Afrion, or benediction-house, i.e., the Round Towers.

fore shall ye abide at the door of the tabernacle of the congregation day and night seven days, and keep the charge of the Lord, that ye die not; for so I am commanded." And again, Ezekiel xliii. 25—" Seven days shalt thou prepare every day a goat for a sin-offering: they shall also prepare a young bullock and a ram out of the flock, without blemish. Seven days shall they purge the altar, and purify it; and they shall consecrate themselves."

The enrolment of their names was also sanctioned by divine command, as Exodus xxviii. 29—" And Aaron shall bear the names of the children of Israel in the breastplate of judgment upon his heart, when he goeth in unto the holy place, for a memorial before the Lord continually." Whilst the ringing of the bell is particularly enforced by a triple repetition, Exodus xxviii. 33, 34—" And beneath upon the hem of it thou shalt make *pomegranates* of blue, and of purple, and of scarlet, round about the hem thereof; and *bells* of gold between them round about. A golden *bell* and a *pomegranate*, a golden *bell* and a *pomegranate*, upon the hem of the robe round about."

This last-cited text is of the most inconceivable advantage in the development of the subject which we thus pursue. The most superficial must have noticed how that, in the tracing of this analogy between the ceremonies of the Gentiles and the Hebrews, I have studiously guarded against its appearing an imitation, on the part of the former, from the ritual of the latter. The priority in point of date will certainly appear on the Gentile side. Meanwhile, ere other links of conformity crowd upon our path, it will be well to take heed to the frequency of the word *pomegranate*, as occurring in the Scriptures.

It has already appeared that one of the names of the *Syrian goddess,* in whose honour the Hieropolitan Priaps were erected, was *Rimmon.* This epithet you have had before expounded as expressive of that *fruit ;* and as we see that, both in the Jewish and the Pagan formulæ, it occupied so prominent a position *, it must occasion you no surprise if, by and by, I discover it amongst the mouldings † of our consecrated and venerable Round Towers.

As to their devotions at the lake, and the propinquity of the lake itself to the temple, it is in direct similitude to the " molten sea," mentioned 1 Kings viii. 23, 24, 25, 26, " the brim whereof was wrought like the brim of a *cup, with flowers* of lilies," &c. ;—while the cruel and shocking sacrifice with which the whole terminated, was the exact respondent of the Mosaical scape-goat ‡.

Let it not be wondered at, therefore, if on the summit of one of our Round Towers are to be found the traces of the apparatus for a bell. For independently of what Walsh and others inform us of, viz., that the Irish—enjoying tranquillity and repose after the expulsion of the Ostmen, and so recalling their attention to the cultivation of Christianity, after their release from that scourge—converted those structures of exploded paganism, to the only obvious use to

* The Ghabres to this day chew a leaf of it in their mouths, while performing their religious duties round the sacred fire.

† Those are what Montmorency would fain make out to have been *roses* imported from the Vatican.

‡ A similar sacrifice is described by Major Archer as still practised in the mountains of Upper India, which he himself witnessed. " An unfortunate goat," says he, " lean and emaciated, was brought as an offering to the deities; but so poor in flesh was he that no crow would have waited his death in hopes of a meal from his carcass."

which they could then be made subservient, namely, that of *belfries*, for the summoning together of the people to public worship, some remnants of which it is but natural may yet remain—independently, I say, of this, have I not here shown that *bells* entered essentially into the code of the Pagan ceremonial, from whence it is more than probable, nay, a downright certainty, that the first Christian ecclesiastics adopted the use, as the Mahomedans, in their minarets, did so likewise *.

The instance to which I have referred in an early part of this volume, of astonishment created in the English minds, on their first beholding one of those implements, was that of Gildas, who, having finished his education at Armagh, and returned to Britain about the year 508, was engaged by Cadoc, abbot of the church of Mancarban, to superintend the studies of his pupils during his absence for a twelvemonth. Having done so most successfully, and without accepting of any remuneration for his labour, we find, in an

* " Round the *tee* or umbrella at the top (of the Dagobs at Ceylon) are suspended a number of small bells, which with these form *tees* of a great quantity of smaller pagodas that surround the quatine, being set in motion by the wind, keep up a constant tinkling, but not unpleasing sound."—COLEMAN.

The temples of Budh in the Burmese empire are also pyramidical, the top always crowned with a gilt umbrella of iron filagree, hung round with bells.—" The *tee* or *umbrella* is to be seen on every sacred building that is of a spiral form ; the rising and consecration of this last and indispensable appendage, is an act of high religious solemnity, and a season of festivity and relaxation. The present king bestowed the *tee* that covers Shoemadoo : it was made at the capital. Many of the principal nobility came down from Ummerapoora to be present at the ceremony of its elevation. The circumference of the tie is fifty-six feet ; it rests on an iron axis, fixed in the building, and is further secured by large chains strongly rivetted to the spire. Round the lower rim of the tee are appended a number of *bells*, which agitated by the wind make a continual jingling."—SYMES.

ancient life of Cadoc, in the Tinmouth MS., Lam-
beth observe that " Cadoc, returning to his monastery,
found Gildas a noble scholar, with a very beautiful
little bell, which he brought with him from Ireland."

Those bells, then, we may be sure, appertained
exclusively to the service of the Round Towers *.
Having none of these in England, of course they had
no bells, and hence the surprise manifested on the
above occasion. In Ireland, too, they must have been,
now, comparatively obsolete †. And hence we find,
according to Primate Usher, that their (restored) use
was not general in the *churches* here before the latter
end of the seventh century ; while another writer
assures us that it was not until the ninth century
that large ones were invented for the purpose of
suspension ‡.

The shape of the Irish *pagan* bells was precisely

* " It is remarked that in China they have no Pyramids, but Pagodas,
raised by galleries, one above another, to the top: the most celebrated
of these is that called the Porcelain Tower in Nankin, said to be two
hundred feet high, and forty feet at the base, built in an octagonal form.
These Pagodas seem to have been designed for altars of incense, raised
to their aërial deities, with which to appease them ; and their hanging
bells, *with their tintillations to drive away the demons,* lest they should,
by noxious and malignant winds and tempests, disturb their serene atmo-
sphere, and afflict their country."—*Dissertation upon the Pyramids.*

† The reason of this will appear hereafter ; while in the interim I
must observe that this new appropriation of them to Christian purposes
was what occasioned that error on the part of a writer, some centuries
after, who *opined* that it was *Sanctus Patricius* who first presented one
to *Sancto Kierano.* I make no question of the *present :* but does pre-
sentation imply invention ?

‡ Cambrensis tells rather a curious story about St. Finnan's bell :—
" There is," says he, " in the district of Mactalewi, in Leinster, a certain
bell which, unless it is adjured by its possessor every night in a particu-
lar form of exorcism shaped for the purpose, and tied with a cord (no
matter how slight) it would be found in the morning at the church of
St. Finnan, at Clunarech, in Meath, from whence it was brought ; and,"
adds he, " this has sometimes happened."

the same as of those in the present day. They were called crotals, or bell-cymbals. Oblong *square* ones, some of bell-metal, some of iron, from twelve to eighteen inches high, with a handle to sound them by, have been, also, dug up in our various bogs. Of these the museum of the Dublin Society possesses one ; another is preserved by the Moira family. The writer of this article not having seen either of these relics, is rather diffident in the conjecture which he is now about to express ; but from the account received of that in the possession of the house of Moira, he feels strongly disposed to identify its origin with the worship of the above-mentioned deity, Astarte. Lucian expressly tells us that under the veil of this goddess was really meant the *moon ;* and that " the host of heaven,"—including sun, moon, and stars, and typifying the fulgor of that Omniscient germ whence they all had emanated—constituted the object of the ancient Irish adoration, no one, I believe, can longer question. Now in " Hall's Tour through Ireland," 1813, I see this bell described as having " a hole in one of its sides like a quarterly moon ;" and not knowing whether this is the effect of accident or corrosion, or a symbolical property in its original shape, I trust I shall not be deemed fanciful if I ascribe it as a reference to that planet in whose vain solemnities it had been primarily exercised.

Whether this exposition prove eccentrical or otherwise—and, by inspection, it can be readily ascertained—I cannot presume to determine; nor indeed does it value much *. With one thing, however,

* A communication from Mr. Hall himself, just imparted, assures me that, *as far as he could judge*, the aperture was *coeval* with the instrument, and by no means accidental.

I am gratified, that in " Archer's Travels in Upper India," published, as before observed, within the last few weeks, I find that distinguished soldier and shrewd observer, delineate a piece of architecture similar in all particulars to this Syrian Priap—the allusion to which has recalled me to ring this second chime upon the bells—and as the notice is of value I shall give it in his express words :—" A curious structure," says he, " is at the bottom of the hill (Dutteah). It consists of five *conical pillars*, with green painted tops, in a line from east to west ; the two larger ones in the centre : the *pillars* have *tiles stuck in them resembling steps.* We could not learn what was its meaning or use. The village is wholly *Jain,* and is named Serrowlee."

It is not difficult to understand why no information could be obtained, from the *present* inhabitants, as to the object of those edifices. Their remote *antiquity* is a sufficient reply. But I flatter myself that the reader, who has accompanied me from the outset of this antiquarian voyage, can now supply the defect, and explain that *they were a series of Round Towers, or Phalli, erected by the aboriginal Budhists,* of whom the *Jaina* are only the wretched remains ; and that those " tiles," which are " stuck in them, resembling steps," *were for the purpose of ascending by the aid of a hoop,* such as we have shown at Hieropolis. The projecting stones in *our* Priaps, or the cavities that appear after their removal, are thus also accounted for.

CHAPTER XIV.

THE universal ignorance which prevails throughout the East, as to the origin of those antiquities which excite the wonder of every traveller, makes it necessary that we should, again, direct our course towards that hemisphere, to redeem, if possible, its venerable remains from that moral night which successive ages have accumulated around them.

Persia* was the source which poured its vivifying light into the mental obnubilation of our European ancestors. By a reverse of those casualties from which no condition can be exempt, Persia has, in her turn, been made the theatre of darkness : and though, under the fostering auspices of British institutions, the mist has, to a large amount, been dispelled, yet is the proudest era of her splendour left still unexplored, and

* "This word is generally supposed to be derived from Fars, or Pars, a division of the empire of Iran, and applied by Europeans to the whole of that kingdom. It is certainly a word unknown, in the sense we use it, to the present natives of Iran, though some Arabic writers contend that Pars formerly meant the whole kingdom. In proof of this assertion, a passage of the Koran is quoted, in which one of Mahomet's companions, who came from a village near Isfahan, is called Telman of Fars or Pars. We have also the authority of the Scripture for the name of this kingdom being Paras or Phars. The authors of the Universal History, on what authority I know not, state that the word Iran is not a general name of Persia, but of a part of the country. *This is certainly erroneous:* Iran has, from the most ancient times to the present day, been the term by which the Persians call their country ; and it includes, in the sense they understand it, all the provinces to the east of the Tigris, Assyria Proper, Media, Parthia, Persia, and Hyrcania or Mazenderan." —*Sir John Malcolm.*

that is the epoch which called forth into life those
monuments of literature and philosophical eminence,
which, resisting the corrosion of time and the assaults
of war, still proudly elevate their heads towards
those orbs, with whose pompous ceremonial they were
essentially connected, and whose generative proper-
ties they typically symbolized—I mean the Round
Towers.

This was the moment of Persia's halcyon pride:
this the period of her earthly coruscation : to this
have all the faculties of my ardent mind with vigour
been addressed ; and while, in the humble conscious-
ness of successful investigation, I announce its issue to
have far exceeded my hopes, I shall avail myself of
the industry of preceding inquirers to throw light
upon the intervals, of value, which intervene ; but,
lest I should intrude upon the province of their well-
earned honours, I shall, in every such case of borrowed
assistance, allow the writers themselves to speak ; by
which it will additionally appear that, with much
good taste, and with historical honesty, they have
left a vacuum in their researches, for which the
public mind has been long athirst, and which my
exclusive resources could alone supply.

"The Persian empire*," says Heeren, " owed its
origin to one of those great political revolutions which
are of such frequent occurrence in Asia, and the rise
and progress of which we have already considered in
general. A rude mountain tribe, of nomad habits,
rushed with impetuous rapidity from its fastnesses,
and overwhelmed all the nations of southern Asia,

* These quotations from the professor's book are not given *consecu-
tively* as he wrote them ; but *brought together* from detached sections
and chapters.

(the Arabians excepted,) from the Mediterranean to the Indus and Iaxartes. The mighty empires which arose in Asia were not founded in the same manner with the kingdoms of Europe. They were generally erected by mighty conquering nations, and these, for the most part, nomad nations. This important consideration we must never lose sight of, when engaged in the study of their history and institutions."

"Not only is Persia † Proper memorable on account of its historical associations, but also for the architectural remains which it continues to present. The ruins of Persepolis are the noblest monuments of the most flourishing era of this empire, which have survived the lapse of ages. As solitary in their situation as peculiar in their character, they rise above the deluge of years, which for centuries has overwhelmed all the records of human grandeur, around them, or near them, and buried all traces of Susa and of Babylon. Their venerable antiquity and majestic proportions do not more command our reverence, than the mystery which involves their construction awakens the curiosity of the most unobservant spectator. Pillars which belong to no known order of architecture; inscriptions in an alphabet which continues an enigma; fabulous animals which stand as guards at the entrance; the multiplicity of allegorical figures which decorate the walls,—all conspire to carry us back to ages of the most remote antiquity, over which the traditions of the East shed a doubtful and wandering light."

"The Persians have taken more pains than almost any other nation to preserve their records in writing;

* Pars is the Persian, Fars the Arabic, pronunciation of the word.

yet it has been their fate, in common with most other
nations of antiquity, to be indebted for the stability
of their fame to foreign historians. Notwithstanding
the pains they took to register the acts of their
government, the *original documents of their history*,
with a few accidental exceptions, have altogether
perished. And the inscriptions of Persepolis, like
the hieroglyphics of the Egyptians, will, in a manner,
have outlived themselves, unless a complete key be
discovered to the alphabet in which they are com-
posed."

Now, as a set off to these extracts, it will be
necessary to remark that, though true in substance,
they are only so as descriptive of a particular epoch.
Empire after empire rolled over, in succession, before
that which the historian here delineates, and which
was but the motley combination of a rugged swarm
of mountaineers, who stalked with ferocious insensi-
bility over the consecrated relics of monumental glory.

Herodotus and Arrian were the authorities that
seduced him into this mistake, the former of whom
states that " the Persians originally occupied a small
and craggy country, and that it was proposed in the
time of Cyrus that they should exchange this for one
more fertile ; a plan which Cyrus discouraged as
likely to extinguish their hardy and warlike pursuits ;"
and the latter, that " the Persians, when, under Cyrus,
they conquered all Asia, were a poor people, inhabit-
ing a hilly region* ;" but those writers were as misin-
formed, as to all events and particulars relating to this

* I should have observed, that Plato also, speaking of those modern
Persians, says, they were originally a nation of shepherds and herdsmen,
occupying a rude country, such as naturally fosters a hardy race of
people, capable of supporting both cold and watching, and, when needful,
of enduring the toils of war.—Plato de Leg. iii. op. ii. p. 695.

locality, anterior to the time specified above, as any of their contemporaries; and when we reflect how very recent an era in the history of the world was that in which Cyrus appeared, it will be seen how fragile a substratum was that which the professor had adopted for the erection of his materials. We read accordingly, in Terceira's Spanish history of that country, that " there was not at that time (A. D. 1590) one man in Persia (these were the direct descendants of Cyrus's men) that understood their *ancient* letters, for having often seen some plates of metal with *ancient* inscriptions on them, I made inquiry after the meaning of them; and men *well versed* in their *antiquities*, and *studious*, told me that was *Fars kadeem, ancient Persian*, after the old fashion, and *therefore* I should find *no man* that understood it."

Indeed the reasonings of Heeren himself,—and learned I cheerfully acknowledge them,—would seem to make him rise above the narrowness of his Grecian supporters.

" Even previous," says he, " to the time when the Arabs, with the sword in one hand and the Koran in the other, overran and subdued Persia, they were the more open to settlers from the north and east, from the circumstance that Persia was situated on the great highway of nations, by which the human race spead itself from east to west. All that is meant to be asserted is, that the various races who successively had dominion in these parts, all belonged to the same original stock.

" This fact, which the observations of the best modern travellers tend to confirm, may explain how it has come to pass that many districts, anciently celebrated for their fertility, are at present barren and

unproductive. A single invasion, by destroying the water-courses, is sufficient to reduce, in a short time, a fertile and flourishing country to an arid desert; and to how many such disastrous contingencies has not Persia at all times been exposed!"

"Another fact, suggested by the languages of Asia and the ancient dialects of Persia, is too important to be passed over in silence. Not only in the Persian territory but in other parts of Eastern Asia, particularly the two Indian peninsulas, we find languages which still subsist, mixed up with others which are preserved to us only in a few written names. To this class belongs, in Persia, the Zend and Pehlivi, already mentioned; in Hindostan, the celebrated Sanscrit, as well as the Pali in the Burman peninsula.

"Accordingly, we shall venture to consider as the same parent stock the race which bore rule in Iran, comprehending all the inferior races, and which may be termed in general the Persian or Medo-Persian, inasmuch as the countries in its occupation were termed, in a wider sense, the land of Persia.

"They have been denominated by Rhode (Heilige sagen, &c.) the people of Zend, not improperly, if we consider the Zend as the original language of all the race... not confined to Persis, properly so called, but extending over the steppes of Carmania and to the shores of the Caspian. Even at the present day they are comprised under the general name of Persia, though Farsistan, the original country of the Persians, forms a very small part of this territory.

"The Semitic and the Persian were, therefore, the principal languages of Asia; the latter being spoken as far as the Indus. Our knowledge of the languages prevalent on the other side of that river is as yet too

defective to enable us to speak with any thing like
certainty. Possibly it may be reserved for our own
age to arrive at important conclusions on this subject,
if the affinity between the Zend and the Sanscrit, the
sacred languages of Persia and Hindostan, should be
established,—if the spirit of discovery, which charac-
terizes the British nation, should succeed in rescuing
from oblivion some more remains of ancient Indian
literature, and a second Anquetil Duperron present
the public with the sacred books of the Brahmans,
with the same success that his predecessor has illus-
trated those of the Parsees."

Though I cannot avoid concurring in the laudable
hope that " our own age" may witness important
conclusions on this subject, still it strikes me,—*and I
earnestly urge it as worthy the notice of a Reform
Ministry*, that until the *Irish Language* be raked from
its ashes, no accuracy can ever be obtained either in
the Zend, Pahlavi, or Sanscrit *dialects*, which are but
emanations from it, or in the *subject matter*, historical
or religious, which they profess to pourtray.

" In the interior of these districts is situated a con-
siderable lake, called the lake Zevora, unquestionably
the *Aria Palus* of antiquity. A large river, anciently
bearing the same name, at present called the Ilmend,
empties itself into this inland sea from the deserts to
the south-east, and Christie fell in with another stream
farther to the north, called the Herat, near a town of
the same name.

" I consider (with Kinneir) the city of Herat to be
same with the ancient Aria, or, as it was also called,
Artacoana. We are told that Alexander on his march
to Bactriana inclined to the south to visit Aria. We
must carefully distinguish between the terms Aria

and Ariana, as used by the Greeks. The former was applied to a province which we shall have occasion to describe in the sequel. The latter is equivalent to Iran, and appears to have been formed from the ancient term in the Zend language, Eriene. The whole of Iran composes a sort of oblong, the Tigris and Indus forming its sides to the east and west; the Persian Gulf and Indian Ocean bounding it to the south; and the Caspian, with Mount Taurus and the river Oxus, shutting it in to the north. These were also the limits of the ancient Ariana; (see Strabo, p. 1048.) except that, towards the west, its boundary was an imaginary line separating it from Persia Proper. Of this more extensive district, Aria (according to Strabo) formed only a part, distinguished by its superior fertility. Herodotus appears to have been unacquainted with the term Aria; he merely mentions the Arii as a nation allied to the Medes.

" Aria, lying to the east of Media, derived its name from the river Arius, the modern Heri : and the Arians and Medes were originally the same race; the Medes, according to Herodotus, having originally borne the name Arians. It is apparent, from the same place, (Herod. vii. 62.) that what were called the *Median habits* were not confined to Media Proper, but extended to the countries lying eastward, and as these touched on Bactria, we cannot be surprised at the conformity which prevailed."

These latter quotations I have thought fit to introduce to show the ignorance of the modern Greeks,— those of Cyrus and Herodotus's days—compared with their Pelasgic predecessors—*Iran*, the real name for all those countries of higher Asia as far as the Indus [*], being

* Επικτεινεται δε τ'ουνομα της Αριανης μεχρι μερους τινος και Περσων και Μηδων και

called, in the Zend, *Eriene*, the Greeks, whose intercourse with the East now for the first time began, without troubling their brains to ascertain what the word in either form, meant, transmuted this latter into *Ariana*, whereas their forefathers, the Pelasgi, a literary and a religious tribe, changed its namesake in the West, our own *Iran*—which, in the Pahlavi dialect, was called *Erin*, and in the Zend, would also be called *Eriene*—into *Ierne*, thereby evincing their knowledge of the import of the term, and registering their subscription in its *sacred* attributes *.

The following, however, is more to the point, and, in itself, sufficient to redeem the professor's entire work from any occasional inclination to Grecian subserviency.

" It cannot be doubted that, at some remote period, antecedent to the commencement of historical records, one mighty race possessed these vast plains.

" The traditions of this race preserve some very important particulars respecting their descent, their ancient abodes, and their gradual dissemination through the land of Iran. These traditions are preserved in the beginning of the Vendidat, the most important, and it is probable, the most ancient of all their sacred books, the collection of which is styled the Zendavasta, to which we shall have occasion to refer hereafter. The two first chapters of this work, entitled *Fargards*, contain the above traditions,

ιτι των προσαρκτον Βακτριων και Σογδιανων. ιισι γαρ πως και ομωγλωττοι παρα μικρον. —Strabo, p. 1094.

* All the other variations are thus similarly accounted for ; being but offshoots of the same radix, such as I have already shown, page 128, in reference to Ireland—while the careful reader will of himself see that the name of that lake in Persia, of which the Greeks and Romans, conjointly, manufactured Aria Palus, corresponds to our Lough Erne, and must doubtless have been so called in Persia also, for *Palus* is evidently but the translation of Lough.

not wrapt up in allegory, but so evidently historical
as to demand nothing more than the application of
geographical knowledge to explain them. With the
exception of the Mosaical Scriptures, we are ac-
quainted with nothing which so plainly wears the
stamp of remote antiquity, ascending beyond the
times within which the known empires of the East
flourished; in which we catch, as it were, the last
faint echo of the history of a former world, anterior
to that great catastrophe of our planet, which is at-
tested in the vicinity of the parent country of these
legends, by the remains of the elephant, the rhino-
ceros, and the mammoth, and other countries pro-
perly belonging to the countries of the south. It
would be a fruitless labour to attempt to assign dates
to these remains, but if the compiler of the *Vendidat*
himself, who was long anterior to the Persian, and as
we shall have occasion to show, probably also to the
Median dynasty, as known to us, received them as the
primeval traditions of his race, our opinion of their
importance may be fully justified.

" These legends describe as the *original* seat of the
race, a delicious country, named Eriene-*Veedjo,* which
enjoyed a climate singularly mild, having seven
months summer and five of winter. Such was the
state at first, as created by the power of Ormuzd;
but the author of evil, the death-dealing Ahriman,
smote it with the plague of cold, so that it came to
have ten months of winter and only two of summer.
Thus the nation began to desert the paradise they at
first occupied, and Ormuzd successively created for
their reception sixteen other places of benediction
and abundance, which are faithfully recorded in the
legend.

" What then was the site of the Eriene referred to ? The editors and commentators on the Zendavesta are inclined to discover it in Georgia, or the Caucasian district; but the opinion must necessarily appear unsatisfactory to any one who will take into account the whole of the record, and the succession of places there mentioned as the abodes of the race. On the contrary, we there trace a gradual migration of the nation from east to west, not as this hypothesis would tend to prove, from west to east. The first abode which Ormuzd created for the exiled people was Soghdi, whose identity with Sogdiana is sufficiently apparent; next Môore, or Maroo, in Khorasan; then Bakhdi, or Balkh (Bactriana), and so on to Fars itself, and the boundaries of Media or India. The original country of Eriene must therefore lie to the east of Leed, and thus we are led, by the course of tradition, to those regions which we have already referred to, as the scene of the traditions and fables of the nation, viz., the mountainous tracts on the borders of Bucharia, the chain of Mustag and Beloor-land, as far as the Paropamisan range on the confines of Hindostan, and extending northwards to the neighbourhood of the Altain chain. This savage and ungenial region enjoys at present only a short summer, at the same time that it contains the reliques of an ancient world, which confirm, by positive proof, the legend of the Vendidat, that anciently the *climate* was of a *totally different character.* When the altered nature of their original seats compelled the race to quit them, Ormuzd prepared for them other places of repose and abundance, within the precincts of that territory which has *preserved to the present day the appellation*

of Iran ; the nation carrying with them the name of
Eriene, which is obviously the same with Iran.

" Jemshid, the father of his people, the most
glorious of mortals whom the sun ever beheld. In
his day animals perished not : there was no want
either of water or of fruit-bearing trees, or of animals
fit for the food of mankind. During the light of his
reign there was neither frost nor burning heat, nor
death, nor unbridled passions, nor the work of the
Deevs. Man appeared to retain the age of fifteen ;
the children grew up in safety as long as Jemshid
reigned the father of his people *.

" The restoration of such a golden age was the end
of the legislation of Zoroaster, who, however, built his
code on a religious foundation agreeably to the prac-
tice of the East ; and the multifarious ceremonies he
prescribed had all reference to certain doctrines inti-
mately associated with his political dogmata ; and it
is absolutely necessary to bear in mind their alliance,
if we would not do injustice to one part or other of
his system.

" On these principles Zoroaster built his laws for
the improvement of the soil by means of agriculture,
by tending of cattle and gardening, which he per-
petually inculcates, as if he could not sufficiently im-
press his disciples with a sense of their importance.

" According to his own professions he was only the
restorer of the doctrine which Ormuzd himself had
promulgated in the days of Jemshid : this doctrine,
however, had been misrepresented, a false and de-
lusive magia, the work of Deevs, had crept in, which

* Zendavesta, i. 14.

was first to be extinguished, in order to restore the pure laws of Ormuzd.

"Even Plato, the first Grecian writer who mentions Zoroaster, speaks of him as *a sage of remote antiquity;* and the same is established by the evidence of Hermippus and Eudoxus, which Pliny has preserved. The second Zoroaster, supposed by Toucher to have flourished under Darius Hystaspes, is the mere figment of some later Grecian authors of little credit.

"On the whole, we *are compelled* to carry back Zoroaster to the period when Bactriana was an independent monarchy, *a period anterior to the very commencement of the Median empire*, as related by Herodotus, ascending *beyond the eighth century* before the Christian era. Whether we must refer him to a *still more ancient epoch*, prior to the Assyrian monarchy, the chronological notices we have already given are all that can be afforded, except we be prepared to transport the sage beyond the *utmost limits of recorded history*."

As I have no longer occasion, however, for the *sage* than to show that he was a *reformer;* and though at least " eight (more likely *eighteen*) hundred years before the Christian era,"—yet was he even then, comparatively, a *modern*,—I shall now turn to other sources to ascend to the dynasties that had preceded him.

" The rare and interesting tract on twelve religions," says Sir W. Jones, " entitled the Dabistan, and composed by a Mahomedan traveller, a native of Cashmere, named Moshan, but distinguished by the assumed surname of Fani, or Perishable, begins with a wonderfully curious chapter on the religion of Hushang, which was *long anterior* to *Zeradust (Zo-*

raaster), but had continued to be *secretly professed* by many learned Persians, even to the author's time; and several of the most eminent of these dissenting, in many points, from the Gabrs, and persecuted by the ruling powers of their country, had retired to India, where they compiled a number of books, now extremely scarce, which Moshan had perused, and with the writers of which, or with many of them, he had contracted an intimate friendship. From them he learned that a *powerful monarchy had been established for ages in Iran, before the accession of Cayemurs;* that it was called the Mahabadean dynasty, for a reason which will soon be mentioned; and that many princes, of whom seven or eight only are named in the Dabistan, and among them Mahbul, or Maha Beli, had raised the empire to the zenith of human glory. If we can rely on this evidence,—*which to me appears unexceptionable,*—the Iranian monarchy must have been the oldest in the world."

Sir John Malcolm had some scruples as to the authenticity of this production, and entered upon a very severe analysis of its contents; merely because the *idols* which the ancient Persians are therein stated to have adored, and the *mode* of their adoration, were dissimilar to those of India! Was it necessary that they should be alike? It is true, that from Persia everything Indian flowed; but there, on its importation, it partook of the peculiarities of the soil and climate; while, even in Persia itself, a great degeneracy occurred; and the deterioration and moral laxity, thus superinduced, was what the virtuous Zerdust so deplored, and what *kindled* his *fervour* to new model the system.

But " the introduction of the angel *Gabriel*," he

says, " appears of itself enough to discredit the
whole work." Was Sir John sure that this render-
ing was literal? He himself admits that he was
" following a Mahomedan author, who has certainly
made a *free* translation of the Pahlavi text." And,
if so in one case, why not in another? But even
admitting that there was no *freedom* at all used in
the matter; and that *Gabriel* is the rigid version of
the name of the messenger employed, this should not,
in the least, affect our reliance upon the Dabistan, as
I shall adduce a greater *coincidence* than this, nay, a
downright *identity*, not only of *name* but of *essence*,
between the divine dispensation in all previous ages,
and the spiritual form of it with which we are at pre-
sent blessed.

But you will say, perhaps, that Moshan Fani's
authorities were, in a great measure, *floating*, and
dependent upon *histories* of a merely oral stamp,
which—wanting as they do, the impress of lettered
perpetuity, and subject, as they are, to variation,
both of curtailment and of addition, besides the colour
of depreciation or enhancement, which they must
furthermore undergo, according to the nature of the
successive *media* through which they pass,—cannot,
after repeated transfusions, retain much similarity
with the original truth, nor afford to a rational and
thinking mind, however they may gratify selfish or
national love, much stability for conviction or satis-
factory acquiescence?

To the first I shall reply that it seems not correct,
as the manuscripts by which he was guided appear
still in existence; and this was not without its influ-
ence on Sir John's own scepticism, when he declares,
that " The doubtful authority of this work has

received some support from the recent discovery of a volume in the ancient Pehlivi, called the Dussadeer, or Zemarawatseer, to which its authors refer."

Then, as to the *vanity* alluded to, the compiler may well be acquitted of any, as being of a different creed, and proverbially intolerant, he could not, *did not truth oversway*, have felt much communion of pleasure in celebrating the glories of a defunct religion. And though I concede that *that* species of information, which arises from the traditions of successive races of men, cannot be so satisfactory as that which is *stereotyped* in alphabetic characters; nay, that, according. as it diverges from its first outlet, it is likely to diverge also from exactness ; still I do insist, that the prevalence of those *traditions*, wherever they occur, argues some alliance with *fact* and *reality ;* just as idolatry itself, in all its ramifications, is but the corrupt transmission of original pure religion.

CHAPTER XV.

THE objections against the Dabistan being thus superseded; and the idea of its being an " invention *," having never crossed any one's thoughts, I shall now give a bird's-eye view of its tenour in Sir John's own summary thereof.

" It has been before observed," says he, " that the idolatrous religion which Mohsin Fani ascribes to the ancient Persians, bears no resemblance to the worship of the Hindoos : it seems nearest that which was followed by a sect of *Sabians,* who, we are told, *believed in God,* but *adored the planets,* whom *they deemed his vicegerents, that exercised an influence over all created things in the world.* This sect of Sabians were said to follow the *ancient* Chaldeans, and to inherit their skill in astronomy, a science built upon the same foundation as the adoration of the planets†. And this leads us to remark, that the very title of the work from which Mohsin Fani gives an account of this worship, appears more like that of a treatise

* " And what would hardly appear possible, as we cannot discover what purpose such a finished fable of idolatrous superstition would be meant to answer."—Sir John Malcolm's History of Persia, vol. i. p. 191.

† Yet in Hindoostan, also, as we learn from Major Archer, " an *astrologer* is a constituted authority in all the villages, and nothing pertaining to life and its concerns is commenced without his sanction."

upon astrology, than upon religion. He calls it
Akheristan, or *the region* of the *stars*. It is, however,
impossible to enter into any minute comparison of the
religion he ascribes to the ancient Persians, and the
sect of Sabians that have been noticed, *because we
have only a very general account of the tenets of the
latter.*"

As to the *impossibility* here complained of, it is
obvious that *there is none:* whoever has digested
even the early part of this essay will own it was but
ideal. With this I should have contented myself, but
that I feel called upon to correct another misconcep-
tion, which the above may have produced.

That Sabaism meant *idolatry* in the way there insi-
nuated, I utterly and altogether repudiate. It was
the religion of the early Greeks before their degene-
rate mythology had loaded it with so many absurdi-
ties *; and that it was so, is evident from the term
in their language, which expresses " to worship," *viz.*,
σεϐομαι, an evident derivation, from which is angli-
cised, Sabaism †. The object of this religion was the
host of heaven, meaning the sun, moon, and stars.
The names assigned to the reputed idols, *viz.*, Ura-
nus, *i. e.* Heaven, and Gea, *i. e.* Earth, with the
energies of the sky and nature typified under the
names of the " Cyclops" and " Giants," incontro-
vertibly demonstrate the truth of this position.

* Tout, dans le systême primitif de la religion des Grecs, atteste la
transposition des traditions comme des principes; tout y est vague,
sombre et confus.—DE SACY.

† The Sabians themselves boasting the origin of their religion from
Seth, and pretending to have been denominated from a son of his called
Sabius, as also of having among them a book, which they called the
Book of Seth.—*Prideaux*, part i. book iii.

I have said that the name Cyclops, in this religious
code, was meant to figure forth the energies of the
atmosphere; I need but mention their denominations
to establish my proof. They are " Steropes," from
στεροπη, lightning; Argues, from αργης, quick-flash-
ing; and Brontes, from βροντη, thunder. Even the
celebrated name of *Hercules* * himself, and the twelve
labours poetically ascribed to him,—who, we must
observe, many ages before the Tirynthian hero is
fabled to have performed his wonders, or his mother
Clymena to have been born, had temples raised to
him in Phœnicia and Egypt, as well as at Cadiz and
the Isle of Thasos—are nothing more than a figura-
tive denotation of the annual course of the solar
luminary through the signs of the Zodiac.

In support of this I shall quote the authority of
Porphyry, who was himself born in Phœnicia, and
who assures us that " they there gave the name of
Hercules to the sun, and that the fable of the twelve
labours represents the sun's annual path in the
heavens." Orpheus, or the author of the hymns that
pass under his name, says that Hercules is " the god
who produced time, whose forms vary, the father of
all things and destroyer of all; he is the god who
brings back by turns Aurora and the night, and who
moving onwards from east to west, runs through the
career of his twelve labours; the valiant Titan, who
chases away maladies, and delivers man from the evils
which afflict him." The scholiast on Hesiod like-
wise remarks, " The zodiac in which the sun per-
forms his annual course is the true career which
Hercules traverses in the fable of the twelve labours;

* This is only a corruption from the Irish word *Ercol*, the sun.

and his marriage with Hœbe, the goddess of youth, whom he espoused after he had ended his labours, denotes the renewal of the year at the end of each solar revolution." While the poet Nonnas, adverting to the sun as adored by the Tyrians, designates him Hercules Astrokiton, (αστροχιτων,) or the god clothed in a mantle of stars; following up this description by stating that " he is the same god whom different nations adore, under a multitude of different names—Belus, on the banks of the Euphrates—Ammon, in Libya—Apis, at Memphis—Saturn, in Arabia—Jupiter, in Assyria—Serapis, in Egypt—Helios, among the Babylonians — Apollo, at Delphi — Æsculapius, throughout Greece," &c. &c.

Even the father of history himself, the great Colossus of the Greeks, whilst claiming for his countrymen the honour of instituting their own theogony, evinces in the attempt more of misgiving and doubt than was consistent with the possession of authentic information. His words are these :—" As for the gods whence each of them was descended, or whether they were always in being, or under what shape or form they existed, the Greeks knew nothing till very lately. Hesiod and Homer were, I believe, about four hundred years older than myself, and no more, and these are the men who made a theogony for the Greeks; who gave the gods their appellations, defined their qualities, appointed their honours, and described their forms; as for the poets, who are said to have lived before these men, I am of opinion they came after them."

But even this assumption, were it conceded to the utmost, would not militate against the doctrine which I have laid down; for Homer's education was received

in Egypt, and India was the medium which illumi-
nated the latter country; nothing, therefore, pre-
vents our yielding to the stream of general authority
in ascribing the introduction to the Pelasgi. The
word χρονος itself, or "the father of Jove," was nothing
more than an equivalent with the Latin *tempus ;* and
for the very best possible reason, because the revolu-
tions of this planet, as of the other celestial orbs,
came, from their periodical and regular appearances,
to be considered the ordinary measurements of the
parts of duration or time.

It must, no doubt, appear a contradiction that
Chronos,—the "son of Uranus, and Terra," as we
were told at school, and the first person, as somewhere
else stated, who was honoured with a crown,—should
be called an "orb," and have "periodical appear-
ances;" and that those appearances should regulate
our estimate of days, weeks, years, and seasons. The
difficulty, however, will cease, when we consider that
though the *sun, moon,* and *stars* were the primary
objects of false worship, the deification of dead men,
deceased heroes, afterwards crept in, the consequence
of which was a mixed kind of idolatry, consisting of
stars and *heroes,* or *heroines, deceased*—a planet being
assigned to each as the greatest possible honour.
"That whom men could not honour in presence, be-
cause they dwelt far off, they took the counterfeit of
his visage from far, and made an express image of
a king, whom they honoured, to the end that by their
forwardness they might flatter him that was absent,
as if he was present *."

Let us now see how the religion of the ancient
Irish harmonizes with that of the Dabistan, as illus-

* Wisdom of Solomon, xiv. 16, 17.

trated in the composition of some of our ancient names. Here *Baal* or *Moloch,* and *Astarte* are obviously in the foreground ; whilst the popular and vernacular names for those luminaries amongst the peasantry themselves, namely, *Grian* for the *sun,* *Luan* for the *moon, Righ* for *king,* and *Rea* for *queen,* in their appropriation to several localities throughout the country, indicate, but too plainly, the melancholy tale of their former deification.

To instance some few of those names, that strike me as *demonstrative* of this Sabian worship, I shall begin with

Baltinglas *.—This name of a town and mountain

* To this exactly corresponds, as well in import as in appropriation, the name of one of the hills upon which Rome was built, that is, *Pala-tinus,* which—no doubt, to the amazement of etymological empirics—is nothing less than a compound of *Baal* and *tinne;* that is, *Baal's fire*— the initial B and P being always commutable. And *Aven-tinus,* the epithet of another of the Seven Mounts, is derived from *Avan,* a river ; and *tinne,* fire, meaning the fire-hill, near the river. And as the former was devoted to the *sun,* so the latter was to the *moon;* in confirmation of which it got another name, viz., *Re-monius,* of which the component parts are *Re,* the moon ; and *moin,* an elevation.

The *Pru-taneion,* also, amongst the Greeks, was what? A *fire*-hill. Startle not, it is a literal truth. But the Dictionaries and Lexicons say nothing about these matters ? nay, offer other *explanations ?* mystifications, Sir, if you please, whereby they implicate, as well themselves as their readers, in absurdities ; which could not be expected to be otherwise, uninstructed, *as their authors necessarily were,* in the elements of that language whence all those words have diverged.

Pru-taneion, then, is compounded of *Bri,* a mount, and *tinne,* fire ; the B, as before observed, being commutable with *P,* particularly amongst the Greeks, who indifferently called Britain Βρεταυικη and Πρεταυικη (*νησος* being understood). Every community had, of old, one of those *Bri-tennes,* or *fire mounts,* natural or artificial. The guardian of the sacred element therein was called, *Bri-ses;* and the dwelling assigned him, hard by, *Astu.* The number of those latter Cecrops reduced, in Attica, from one hundred and sixty, to twelve. Of these Theseus appointed the *principal station* at *Cecropia,* the name of which he changed, by *way of eminence,* to *Astu;* and hence this latter word, which originally but represented the abode of the *Sacerdos,* came ultimately to signify a *city* at large ; as *Prutaneion* did a Common Council Hall.

in the county of Wicklow, and province of Leinster, is equivalent to Baal-tinne-glass, that is, " Baal's-fire-green," alluding to the colour of the grass at the spring season. These *igneous* betrayals of human frailty and superstition were celebrated throughout Ireland at both the *vernal* and *autumnal* equinoxes, in honour of the twin divinities so often adverted to in the course of this book. The eve of the vernal one was called *Aiche Baal-tinne*, that is, the night of Baal's fire, the eve of the autumnal, *Aiche Shamain*, that is, the night of the moon's solemnity; on both which occasions fires were lighted on all " *the high places* " dedicated to their worship.

The return of these respective seasons gave rise to various superstitions amongst the illiterate populace, one of which was that of borrowing a piece of money at the first sight of the new-moon, if they had it not themselves, as an omen of plenty throughout the month *. And their praying to that luminary, when first seen after its change, is so well known as to be mentioned even by a French writer, whom Selden, " De Diis Syriis," quotes in these words:—" Se mittent a genoux en voyant la lune nouvelle, et disent en parlant a lune, laise nous ausi sains que tu nous as trouvé *."

The new moon nearest to the winter solstice was

* To this day, the most kindly wish, and ordinary salutation, of the Irish peasant, continues to be *Bal dhia duit, Bal dhia ort*, that is the god Baal to you, or the god Baal upon you.

† The Irish mode of expressing it is *Slan fuar tu sin, agus slan adfaga tu sin*. The Caffres who reside all round the Cape, pay their adoration to the moon, by dancing to her honour when she changes, or when she is at the full. They prostrate themselves on the ground, then rise up again, and, gazing at her orb, with loud acclamations, make the following address :—" We, thy servants, salute thee. Give us store of milk and honey ; increase our flocks and herds, and we will worship thee."

celebrated with peculiar ceremonies. On that night
the chief Druid, attended by crowds of the people,
used to go into the woods, and cut with a golden
sickle a branch of the mistletoe of the oak, which he
would carry in procession to the sacred grove. This
golden sickle or crescent, corresponded in form and
nature with that which Aurelius Antoninus, the Ro-
man emperor, wore at his coronation, to intimate his
adherence to the Phœnician doctrines in which he
had been early instructed—his adopted name still
further intimating that he had been, what *it* literally
signifies, Heliogabalus, that is, priest of the sun *.
The crescent itself is the favourite badge of *Sheevah*,
the *matrimonial* deity of the Indians, which he is re-
presented as wearing in front of his crown.

After the introduction of Christianity, its first
preachers wishing to defer to the prejudices of the
inhabitants, yet not so as to interfere with the cele-
bration of Easter at the vernal equinox, with an ac-
commodating policy, retained the Baal-tinne ceremo-
nial, only transferring it to the *saints' days ;* thus
diverting their attention from their former devotion,
and fixing it upon those who, in their zealous propa-
gation of the gospel truths, may be considered as
Christian *stars ;*—conformably to that gracious cha-
racter of " a burning and shining light," which our
Saviour himself applied to his precursor, St. John.

In honour of this Apostle, June 24th, the day of
his nativity, was substituted, in the old ecclesiastical
calendar, for the pagan solstice festival, and called
solstitium vulgi, the vulgar solstice.

The intention of the transfer was, however, lost
sight of by the illiterate ; and when they would

* The word is more *mysterious*, as I shall explain elsewhere.

kindle their fires on the tops of *mountains* on those occasions, they used to blend with them the features of the pagan institution, by passing children and cattle between them for the purpose of purification.

The propriety, therefore, of thus subserving to deep-rooted prejudices, has by some been impugned; but " surely," after all, to use the words of a very able writer, " they were much wiser and better who, in those early times, grafted the evangelical upon the druidical culture, than they who, in subsequent times, instituted a system of extirpation in order to regenerate."

The other pagan solemnities were similarly metamorphosed, and partook of similar transmutations. The first of May alone retained the name and characteristics of its original appropriation, being still called " *La-Beuil-tinne*," that is, the day of Baal's fire, as familiarly as the name of *Christmas* is given to the 25th of December. On it, too, fires are kindled on " high places," as before; and children and cattle purified by passing between them;—

> ———" Yet, oh ! remember
> Oft I have heard thee say, the secret heart
> Is fair Devotion's temple : there the saint
> Even on that living altar lights the flame
> Of purest sacrifice, which burns unseen,
> Not unaccepted.*"

I next turn to Killmalloch, the ancient name of which, as given by Ptolemy, was Macollicon,—a metathesis for Mallochicon; and the final, *icon*, which is only a Greek termination, being taken away, leaves Malloch, that is, Moloch, the Apollo or great divinity of the ancient universe.

To divert the natives from this misplaced enthusiasm, one of the early converts to Christianity as-

* Hannah More.

sumed to himself the name of *Maloch ;* and then pre-
fixing to it the adjunct *Kill,* made it the *church* of
Maloch, instead of the *city* of *Moloch.*

Here is still to be seen, careering towards the skies,
one of those " *singular* temples of round form,"—of the
existence of which Vitruvius was so ignorant, but whose
dogmatic enunciation of " monopteres" and " perip-
teres," sounds as feebly in *my* ears, as Montmorency's
assumption that the Round Towers were dungeons!
—and the violence which this structure has latterly
undergone—by the effort made to incorporate it with
the Christian cathedral, built beside it in rivalship,
after an interval of nearly three thousand years—is one
of the most triumphant evidences which truth can
produce in suppression of error. My soul burned
with earnestness to visit this hallowed scene, upon
which I had revolved so much, and which I associated
in my fancy with the recorded glories of Apollo. I
have, at last, seen it ; and he must be indeed a slave
to faction, or the dupe of prejudice, who will not sub-
scribe to that evidence which the very stones pro-
claim.

Apollo's Temple, or the Round Tower, stands at
the corner of the cathedral, subsequently built half-
around it : and, as you ascend the parapet of the
latter, by an *intermural* staircase, having to pass, after-
wards, from one side of this parapet to the other, just
at the very corner by which the Tower is girt, the
pass being very narrow, and almost terrific in dimen-
sions, wholly defenceless besides, on the right hand
which looks down into the body of the cathedral, the
constructors of this latter edifice were obliged, in their
desire to intermarry Christianity with paganism, to
scoop off, or rather to file, about six inches of the
ancient rotund structure, all along, on the left, to the

height of the human figure, so as to allow more room; yet even thus mutilated, I could not but reverence and bow down before the Tower.

> " For, even the faintest relics of a shrine,
> Of *any* worship, wake some thoughts divine *."

After this transformation, Kilmalloch assumed an entirely Christian aspect; and the monastic buildings that crowded the town surpassed, in their style, any thing similar throughout the island. The materials, however, of which those were constructed, being inferior in quality to the *Tuathan* composition, did not long keep place; so that now, whilst the Round Tower still maintains its bold pre-occupancy, the Christian churches exhibit but a pile of ruins!

The dreariness of this once imperial site is a moving instance of worldly vicissitudes; and one can scarcely avoid, when passing by the loneliness of its dilapidated mansions, applying the apposite and melancholy apostrophe attributed to Ossian, " Why dost thou build the hall, son of the winged days? Thou lookest from thy towers to-day; yet a few years, and the blast of the desert comes, it howls in thy empty courts."

Ard-Mulchan, the name of a village in the barony of Duleck, county Meath, comes from *Ard,* the high place, or mound, *Mulchan* of Moloch. And, however extraordinary it may appear to some readers, I cannot but hazard my opinion, that the name of the individual to whom St. Patrick had been sold during his captivity in this island, viz., *Milco*-Mac-Huanan, that is, Milco, the son-of-Huanan, originated in the circumstance of the family's devotion to the service of this idol; and if a doubt remained as to the justness

* Byron.

of this conclusion, it will, methinks, be removed, when we consider the close of his mortal career, and the unfortunate blindness with which he clung to his fatuity.

He was a petty prince of that part of the country, afterwards called Dalruadia, or the principality of the Dalruads, from the prevalence of that demi-tribe, in Ulster ; and when Patrick,—in prosecution of that mission of grace, to which he had been deputed by divine interposition ; and impelled, perhaps, moreover, by a compassionate zeal and Christian recollection of his previous bondage,—undertook, amongst other conversions, that of his former master, we find that the sentiment was not reciprocated on *his* part ; but that, either ashamed of allowing himself to be persuaded, in his old age, to abandon the religion in which he had been early initiated ; or marked out by Providence as an awful victim to the prevailing superstition, he plunged himself into a fire which had accidentally broke out in his castle, and so was consumed by that element which he had before worshipped as his God !

Athlone,—or as anciently and correctly written Ath-luain,—the name of a town situated on the river Shannon, where *it is fordable,* bounding Leinster in Westmeath, and Connaught in Galway, is compounded of the words *Ath,* which signifies a ford ; and *luain,* of the moon. The common people still call it Blah-luin, an evident corruption of *Baile-ath-luin,* that is, the village of the ford of the moon ; equivalent to Moon-ford-town. This name establishes the analogy of the Syrian Astarte with the worship here paid to the " queen of night," and the many lunettes, or gold crescents, found buried in the *neighbourhood,* are " confirmation gstron" of the inference deduced.

The moon, whose course through the heavens regulated the months of the early lunar year, and whose influence was regarded by the ancients, in common with that of the sun, as one of the *fertilizing principles* of *nature*, and as exerted chiefly amid wilds and woods, at a distance from the crowded abodes of man, had in this spot, apparently, a peculiar claim for her special appropriation. For, here the aged majesty of the river Shannon, the Ganges of Ireland— as we find reciprocally that Shannon is one of the Gangian names, and Saor, or Suir, the name of another Irish river, meaning " sacred" water, belongs also to the Indus itself—displays its imposing grandeur in all the varieties of sublime and delightful scenery. Not far off is one of those beautiful lakes into which this monarch of waters expands himself, to bask, as it were, in repose, from the tiresome gaze attending the crowded path of his ordinary travels ;

" Tho' deep, yet clear ; tho' gentle, yet not dull ;
Strong without rage ; without o'erflowing full *."

Lough Rea is the name of the lake above referred to, which, from its proximity to Athlone, gives concurrent sanction to the derivation above assigned. For *Rea*, in Irish, corresponds to Malcoth, or Astarte, *i. e.*, queen, that is, Shamaim, of the heavens ; as *Righ* does to Baal, or Molock, master, or king of the same ; and both re-echoed in the *regina* and *rex* of the Latins †.

I should further notice, that in the Barony of Castle-*reagh*,—a name which, though prefaced by a

* One superstition of the Pagans never fails to assert its influence upon spots like this—the *genius* loci is always ascendant.—DEANE.

† *Ab-roch* also, the official title of Joseph, when appointed regent of Egypt, signifies father of the *king*.

modern adjunct, still testifies its devotion, at one time,
to the moon—there has been, some years ago, dug
up one of those beautiful plates of gold, shaped like
a half-moon, at once confirmatory of the propriety
of the local name, and of the nature of the worship
of its primitive incumbents having been lunar or
Sabian. This relic is now in the possession of the
Downshire family.

In reference to *Shannon*, to which I have before
adverted, as being one of the names of the *Ganges*,
it is not a little curious that *Durga*, the supposed
divinity of this water, and whose festival is annually
solemnized all through Hindoostan, should be repre-
sented by *Derg*, the supposed divinity of the *Shan-
non*, and should have its name still more perpe-
tuated in the Irish word *Dearg-art*, that is, the abode
of Derg, in Lough Derg, the lower lake upon this
river.

From its mouth to its source this noble stream is
characterized with relics of primeval worship, cor-
responding, in form and tendency, with those on
the banks of its Indian namesake. Scattery Island,
or as it should more properly be called, Inis Catty,
situated very near where it discharges itself into the
sea, retains a beautiful Round Tower, to which has
been afterwards appended, in the Christian times,
the mystical number of seven churches, and the
ruins of which are still perceptible. The circumstance
of an early professor of our heaven-taught religion
having taken up his secluded residence within the pre-
cincts of this spot, has led many moderns to suppose
that the river obtained its name from him, whereas
the word *Shannon* is derived from *Shan Aoun*, that
is, the " aged river ;" and the saint received his name

from that *pious policy* before explained, as well as from the constancy of his abode in its vicinity—not *vice versâ* *.

Killeshandra, the name of a town in the county of Leitrim, on the borders of the county of Cavan, signifies, in Irish, " the temple of the moon's cycle," or circle. In Sanscrit, which is a dialect of the aboriginal Irish †, it denotes exactly the same. We find besides Herodotus making mention, B. xi. c. 98, of a city in Egypt, during the Persian dominion, called Archandra, that is, " the city of the moon." He asserts that it is not Egyptian, neither derived from the wife of Danaus, the daughter of Archander : yet the opposite may be well supported, without at the same time injuring this derivation, for the daughters of Danaus were certainly initiated in the *Phallic rites ;* nay, they were the persons who first imported them into Attica : and it is eminently worth notice, that this was the very spot‡ where the Tuath-de-danaan kings happened to be stationed upon the first Scythian deluge ; the word " Kill" having been

* The Himalaya are the peculiar abodes of the gods of the Hindoos ; the rivers, issuing from the eternal snows, are goddesses, and are sacred in the eyes of all. Shrines, of the most holy and awful sanctity, are at the fountain heads of the Ganges and Jumna ; and on the summit of Kedar Nauth, Cali, that goddess of bloody rites, is supposed to have taken up her residence. One, among the numerous proceedings of her votaries, is to scramble as high up the mountain as they can attain, taking with them a *goat* for an offering : the animal is turned loose with a *knife* tied round his neck ; the belief is, that the goddess will find the victim, and immolate it with her own hand.—ARCHER.

† This adjective I apply indiscriminately to Persia or to Ireland.

‡ It lies in the district of *Ins-oin,* which means the *abode* of *Magicians ;* corrupted now to *Inis*-owen, which would import Eugene's *island.* An aggravated blunder—the place being in the *very centre* of the country, with which such an imaginary chevalier was never associated.

prefixed to it only upon the introduction of Christianity.

Granard, the name of a town in the county of Longford, is compounded of the words *Grian*, the sun, and *ard*, a height, that is, the sun's high-place. Nor, I suspect, will it be deemed an over-effort of criticism, if I repeat, that in our Irish *Grian* is to be found the root of that epithet of Apollo, *Grynæus* *, which was also the name of a city of Asia Minor, consecrated to his worship, and favoured, as Strabo informs us, with a grove, a temple, and an oracle of that deity. The river Granicus, too, was derived therefrom, because its source lay in Mount Ida, sacred to *Grian*, or the sun, whereon was situated the *Idean stone*, upon which, we are told, Hector was wont to sacrifice ; and corresponding to the *Cromleachs*, so common throughout this island. The word *Carne*, also, meaning a heap of stones, on which an inferior order of clergy, thence called *Carneach*, used to officiate, belongs to the same root, as both Ovid and Macrobius declare that it was called, by the ancients, Grane †.

As Lough *Rea* had been dedicated to the moon, so was the other luminary also honoured with a lake,—

* His tibi *Grynæi* nemoris dicatur origo,
Ne quis sit lucus, quâ se plus jactet *Apollo*.
 VIRG. Ecl. 6.

† *Granem* dixere priores.—OVID.

Although those heaps are now but signals of accidental or violent death, for which each passenger bespeaks his sorrow by *adding a small stone*, yet we see that in their origin they were more religiously designed; and while this *latter practice* is observed also in India, it appears that they have retained there more correctly the primitive idea, as may be inferred from these words of Major Archer:—" On the right and left are several cairns of stones, erected by parties of travellers as they cross, in *acknowledgment to the deities or presiding spirits for their protection.*"

called after his name,—which we find in the adjoining
country, where Lough *Grany* signifies the Lake of
the *Sun;* as we do also *Beal-ath*, or Ath-en-righ, that
is, the *Ford of Baal*, or the *Ford of the King*, i. e., the
Sun ; coresponding to *Ath-lone*, or *Ford of the Moon.*

The above are but a few of those imperishable
memorials intertwined round those haunts which our
forefathers have trod ; the import of which, however,
has been so perverted by *modern scribblers,* as to give
occasion to O'Flaherty to give up their solution in
despair, and, as a cover to his retreat, to pronounce
them " as outlandish in their sound, as the names of
the savages in some of the American forests*." In this
rhodomontade, however, he was much more fortunate
than he had intended, or, as the Englishmen say of
our countrymen, " he blundered himself into the
right." Little did he suspect how near a connexion
there existed between the two people whom he
affected, thus ridiculously, to associate; and any one
who attends to the position which I subjoin, inde-
pendently of many others that could be brought in
support of it, will admit the happiness of this unin-
tional coincidence. The Algan Kinese are the most
influential and commanding people in the whole of
North America; their name in Irish indicates as
much, viz., *Algan-Kine,* or *Kine Algan†*, a *noble* com-
munity. The language of this people is the master
one of the whole country ; and, what is truly remark-
able, understood, as Baron de Humboldt asserts, by
all the Indian nations except two. What then are
we to infer from this obvious affinity? Most

* Ogyg. seu Rer. Iber. Chron., part i. p. 16.

† One of the ancient names of Ireland is *Inis Algan,* that is, the
Noble Island.

undoubtedly, that a colony of the same people who first inhabited Ireland, and assigned to its several localities those characteristic names, which so disconcerted the harmony of Mr. O'Flaherty's acoustic organs, had fixed themselves, at an early date, in what has been miscalled the *New World*.

Small, however, as is the number of the names here selected, they are enough, I flatter myself, to establish the prevalence of our Sabian ritual. But what puts this matter beyond anything like a question is the inscription upon a stone, still extant, in the county of Dublin, evidently a symbol of the *Sun* and *Moon*, which, like Osiris and Isis of Egypt, were considered by the ancient Irish as *united* in matrimony.

> " God, in the nature of each being, founds
> Its proper bliss, and sets its proper bounds :
> But as he framed a whole the whole to bless,
> On mutual wants built mutual happiness ;
> So from the first, eternal order ran,
> And creature linked to creature, man to man.
> Whate'er of life all quickening ether keeps,
> Or breathes through air, or shoots beneath the deeps,
> Or pours profuse on earth, one nature feeds
> The vital flame, and swells the genial seeds.
> Not man alone, but all that roam the wood,
> Or wing the sky, or roll along the flood,
> Each loves itself, but not itself alone,
> Each sex desires alike, *till two are one*."—POPE.

CHAPTER XVI.

" WOMAN, the poetry of Nature," says an elegant writer of the present day, " has ever been the theme of the minstrel, and the idol of the poet's devotion. The only ideas we entertain of a celestial nature are associated with her ; in her praise the world has been exhausted of its beauties, and she is linked with the stars and the glories of the universe, as if, though dwelling in a *lowlier* sphere, she belongedto a *superior* world."

This deification of the *female character* was the true *substance* of those imaginary *goddesses*, so sadly disfigured by the circumscribed stupidity of Greek and Roman mythologists. *Juno, Baaltis, Diana, Babia, Venus, Aphrodite, Derceto, Militta, Butsee, Semiramis, Astarte, Io, Luna, Rimmon, Lucina, Genitalis, Ourania, Atargatis,* &c., &c., were all but fictitious and ideal forms, resolving themselves into *one and the same representation* of that sweetest ornament of the creation, *woman ;* and the same terms being applied to the *moon*, with the same *symbolic* force and the same *typical* significance, illustrates the aptitude of that *tributary* quotation, with which this chapter has commenced, and to the beauty of which the heart of every " man that is born of woman" must feelingly respond.

Europa itself, now geographically appropriated, as a denomination, to one of the quarters of the globe,

was, originally, synonymous with any of the above-mentioned names; and partook in the acquiescence paid by adoring millions to the all-fascinating object of so refined an allegory.

Of all those various epithets, however vitiated by time, or injured by accommodation to different climates and languages, the import,—intact and undamaged,—is still preserved in the *primitive Irish tongue,* and in that alone; and with that fertility of conception whereby it engendered *all myths,* and kept the human intellect suspended by its *verbal phantasmagoria,* we shall find the *drift* and the *design,* the *type* and the *thing typified,* united in the ligature of one *appellative chord,* which to the *enlightened* and the *few,* presented a chastened, yet sublime and microscopic, *moral* delineation; but to the *profane* and the *many* was an impenetrable night, producing submission the most slavish, and mental prostration the most abject; or, whenever a ray of the *equivoque* did happen to reach their eyes—perverted, with that propensity which we all have to the depraved, into the most reckless indulgence and the most profligate *licentiousness.*

In the limits here prescribed for the developement of our *outline,*—which even the most heedless must have observed, instead of being compressed, as intended, within the compass of one volume, could more easily have been dilated to the magnitude of four,—it cannot be supposed that I could dwell, with much minuteness, upon the several collateral particulars to which I may incidentally refer. As, however, that *twofold tenour* to which I have above alluded, may require something more in the way of illustration, I shall take any two of the aggregate of names

there collected, and in them exemplify what has been said.

Suppose them to be *Militta* and *Astarte.* Of these, then, the first means *appetency,* such as is natural between the sexes; and the second *dalliance,* of the same *mutual* sort; and while both, alike, typify the *delights* of *love,* they both, equally, personate the *mistress* of the *starry* firmament, whose influence was courted for the maturity of all such connexion, as the season of her splendour is the most suitable for its gratification.

From *Astarte* (Ασταρτη), the Greeks formed *Aster* (Αστηρ) a star, thereby retaining but one branch of this duplicity.—The Irish deduced from it the well-known endearment, *Astore;* and I believe I do not exaggerate, when I affirm, that, in the whole circuit of dialectal enunciations, there exists not another sound, calculated to convey to a native of this country so many commingling ideas of *tender pathos,* and of *exalted adventure,* as this syllabic representation of the *lunar* deity *.

Such was *Sabaism,*—composed of love, religion, and astrology: such too was *Budhism,* as I have already shown; and *Phallism,* being but another name, equivalent with this latter, it follows that the whole three—*Sabaism, Budhism,* and *Phallism*—are, to all intents and purposes, but *identically one.*

This being about to be demonstrated, a few pages forwards, as *the oldest species of worship recognized upon earth,* it were needless, one would hope, to enter into a comparison, in point of antiquity, between

* The children gathered the wood, the fathers kindled the fire, and the women kneaded the dough, to make cakes for the queen of heaven. —Jerem. vii. 18.

it and any of its living derivatives. But as many
learned men, misled by that cloud which heretofore
enveloped the subject, have promulgated the belief
that *Brahminism* was the parent stock, whence *Bud-
hism*, with its adjuncts, diverged as a scion, I shall,
omitting others, address myself to the consideration
of Mr. Colebrooke's arguments, which I select from
the mass, in deference to a character so honourably
interwoven with the revival of eastern literature.

" The mythology of the orthodox Hindus," says
this venerable and good man, " their present chrono-
logy, adapted to astronomical periods, their legendary
tales, and their mystical allegories, are abundantly
extravagant, but the Jains and the Bauddhas surpass
them in monstrous exaggerations of the same kind.
In this rivalship of absurd fiction it would not be un-
reasonable to pronounce that to be the most modern
which has outgone the rest."

His second position is, that " the Greek writers
who mention the Bramins, speak of them as a flourish-
ing society, whereas the Budhists they represent as
an inconsiderable handful : therefore," &c.

To the first I shall oppose Dr. Buchanan's testi-
mony, who states that " however idle and ridiculous
the legends and notions of the worshippers of Bouddha
may be, they have been in a great measure adopted
by the Brahmins, *but with all their defects monstrously
aggravated.*"

And even, had we not this rebutting evidence, the
inference, in itself, is decidedly weak ; for it would go
equally to establish that *Romanism* is more recent
than *Protestantism*, as containing a greater number of
ceremonial observances than this latter does : whereas
the reverse is what *reason* would lead us to conclude,

viz., that *ritual multiplications* are the growth of *longevity*, and that the retrenchment of their number is what reformation aspires to.

I make a free-will offering, unrestricted and unimpeded, of all the value that can belong to Grecian historians — the Greeks, whom their own countryman, Lucian, so justly banters as distinguished for nothing so much as a total indifference to truth! But admitting them to be as veracious as they were notoriously not so, the intercourse, of the very earliest of them, with India and its dependencies, was much too modern, to allow their statements to be further conclusive, than as refers to the time being: and I am very ready to allow that, at the particular moment described, the Budhists were in the wane, while the Brahmins ruled ascendant—nay, that there were but a few straggling votaries of the former creed then existing at all in that country, the latter, though schismatics from the ecclesiastical root, having, by gaining over the civil power on their side, effected their expulsion many ages before.

The subterranean temples of Gyah, Ellora, Salsette, Elephanta, and those other monuments of piety and civil eminence which still shed a lustre over India, and which no subsequent state of the arts could rival, much less eclipse, owe their existence to an era anterior to this catastrophe. The Budhists were the architects when in the zenith of human power. The sculptures and devices establish this fact: for of the whole list of deities personated in those inscriptions, the Brahmins have retained none but such as suited their purpose. These, in all conscience, were numerous enough; and as the Brahmins, when at the helm, permitted not the introduction of

" strange gods," it is evident that those, which they
have in common with the Budhists, are but *cull-
ings* from the " mother-church," ill-understood and
worse interpreted ; the similarity, however, being still
so great as, after a lapse of centuries, to give rise
to the question of, whether the stem or the branch,
the sire or the offspring, had the priority in point of
time!

 " J'ai remarqué," says the philosopher Bailly,
" que les Brames aimaient à être appellés Paramènes,
par respect pour la mémoire de leurs ancêtres, qui
portoient ce nom *." Monsieur Gebelin is more
explicit. " Pausanias nous dit, que Mercure, le même
que Butta, ou Budda, un des fondateurs de la doc-
trines des Paramènes, ou Brames, est appellé Para-
mon †."

This Paramon, who had seceded from the Budhist
doctrine, and placed himself at the head of that sect
who still bear his name, was the son of *Budh-dearg*, a
religious denomination, most painfully inexplicable to
inquirers into those matters, but which *one, at least,*
from his acquaintance with the Irish language, should
have better known. " I think," says Vallancey, "*dearg*
is a contraction for *darioga*, rex supremus, which cor-
responds with the Chaldæan *darag*, dux, an epithet
given to *Budya !*"

All those words, in fact, *dearg, darioga,* and *darag,*
are *one and the same,* adjuncts, it is true, of Budya,
but meaning neither *dux, rex,* nor *supremus,* except in
as much as they were *his* epithets, the correct render-
ing being *red,* which, added to Budh, signifies the
Red Lingam, the *Sardana-palus,* the *Eocad,* the *Penis*

* Lettres sur les Sciences, p. 202.
† Hist. du Calendrier, pref. p. 14.

sanctus, the *god* of *nature*, the *ruber palus*, the *Helio-go-balus*, the *corporeal spirit*, the *agent of production*, the *type of life*, as it is also the *concurrent symbol of universal dissolution*.

These several terms, which are, each and all, convertible, pourtray not only the procreative powers of the *male* world personified, but likewise its symbols, which were the *Round Towers ;* and not these only, but *Obelisks* * also, and *naturally erect* stones †, which, though not circularly fashioned, yet typified, in their ascension, the upward bent of all vegetable growth.

This is the true solution of those enigmatical *lithoi*, by which the ancients represented the *bounty* of Providence. *Maghody* was the name appropriated to him under this character ; and the import of this word conveying, literally, the idea of the *Good God*, shows the philosophic feeling, no less than it does the religious seriousness, of the grateful contrivers ‡. And while reminded by the thought, perhaps I may be per-

* Obeliscum Deo soli, speciali munere, dedicatum fuisse.—AMMIANUS.

† Chinenses et Indi, præter imagines in pagodis et delubris, prægrandes aliquando etiam *integras rupes*, presertim si naturâ in *pyramidalem formam* vergebant, in idola formari solebant.—HYDE.

‡ Is it not pitiable, therefore, to hear Mr. Deane, in the last volume of the Transactions of the Society of Antiquaries, London, ascribe the erection of those obelisks which he met in Britanny, to the following text? viz.,—" Behold Saul lay sleeping within the trench, and his spear stuck in the ground at his bolster."—1 Sam. xxvi. 7.

When Captain Pyke landed in the island of Elephanta, near Bombay, he found in the midst of a Gentoo temple a low altar, on which was placed a large polished stone, of a *cylindrical* form, standing on its base, the top *rounded*, or convex; they called it *Mahody*,—that the name of the inconceivable God was placed under it aloof from profanation.

Launder, in his Voyage to India, p. 81, saw one *erected* in a *tank* of water. Herodian tells us he saw a similar stone, round at the bottom, diminishing towards the top in a conical form, at Emessa, in Phœnicia, and that the name they gave it was Heliogabalus.—VALLANCEY.

mitted, with humble deference, to suggest to literary
gentlemen occupied in the translation of Eastern
manuscripts, that whenever they meet with any pro-
per name of the inconceivable Godhead, or of any
place or temple devoted to his use, and beginning
with the word *Magh;* such as *Magh*-Balli-Pura*;
they should not render *Magh* by *great*—which hitherto
had been the practice—but by *good;* as it is not the
power of the divinity that is thereby meant to be
signified, but his *bounty:* such as his votaries chiefly
supplicated, and such as was most influential to
ensure their fealty.

" Christnah, the Indian Apollo, is the darling,"
says Archer, " of the Hindoo ladies ; and in his
pranks, and the demolishing pitchers of milk, or milk-
pitchers, has acquired a fame infinitely surpassing
that enjoyed by the hero of the agreeable ditty en-
titled *Kitty of Coleraine !*"

I confess I do not understand the levity of tempe-
rament which betrays itself in this witticism. For
my part I cannot contemplate any form of religion
without a sensation of awe. There may be much
imposture, much also of hypocrisy, and no small share
of self-delusion amongst *individuals* of every sect, but
sincerity will be found in the *aggregate* of each :
and where *certainty* is not attainable by finite com-
prehensions, nay, where *unity* is incompatible with
freedom of thought and will, it would more become
us, methinks, to make allowance for each other's
weaknesses, than to vilify any worship, which, after
all, may only differ from our own as to mode. Chris-
tianity, beyond a question, does not inculcate such
intolerance. The *true* follower of that faith recog-

* *i. e.* the *Good*-Baal-Peor.

nizes in every *altar* an evidence of common piety ; perceives in every articulation of the name of *Lord,* a mutual sense of dependence and a similar appeal for succour ; and taking these as inlets into the character of the supplicant, he traces an approximation to that hope whereby he is himself sustained, and rejoices in the discovery . yet is it no less true, that, when, super-added to these generalities, he beholds the " image" of his Creator, acknowledging the mission of the second Godhead, and by reliance on the all-fulness of his immaculate atonement, immersed in the waters of regenerating grace, his bosom expands with *more* gladness, and he welcomes the stranger as a brother.

That the rebuke here intended is not gratuitous or uncalled for, I refer to the testimony of Sir William Jones, who, with some infusion, I regret, of the same irony and incredulity, offers the following portrait, the result of tardy conviction, of the super-human quali-fications of this identical Christnah, *viz.,*—" The prolix accounts of his life are filled with narratives of a most extraordinary kind, and most strangely variegated. This incarnate deity of Sanscrit romance was not only cradled, but educated among shep-herds. A tyrant, at the time of his birth, ordered all the male infants to be slain. He performed amazing but ridiculous miracles, and saved multitudes partly by his miraculous powers, and partly by his arms : and raised the dead, by descending for that purpose into the infernal regions. He was the meekest and best tempered of beings ; washed the feet of the Brahmans, and preached indeed sublimely, but always in their favour. He was pure and chaste in reality, but exhibited every appearance of libertinism. Lastly, he was benevolent and tender, and yet fomented and conducted a terrible war."

Mahony, also, is a reluctant witness to the same effect. " The religion of Bhoodha," says he, " as far as I have had any insight into it, seems to be founded on a mild and simple morality. Bhoodha has taken for his principles *wisdom, justice,* and *benevolence ;* from which principles emanate ten commandments, held by his followers as the true and only rule of their conduct. He places them under three heads, *thought, word,* and *deed ;* and it may be said that the spirit of them is becoming and well-suited to him, whose mild nature was first shocked at the sacrifice of cattle *."

I have already shown that Budha is but a title, embodying an abstract ; that, therefore, it was not limited to one individual, but applied indiscriminately to a series. As I shall soon bring this succession nearer to *our own fire-hearths,* and in a way, perhaps, which may, else, electrify over-sensitive nerves, it may be prudent that I should premise another citation, descriptive of an answer, made by a dignitary of their creed, to the last-mentioned author upon his enunci-ating a principle of the Hindoo doctrine. " The Hin-doos," rejoined the priest, " must surely be little ac-quainted with this subject, by this allusion to only one (incarnation). Bhoodha, if they mean Bhoodha Dhannan Raja, became man, and appeared as such in the world at different periods, during ages before he had qualified himself to be a Bhoodha. These various incarnations took place by his supreme will and pleasure, and in consequence of his superior qualifications and merits. I am therefore inclined

* Wilford, in like manner, after a more mature acquaintance with the system, says, " I beg leave here to retract what I said in a former Essay on Egypt, concerning the followers of Buddha."

to believe, that the Hindoos, who thus speak of the incarnation of a Bhoodha, cannot allude to him whose religion and law I preach, who is now a resident of the hall of glory, situated above the twenty-sixth heaven."

Now it is stated in the Puranas, that a giant, named Sancha-mucha-naga in the shape of a *snake*, with a mouth like a *shell*, and whose abode was in a shell, having two countenances, was killed by *Christnah ;* and as this irresistibly directs our reflection to the early part of the book of Genesis, I shall adduce what Mr. Deane has set forth on this latter head.

"The tradition of the serpent," says he, " is a chain of many links, which, descending from Paradise, reaches, in the energetic language of Homer,

Τοσσόν ἔνερθ' ἀΐδεω, ὅσον οὐρανός ἐστ' ἀπο γαίης,

but conducts, on the other hand, upwards to the promise, that ' the seed of the woman should bruise the serpent's head.'.... The mystic serpent entered into the mythology of every nation, consecrated almost every temple, symbolized almost every deity, was imagined in the heavens, stamped upon the earth, and ruled in the realms of everlasting sorrow This universal concurrence of traditions proves a common source of derivation, and the oldest record of the legend must be that upon which they are all founded. The most ancient record of the history of the serpent-tempter is the book of Genesis! In the book of Genesis, therefore, is the fact from which almost every superstition, connected with the mythological serpent, is derived *."

That " the oldest record of the legend must be that

* Observations on Drakontia. London, 1833.

upon which they are all founded," no one can gainsay, inasmuch as the parent is always senior to the off-spring : but it is not quite such a *truism* that " the most ancient record of the history of the serpent-tempter is the book of Genesis." Before a line of it was ever written, or its author even conceived, the allegory of the serpent was propagated all over the world. Temples, constructed thousands of years prior to the birth of Moses, bear the impress of its history. " The extent and permanence of the superstition," says the erudite ex-secretary of the Asiatic Society, now Professor of Sanscrit in the University of Ox-ford, " we may learn from Abulfazl, who observes that in seven hundred places there are carved figures of snakes, which they worship. There is, likewise, reason to suppose that this worship was diffused thoughout the *whole* of India, as, besides the nume-rous fables and traditions relating to the *Nagas*, or *snake gods*, scattered through the Puranas, vestiges of it still remain in the actual observances of the Hindus."

To explore the origin, however, of this Ophite veneration, all the efforts of ingenuity have hitherto miscarried : and the combination of *solar* symbols with it, in some places of its appearance, has, instead of facilitating, augmented the difficulty. " The portals of all the Egyptian temples," observes the Gentleman's Magazine, " are decorated with the same hierogram of the *circle* and the *serpent*. We find it also upon the temple of Naki Rustan, in Persia, upon the triumphal arch at Pechin, in China ; over the gates of the great temple of Chaundi Teeva, in Java, upon the walls of Athens, and in the temple of Minerva, at Tegea—for the Medusa's head, so com-

mon in Grecian sanctuaries, is nothing more than the Ophite hierogram, filled up by a human face. Even Mexico, remote as it was from the ancient world, has preserved, with Ophiolatreia, its universal symbol *."

How would Mr. Deane account for this commixture? "The votaries of the sun," says he, "having taken possession of an Ophite temple, adopted some of its rites, and thus in process of time arose the compound religion, whose god was named Apollo."

But, sir, the symbols are *coeval*, imprinted *together* upon those edifices, at the *very moment* of their construction; and, therefore, "no process of time" was required to amalgamate a religion whose god (it is true) was Apollo, but which was already inseparable, and, though compound, one.

I have before established the sameness of design

which belonged, indifferently, to *solar* worship and to

* The Mexican hierogram is formed by the intersecting of two great serpents which describe the circle with their bodies, and have each a human head in its mouth.

phallic. I shall, ere long, prove that the same cha-
racteristic extends, equally, to *ophiolatreia ;* and if *they
all three be identical,* as it thus necessarily follows,
where is the occasion for surprise at our meeting
the *sun, phallus,* and *serpent,* the constituent symbols
of each, *embossed upon* the *same table,* and *grouped*
under the same *architrave?*

"Here," says a correspondent, in the Supplement
to the *Gentleman's Magazine* of August last, "we
have the umbilicated *moon* in her state of opposition
to the sun, and the sign of fruitfulness. She was
also, in the doctrines of Sabaism, the northern gate,
by which Mercury conducted souls to birth, as men-
tioned by Homer in his description of the Cave of the
Nymphs, and upon which there remains a commen-
tary by Porphyry. Of this cave Homer says :—

> ' Fountains it had eternal, and two gates,
> The northern one to men admittance gives;
> That to the south is more divine—a way
> Untrod by men—t' immortals only known.'

"The *Cross,* in gentile rites, was the symbol of
reproduction and resurrection. It was, as Shaw
remarks, ' the same with the ineffable image of
eternity that is taken notice of by Suidas.' The
Crescent was the lunar ship or ark that bore, in Mr.
Faber's language, the Great Father and the Great
Mother over the waters of the deluge ; and it was
also the emblem of the boat or ship which took aspi-
rants over the lakes or arms of the sea to the Sacred
Islands, to which they resorted for initiation into the
mysteries ; and over the river of death to the man-
sions of Elysium. The *Cockatrice* was the snake-
god. It was also the basilisk or cock-adder. ' Habet

caudem ut coluber, residuum vero corpus ut gallus."
The Egyptians considered the basilisk as the emblem
of eternal ages : ' esse quia vero videtur ζωῆς κυριεύειν
καὶ θανάτου, ex auro conformatum capitibus deorum
appingebant Ægyptii.' What relation had this with
the Nehustan or Brazen Serpent, to which the
Israelites paid divine honours in the time of Heze-
kiah? What is the circle with the seasons at the
equinoxes and solstices marked upon it?—the signs
of the four great Pagan festivals celebrated at the
commencement of each of these seasons? The corner
of the stone which is broken off, probably contained
some symbol. I am not hierophant enough to un-
riddle and explain the hidden tale of this combina-
tion of hieroglyphics. We know that the sea-goat
and the Pegasus on tablets and centeviral stones,
found on the walls of Severus and Antoninus, were
badges of the second, and the boar of the twentieth
legion ; but this bas-relief seems to refer, in some
dark manner, to matters connected with the ancient
heathen mysteries. The form of the border around
them is remarkable. The stone which bears them
was, I apprehend, brought in its present state from
Vindolana, where, as I have observed, an inscription
to the Syrian goddess was formerly found. The sta-
tion of Magna, also, a few years since, produced a
long inscription to the same goddess in the Iambic
verse of the Latin comedians ; and a cave, containing
altars to Mithras, and a bust of that god, seated
between the two hemispheres, and surrounded by the
twelve signs of the Zodiac, besides other signa and
ἀγάλματα of the Persian god, was opened at Borco-
vicus only about ten years since. These, therefore,
and other similar remains, found in the Roman sta-

tions in the neighbourhood of Vindolana, induce me to think, that the symbols under consideration, and now for the first time taken notice of, were originally placed near the altars of some divinity in the station of the Bowers-in-the-Wood. I know of no establishment that the Knights Templars had in this neighbourhood."

The modesty of " V. W." is not less than his diligence ; and both, I consider, exemplary and great. But he will excuse me, when I tell him, that the *Cross*, the *Crescent*, and the *Cockatrice*, are still *maiden* subjects after his hands. Neither Faber, Shaw, nor Suidas, pretend even to approach those matters, save in their *emblematic* sense ; and, as every emblem must have a substratum, I, for one, cannot content myself with that remote and secondary knowledge, which is imparted by the *exoteric type*, but must enter the penetralia, and explore the secrets of the *eisoteric temple*.

> " As an old serpent casts his scaly vest,
> Wreaths in the sun, in youthful glory dress'd ;
> So, when Alcides' mortal mould resign'd,
> His better part enlarg'd, and grew refin'd ;
> August his visage shone ; almighty Jove
> In his swift car his honour'd offspring drove :
> High o'er the hollow clouds the coursers fly,
> And lodge the hero in the starry sky *."

* Ovid.

CHAPTER XVII.

" CHILLY as the climate of the world is growing—
artificial and systematic as it has become—and un-
willing as we are to own the fact, there are few
amongst us but who have had those feelings once
strongly entwined around the soul, and who have felt
how dear was their possession when existing, and
how acute the pang which their severing cost.
Fewer still were the labyrinths unclosed in which
their affections lay folded, but in whose hearts the
name of *woman* would be found, although the rough
collision with the world may have partially effaced
it."

This instinctive influence, which the daughters of
Eve universally exercise over the sons of Adam, is
not more irresistible in the present day, than it
proved in the case of their great progenitor. *Love,*
however disguised—and how could it be more beauti-
fully than by the scriptural penman?—*love, in its
literal and all-absorbing seductiveness,* was the simple
but fascinating aberration couched under the figure
of the *forbidden apple.*

All the illusions of fancy resolve themselves into
this sweet abyss. The dreams of commentators may,
therefore, henceforward be spared ; the calculations
of bookmakers, on this topic, dispensed with : what-

*

ever be *my* fate, one consolation, at least, awaits me,
that, in addition to the *Towers*, I shall have expounded
the mysteries of Genesis.

In the *Irish* language, which, as being that of
ancient Persia, or *Iran*, must be the oldest in the
world, and of which the *Hebrew*, brought away by
Abraham from Ur of the Chaldees *, is but a dis-
tant and imperfect branch,—well, in this primordial
tongue, the nursery at once of science, of religion,
and of philosophy, all *mysteries,* also, have been ma-
tured : and it will irrefutably manifest itself, that in
it, exclusively, was woven that elegantly-wrought veil,
of colloquial illusiveness, which shrouds the *nature* of
our first parents' downfal.

How, think you, was this accomplished? By
assigning to certain terms a two-fold signification, of
which one represented a certain *passion, quality,* or
virtue, and the other its *sensible index.* To the latter
alone had the *multitude* any access ; while the sanctity
of the former was guarded against them by all the
terrors of religious interdicts.

For instance, in the example before us, *Budh,*
or *Fiodh*—which is the same thing—means, pri-
marily, *lingam,* and secondarily, a *tree.* Of these, the
latter, which was the popular acceptation, was only
the *outward signal* of the former, which was the *in-
ward* mystified *passion,* comprehended only by the
initiated. When, therefore, we are told that Eve
was desired not to taste of the *tree,* i. e., *Budh,* we
are to understand that she was prohibited what *Budh*
meant in its true signification, viz. *lingam :* in other
words, that when cautioned against the *Budh,* it

* Genesis xi. 31.

was not an *insensible tree*, its symbolic import, that was meant thereby, but the *vital phallus*, its *animate prototype* :—that, in short, " *missis* ambagibus," the word *Budh* was to be taken, *not figuratively*, but *literally* *.

Agàin, in this cradle of literary wonders—the Irish language—every letter in its alphabet expresses some particular *tree ;* but its second, *Beth,*—whence the *Beta* of the Greeks, and a formative only of *Budh,* the radix,—signifies—in addition to the *tree* which it represents †—*knowledge,* also ! And *here, obvious as light, and impregnable to contradiction, you have the tree of knowledge, in natural nakedness, divested of all the mystery of pomiferous verbiage, and identified in attributes, as in prolific import, with the name and essence of the sacred* Budh ‡ !

* See pages 503—4—5—6 for the explication of the serpent and the rest of the allegory.

† The Betula, or birch-tree.

‡ Were additional proof required that this is the true solution of the Mosaic *myth,* respecting the forbidden *apple,* it is irresistibly offered to any one who will see that relic of Eastern idolatry, presented by Lieutenant Colonel Ogg to the Museum of the East India Company, London, which consists of a tabular frame of white marble, furnished with a fountain, and emblematically stored with religious devices; the most extraordinary of which is a representation of the *Lingam* and *Yoni* in *conjunction,* around the bottom of which, in symbolical suggestion, is coiled a serpent; while the top of another Lingam, placed underneath, is embossed towards the termination, which is *conical* and *sunny,* with four heads, facing the cardinal points, and *exactly corresponding with those which grace the preputial apex* of the " Round *Tower*" of Deve-*nish.* Those four heads represent the four gods of the Budhist theology, who have appeared in the present world, and already obtained the perfect state of Nirwana; viz., Charchasan, Gonagon, Gaspa, and Goutama. And the entire coincidence between this Lingam and the characteristics of our Round Towers is such as to convince the most obdurate sceptic, even had I not put the question beyond dispute before, that they were *uniform* in design, and *identical* in purpose.

Here then we have, at length, arrived at the *fountain head* and *source* of the *mystery* of *Budhism*. Eve herself, I emphatically affirm, was the *very first Budhist.*—And, accordingly, we find that, in former ages, women universally venerated the *Budh*, and carried images of it, as a talisman, around their necks and in their bosoms * !

But if Eve was the first Budhist, the first priest of the Budhist order was her first-born, but apostate son Cain : and, in his acknowledging the bounty of *Budh*, the *sun*, who matures the fruits of the earth,—and thereby recognizing Jehovah only as the God of *nature* and of *increase,*—rather than in looking forward by faith to the redemption by *blood,* as a different sacrifice would have intimated, consisted " the whole front and bearing " of his treason and offence †.

" If thou doest well, shalt thou not be accepted ? And if thou doest not well, a sin offering lieth at the door ‡"—the means of propitiation are within your immediate reach.

* Venus preferred a *cestus,* or a talisman of her own sex, as we are told in the fourteenth book of the Iliad, where it is said, that

> " the Queen of Love
> Obeyed the sister and the wife of Jove,
> And from her fragrant breast the zone unbraced,
> With various skill and high embroidery graced.
> In this was every art, and every charm,
> To win the wisest, and the coldest warm :
> Fond love, the gentle vow, the gay desire,
> The kind deceit, the still reviving fire,
> Persuasive speech, and more persuasive sighs,
> Silence that spoke, and eloquence of eyes."—HOMER.

† The offerings made at the present day are precisely of the same kind. " Boiled rice, fruits, especially the cocoa-nut, flowers, natural and artificial, and a variety of curious figures made of paper, gold leaf, and the cuttings of the cocoa-nut kernel, are the most common."—SYMES.

‡ Genesis iv. 7.

The endearing tone, in which this is conveyed, bespeaks an appeal to some usage familiar to the party. It betokens, indisputably, that, on previous occasions, when Cain had acted " well," he had met with no rejection.—And for the truth of this, Jehovah refers to the defendant's own experience and self-convincing consciousness.

Cain, therefore, was a priest under a former dispensation; and a favoured one too; and his being deprived of this office, or, in other words, " cast off from the presence of the Lord," was the great source and origin of his present wretchedness.

But if a priest, he must have been so to a larger congregation than his father, mother, and brother: and besides he, as well as Abel, must have had *wives ;* but the Scriptures do not tell us that Adam and Eve, as individuals, had any *daughters ;* it follows, therefore, that the consorts of the two brothers must have sprung from some *other* parents. There, then, were more men and women on the earth than Adam and Eve : and this is still further confirmed by the apprehensions expressed by Cain himself, after the murder of Abel, lest he might be slain by some one meeting him.

Yes, in the paradisaical state, before " sin entered into the world," the earth was as crowded with population as it is at present ; and Adam and Eve are only put as representatives, male and female, of the entire human species, all over the globe *.

* Methinks I hear some wiseacre start up here and say, this cannot be, because man in an *uncivilised* state occupies more space than when restricted by social usages. Pray, sir, who told you that man was then *uncivilised ?* Then, in fact, it was that he may be called truly civilised, as more recent from the converse of his Creator.

Here I cannot do better than set the reader right as to the rendering of a subsequent text, which says, that " God set a mark upon Cain lest any one meeting him should kill him ;" nor can I recollect another instance wherein human ingenuity, while struggling after truth, has been more directly instrumental in the dissemination of error.

One would suppose that the setting " a mark upon" a person, instead of allaying his fears of being molested by those meeting him, should, on the contrary, aggravate them, from its extraordinary aspect. Besides, in the innumerable fantasies which commentators have conjured up, as specifications of this " mark," no vestige whatsoever has been yet traced, on the human form, to justify the inference.

We are obliged, therefore, at last, to recur to the *truth ;* and it fortunately happens, that this is accessible, by only translating the original as it should properly be, thus, *viz.,* " And God *gave* Cain a *sign* lest any meeting him, should kill him."

The only question now is, what that *sign* was which God *gave* to Cain? And to resolve this, we have but to bethink ourselves of his dereliction,—namely, the offering worship to Budh, *i. e., nature,* or the *sun:* and his refusing to sacrifice, in consequence of such devotion, anything endowed with *life,* of which Budh, *i. e.* Lingam,—according to the double acceptation of the word,—was the type, as it is also the *sign* of Budh, the sun,—and we have infallibly developed the answer and the secret.

Stamping the nature of his crime, and at the same time indicating that, in the now fallen condition of man, this badge of his revolt would be rather a security against trespass, and a passport to accept-

ance, than an inducement to annoyance, God shows
to Cain, as much in derision as in anger, the *substan-
tial* image of that deity to which he had but just be-
fore done homage, viz., Budh; and thereupon Cain
goes, and, on "the land a wanderer," he erects this
sign into a deified *Round Tower.*

Perhaps the reader would like to have some *col-
lateral* proofs for these startling interpretations. I
shall give them, as convincing as the solution itself
is irrefutable and true.

The Maypole festival, which the Rev. Mr. Maurice
has so satisfactorily shown to be but the remains of
an ancient institution of India and Egypt, (he should
have added Persia, and, indeed, placed it first,)
was, in fact, but part and parcel of this Round
Tower worship. May the first is the day on which
its orgies were celebrated; nor is the custom, even
now, confined to the British isles alone, but as natu-
rally prevails universally throughout the East, whence
it emanated, *of old,* to us. Lest, too, there should be
any mistake, as to the object of adoration, we are told
in the second volume of the Asiatic Researches, in a
letter from Colonel Pearce, that Bhadani, i. e., Astarte,
i. e., Luna, i. e., Venus, i. e., "Mollium mater cupi-
dinum," was the goddess in whose honour those fes-
tivities were raised.

Now as astronomy was connected with all the cere-
monies of the ancients, the sun's entrance into Taurus,
which in itself bespeaks the vigour of reanimated
productiveness, at the vernal equinox, was the sym-
bol in the heavens associated by the worshippers with
this allegorical gaiety. But this event takes place a
little earlier every year than the preceding one, by
reason of what astronomers call the *precession,* so that

at present, it occurs at a season far more advanced
than it did at first.

Theory and observation both concur in establish-
ing, that 72 years is the period which the equinox
will take to precede one degree of the 360, into which
the heavens are divided—2160 years, thirty degrees,
that is, one sign,—and 25,920, 360 degrees, or the
twelve signs of the zodiac. If, therefore, we compute,
at this rate, the precise year at which the vernal
equinox must have coincided with the first of May,—
which must certainly have been the fact at the origin
of the institution,—it will prove to have been about
the 4000th before the Christian era, which exactly cor-
responds with the time of Cain, and irrefutably con-
firms the origin, which I have assigned, to the wor-
ship of the Budh, Tower, Phallus, or Maypole.

Mr. Maurice's position deserves to be remarked. *" I
have little doubt, therefore,"* says he, *" that May-day,
or at least the day on which the sun entered Taurus,
has been immemorially kept as a sacred festival, from
the creation of the earth and man, originally intended
as a memorial of that auspicious period, and that mo-
mentous event."*

It is with extreme reluctance that I would dissent
from a writer who has contributed so largely, as the
gentleman before us, towards the restoration of lite-
rature ; but since we agree as to the *era* of the origin
of the festival, and *substantially* as to its *design*, I
have the less hesitation in recording my belief that
it was not the creation of the earth, or of man, that was
intended to be commemorated, but the commence-
ment of a *new dispensation*, consequent upon *man's
defection* *.

* In fig. 1, Plate 33, of Mr. Coleman's book, " is a four-headed
Linga, of white marble, on a stand of the same, surrounded by Parvati,

Lord, from the Shaster, quotes the following abstract, marking the opinion of the Easterns themselves, as to Adam and Eve having had many contemporaries. This relates an interview between a different couple. " Being both persuaded that God had a hand in this their meeting, they took council from this book, to bind themselves in the inviolable bond of marriage, and with the courtesies interceding between man and wife, were lodged in one another's bosoms : for joy whereof the sun put on his nuptial lustre, and looked brighter than ordinary, causing the season to shine upon them with golden joy ; and the silver moon welcomed the evening of their repose, whilst music from heaven, as if God's purpose in them had been determinate, sent forth a pleasing sound, such as useth to fleet from the loud trumpet, together with the noise of the triumphant drum. Thus proving the effects of generation together, they had fruitful issue, and so peopled the East, and the woman's name was Sanatree."

This *Maypole* ceremony, under the name of *Phallica, Dionysia,* or *Orgia,* which last word, though sometimes applied to the mysteries of other deities, belongs more particularly to those of Bacchus *, was cele-

Durga, Ganes, and the Bull Nandi, in adoration. The size of the stand or tablet is about two feet square, and the whole is richly painted and gilt. On the crown of the Linga is a refulgent sun." In fig. 2 of same " is a Panch Muckti, or five-headed Linga, of basalt, of which the fifth head rises above the other four, surmounted by the hooded snake. Each of the heads has also a snake wreathed around it, as well as around the Argha. The Bull Nandi is kneeling in adoration before the spout of the Yoni."

* And *Bacchus*, in reality, was but another name for one of the various *Budhas*. Even under the name of *Dionysos* we find him, to this hour, amongst ourselves. " On *Sliabh Grian*, or the *Hill* of the *Sun*," says Tighe, " otherwise called Tory Hill, in the county Kilkenny, is a

brated, at one time, throughout Attica with all the
extravagance of religio-lascivious pomp. Archer, in
his " Travels in Upper India," arrived at a village
just a few hours only after the May gaieties were
over, and found the *pole* still standing. " The occa-
sion," says he, " was one of festivity, for all had
strings of flowers about their heads, and they spoke
of the matter as one of great pleasure and amuse-
ment." As, however, he did not come in for the
actual observances, I shall supply the omission by
detailing the form of its celebration in our own
country.

"Anciently," says M'Skimin, in his History of
Carrickfergus, " a large company of young men
assembled each May-day, who were called May-
boys. They wore above their other dress white linen
shirts, which were covered with a profusion of
various coloured ribbons, formed into large and
fantastic knots. One of the party was called King,
and the other Queen, each of whom wore a crown,
composed of the most beautiful flowers of the sea-
son, and was attended by pages who held up the
train. When met, their first act was *dancing to music
round the pole*, planted the preceding evening; after
which they went to the houses of the most respect-
able inhabitants round about, and having taken a
short jig in front of each house, received a voluntary
offering from those within. The sum given was
rarely less than five shillings. In the course of this
ramble the King always presented a rich garland of

circular space, sixty-four yards in circumference, covered with stones.
In this stands a very large one, and on the east side another, reared
on three supporters, and containing an inscription, which in Roman
letter would exhibit " Beli Dinose."

flowers to some handsome young woman, who was
hence called ' the Queen of May' till the following
year."

With this compare the description given by the
author of the " Rites and Ceremonies of all Na-
tions," of a similar worship as celebrated amongst
the Banians. — " Another god," says he, " much
esteemed and worshipped by these people, is called
Perimal, and his image is that of a *pole*, or the *large
mast of a ship*. The Indians relate the following
legend concerning this idol. At Cydambaran, a city
in Golcondo, a penitent having accidentally pricked
his foot with an awl, let it continue in the wound for
several years together; and although this extrava-
gant method of putting himself to excessive torture
was displeasiug to the god Perimal, yet the zealot
swore he would not have it pulled out till he *saw the
god dance*. At last, the indulgent god had compassion
on him, *and danced, and the sun, moon, and stars danced
along with him,* During this celestial movement, a
chain of gold dropped from either the sun or the god,
and the place has been ever since called Cydam-
baran. It was also in memory of this remarkable
transaction, *that the image of the god was changed
from that of an ape to a pole,* thereby intimating,
(adds the good-natured expositor of himself,) that
all religious worship should reach up towards heaven,
that human affections should be placed on things
above."

Now, this mysterious *Peri-Mal* is but an euphony
for *Peri-Bal*, that is, the *Baal-Peor* before explained :
and when you remember the destination which I have
there assigned him, you will perceive the propriety
of his having been represented by a *mast* or May-

pole. As to the Indian legend, it only shows the antiquity of the rite, superadded to that religious *investment* which was meant as a shield against profanation.

Vallancey also mentions the following additional custom, which he himself witnessed in the county of Waterford—" On the first day of May, annually, a number of youths, of both sexes, go round the *parish to every couple married within the year*, and oblige them to give a ball. This is ornamented with gold or silver coin. I have been assured, they sometimes expended three guineas on this ornament. *The balls are suspended by a thread, in two hoops placed at right angles, decorated with festoons of flowers. The hoops are fastened to the end of a long pole, and carried about in great solemnity, attended with singing, music, and dancing.*"

The *mummers*, in like manner, who went about upon this day, demanding money, and with similar solemnities, as if for the *moon in labour*, were derived from the same origin. In Ceylon this practice is confined to " women alone *", who, as the editor of the " Rites and Ceremonies," &c., informs us, " go from door to door with the image of *Buddu* in their hands, calling out as they pass, ' Pray, remember *Buddu* †.' The meaning is, that will enable them to sacrifice to the god. Some of the people give them money, others

* " There are in India (also) public women, called *women of the idol*, and the origin of this custom is this : when a woman has made a vow for the purpose of having children, if she brings into the world a pretty daughter, she carries it to Bod,—so they call the idol which they adore, and leaves it with him."—Renaudot's Anc. Rel. p. 109.

† It is generally known, that the religion of Boudhou is the religion of the people of *Ceylon*, but no one is acquainted with its forms and precepts.—JOINVILLE.

cotton thread, some rice, and others oil for the lamps. Part of these gifts they carry to the priests of *Buddu*, and the remainder they carry home for their own use."

The money collected in Ireland, on the same occasion, would appear to have been somewhat similarly expended, having been " mostly sacrificed to the jolly god ; the remainder given to the poor in the neighbourhood."

> Here, for a while, my proper cares resigned,
> Here let me sit in sorrow for mankind ;
> Like yon neglected shrub, at random cast,
> That shades the steep, and sighs at every blast*.

* Goldsmith.

CHAPTER XVIII.

W HEN I cast back my eye upon this narrative, through the long perspective of ages which it involves, I confess I feel incommoded by some misgivings of self-distrust. When I consider the *mighty* individuals, of *transcendant* powers and almost *inexhaustible* resources, who, having reconnoitred its coast, either *perished* in the impotency of effecting a landing, or, more wisely, *receded* from it as impregnable, I am *thrown back*, as it were, upon myself, and impeded by the comparison of my own littleness.

But if " God has often chosen the small things of the earth to confound the great ; " and if success in past undertakings be any guarantee against the illusiveness of inward promise ; if the roads be all chalked, the posts lighted, and the sentinels faithful, why, *then*, allow the influence of petty fears to mar, at all events, the *project* of an ennobling enterprise ?

In that cherished volume, whence our first lessons upon religion have been deduced, and which, as embodying the principles of our *happiness* here, and our *hopes* hereafter, has been honoured with the *pre-eminent* and distinctive appellation of the *Bible*, or *Book*, there occur numerous phrases of *mysterious* import, but *pregnant* significancy, which pious men, unable to solve, have contented themselves with classifying as under the head of " above reason"—

" contrary," and " according to," being the two other constituents of their predicamental line.

Those *conventional* terms which *expediency* alone has invented, are, to say the least, arbitrary; and as all men have an equal right to form a *specification* of their subject-matter, I shall, without disconcerting the *order* of the above *division*, endeavour, only, to rescue the points to which I refer, from immersion in the *first* class * ; or—if allowed the latitude of *parliamentary* elocution—to take them out from the condemnation of *Schedule A.*

To begin, then, with the following text, viz., " *The sons of God* saw the daughters of men that they were fair, and they took them wives of all which they chose †."

What do you understand by the expression " sons of God ?"

His peculiar people, you reply; such, for instance, as *called upon his name*‡ ; or, perhaps, Seth's descendants in opposition to those of Cain, the unrighteous.

Turn, sir, to the beginning of the first and second chapters of *Job,* and read what you are there informed of.

" Now there was a day when the *sons of God* came to present themselves before the Lord, and Satan came also among them." And " Again, there was a day, when the *sons of God* came to present themselves before the Lord, and Satan came also among them to present himself before the Lord."

Well, what is your answer now? or will it not be different from what it was before? Can you seriously

* That is, "*above* reason."
† Genesis vi. 2. ‡ Ibid., iv. 26.

imagine that it was *any* race of *ordinary* human beings that was thus denominated? *And* are you not compelled to associate the idea, with some one of the other *superior* productions, of omnipotent agency?

I will make you, sir, if you have candour in your constitution, acknowledge the fact. Listen—" Where wast thou when I laid the foundations of the earth? Declare if thou hast understanding : when the morning stars sang together, and all the *sons of God* shouted for joy *."

Here allusion is made to a period antecedent to the existence of either *Cain* or *Seth*. The *myriads* of revolving ages suggested by the interrogatory set even *fancy* at defiance ; nor are their limits demarked by the *vague* and *indefinite exordium* of even the talented and otherwise highly-favoured legislator, Moses himself†. And yet, in this incomprehensible *inane* of time, do we see the *sons of God shouting for joy,* before the species of man,—at least, in his degenerate sinfulness,—had appeared upon this surface !

It is manifest, therefore, that some *emanation* of the Godhead, distinct from *mere* humanity, is couched under the phrase of " the sons of God ;" and accordingly we perceive, that, when they " went in unto the daughters of men, and they bare children to them," it is *emphatically* noticed, as an occurrence of *unusual* impress, that " the same became mighty men, which were of old, men of renown ‡."

At the commencement of the verse, whence the last extract has been taken, you will find the name of *giant*

* Job xxxviii.
† *In the beginning* God created, &c. Gen. 1. i.
‡ Genesis vi. 4.

mentioned; and instantly after, as if in *juxta-position*, nay, as if *synonymous* with it in meaning, is repeated " the sons of God :" thereby identifying both in nature and in character, and proving their sameness by their convertibility.

The Hebrew word from which *giant* has been translated, signifies *to fall :* and what, do you suppose, constituted this *apostacy ?* In sooth, nothing else than that *carnal intercourse,* which they could not resist indulging with the " daughters of men," *when their senses told them they were lovely* *. Thus do both names corroborate my truth; while both reciprocally illustrate each other.

" It may seem strange," says Wilford, " that the posterity of Cain should be so much noticed in the Puranas, whilst that of the pious and benevolent Ruchi is in a great measure neglected. But little is said of the posterity of Seth, whilst the inspired penman takes particular notice of the ingenuity of the descendants of Cain, and to what a high degree of perfection they carried the arts of civil life. *The charms and accomplishments of the women are particularly mentioned.* ' The same became mighty men, which were of old, men of renown.' "

And again,—" We have been taught to consider the descendants of Cain as a most profligate and abominable race. This opinion, however, is not countenanced, either by sacred or profane history. That they were not entrusted with the sacred deposit

* Dr. Gill, very *innocently,* would account for it otherwise, viz. " *either* because they made their fear *fall* upon men, *or* men through fear to *fall* before them, because of their height and strength—or rather because they fell and rushed on men with great violence, and oppressed them in a cruel and tyrannical manner ! ! ! "

of religious truths, to transmit to future ages, is suf-
ficiently certain. They might, in consequence of this,
have deviated gradually from the original belief, and
at last fallen into a superstitious system of religion,
which seems, also, a natural consequence of the fear-
ful disposition of Cain, and the horrors he must have
felt, when he recollected the atrocious murder of his
brother Abel."

This, so far as it goes, is satisfactory enough ; but
it is *groping in the dark*, and *without a pilot*. A few
pages, in the distance, will, however, bring us to the
right understanding of these points also : meanwhile,
I return to the Mosaical record, for the insight therein
afforded into the history of Cain.

We are told, then, that he " knew his wife, and
she conceived and bare *Enoch :*" and as this name
signifies *initiation in sacred rites*, as well as it does an
assembly of congregated multitudes—in which latter
sense, it was accurately applied to the " city" which
he had " builded"—it shows that the new religion
bade fair for perpetuity.

Irad, the name of Enoch's son, proves the crown-
ing finish of the matured ceremonial, for intimating,
as it does, *consecrated to God*, we are naturally led to
connect its bearer with the profession of that worship
which his name represented.

As *Irad* signifies *consecrated to God*, so *Iran* does
the land of those so consecrated ; and, accordingly, we
may be assured, that it was in *that precise region* that
the Budhists had first established the *insignia* of their
empire *

* Philosophers will ultimately repose in the belief, that Asia has been
the principal foundry of the human kind; and *Iran*, or *Persia*, will be
considered as one of the cradles from which the species took their de-

Let us, now, inquire what light will the *Dabistan* afford to our labours. It is known that Sir John Malcolm was no ready convert to its merits; his abridgement of it, therefore, cannot be suspected of any colouring; and, as I like the testimony of reluctant witnesses, I shall even make *him* the interpreter of its recondite contents.

" In almost all the *modern* accounts of Persia," says he, " which have been translated from Mahomedan authors, *Kaiomurs* is considered the *first king of that country:* but the Dabistan, a book professedly compiled from works of the ancient Guebrs, or worshippers of fire, presents us with a chapter on a succession of monarchs and prophets who preceded Kaiomurs. According to its author the Persians, previous to the reign of Kaiomurs, and consequently *long before the mission of Zoroaster*, venerated a prophet called *Mahabad*, or the Great (rather the *Good*) Abad, whom they considered as the father of men. We are told in the Dabistan that *the ancient Persians deemed it impossible to ascertain who were the first parents of the human race*. The knowledge of man, they alleged, was quite incompetent to such a discovery: but they believed, on the authority of their books, that Mahabad was the person left at the *end of the last great cycle*, and consequently the father of the present world. The only particulars they relate of him are, that he and his wife, having survived the former cycle, were blessed with a numerous progeny, who inhabited caves and clefts of rocks, and were uninformed of

parture to people the various regions of the earth.—Dr. Barton, Trans. Phil. Soc. Philad. vi. p. 1.

It follows that Iran or Persia, (I contend for the *meaning*, not *the name*,) was the central country which we sought.—Sir W. Jones, Asiatic Researches.

both the comforts and luxuries of life: that they
were at first strangers to order and government, but
that Mah-abad, inspired and aided by Divine Power,
resolved to alter their condition; and, to effect that
object, *planted gardens, invented ornaments,* and *forged
weapons.* He also taught men to take the fleece
from the sheep, and to make clothing; he built cities,
constructed palaces, fortified towns, and introduced
among his descendants all the benefits of art and
commerce.

" Mah-abad had thirteen successors of his own fa-
mily; all of whom are styled *Abad,* and deemed
prophets. They were at once the monarchs and the
high priests of the country; and during their reigns,
the world, we are informed, enjoyed a golden age,
which was, however, disturbed by an act of Azer-
abad, the last prince of the Mahabadean dynasty,
who abdicated the throne, and retired to a life of
solitary devotion.

" By the absence of Azer-abad, his subjects were
left to the free indulgence of their passions, and every
species of excess was the consequence. *The empire
became a scene of rapine and of murder.* To use the
extravagant expression of our author (the Dabistan),
*the mills, from which men were fed, were turned by the
torrents of blood that flowed from the veins of their
brothers ; every art and science fell into oblivion ; the
human race became as beasts of prey, and returned to
their former rude habitations in caverns and mountains.*

" Some sages, who viewed the state of the empire
with compassion, intreated Iy-Affram, a saint-like,
retired man, to assume the government. This holy
man, who had received the title of Iy (pure), from his
pre-eminent virtues, refused to attend to their request,

till a divine command, through the angel *Gabriel*, led him to consent to be the instrument of restoring order, and of reviving the neglected laws and institutions of Mah-abad. Iy-Affram founded a new dynasty, which was called the Iy-abad; who, after a long and prosperous reign, suddenly disappeared, and the empire fell again into confusion. Order was restored by his son, Shah Kisleer, who was with difficulty prevailed upon to quit his religious retirement to assume the reins of government. His successors were prosperous till the elevation of the last prince of the dynasty, whose name was Mahabool. This monarch, we are told, was compelled, by the increasing depravity of his subjects, to resign his crown.

" He was succeeded by his eldest son, Yessan, who, acting under divine influence, supported himself in that condition which his father had abandoned. This prince founded a new dynasty, which terminated in his descendant, Yessan-Agrin. At the end of his reign the general wickedness of mankind exceeded all bounds, and *God made their mutual hostility the means of the Divine vengeance, till the human race was nearly extinct.* The few that remained had fled to woods and mountains, *when the all-merciful Creator called Kaiomurs, or Gilshah, to the throne.*"

We only now want a key to unlock the portals of this *Magh-abadean* household; and I flatter myself that *this*, which I am about to tender, will consummate, to an accuracy, that very desirable purpose.

Cain's immediate progeny are they which are included under the above denomination. Their faith and worship are exactly symbolised under its derivative dress. *Magh*, as before explained, is *good ;* and

Abad, an *unit;* that is, when combined, the *Good
One*, or *Unit*, the author of fruitfulness and produc-
tiveness—in which light alone, as all-bountiful and
all-generous, was he recognised by this family.

This unity of the Godhead was what was *reli-
giously* comprehended under the *Phallic* configuration
of the Round Tower erections ; and this, furthermore,
elucidates that, heretofore enigmatical, declaration of
the Budhists themselves, *viz.*, that the pyramids, in
which the sacred relics are deposited, " *be their shape
what it will, are an imitation of the worldly temple of
the Supreme Being* *."

But if *Magh-abadean* was the name adopted by
them with this *spiritual* tendency, *Tuath-de-danaan*
was that which pictured them a sacerdotal institu-
tion. The last member of this compound I have
already expounded. It remains that I develope what
the two first parts conceal.

Tuath, then, is neither more nor less than a dia-
lectal modification for *Budh,* which, according to the
license of languages, transformed itself, otherwise, and
indifferently, into *Butt*, Butta, Fiod, Fioth, *Thot, Tuath,
Duath, Suath*, Pood, Woad ; and in the two last
forms—of which one is Gothic, and the other Ta-
mulic—admitted a final syllable,—which was but an
insignificant termination,—namely, *en,* making *Pood-
en* and *Woad-en ;* or *Poden* and *Woden.*

In these several variations, and the innumerable
others, which branch therefrom, while the *sensible*
idea is preserved underneath, there is superinduced
another of a more refined complexion. Thus, *Budh,*

* An edifice of this kind, in which the *relics* of Budha were kept,
near Benares, is described by Wilford as about *fifty feet high, of a
cylindrical form, with its top shaped like a dome.*

while it primarily represents the *sun*, its type, the *penis ;* and again, *its* sign, a *tree*, expresses, also, the attributes of *magic, science, divination,* and *wisdom.*

These were the consequences of that *mysterious* garb in which the priests invested the *true* elements of their religion. Being themselves the sole possessors of its inward secrets; and all literature and erudition going hand in hand, also, therewith, it was so dexterously managed, that a sort of reverential feeling attached, not only to those *qualities* in the abstract, but to the consecrated *personages* who were their depositories. Hence, while *Budh* came to signify *divination* and *wisdom, Budha,* its professor, did a *divine* and *wise man ;* and *Tuath,* being only a modification of the former epithet, *Tuatha* is the corresponding transmutation of the latter.

Tuatha, therefore, signifies *magicians* ;* and so we have the *first* component of *Tuath-de-danaans* elucidated. The *second* requires no Œdipus to solve it, *De* being but the vernacular term whereby was expressed the *Deity ;* and as I have previously established the import of *Danaans* to have been *Almoners,* it follows that the aggregate tenour of this religious-compound-denomination is *the Magician-god-almoners,* or the Almoner-magicians of the Deity.

* " Tuatha *Heren* tarcaintais
Dos nicfead sith laitaith nua."
That is,
The *magicians* of Ireland prophesied
That new times of peace would come.

I would point your attention to this stanza, not only as confirmatory of the solution above given for the word *Tuatha,* but as furnishing another link in that great chain of analogy, which I have traced between the names of Ireland and ancient Persia. *Haran,* in Mesopotamia, is but the prefixing of an aspirate to *Eran,* the Pahlavi variation for *Iran,* the original name for that *Sacred Land.*

As from *Budh* was formed *Fiodh*, so from Fiodh arose Fidhius ; and as I have before shewn that *Hercules* and *Deus* were synonymous terms, and both personifications of the *Sun*, so, accordingly, we find that this *symbolical* adjunct was reciprocally appropriated to one as to the other.

I dwell upon those terms with the more impressive force, because that *the spirit of no one of them* has ever before been developed. *Me Deus Fidhius*, and *Me Hercules Fidhius*, we were taught at school to consider as appeals to the *God of Truth*, and the *Hercules of Honour*. Most assuredly those virtues are comprehended under the *radix* of the great *mysterious* Original ; but the dictionaries and lexicons that gave us those significations, knew no more of what that *Original* was, than they did of the connexion between soul and body.

Deus Fidhius, then, means God the *Budha*, and as such the *All-wise*, the *All-sacred*, the *All-amiable*, and the *All-hospitable ;* and *Hercules* Fidhius, that is, *Hercules* the Budha, is, in sense and meaning, exactly the same.

The Latin word *Fides*, and the English *Faith*, are but direct emanations from the same communion. A thousand other analogies must suggest themselves now in consequence. In a word, if you go through the circle of natural *religion* and artificial *science*,—if you analyse the vocabulary of conventional *taste* and of modish etiquette, you will find the *constituent particles*, of all the leading outlines, resolve themselves into the *physical* symbolization of the radical Budh.

What inference, I ask my reader, would he draw from the above facts? Unquestionably that at the

outset of social life, mankind at large had used but one lingual conversation; and as the *Irish* is the only language in which are traced the germs of all the diverging *radii*—nay, as it is the *focus* in which all amicably meet—it follows, inevitably, that it must have been the universal language of the first human cultivators—the nursery of letters, and the cradle of revelation.

> " How charming is divine Philosophy !
> Not harsh and crabbed, as dull fools suppose,
> But musical as is Apollo's lute,
> And a perpetual feast of nectared sweets
> Where no crude surfeit reigns."

CHAPTER XIX.

The *Tuath-de-danaans,* or Mahabadeans, being thus far proved as the first occupiers of Iran, it may be asked, how happens it that no Persian historians, anterior to Mohsan Fani, have noticed their existence? In the first place, I answer that *they all* have mentioned them, however *unconsciously* by themselves, or *inadvertently* by others. And even had this not been the fact—had not a single syllable been recorded, bearing reference to their name, the remote era, in itself, of their detachment from that country, would be the best possible apology for the omission.

The professed writers upon Persia belong all to a recent period; and the magazines which they consulted, for the scanty information which they furnish, were either Arabs or Greeks—the former a body of predatory warriors, whose only insight into letters arose from the opportunities which their rapines had supplied them; and the latter, a community who, insensible to the beauties of moral truth, took delight in distorting even the most commonplace occurrences, into the most unnatural incredibilities and misshapen incongruities.

But independently of these causes, another more powerful one had, long before, co-operated. A rival dynasty, starting up from amongst themselves, succeeded, by the issue of a religious revolution, to effect their expulsion; and that once ascertained—the doors

of admission ever after closed against their return—the
victors were not satisfied with the monopoly of civil
power, but they must wreak their vengeance still
more, by the erasure of every vestige of the former
sway.

In this devastating course, the Round Towers, as
the temples of their figurative veneration, were par-
ticularly obnoxious; and, accordingly, we may be
assured, that it was owing to the durability of those
edifices, and not to the clemency of the assailants,
that any one of them has been able to survive the
hurricane.

Who, you will ask, were those destroyers? They
were the *Pish-de-danaans.* And so energetically did
they prosecute their extinguishing plan, aided, be-
sides, by the antiquity of its remote occurrence, that
all writers upon that country, before the compilers of
the Dabistan, have set them down as its first dynasty,
making the Kaianians, the Askanians, and the Sassa-
nians, their successors.

Here I am obliged, in compliance with the justice
of my subject, to expose an error of a gentleman,
whom I would rather have overlooked.

" The *Tuatha-dadan* of the Irish," says Vallancey,
" are the *Pish-dadan* of the Persians;" which he pre-
tends to prove as follows:—" First, then," says he,
" *Tuath* and *Pish* are synonimous in the Chaldee, and
both signify mystery, sorcery, prophets, &c. : they are
both of the same signification in the Irish ; therefore
by *Pish-dadan* and *Tuatha-dadan*, I understand the
Dadanites, descended of Dedan, who had studied the
necromantic art, which sprung from the Chesdim, or
Chaldeans."

Of a piece with this was his assertion that *Nuagha*

Airgiodlamh of the Irish, was *Zerdust* of the Per-
sians! And wherefore, think you, reader? Because,
forsooth, *Airgiodlamh* signifies *silver*-hand, and Zer-
dust, *gold*-hand! Yes, but he made out another
analogy, and it is worth while to hear it; viz., that
Nuagha had his *hand cut off* by a Fir-Bolg *general ;*
while Zerdust's *life was taken away* by a Turanian
chieftain ! ! !

This is but an *item* in that great ocean of incerti-
tude, in which that enterprizing etymologist had, un-
fortunately, been swallowed up. Having perceived
by the perusal of the manuscripts of our country, that
there must have been a time, when it basked in the
sunshine of literary superiority; yet unable tangibly
to grapple with it, having no *clue* into the *origin* of
its *sacred* repute, or the collateral particulars of its
date, nature, or promoters, he was tossed about by the
ferment of a *parturient* imagination, without the
saving ballast of a *discriminating* faculty.

The General's work, accordingly, is one which
must be read with great reserve ; not because that it
does not offer many valuable hints, but because that
its plan is so *crude,* and its matter so *ill-digested*—the
same thing being *contradicted* in one place, which was
affirmed in another, or else *repeated* interminably,
without regard to *method* or to *style*—that when you
have waded through the whole, you feel you have
derived from it no other benefit, than that of whetting
your avidity for a *correct* insight into those subjects,
of which the author, you imagine, must have had some
idea, but which also, it is evident, however indefa-
tigable he was in the attempt, he had not, himself,
the power to penetrate.

The great praise, therefore, which I would award

to this writer, is that, with one leg almost in the grave, he sat down, in the enthusiasm of a youthful aspirant, to master the difficulties of the Irish tongue, which, *mutilated* though it be, and *begrimed* by disuse, he knew was, notwithstanding, the only sure inlet to the *genius* of the people, as well as to the *arcana* of their antiquities, the most precious, as they are, and fruitful, of any country on the surface of the globe.

But though his perseverance had rendered him the best *Irishian* of his age, and of many ages before him, yet has he committed *innumerable blunders*, even in the exposition of the most simple words; and the question now in point will verify this declaration, with as much exactitude as any other that could be adduced.

Tuath, then, and *pish* are by no means *synonymous;* neither do they signify *mystery* or *prophets*, except in a secondary light. In their original acceptation, they are the *antipodes* of each other, as much as *male* is to *female,* and as *relative* is to *correlative* *.

They are the distinctive denominations for the *genital organs* of both sexes, respectively—*Tuath* signifying *Lingam ;* and *Pish, Yoni.*

I have already explained that *Tuath* is but a modification of the word *Budh*—the final *dh* of the latter having been changed into the final *th* of the former, only for euphony ; because that prefixed to *de-danaan* the collision of the two *d's,*—as *Bud*-de-danaan— would not sound well ; it was, therefore, made *Buth-*

* General Vallancey was equally ignorant as to the meaning of the additional words *De-danaan.*

de-danaan ; and,—the initials *b* and *t* being always
convertible,—hence became *Tuath*-de-danaan.

The case was exactly *opposite* with respect to
pish : l mean so far as the alteration of two of its
letters is concerned. *Pith* is the *usual* method of
pronouncing that term : nor is it, except when fol-
lowed by a *d*, that it assumes the other garb. But
as *dh*, in the former instance, was commuted into *th*,
so *th*, in this latter, is still farther into *sh ;* there-
fore, instead of *Pith*-de-danaan, we make it *Pish*-de-
danaan.

To screen those two ligaments of *sexual* familiarity
from the peril of profane and irreverent accepta-
tions, all the investiture of *magic* was shrouded
upon them. The vocabulary of *love* and of *religion*
became one and the same : *mystery* and *enchantment*
were identified, and the *negotiations* of the earth,
and the *revolutions* of the heavens, were blended
with the *witchery* of *amative sway.*

In this universality of domain, no one of those
dear *helpmates* had a greater portion of honour
assigned to it, than the other. They were equal in
power, and alike in attributes. And to set this
equality beyond the contingencies of doubt, it was
withal arranged, that while *each, primarily,* retained
its *distinct sexual* interpretation, they should *both,
secondarily,* harmonise under another *mutual* exposi-
tion ; and, what more appropriate one could be
devised, than that of the *influence* which they exer-
cised? and of the *veil* with which they were guarded ?

Magic, therefore, and *mystery,* were the two *se-
condary* imports, in which both were *united ;* and the
ambiguity thus occasioned, was what cast Vallancey

upon that shoal, which proved similarly fatal to many
a preceding speculator.

To exemplify—*Budh*, or *Tuath*, in its literal and
substantive acceptation, implies the *Lingam ;* collate-
rally, *magic ;* and by convention, *mystery, prophets,
legislators,* &c. *Pish*, in like manner, or *Pith*, de-
notes, literally, the *Yoni ;* collaterally, *magic ;* and
by convention, *mystery, prophets, legislators,* &c. And
the offshoots of either, in an inferior and deteriorated
view, such as *Budh-og* from the former, and *Pish-og*
from the latter, intimate, indiscriminately, *witchcraft,
wizard,* or *witch.*

Now the words *De-danaans,* having been already
illustrated as meaning *God-Almoners,* if we prefix to
them, severally, *Tuath* and *Pish,* they will become
Tuath-de-danaans, and *Pish*-de-danaans; the former
expressing, literally, *Lingam*-God-Almoners ; and the
latter, literally, *Yoni*-God-Almoners ; and both equally,
by convention, *Magic*-God-Almoners.

As we have had exhibited numerous representations
of the homage paid to the *paternal* member of this
theocracy, perhaps I may be permitted to adduce a
single quotation demonstrative of the honours shown
to his *maternal* colleague.

" The Chinese," says the author of ' Rites and
Ceremonies,' " worship a goddess, whom they call
Puzza, and of whom their priests give the following
account :—They say that three nymphs came down
from heaven to wash themselves in a river, but scarce
had they got into the water before the herb *Lotos* *
appeared on one of their garments, with its coral

* The Lotos was the most sacred plant of the ancients, and typified
the *two* principles of the earth's fecundation combined—the germ stand-
ing for the *Lingam ;* the filaments and petals for the *Yoni.*

fruit upon it. They were surprised to think whence
it could proceed; and the nymph, upon whose gar-
ment it was, could not resist *the temptation of in-
dulging herself in tasting it.* But by thus eating some
of it, she became *pregnant,* and was delivered of a
boy, whom she brought up, and then returned to
heaven. He afterwards became a great man, a con-
queror and legislator, and the nymph was afterwards
worshipped under the name of *Puzza* *."

And thus we see that *Budh* and *Pish* were the
actual regulators of the solar universe.

Time, however, dissolved the chain which linked
together those *mysterious absolutes :* or, rather, the
zealots of each contrived to sever an attachment,
which was intended, by nature, to be reciprocal and
mutual †. War, devastating, desecrating war, spread
abroad over the plain ! Human energies were evoked
into an unknown activity ! Men's passions, always
inflammable by the jealousy of partisanship, were
here furthermore stimulated by the rancour of re-
ligion ! And hearts were lacerated, and countries
were depopulated in sustainment of the consequences
of a physiological disquisition !!!

But what do you conceive to have been the topic
at issue ? Verily, it was whether the *male or the female
contributed more largely to the act of generation !—*
those who voted for the *female* side, ranging them-
selves under the banners of *Pish,* and those for the
male under the standard of *Budh,* while both equally

* This *Puzza* is nothing more than our Irish *Pish :* and, what is
miraculously *coincident,* the title of the enthusiast who annually kills
somebody in honour of her, under the name of the goddess *Manepa,* at
Tancput, is *Phut,* or Buth; that is, the Budh of the Irish !

† Therefore shall a man leave his father and his mother, and shall
cleave unto his wife; and they shall be one flesh.—Genesis xi. 24.

appealed to heaven for adjudication of their suit, by
arrogating to themselves the adjunct of *De-danaans*,
or God-Almoners.

> " Not but the human fabric from its birth
> Imbibes a flavour of its parent earth,
> As various tracts enforce a various toil,
> The manners speak the idiom of the soil."

Whether or not, however, the result is to be con-
sidered as decisive of the matter in dispute, one thing
at least is certain, viz., that the *Pish*-God-Almoners
obtained the victory; and the *Budh*-God-Almoners
were thrown upon the ocean; over whose bosom,
wafted to our genial shores, they did not only import
with them all the culture of the East, with its ac-
companying refinement and polished civilization; but
they raised the isle to that pinnacle of literary and
religious beatitude, which made it appear to the
fancies of distant and enraptured hearers, more the
day-dream of romance, than the sober outline of an
actual locality.

I shall now illustrate a part of those truths by the
Indian history of the circumstances, as copied from
their Puranas, by one who had no anticipation of my
differently-drawn conclusions, and one, in fact, who
did not know either the *scene* or the *substance* of the
occurrence which he thus transcribes.

" Yoni, the *female nature*, is also," says Wilford,
" derived from the same root (*yu*, to mix). Many
Pundits insist the Yavanas were so named from their
obstinate assertion of a superior influence in the
female over the *linga* or *male nature*, in producing a
perfect offspring. It may seem strange, that a question
of mere physiology should have occasioned not only
a vehement religious contest, but even a bloody war;

yet the fact appears to be historically true, though the Hindu writers have dressed it up, as usual, in a veil of historical allegories and mysteries, which we should call obscene, but which they consider as awfully sacred.

" There is a legend in the Servarasa, of which the figurative meaning is more obvious. When Sati, after the close of her existence as the daughter of Dascha, sprang again to life in the character of Parvati, or Mountain Spring, she was re-united in marriage to Mahadeva. This divine pair had once a dispute on the comparative influence of the sexes in producing animated beings, and each resolved, by mutual agreement, to create apart a new race of men *. The race produced by Mahadeva were very numerous and devoted themselves exclusively to the worship of the *male deity ;* but their intellects were dull, their bodies feeble, their limbs distorted, and their complexions of many different hues. Parvati had, at the same time, created a multitude of human beings, who adored the *female power* only, and were all well shaped, with sweet aspects and fine complexions. A furious contest ensued between the two races, and the *Lingajas* were defeated in battle ; but Mahadeva, enraged against the *Yonijas*, would have destroyed them with the *fire of his eye*, if Parvati had not interposed and spared them † ; but he would spare

* " There is a sect of Hindus, by far the most numerous of any, who, attempting to reconcile the two systems, tell us, in their allegorical style, that Parvati and Mahadeva found their *concurrence* essential to the perfection of their offspring, and that Vishnu, at the request of the goddess, effected a reconciliation between them ; hence the *navel* of Vishnu, by which they mean the *os tincæ*, is worshipped as one and the same with the sacred *Yoni*."

† She " made use of the same artifice the old woman, called Baubo,

them only on condition that they should instantly
leave the country, with a promise to see it no more ;
and from the *Yoni,* which they adored as the sole
cause of their existence, they were named Yavanas."

It is evident that a mistake has been committed in
the above narrative, making the *victors* the persons
who were obliged to quit! and we know from testi-
mony, adduced upon a different occasion, that in-
stances of such confusion were neither unfrequent
nor uncommon *. But even admitting it to be accu-
rate, the apparent contradiction is easily reconciled ;
as it is probable, that the contest was protracted for a
long period of time, before it was ultimately decided in
favour of one party ; and, in the alternations of suc-
cess, one side being up to-day, and another upper-
most to-morrow, what could be more natural than
that a colony of the *Yavanas,* or *Pish-de-danaans,*—
which is the same,—should have fled for shelter to
India, before that the auspices of their arms, propelled
by the *fair cause* which they vindicated, had, at length,
accomplished the overthrow of their adversaries.

This object, however, once obtained—full mas-
ters of their wishes—and sole arbiters of Iran—they
were not satisfied with the mere extinction of all the
symbols of their predecessors,—save and except the
Towers which stood proof to their attacks—but they
established there instead a code, as well political as
moral, more consonant with their own prejudices:
and the wonder would be great, indeed, if, after this

did to put Ceres in good humour, and showed him the prototype of the
Lotos. Mahadeva smiled and relented ; but on the condition that they
should instantly leave the country."

* But such is the confusion and uncertainty of the Hindu records,
that one is really afraid of forming any opinion whatever.—WILFORD.

triumphant assertion of *female* power, gratitude and
religion should not both combine in making the *type*
of that influence—the sacred *crescent*, or *yoni*—the
personification of their doctrines; and *woman herself*,
all lovely and all-attractive, the concentrated temple
of their divinity upon earth!

Such was the commencement of the Pish-de-
danaan dynasty in Persia; and its influence still ope-
rating, after a long interval of time, is what the his-
torian unconsciously describes in the following terms,
viz.:—

" If we give any credit to Ferdosi, most of the
laws of modern honour appear to have been under-
stood and practised with an exception in favour of
the ancient Persians, whose duels, or combats (which
were frequent), were generally with the most distin-
guished among the enemies of their country or the
human race. The great respect in which the female
sex was held was, no doubt, the principal cause of
the progress they had made in civilization. These
were at once the cause of generous enterprise and its
reward. It would appear, that in former days the
women of Persia had an assigned and honourable
place in society; and we must conclude, that an
equal rank with the male creation, which is secured
to them by the ordinances of Zoroaster, existed long
before the time of that reformer, who paid too great
attention to the habits and prejudices of his country-
men, to have made any serious alterations in so im-
portant an usage. We are told by Quintus Curtius,
that Alexander would not sit in the presence of Sisy-
gambis till told to do so by that matron, because it
was not the custom in Persia for sons to sit in pre-
sence of their mothers. There can be no stronger

proof than this anecdote affords, of the great respect in which the female sex were held in that country at the period of his invasion *."

> Without thee, what were unenlightened man?
> A savage roaming through the woods and wilds
> In quest of prey ; and with the unfashioned fur
> Rough clad ; devoid of every finer art,
> And elegance of life. Nor happiness
> Domestic, mixed of tenderness and care,
> Nor moral excellence, nor social bliss,
> Nor grace, nor love, were his †.

* Sir John Malcolm, vol. i. p. 270.
† Thomson.

CHAPTER XX.

But you will say that I have ventured nothing like proof, of the paradoxical affirmation propounded a short while ago, as to the *Tuath-de-danaans* having been mentioned, by all Eastern writers, in connexion with Persia; and yet unnoticed, the while, by themselves, not less than unheeded by their readers?

True: I but awaited the opportunity which has just arrived.

Are you not aware, then, how that all oriental writers, when referring to Budha, who was born at Maghada, in South Bahar, state that he was the son of *Suad-dha-dana?* And have I not already shown you that *Suadh* and *Tuath* were but disguises of each other, and both resolvable into Budh?

Those first components, therefore, in each being the same, look at the entire compound words, *Tuath-de-danaan,* and *Suad-dha-dana,* and are not the rest, also, infallibly identical?

Admitting this, you reply, how could they, in that early age, make their way to Ireland? which, from its extreme position, must have been the very last place they would have thought of!

If the question refers to the route pursued, I decline its solution, as not necessary for my design. " A piece of sugar, or a morsel of pepper, in a neglected corner of a village inn, would be a certain

proof," says Heeren, " of the trade with either Indies, even if we possessed no other evidences of the commerce of the Dutch and English with those countries." And when I have already made the coincidences between the two Irans and their inhabitants, their forms of worship, their language and mode of life, to be historical axioms, I surely cannot be expected to waste labour upon such a trifle, which sinks into nothing against *evidences* of the actual fact *.

But if the length of the voyage be the obstacle insinuated, then would I find some difficulty to—do what?—keep my muscles grave: as if, forsooth, the adventurous sons of man could only, slowly and imperceptibly, and like so many ants pushing a load before them, introduce themselves, inch by inch, and in measured succession, into the diversified terraqueous globe spread abroad for their enjoyment!— when we have direct demonstration that such was far from having been the case, in the instance of a colony, which starting from Tyre, and leaving behind, on all sides, the most inviting and delicious countries, planted itself down, perhaps, from the mere spirit of romance, in the circumscribed little island of Cadiz, long before Carthage or Utica had existence even in name !

No, sir, we must not be so fond of derogating from the ancients all participation in those embellishments which promote society. Asia was the cradle of the whole human race ; and thence, as its popu-

* When history fails in accounting for foreign extraction of any people, or where it is manifestly mistaken, how can this extraction be more rationally inferred and determined, or that mistake rectified, than from the analogy of languages? And is not this at once sufficiently conclusive, if nothing else was left them ?—*Eugene Aram.*

lation overflowed, migratory herds in different states
of civilization, and with different forms of religious
culture, poured in their successive colonies with multi-
tudinous inundation into the other continental lands ;
but, with more zeal, and with stronger preference,
into those compact little nests which have been sig-
nificantly denominated the " Isles of the Gentiles."

Vessels rode over the briny surges with as proud
a canvas as now receives the gale *. The model of
the ark would be lesson sufficient, to instruct an en-
terprising generation in the science of naval archi-
tecture : and we may well suppose that, of all pur-
suits cultivated by human art, this would have occu-
pied the very foremost regard, by a people just
rescued, through its salutary instrumentality, from
the desolating scourge of an all-swallowing abyss.

" Well, then, at all events,"—I fancy I hear you
exclaim,—" you admit the story of the *deluge ?*"

Certainly ; and that of *Noah,* and the *ark,* and the
dove, and the *raven.* But did I not, also, concede
the story of the *giants,* and of the *serpent ?* of the *sons
of God,* and of the *tree of knowledge ?* Nay, *have I
not put the truth of those particulars beyond the possibi-
lity of scepticism,* much more of *denial ?* But, believe
me, that the *liquid* which composed this " deluge"
was more of the colour of *claret* than it was of *water ;*
—that there was no more of *wood* or *timber* in the
construction of this " ark" than there was in that of
the " tree of knowledge"—that those two latter were

* The merchants of Magadha formed not only a particular class, but
also a particular tribe. It seems that they were bold, enterprising, and,
at the same time, cautious and circumspect ; hence they are said to be
merchants by the fathers', and warriors by the mothers' side, according
to Mr. Colebrook's account of the Hindu classes.—Asiat. Res. ix. p. 79.

congenial and correspondent to each other,—in their configuration and intention,—and that *flesh* and *blood* were the elements of which they were both composed.

> For all that meets the bodily sense, I deem
> Symbolical, one mighty alphabet
> For infant minds————

Could the coincidence of measure * between the great Egyptian *pyramid*, at its base, and that of the Noachic *ark*, in ancient cubits †, have been accidental, do you imagine? And if not, what community of purpose, do you think, had been subserved by such numerical analogy?

The *triangle*, in the old world, was a sacred form. It represented the properties—capacity and dilatation—of the *female* symbol. Lucian, in his " Auction," states the following dialogue as having occurred between Pythagoras and a purchaser, viz. :—

PYTH. How do you reckon?

PUR. One, two, three, four.

PYTH. Do you see? What you conceive *four*, these are *ten ;* and a perfect *triangle*, and our *oath*.

* See " A Dissertation on the Antiquity, Origin, and Design of the principal Pyramids of Egypt," &c. &c.

† Mersennus writes thus :—" I find that the cubit (upon which a learned Jewish writer, which I received by the favour of the illustrious Hugenius, Knight of the Order of St. Michael, supposes the dimensions of the temple were formed) answers to $23\frac{1}{4}$ of our inches ; so that it wants $\frac{3}{4}$ of an inch of two of our feet, and contains two Roman feet and two digits, and a grain, which is $\frac{1}{4}$ of a digit." The Paris foot, with which Mersennus compared this cubit, is equal to $1\frac{68}{1000}$ of the English foot, according to Mr. Greaves ; and consequently is to the Roman foot as 1068 to 967. In the same proportion, reciprocally, are $23\frac{1}{4}$ and $25\frac{68}{100}$. That cubit, therefore, is equal to $25\frac{68}{100}$ *unciæ* of the Roman foot, and consequently falls within the middle of the limits $25\frac{57}{100}$ and $\frac{79}{100}$, with which we have just circumscribed the sacred cubit ; so that I suspect this cubit was taken from some authentic model, preserved in a secret manner from the knowledge of the Christians.—Sir ISAAC NEWTON.

Now, Pythagoras, though a Samian, was edu-
cated in Egypt; and the religious mysteries, with
which he had been there imbued, are what is so pro-
fanely ridiculed by this infidel scoffer.

It is not my province to justify the ceremonial of
the Egyptians, any further than as indicative of gra-
titude to the Godhead: but the reflection must sug-
gest itself to every observant mind, that they are
never called *idolaters* in any part of the Pentateuch;
and Plutarch, in addition, *positively asserts*, that
" they had inserted nothing into their worship with-
out a reason,—nothing merely fabulous,—nothing
superstitious; but their institutions have reference
either to morals or something useful in life, and bear
a beautiful resemblance, many of them, to some *facts*
in *history*, or some *appearance* in *nature*."

If we investigate the secret of this Pythagorean
asseveration, we shall find that the numbers 1, 2, 3,
4, thrice joined, and touching each other, as it were,
in three angles, in this manner—

constitute an equilateral *triangle*, and amount also, in
calculation, to *ten*. While the *inward* mystery,
couched under its figure, embraced *all that was so-
lemn in religion and in thought*, being, in fact, the
index of *male* and *female* united—the unit, in the
centre, standing for the Lingam.

Look now at the form of the great Egyptian pyra-
mid; and is it not precisely that of the above tri-
angle? Is there not, also, an *aperture* into it, about

the middle as here * ? And when to all, we add the notion of *wells* of water withinside, is not the demonstration complete, that the goddess of the *Lotos*, the soft promoter of *desire*, the arbitress of *man*, and the compeer of the *angels*, was the honoured object of its symbolical erection † ?

In 1 Pet. iii. 20, it is asserted that only " eight persons" were preserved in the ark. Let us suppose them to have been Noah and *his* wife, with his three sons and *their* wives. At a comparatively short interval, after the date assigned to this event,—at most but 352 years,—on Abraham's arrival in the land of Egypt, we find a flourishing kingdom, an organised police, a systematic legislature, and comprehensive institutions, diffused over its surface. All the other parts of the world, we must be ready to presume, if not equally enlightened, were, at least, as populous; and I put it to your good sense to decide, whether *eight* individuals could, within that period, not only procreate so plentifully as to replenish the whole earth, but enlighten it, additionally, with such a coruscation of science, as no subsequent era has been since able to eclipse ?

Indeed, the Scriptures themselves give us, elsewhere, to understand that St. Peter did not correctly interpret this history. " Come thou," says Genesis vii. 1, " and *all thy house*, into the ark ! " This gra-

* And he brought me to the door of the court; and when I looked, behold a *hole* in *the wall*. Then said he unto me, Son of man, dig now in the wall; and when I had digged in the wall, behold a door: and he said unto me, Go in, and behold the wicked abominations that they do here. So, I went in, and saw; and, behold, every form of creeping things, and abominable beasts, and all the idols of the house of Israel, pourtrayed upon the wall round about.—EZEKIEL.

† " Inter omnes eos, non constat à quibus factæ sint, justissimo casu obliteratis tantæ vanitatis authoribus."—PLIN.

cious invitation, at so critical a juncture, would have been too welcome a proffer, to be lost sight of by any one, who could make it available; and must not we suppose that the *domestics* to whom the extension was addressed, with their several dependents and collateral offspring, would have been glad and happy to grasp at it with delight?

But the name of the type itself is worth a hundred deductions from equivocal premises. The *coffer* of the law, the *coffin* of Joseph, the *money chest* of the temple, are all severally translated *ark*, and recorded in Hebrew by the word אָרן *aron:* but the " *ark* of Noah *," and Moses's " ark of bulrushes †" are peculiarly designated, תבת *Thebit*, or תבה *tebah* ‡.

What is the meaning of these mysterious terms?

　　　" Quo spectanda modo, quo sensu credis, et ore?"

As the *Tau* of the Hebrews is, indifferently, in power, *T* and *Th*, *Thebit* has as good a right to be spelled with, as without, an *h*, at the end of it,— and, indeed, a better right, considering the elements whereof it is compounded. *Thebith,* then, is the proper and true sound, and the mystery of its import I thus unravel.

Its first syllable, *The*, signifies *sacred* or conse-

* עשהלך תבת עצי גפר קנים
תעשה את התבה וכפותאתה
מבית ומחוץ בכפר וזה אשר
תעשה אתה שלש מאות אמה
ארך חתכה חמשים אמת
רחבה ושלשים אמה קומתה
Gen. vi. 14.

† Exod. ii. 3.

‡ The Septuagint translators, not perceiving any difference, rendered all, similarly, by the word κιβωτός !

crated*; and since the letters *b* and *p* are commutable
—*bith* is the same as *pith*, that is, *Cteis* or *Yoni*. The
words *The-bith*, then, together, in all the attraction of
truth, intimate the *consecrated Cteis;* or the *sacred
Yoni* † !

But *Pith*, itself, is only a *conversion* of *Fidh*,—the
initial letters *P* and *F* being always interchangeable,
and not more so than the penultimates *t* and *d*. And
Fidh, in its abstract and original position, such as
we have early seen it, is *masculine*, the plural of
Budh, conveying variously the significations of *Lin-
gams, trees,* and *bulrushes.* Here, however, where it
is *feminine*, its sex *reversed*, and the *anatomy* of *nature*
pourtrayed by the *physics* of *language*, the idea of
the *bulrushes* alone presents itself; and the *basket*
in which Moses was *saved* from the waters, and
which was made of such reeds, was appropriately
denominated by this mysterious symbol, as a type of
the *virginity* in which the Messiah was to be incar-
nated, not less than of the *redemption* which was to
accrue from his sufferings.

Another stage has been thus advanced; and lo !
the beautiful union which subsists, *as to design,* be-
tween the results of our discoveries, and the consoling
assurances of pure Christianity !

Let us now proceed a little farther in this course—

" Sanctos ausi recludere fontes ‡,"

and connect these truths with the *Tuath*-de-danaans
and the *Pish*-de-danaans.

* As does also *Tha, To, Ti, Tho, Thu,* with their several commu-
tables, derivatives, formatives, &c.

† And the *Valley of To-phith,* in which human victims were sacri-
ficed, thus discloses, in the *symbolic secret of its shape,* that the propitia-
tion of this *instrument* was the grand object of the sacrificers.

‡ Virgil.

" Noah was a just man," observes the scriptural historian, " and *perfect in his generations ;* and Noah walked with God *."

The name of this patriarch implies literally a *boat :* the character assigned him is not so well understood.

To succeed in the investigation we must have recourse to the context : and here, the first thing that strikes us is the observation " that the earth was *corrupt* before God, and filled with *violence ;* for all *flesh* had corrupted his way upon the earth †."

A passage in the New Testament will be the best comment upon this subject, where the patience of God with the iniquities of mankind being at length exhausted, it is said, that he " gave them over to a *reprobate mind,*" " to dishonour their own bodies between themselves ‡."

But Noah did not participate in those unhallowed abominations, and he, accordingly, " found grace in the eyes of the Lord §."

We now, therefore, see the propriety of the name assigned to his *ark* ‖—and the intimation of approval conveyed by the divine command of " Come thou and all thy house into it," was but another form of the injunction elsewhere conveyed, to the same effect, in the words, " Be ye fruitful and multiply ¶."

Noah, then, and *Kaiomurs* ** were one and the same person, the reformer of the human species, and the

* Genesis vi. 9. † Genesis vi. 12. ‡ Romans i. 20—24.
§ Genesis vi. 8. ‖ *The-bith.* ¶ Genesis ix. 1.
** This king is stated to have reclaimed his subjects from a *state* of the *most savage barbarity.* He was, we are told by our author, the son of Yussan-Ajum, while others call him the grandson of Noah; *all agree in acknowledging him as the founder of a dynasty, which are known in history as that of the Paishdadian.*—Sir John Malcolm.

first monarch of the Pish-de-danaan dynasty. *Yavana* was another name appropriated to him, and equivalent with *Noah*, excepting only that the former is literal, and the latter figurative. An advantage, however, arises from this difference, for when we know that *Yavana* means the *yoni*, and *Noah* a *boat*, and that both were equally characteristic of the same individual character, we conclude that the latter denomination was but the symbol of the former,—that, in fact, it was the *lunar boat**, or the *crescent*, the *concha Veneris*, and the type of *comfort* † that was veiled under the mystery of this ambiguous device.

This fact once explained, you have the immediate

solution of those " semicircular implements" so uni-

* The Irish name for a *boat* is *baudh*, which is only a formative of *pith*.

† Genesis v. 29.

versal throughout this island, and which Ledwich acknowledges " have created more trouble to the antiquarians to determine their use, than all the other antiquities put together."

These are all made of the finest gold, and, as emblems of the *yoni*, which was the Roman *palladium*, used to have been worn as *breast*-plates by the priests and sovereigns. They would sometimes, also, exhibit them as ornaments to the *head*-dress : and when so designed, the two terminating angles used to have been furnished with circular cups, whereby they would better adhere to the part : of such, likewise, we have the following specimen *.

Yun is the usual mode of pronouncing *Yavanna ;*

* If the reader will now turn to page 223, will he not think it probable that the *symbol* contained on the broken-off portion of the stone, there represented, must have been the phallus ?

and as the veneration of posterity for the virtues of this legislator, at a moment when vice had threatened a general decay *,—led them to consider him a god, he hence obtained the prefix of *Deo* or *Deu*, which along with that of *Cali*, whose champion he showed himself, make up the romantic, emblematic, and nominal representation of *Deucaliyun* †.

> " Safe o'er the main of life the *vessel* rides,
> When *passion* furls her sails, and *reason* guides;
> Whilst she who has that surest rudder lost,
> Midst rocks and quicksands by the waves is tost;
> No certain road she keeps, nor port can find,
> Toss'd up and down by every wanton wind ‡."

The struggles for ascendancy between contending parties are not the growth of a day; still less are they unstained by the effusion of blood. *Deluge* was no very extravagant hyperbole to apply to such a carnage; for, independently of our knowing that *every* visitation, whether by *fire, water,* or *sword,* was so denominated by the easterns, we have the Scriptures themselves illustrating this use of the term, in applying it to the description, at a far later period, of an equally severe and no less distressing catastrophe.

" Now, therefore, the Lord bringeth upon him the waters of the river, strong and many, even the King of Assyria and all his glory; and he shall come up over all his channels, and go over all his banks. And he shall pass through Judah; he shall overflow and

* Who can forget the fable in Ovid, *de jactibus lapidibus ?*

† But as his descendants gave him his right as to the title of Deva, and decreed divine honours to be paid to him, we shall henceforth call him Deva-cala-*Yavana;* or, according to the vulgar mode of pronouncing this compound word, Deo-cal-*Yun*, which sounds exactly like *Deu-calion* in Greek.—WILFORD.

‡ Fielding.

go over, he shall reach even to the neck ; and the stretching out of his wings shall fill the breadth of thy land, O Immanuel *."

But how, you ask, account for the marine strata, and other remains, found within the earth's recesses ?

I answer, they were there, imbedded and inanimate, before ever man was placed above them as a denizen.

" It is clearly ascertained," says Cuvier, " that the oviparous quadrupeds are found considerably earlier, or in more ancient strata, than those of the viviparous class. Thus the crocodiles of Harfleur and of England are found immediately beneath the chalk. The great alligators and the tortoises of Maestricht are found in the chalk formation, but these are both marine animals. This earliest appearance of fossil bones seems to indicate, that dry lands and fresh waters must have existed before the formation of the chalk strata ; yet neither of that early epoch, nor during the formation of the chalk strata, nor even for a long period afterwards, do we find any fossil remains of *mammiferous land* quadrupeds. We begin to find the bones of the mammiferous sea animals, namely, of the lamantin and of seals, in the course of shell limestone which immediately covers the chalk strata in the neighbourhood of Paris. But no bones of the mammiferous land quadrupeds are to be found in that formation ; and notwithstanding the most careful investigations, I have never been able to discover the slightest trace of this class, excepting in the formations which lie over the coarse limestone

* Isaiah viii. 7—8.

strata : but on reaching these more recent formations, the bones of land quadrupeds are discovered in great abundance.

" As it is reasonable to believe, that shells and fish did not exist at the period of the formation of the primitive rocks, we are also led to conclude that the oviparous quadrupeds began to exist along with the fishes, while the land quadrupeds did not begin to appear till long afterwards, and until the coarse shell-limestone had been already deposited, which contains the greater part of our genera of shells, although of quite different species from those that are now found in a natural state. There is also a determinate order observable in the disposition of those bones with regard to each other, which indicates a very remarkable succession in the appearance of the different species.

" All the genera which are now unknown, as the Palæotheria, Anapalæotheria, and with the localities of which we are thoroughly acquainted, are found in the most ancient of the formations of which we are now treating, or those which are placed directly over the coarse limestone strata. It is chiefly they which occupy the regular strata which have been deposited from fresh waters, or certain alluvial beds of very ancient formation, generally composed of sand and rounded pebbles.

" The most celebrated of the unknown species belonging to known genera, or to genera nearly allied to those which are known, as the fossil elephant, rhinoceros, hippopotamos, and mastodon, are never found with the more ancient genera, but are only contained in alluvial formations. Lastly—the bones of species which are apparently the same with those

that still exist alive, are never found except in light
and alluvial depositions."

From all which, this philosopher draws the follow-
ing just conclusion, viz.,—"Thus we have a collection
of facts, a series of epochs anterior to the present
time, and of which the successive steps may be
ascertained with perfect certainty, though the periods
which intervened cannot be determined with any
degree of precision. These epochs form so many
fixed points, answering as rules for directing our in-
quiries respecting this ancient chronology of the
earth."

To return—" God said unto Noah, the end of all
flesh is come before me; for the earth is filled with
violence through them; and, behold, I will destroy
them with the earth *."

Now, we see that the earth has *not* been destroyed,
and *this single circumstance, in itself,* ought to have
been enough to show us that the whole register was
but figurative. The *raven* and the *dove* were indis-
pensable auxiliaries to the structure of the allegory:
the former typifies the *massacre* that prevailed during
the period of the contest; and the latter, in its meek
and its tender constancy, the invariable attendant,
besides, of *Venus* and the *boat,* characteristically pour-
trays the overtures made for an accommodation, until,
after a second embassy, the *olive-branch* of peace was
saluted, and the cessation of hostilities was the con-
sequence †.

Behold, then, the folly of those dreamers who
would make *Thebith* so called, as if the *ark* had
rested upon it! Why, Sir, in the entire catalogue of

* Genesis vii. 2. † Genesis viii. 10—11.

local names, there is no one half so common as that
of *Thebith* and *Thebæ!* And surely you will not
claim for your *ideal* man-of-war, in addition to other
properties, that of *ubiquity* also, by making it perch
upon all those places, at one and the same time!

No, these scenes have been all denominated from
the form of religion which they recognized, and of
which the *Pith, Yoni,* or *sacred Boat,* was the conven-
tional sign: as the countries of *Phut,* that is, *But,*
and *Buotan,* were so designated, likewise, from their
adopting the *opposite* symbol, viz., the *Budh, Phallus,*
or *sacred Lingam!*

Perplexed in this entanglement, and tossed about
in " a sea of speculation," Mr. Jacob Bryant, in some
respects a clever man, after a fatiguing cruise of
somewhat more than half a century, fell at last a
victim in the general shipwreck.

<div align="center">" Your wise men don't know much of navigation."</div>

The *Gentiles,* says he, worshipped Noah's *ark!* Yes
they did; but *not in the sense in which he under-
stood it* *.

Another *axiom* of his is, that the *deluge* must have
really happened, because that the *tradition* of it is

* The following is an abstract of the Hindoo version of this allegory,
as copied from their Puranas:—" Satyavrata, having built the *ark,* and
the flood increasing, it was made fast to the peak of Nau-baudha, with
a cable of a prodigious length. During the flood, Brahma, or the
creating power, was *asleep* at the bottom of the abyss: the *generative
powers of nature,* both male and female, were reduced to their simplest
elements, the *Linga* and the *Yoni.* The Yoni assumed the shape
of the hull of a *ship,* since typified by the Argha, whilst the Linga
became the *mast.* In this manner they were wafted over the deep,
under the care and protection of *Vishnu.* When the waters had retired,
the *female power* of nature appeared immediately in the character of
Capoteswari, or the *dove,* and she was soon joined by her consort, in
the shape of *Capoteswara.*"

universal! To this, also, I chime in my affirmative response, and proclaim, yea. But the *tradition* of the *tree of knowledge* is equally *universal.* And though the *ground-work* of *both occurred,* and was *substantively true,* yet was the *description* of *neither* more than a graceful *allegory ;* while the salutary *alarm* imparted under this guise, and the monitory *lesson* suggested by its horrors, in *amusing* the fancy, *edified* it, at the same moment, by keeping before it a *picture* of that *spiritual desolation,* which *sin* leaves in the *citadel* of the *soul* *.

" Moses," says the Apostle, " was learned in all the wisdom of the Egyptians, and was mighty in words and in deeds †."

Now Strabo assures us that the Egyptians of his day were as ignorant, as he was himself, of the origin of their religion, of the import of their symbols, and of their national history. They pretended to retain some *evanescent* traces thereof in the time of Diodorus; but so scrupulously exact were they in the concealment of their tenour, that to pry into them, profanely, was morally impossible.

Herodotus himself, who neglected no channel of information, found it no easy matter to glean a few *initiatory* scraps from them. And even these were accompanied with such solemn denunciations, that his embarrassment is betrayed when but alluding to their tendency.

If, during Moses's residence at Pharaoh's court, his opportunities of insight were greater, it is still self-evident that the accomplishments which he obtained were more of a secular character than of a religious

* See page 63. † Acts vii. 22.

cast—that the *courtier* was the first object of the young princess's directions, and the qualifications of the *statesman* her next ambition for her charge. The *mysteries* of the priests were too awful, and too sanctified, to be debased to the routine of a school-boy's rehearsal; and even when ripening age did bespeak a more chastened mind, the communication of their contents was obscured by the interposition of an almost impenetrable umbrage.

Thus palliated by types, Moses did, however, imbibe from the Egyptians all the knowledge which they then possessed of the nature of their ceremonies; and the record of the *fall*, the *deluge*, and the *creation*, are the direct transcripts of the instruction so conveyed. But though it is undeniable, from their *symbols*, that the Egyptians must have been well apprised of the *constitution* of those rites, yet am I as satisfied as I am of my physical motion, that the foldings of that *web*, in which they were so mystically *doubled*, was lost to their grasp in the labyrinths of antiquity.

Moses, therefore, could not have *learned* from the Egyptians more than the Egyptians themselves had *known*. He related the allegory as he had *received* it from them : and it is, doubtless, to his ignorance of its *ambiguous* interpretation, *accessible only through that language in which it was originally involved*, that we are indebted for a transmission, *so essentially Irish*.

The *Pish*-de-danaan dynasty which rose upon the ruins of the *Tuath*-de-danaans, in *Iran*, was itself, in after ages, ejected from that country. *Egypt* was the retreat of their shattered fortunes; and there, during their abode, under the name of the *Shepherd-kings*,

they erected the *Pyramids*, in honour of *Pith*, or *Padma*-devi, but at an age long anterior to what may be presumed from Manetho *.

Previously, however, to their arrival in Egypt, Shinaar in Mesopotamia afforded them an asylum. Here it was that Nimrod broke in † : and, as I have before but *transiently glanced* at that circumstance, I shall now revert to it with more precision.

Between the tenets of the *Pish*-de-danaans and those of their *Tuath*-de-danaan predecessors, there was but a single point of dissentient belief. The language, the customs, the manners and modes of life of both were the same. To all intents and purposes they were one identical people.

But as the former had imagined that the *Yoni* alone was the author of *procreation,* while the others claimed that honour for their own symbol, the *Lingam,* an animosity ensued, which was not allayed even by the consciousness, that *each,* secretly, worshipped the type of the *other's* creed.

The *goddess,* however, prevailed in the struggle, and her glories in Iran were great and far spread. Monarchs bowed at the nod of her omnipotence, and the earth swelled with the gestations of her praise ‡.

* The *date* of those Uksi was not the only misconception this historian has committed. He was equally in the dark as to the *place* whence they came, and, for want of a better name, called them, at a venture, Arabians!

† See page 64.

‡ Most of the *oracles* in the ancient world were but *personifications* of this influence—the *goddess* invariably being the sacred Yoni. And the priestesses so far prevailed upon the credulous worshippers as to make them believe that *she* actually spoke! The oracle of *Delphi,* the most venerable in all Greece, obtained its name from the *very thing*— the first syllable *De,* signifying *divine* or *sacred;* and the second *phi,* i. e., phith, *yoni:* the letter *l* having been inserted only for euphony. Even in the *Greek* language this import is not yet lost.

" *Sed ultima dies semper homini est expectanda.*" A rude and a lawless swarm of stragglers, headed by an adventurer of commanding abilities and determined heroism, *deluged,* in turn, the *Boatmen,* or the *Noachidæ* *, and swamped them in a *flood,* as *sanguinary* and as *disastrous,* as that which they had, themselves, before, brought upon the adversaries of their zeal.

But it was not the *bloodshed* of the scene that affected them half so much as the *insult* offered by the erection of the *Tower* †*!* And as no clue can be so adequate for the analysis of this *enigma,* as that which they themselves have bequeathed—for it was from the *Yavanas* or *Pish*-de-danaans that Moses had been taught the fact—I shall place such before your eyes, in all the eloquence of a self-interpreting dissyllable.

מגדל is the name by which the scriptural record

* As *Noah* was himself named from the *symbolical boat,* so was his eldest son *Japheth,* from its sanctified *prototype.* *Ja-Phith* signifies *consecrated to Pith,* or the *Yoni.* And again, *his* son's name, *Ja-van,* means *consecrated to woman.*

† " In the city of Babylon there is a temple with brazen gates, consecrated to Jupiter Belus, being four square; and each side being two furlongs in length. In the midst of this holy place there is a solid tower, of the thickness and height of a furlong; upon which there is another tower placed, and upon that another; and so on, one upon another, insomuch that there are eight in all. On the outside of these there are steps or stairs placed, by which men go up from one tower to another. In the middle of these steps there are resting-places; and rooms were made for the purpose, that they who go to the top may have conveniences to sit down and rest themselves."—HERODOTUS.

" 'Tis a tower exactly round, in form of a cone, or round pyramid; the diameter, or thickness at the base, being 81 feet; the circumference, or way round, 254½ feet; the height perpendicular likewise 81 feet, equal to the diameter; the height likewise, oblique, 90½ feet; and the angles of the sides equal to those of the former design: the whole likewise a mass of brick and bitumen work, amounting to 140,589 cubic feet, upon 5207 square."—MARK GREGORY.

perpetuates this structure *. If you put this into English letters, and read them regularly, from left to right, it will be *Lidgam*. But the Hebrews read in the opposite direction, from right to left; and that is the very cause of the appearance of the *d* in the word; for as *Magnil*—reading backwards—would produce a *cacophony*, the *n* of the original was left out, and *d* substituted, making *Magdil:* reinstate, therefore, the *n*, and enunciate the Hebrew word, as you would the Irish or the Sanscrit, and it will not only unmask the *secret* of this long disputed edifice, but *be, sound,* and *personate,* in all the nicety of accentuation, *Lingam,* and thus prevent all further controversy about the character of the *Tower* of Babel.

> The waies through which my weary steps I guide,
> In this researche of old antiquitie,
> Are so exceeding riche, and long, and wyde,
> And sprinkled with such sweet varietie,
> Of all that pleasant is to eare and eye,
> That I, nigh ravisht with rare thought's delight,
> My tedious travel quite forgot thereby;
> And when I gin to feel decay of might,
> It strength to me supplies and cheers my dulled spright †.

* Genesis xi. 4.

† Spenser's Faerie Queene.

CHAPTER XXI.

I HAVE stated that it was from the *Pish*-de-danaans or Yavana philosophers of Egypt that Moses had learned the allegories of the Deluge and of the Fall. I now add, *that it was by them also he had been instructed in that consolatory assurance which told him* that the " seed of the woman should bruise the serpent's head *."

In truth, it was this very promise made to the ancestors of those people in *Paradise*, which is but another name for *Iran* †, that gave rise to the *schism* between them and the *Tuath*-de-danaans.

" Unto the woman he said, I will greatly multiply thy sorrow and thy *conception ;* in sorrow thou shalt *bring forth children ;* and thy *desire* shall be to thy husband, and he shall rule over thee ‡."

The *nature* of the *crime* is here clearly denoted by the *suitableness* of the *punishment* §. But the same over-ruling Judge, who, in conformity with his justice, could not but chastise the violation of his injunctions, yet, in mercy to man's weakness, and seeing that " he also is flesh," condescended to promise that the

* *Shiloh* is an *Irish* word, literally meaning *seed*, and additionally showing that it was in our *sacred* language all those occurrences were *originally named.*

† Both words equally signify the *happy country*, or the *sacred land.*

‡ Genesis iii. 15.

§ See chap. xvii., page 229.

instrument of his *seduction* should be also the *vehicle* of his *redeeming triumph.*

" I will put enmity between thee (the serpent) and the woman, and between thy seed and her seed ; it shall bruise thy head, and thou shalt bruise his heel *."

Pinning their faith upon the literal fulfilment of these terms, which told them that the *female, as such,* would be the unaided author of a *being,* whose healing effects would restore them to the inheritance so heedlessly forfeited, their veneration for that *symbol* of divine interposition became correspondingly unbounded ; and their enthusiasm, for the principle of its strict verification, was what engendered the thought, that, in the general procreating scheme, the *yoni* was the *vivifier.*

The *Tuath*-de-danaans, or Lingajas, on the other hand, were not less satisfied in their security ; but looking upon the terms with a more *spiritual* interpretation, and led by the operation of ordinary *physics,* to consider the question as a *deviation* from the *general rule,* they erected the symbol of *male* capability as the standard of their doctrine. And thus while the zeal of both parties shook the very frame-work of society, yet did they *concur* in all the *essentials* of their respective religions ; and even the particulars of that *prospect* by which they were both sustained, instead of operating as an exception to the universality of this truth, only confirm its import.

The Jews, who were but *newly* brought forward upon the stage, and who, in the inscrutable councils of heaven, were selected as the objects of God's

* Genesis iii. 15.

immediate superintendence, being informed of the tenour of the Paradisaical hope, abused it more wantonly than ever did the *Pish*-de-danaans or the *Tuath*-de-danaans.

Unable to comprehend, from their narrow mental calibre, any *agency* in the form of a divine *emanation*, and yet fancying, each of them, that she would herself be the mother of the expected Redeemer, their women indulged in all the lusts of *desire*, and, where no opportunity offered for licensed gratification, revelled in the arms of incest.

This alone can apologize for that intensity of passion, exceeding even the dictates of natural thirst, and unrestrained by the consideration of decency or consanguinity, whereof we read in the Old Testament, respecting the Israelitish daughters *; while it also demonstrates, that the *carnality* of their souls did not allow them, thoroughly, to understand the precise nature of the *favour* designed.

Far otherwise the case with the *intellectual* races, which they were now appointed to supersede.

" In order to reclaim the vicious, to punish the incorrigible, to protect the oppressed, to destroy the oppressor, to encourage and reward the good, and to show all spirits the path to their ultimate happiness, God has been pleased to manifest himself, say the Brahmins, in a variety of ways, from age to age, in all parts of the habitable globe. When he acts immediately, without assuming a shape, or sending forth a new emanation, when a divine sound is heard from the sky, that manifestation of himself is called *acasavani*, or an etherial voice : when the voice pro-

* Genesis xix, 31, 32, 33, 34.

ceeds from a meteor, or a flame, it is said to be *agna-
rupi*, or *formed of fire ;* but an *avatara* is a descent of
the Deity in the shape of a mortal ; and an *avantara*
is a similar incarnation of an inferior kind, intended
to answer some purpose of less moment. The Supreme
Being, and the celestial emanations from him, are
niracara, or bodyless, in which state they must be invi-
sible to mortals; but when they are *pratya-sha*, or
obvious to sight, they become *sacara*, or embodied,
either in shapes different from that of any mortal, and
expressive of the divine attributes, as Chrishna
revealed himself to Arjun ; or in a human form,
*which Chrishna usually bore, and in that mode of
appearing, the deities are generally supposed to be born
of women without any carnal intercourse* *.*"

Is this repugnant to the spirit of Christianity?
No; it is its counterpart. " I know," says Job, in the
moment of inspiration, " that my Redeemer liveth †."
Prophetically, you reply ; and you back the opinion
by our Saviour's own appeal, that " Abraham saw his
day and was glad ‡."

Abraham, certainly, believed by anticipation, but
Job by retrospection. And if you will not think my
assertion decisive of the matter, I will produce an
authority to which you will more readily subscribe.

" And all that dwell upon the earth shall worship
him whose names are not written in the book of life
of *the Lamb slain from the foundation of the world* §."

It will be in vain for you to attempt to parry the
evidence of this startling text. No visionary *fore-
sight* will accomplish its defeat: no ideal *substitutions*
will shake its validity.

* Asiatic Researches. † Job xix. 25.
‡ John viii. 56. § Revelation xiii. 8.

" How it came to pass," says Skelton, " that the Egyptians, Arabians, and Indians, before Christ came among us, and the inhabitants of the extreme northern parts of the world, ere they had so much as heard of him, *paid a remarkable veneration to the sign of the cross*, is to me unknown, but *the fact itself* is known. In some places this sign was given to men accused of a crime, but acquitted : and *in Egypt it stood for the signification of eternal life* *."

" V. W." has asserted something similar † ; but neither one nor the other has attempted to fathom its origin.

" The Druids," adds Schedius, " seek studiously for an oak tree, large and handsome, growing up with *two principal arms, in form of a cross*, beside the main stem upright. If the two *horizontal arms* are not sufficiently adapted to the figure, they fasten a *cross*-beam to it. This tree they consecrate in this manner. Upon the right branch, they cut in the bark, in fair characters, the word *Hesus :* upon the middle or upright stem, the word *Taramis :* upon the left branch, *Belenus :* over this, above the going off of the arms, they cut the name of God, *Thau :* under all, the same repeated *Thau* ‡."

" The form of the great temple," observes Dr. Macculloch, " at Loch Bernera, in the Isle of Lewis, the chief isle of the Hebrides, is that of a *cross*, containing, at the intersection, a circle with a central stone ; an additional line being superadded on one side of the longest arms, and nearly parallel to it.

* Appeal to Common Sense, p. 45.

† See Chap. xvi. p. 224.

‡ De Morib. German. xxiv.

Were this line absent, its proportion would be nearly that of the Roman cross, or common crucifix."

And then, in reply to the supposition of its having been converted by the *Christians* into this form, he avers that " the whole is too consistent, and too much of one age, to admit of such ; while at the same time, it could not, under any circumstances, have been applicable to a Christian worship. Its essential part, the circular area, and the number of similar structures found in the vicinity, equally bespeak its ancient origin. It must, therefore, be concluded, that the cruciform shape was given by the original contrivers of the fabric ; and it will afford an object of speculation to antiquaries, who, if they are sometimes accused of *heaping additional obscurity on the records of antiquity,* must also be allowed the frequent merit of eliciting light from darkness. *To them I willingly consign all further speculations concerning it*.*".... "Yet it seems *unquestionable* that the figure of a cross was known to the Gothic nations, and also used by them *before they were* converted to Christianity †."

I do not know whether or not would the Doctor deem *me* an " antiquary," or if he did, in *which class* would he assign me a place. I will undertake, notwithstanding, to solve this difficulty with as much precision as I have the others before it.

The *existence* of the " cross," and its *worship*, anterior to the Christian era, being no longer liable to dispute, it remains only that we investigate the *cause* which it commemorates ‡.

* Western Islands, vol. i. p. 184, &c.

† Highlands, vol. iii. p. 236.

‡ " I inquired," says Mr. Martin, " of the inhabitants, what tradition they had concerning these stones ; and they told me, it was a place

Our first aid in this research will be the notice of its accompaniments; and when we find that it goes ever in the train of a particular divinity, are we not compelled to connect that divinity with the idea of a crucifixion?

Taut, amongst the Egyptians, is emblemized by *three* crosses*. The Scandinavians represent their *Teutates* by a cross. And a cross is the device by which the Irish *Tuath* is perpetuated.

But these are all one and the same name, varied by the genius of the different countries. The *centre* from which they *diverge*, as well as the *focus* to which they *return*, I have shown to be *Budh*: and as this *symbol* of his worship is universally recognized, does not the *crucifixion* thus implied, identify his fate with that of the " Lamb slain from the beginning of the world † ?"

The Pythonic *allegory* which the Greeks have so obscured, in reality originated in this religious transaction. For what is their fable? Is it not that *Apollo* slew with his *arrow* the serpent *Python?* And as Apollo means *son of the Sun*, is not the *substance* of the whole, that the *offspring of a virgin's womb*—that is, an *emanation of the Sun*, or *Budh*—overcame by his

appointed for worship in the time of heathenism; and that the chief Druid stood near the big stone in the centre, from whence he addressed himself to the people that surrounded him."

* United at the feet in this manner ⊢T⊣ . The jewel in the free-masons royal arch is thus formed. Noah was a freemason; and being the inventor of that *mysterious* and *sacredly-religious ceremony*, called the *Deluge*, we may be satisfied that all the *secrets* of that body bear reference to my developments. I look upon their institution as most *solemn* and *majestically sublime*.

† In the accounts transmitted to us of the various *Buddhas*, no term occurs more commonly as descriptive of their innocence and their meek-ness than that of *lamb*.

own *death*—typified by an *arrow*—sin and *sensuality,* of which the *serpent,* i. e. *pith,* is the symbol?

We are now prepared for the reception of that chronicle, transmitted through the Puranas, and noticed already at page 221 ; viz., that a " giant, named Sancha-mucha-naga, in the shape of a *snake,* with a *mouth* like a *shell,* and whose abode was in a *shell,* having *two countenances,* was killed by Christnah."

The *very name* of this allegoric " giant " indicates the *mysterious snake*—his being in the *form* of a *snake* is but the *personification* of *sensuality*—his having a *mouth* like a *shell* alludes to the *concha Veneris,* or the *Pith*—his having his *abode* in that *shell* denotes its being the *seat* of *temptation*—his having *two countenances* implies the *disguise* which *sin* assumes—and his being *slain* by *Christnah* denotes that the *Son of God,* by *mortification and self-denial, and the most rigid abstinence from all worldly pleasures,* verified, in *his own person, the promise made in Paradise,* and for the *minor disquietudes* which *guilt* entails—expressed by the " *heel* " being " *bruised* " by the " *serpent,*"— inflicted a *blow,* which laid low his empire, and stamped the signal of *victory* over his " head *."

" Ye search the Scriptures," says our Saviour, " for in them ye think ye have eternal life : and they are they which *testify* of me †."

Testification can be made only in the case of a past occurrence. It is never used in the way of prophecy. And in conformity with its true import, you will find, from Genesis to Revelation, the concurrent tenor of the Sacred Volume giving proof to the fact of Christ's former appearance upon the earth as man !

But suppose me for a moment to descend from this

* Gen. iii. 15. † Luke iii. 39.

position, and view those previous manifestations as ordinary subjects of history, then hear an outline of what is transmitted to us respecting one of them.

Chanakya, Zacha, or, as our registers have it, Macha *, one of the personifications of Budh, the general appellative of those heaven-sent devotees, was so startling a paragon of human impeccability, as to inspire his followers with the conviction, of his being an incarnation of the Godhead.

He is stated to have been the son of one of the most powerful of eastern kings; but, according to their preconceived notions of the future Redeemer, born of his mother without any knowledge of the other sex.

The circumstances attendant upon his infantine education, and the precocity of his parts, favoured an inauguration upon which their fancies had been long riveted. After a laborious ordeal of pious austerity, not without miraculous proofs and other intimations of Divine approval, he was duly admitted to the honour of canonization, and entered, accordingly, upon his task of consigned Saviour of the world.

The encounters with which he had to contend, in this uphill work, against flesh and blood, were those which were, afterwards, again combated by the *admitted* Saviour whom he had personated. The same faults he reprehended; the same weakness he deplored; the same hypocrisy he rebuked; and the same virtues he inculcated. The purification of the inner spirit was the object which both professed, and the improvement of human morals in social intercourse and relation, the evidence in practice, upon which both equally insisted.

* See page 132.

If Christ promised a *heaven* to the votaries of his truths, Budha did a *nirwana* to his disciples and imitators : and though the former place, to our imagination, sounds *replete with all delights*, while the latter is merely figured as exempt from all *painfulness*, yet *both* agree in one particular, not a little soothing to wounded hope, in being essentially such, as where " the wicked cease from troubling, and where the weary are at rest."

But great as was the resemblance which the personal example and the doctrinal lessons of Macha and Christ bore to one another,. it was as nothing compared to the almost incredible similitude of their respective departures. They both died the inglorious death of the *cross* to reconcile man to his offended Creator ; and in confident dependence upon the best authenticated assurance, exulted on the occasion,.however galling the process, of expiating, by their own sufferings, the accumulated sins of humanity.

Is it to be wondered at, therefore, that the traces which they have left behind them, in their different ages, should bear an analogy to one another ? Or would not the wonder rather be that they did not, in all respects, harmonise?

" Let not the piety of the Catholic Christian," says the Rev. Mr. Maurice, " be offended at the preceding assertion, that the *cross* was one of the most usual symbols among the hieroglyphics of Egypt and India. Equally honoured in the Gentile and the Christian world, this emblem of universal nature, of that world to whose quarters its diverging radii pointed, decorated the hands of most of the sculptured images in the former country, and in the latter

stamped its form upon the most majestic of the shrines of their deities * .”

The *fact* alone is here attested to : not a syllable is said as to the *reason why:* and though I cannot but recognise the *scruples* of the *writer,* nor withhold my admiration from the *rotundity* in which the diction has been cast, yet the reader must have seen that, as to *actual illustration,* it is,—like the Rev. Mr. Deane's *flourish* about the worship of the serpent—*Vox et præterea nihil* † *!* ”

“ You do err, not knowing the Scriptures ‡,” said a master, *without pride,* and *who could not err.* If the remark applied in *his* day, it is not the less urgent in ours. So astounding did the correspondence between the Christian and the Budhist doctrines appear to the early missionaries to Thibet and the adjacent countries—a correspondence not limited to mere points of *faith* and preceptorial maxims, but exhibiting its operation in all the outward details of *form,* the inhabitants going even so far as to wear *crosses* around their necks—that Thevenot, Renaudot, Lacroze, and Andrada, have supposed, in their ignorance of the cause of such affinity, that Budhism must have been a vitiation of *Christianity* before planted ; whereas *Budhism* flourished thousands of years before it, or Brahminism either; and *this cross was the symbol of Budha crucified.*

“ Our second illustration,” says the ‘ Dublin Penny Journal,’ referring to what I have here introduced, “ belongs to a later period, and will give a good idea of the usual mode of representing the *Saviour,* whe-

* Indian Antiquities, vol. ii. p. 361.
† See chapter xvi. p. 221.　　‡ Matthew xxii. 29.

ther on stone crosses, or on bronze, which prevailed
from the sixth to the twelfth century. Such remains,
however, are valuable, not only as memorials of the
arts, but as preserving the Celtic costume of a portion

of the inhabitants of our island in those remote ages.
It will be seen that in *this*, as in one of the shrine-
figures before given, the kilt, or philibeg, is dis-

tinctly marked, and *controverts the erroneous assertion* of Pinkerton, formerly noticed, that " it was always quite unknown amongst the Welsh and Irish *."

How others may receive it, I do not know; but for myself, I confess, I find it no easy matter to maintain the composure of my countenance at this affected *pomposity* of censorial *magniloquence.* The *self-complacency* of the *censor* one could tolerate with ease, if the *assumption* of the *historian* had aught to support it. But alas! every position in the extract is the direct opposite of truth, with the exception of that which asserts another person's error; and even this is beclouded with such egregious obscurations as to show, that leaving *Pinkerton* to P———— † would be consigning the blind to a blinder conductor.

For, in the first place, the *philibeg* was not a *Celtic* costume at all, but belonged to the De-danaan, or Iranian colony ‡, who, on their overthrow here, took it with them to what is now called Scotland. The Firbolgs, who were Celts, and occupied this island before the Iranians, wore another style of dress altogether, which, on the re-conquest of the country by the Scythian swarms, B.C. 1000, became again the national uniform. For the Firbolgs, having assisted the Scythians in dislodging the Iranians from the throne of the kingdom, and agreeing with them furthermore in point of worship and of garb, they did not only make *their own habits,* as well of *religion* as of *dress,* universal throughout the realm, but obliterated every vestige of the *obnoxious* costume, and cancelled every symptom of its characteristic cere-

* Vol. i. page 308, on the article " Fine Arts."
† The initial subscribed to the article.
‡ See Appendix.

monial, except alone those Round Temples of ada-
mantine strength, which defied the assailment of all
violence and batteries.

There was no remnant, therefore, of the kilt to be
met with in Ireland, either in the *sixth* century, or in
the *twelfth,* or indeed for many centuries before the
Christian era at all. This effigy *, therefore, *could
not have been intended for our Saviour,* wanting, be-
sides, the I. N. R. I. †, and wearing the *Iranian regal
crown,* instead of the *Jewish crown of thorns.* There-
fore are we justified in ascribing it to its owner,
Budha, whom again we find imprinted in the same
crucified form, but with more *irresistibility of identifi-
cation,* over the monuments of his name—over the
doors and lintels of the temples of his worship.

* Like the two former effigies, at pages 138 and 140, it is made of
bronze, and found in Ireland after the Tuath-de-danaans. Those found
after their brethren in the East are made of the same metal. " Some-
times," says Archer, " the *images* are of *wood* or *stone,* but these, unless
possessing the rarity of some monkish legend, are not in such repute as
their brothers of *brass.*"

† This is the only *peculiar* monogram of Jesus Christ—I. H. S. be-
longing originally to Budha, though appropriated afterwards to *him.*
ϒ H Σ was its proper form, and it comprehended a mysterious number,
as follows:—

$$\begin{array}{ll} \text{ϒ} \quad . \quad . \quad . \quad . \quad . \quad 400 \\ \text{H} \quad . \quad . \quad , \quad . \quad . \quad 8 \\ \text{Σ} \quad . \quad . \quad . \quad . \quad . \quad 200 \\ \hline \quad\quad\quad\quad\quad\quad 608 \end{array}$$

Another monogram of Budha was Φ P H. It composed the same
numerical enigma, viz.—

$$\begin{array}{ll} \text{Φ} \quad . \quad . \quad . \quad . \quad . \quad 500 \\ \text{P} \quad . \quad . \quad . \quad . \quad 100 \\ \text{H} \quad . \quad . \quad . \quad . \quad . \quad 8 \\ \hline \quad\quad\quad\quad\quad\quad 608 \end{array}$$

Salve vera Deum facies, vultusque paternæ,
Octo et sexcentis numeris, cui litera trina
Conformet sacrum nomen, cognomen et omen.
 MARTIANUS CAPELLA.

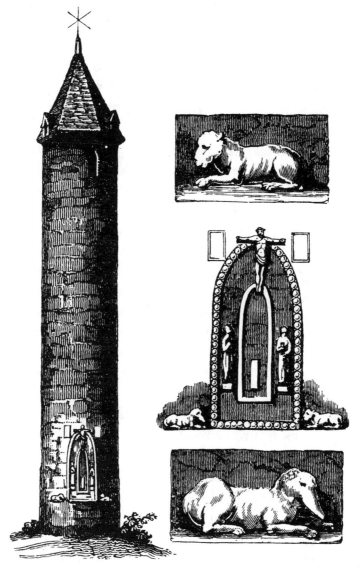

Mr. Gough, describing this edifice, tells us that " On the west front of the tower (Brechin) are two arches, one within the other, in relief. On the point of the outermost is a *crucifix*, and between both, towards the middle, are figures of the Virgin Mary and St. John, the latter holding a cup with a lamb. The outer

arch is adorned with knobs, and within both is a slit or loop. At bottom of the outer arch are *two beasts couchant. If one of them, by his proboscis,* was not evidently *an elephant,* I should suppose them the supporters of the Scotch arms. Parallel with the crucifix are two plain stones, which do not appear to have had anything upon them *."

Captain Mackenzie, in his antiquities of the West and South Coast of Ceylon, which still professes adherence to Budhism, tells us that " *at each side of the doorway* (of the temple at Calane), *inclosed in recesses cut in the wall, are two large figures, the janitors of the god* (Budh) A large elephant's tooth and a small *elephant of brass form the ornament* of a lampstead A female figure of the natural size, decently and not ungracefully arrayed in the same garb, was represented standing in another quarter, holding a lamp in the extended hand. The gallery was entirely covered with paintings, containing an history of the life of Boodhoo—one of these seemed to represent the birth of the divine child. A *large white elephant* made a conspicuous figure in most of these assemblies †."

Scotch arms, indeed! Why, Sir, those animals were recumbent there, in deified transfiguration, before ever *Pict* or *Scot* had planted a profane foot within their neighbourhood. What connexion, let me ask, could this *elephant* and this *bull* have with Christianity, to entitle them to the honour of being grouped with our Saviour? Or, if any, how happens it that we never see them enter into similar combinations, in *churches* or *chapels,* or *convents* or *cathedrals* † ?

* Arch. Soc. Ant. Lond. vol. ii. p. 83.
† Asiatic Researches.

But if they belong not to the Christian ceremonial, they do to something else. They are the *grand, distinctive* and *indispensable adjuncts of Budhism ;* being the *two animals* into which, *according to its doctrine of metempsychosis, the soul of Budha had entered after his death*.

This was the origin of the Egyptian *Apis :* and who is not familiar with the honours lavished upon the sacred *bull?* To this day the *elephant* is worshipped in the Burman empire*, where the genius of *Budism* still lingeringly tarries; and " *Lord of the White Elephant*" is the proudest ensign of power claimed by the successors to the throne of Pegu.

The *human* figures, then, *of course,* cannot be intended for " *St. John* or the *Virgin Mary.*" They represent *Budha's Virgin Mother,* along with his *favorite disciple, Rama.* And thus does the testimony of Artemidorus, who *flourished* 104 *years before Christ,* a native himself of Ephesus, and *who did not himself understand* the *mystery* of that *Virgin* whom he historically records, receive *illustration* from *my proof,* while it gives *it confirmation* in return.

His words are—" Adjacent to Britain there stands an island, where *sacred rites* are performed to Ceres and the *Virgin,* similar to those in Samothrace."

Initiation in the principles of this Samothracian ceremonial was thought so necessary an accomplish-

* " He has a separate apartment, shrouded from vulgar eyes by a black velvet curtain, richly embossed with gold, in a splendid palace at Ummerapoor: and his whole residence is as dazzling and sumptuous as gold and silver can make it. He is furnished with a silk bed, adorned with gold tapestry, hangings, and jewellery, and has his gold appurtenances. Foreign ministers are introduced to his sacred person, and he ranks before every member of the royal court except the king."— SYMES.

ment for every hero and every prince, that no aspirant to those distinctions ever ventured upon his destination, without first paying a visit to that religious rendezvous. The solemnity, attaching to the ritual there performed, was not greater than the veneration paid to the place itself. All fugitives found shelter within its privileged precincts, and the name of *sacred* was assigned it, as the ordinary characteristic of such sanctuaries *.

" There are," says the Scholiast upon Aristophanes, " two orders of mysteries celebrated in the course of the year, in honour of Ceres and *the Virgin*—the lesser and the greater; the former being but a sort of purification and holy preparation for the latter †."

Who this Virgin was, however, none but the *initiated* ever presumed to investigate, the practice observed in respect to her, being the same as that which influenced the other ordinances of antiquity : and which made Strabo himself declare, that " *all that can be said concerning the gods must be by the exposition of old opinions and fables : it being the custom of the ancients to wrap up in enigma and allegory their thoughts and discourses concerning nature, which are, therefore, not easily explained ‡.*"

Proclus also says, " In all initiations and myste-

* It was only as an *epithet* that the title *sacred* could apply to Samothrace : and as such, every other locality, wherein those mysteries were commemorated, shared it in common. But in *this our island*, to which Artemidorus above alludes, and where superior solemnity attended the celebration, the name of *sacred* was no adventitious clause, but, *par excellence*, the *constituent essence* of its *proper appellation.*—See pages 128, 9.

† Μυστηρια δι δυο τιλιιται του ινιαυτου ; Δημητρι και Κορη ; τα μικρα και τα μιγαλα· και ιστι τα μικρα ωσπιρ προκαθαρσις και πραγνιυσις των μιγαλων.

‡ Lib. x. p. 474.

ries, the gods exhibit themselves under many forms, and with a frequent change of shape; sometimes as light defined to no particular figure; sometimes in a human form; and sometimes in that of some other creature *."

With the clue, however, already afforded, we need not be deterred from approaching her fane. The allegorical name, under which they disguised her, was that of *Proserpine:* whom they represent " so beautiful that *the father of the gods himself became enamoured of her, and deceived her by changing himself into a serpent, and folding her in his wreaths* †."

This was the *Greek perversion* of the narrative. They had received it from the Pelasgi, under the garb of a *conception*, by *serpentine insinuation, in a virgin womb:* and, the grossness of their intellects not allowing them to comprehend the possibility of an *emanation*, yet giving unqualified credence to the record, they degraded altogether the *religiousness* of the thought, and supposed that the Almighty, to effectuate his design, had actually assumed the *cobra di capello* form!

So austere was the rule, by which those mysteries were protected, that Æschylus but *barely escaped discerption within the theatre*, for an imagined disrespect to their tendency. Nor was it but on the plea of ignorance and *un*-initiation, that he did ultimately obtain pardon ‡.

This insuperable barrier to the curiosity of the profane, engendered in their conduct a correspond-

* ιις την Πολιτ. Ιλατ. p. 380.

† See the article under her name in the Classical Dictionary, with all the authorities there adduced.

‡ Clem. Alex. Strom. ii.

ing re-action, and, as the *fox* did to the *grapes*, what they could not themselves compass, they strove all they could to vituperate!

" Virtue, however, is its own reward;" and, as the authority of Cicero, having been himself a priest, ought to have some weight in this discussion, it is no small impetus to the cause of truth, to hear this pre-eminent man assign to the efficacy of the precepts, inculcated in those mysteries,—" the knowledge of the God of nature; the first, the supreme, the intellectual; by which men had been reclaimed from rudeness and barbarism, to elegance and refinement; and been taught, not only to live with more comfort, but to die with better hopes *."

> Slave to no sect, who takes no private road,
> But looks through Nature up to Nature's God;
> Pursues that chain which links the immense design,
> Joins heaven and earth, and mortal and divine,
> Sees that no being any bliss can know,
> But touches some above, and some below;
> Learns from this union of the rising whole,
> The first, last purpose of the human soul;
> And knows where faith, law, morals, all began,
> All end in love of God and love of man †.

* Mihi cum multa eximia divinaque videntur Athenæ tuæ peperisse—tum nihil melius illis mysteriis quibus agresti immanique vitâ exculti ad humanitatem mitigati sumus : initiaque, ut appellantur, ita revera principia vitæ cognovimus : neque solum cum lætitiâ vivendi rationem accepimus, sed etiam cum spe meliori moriendi.—*De Legibus,* l. i. c. 24.

† Pope.

CHAPTER XXII.

I WOULD have my reader pause upon the substance of the terms with which the last section concluded—" Not only to live with more comfort, but to die with better hopes ! "

Have you read them? Have you digested them? And are you not ashamed of your illiberality?

From what pulpit in Christendom will you hear better or more orthodox truths? Where will you find the Gospel more energetically enunciated? And, with this *testimony* staring you in the face—in defiance of inner light—and imperiously subjugating the allegiance of rationality—will you still persist in limiting the benevolence of your " Father?" and in withholding every symptom of paternal regard from his own handywork, until the beginning of the last two thousand years? that is, as it were, till yesterday?

" I tell you, that if these should hold their peace, the *stones* would immediately cry out *."

" On a bank near the shore," says Cordiner, in his Antiquities of Scotland, " opposite to the ruins of a castellated house, called Sandwick (in Ross-shire), and about three miles east from Ferns, a very splendid obelisk is erected, surrounded at the base with

* Luke xix. 20.

large, well-cut flag stones, formed like steps. Both sides of this column are elaborately covered with various enrichments, in well finished carved work. The one face presents a sumptuous cross, with a figure of St. Andrew on each hand, and some uncouth animals and flowerings underneath. The central division, on the reverse, renders it a piece of antiquity well worthy of preservation ; there is exhibited on that such a variety of figures, birds, and animals, as seemed what might prove a curious subject of investigation; I have, therefore, given a distinct delineation of them at the foot of the column, on a larger scale, that their shapes might be distinctly ascertained, and the more probable conjectures formed of their allusion."

What, on earth, business would St. Andrew have in company with " uncouth animals?" What have " birds," " figures," and " flowerings" to do with Christianity? If this " obelisk" had not been erected here, in commemorative deification, centuries upon centuries before the era of his Saintship's birth, why should the " cross," which " one face presents," be decorated with " enrichments" brought all the way from Egypt?

Look at these hieroglyphics: and where will you find anything congenial to them within the empire of the Romans? Here is the *Bulbul of Iran**, the *boar* of Vishnu, the elk, the fox, the lamb, and the dancers. All the other configurations, without going through them in detail, are not only, in their nature and im-

* " The *Bulbul of Iran* has a passion for the rose, and when he sees any person pull a rose from the tree he laments and cries."—*Persian Poem*, quoted in Ouseley's Oriental Collections.

port, essentially eastern, but are actually the *symbols
of the various animal-forms under which they con-
templated the properties of the Godhead.* As the *cross,*
however, is that to which we are more immediately
directed, I shall confine myself, for the present, to
the establishment of its antiquity.

No one will question but that *Venus* was antece-
dent to the days of *St. Andrew ;* and *she* is repre-
sented with a *cross* and a circle*! *Jupiter* also, it
will be admitted, was anterior to his time; and we
find him delineated with a *cross* and a horn ! *Saturn*
is said to have been sire to the last-mentioned god,
and, by the laws of primogeniture, must have been
senior to him; yet we find *him* also pictured with a
cross and horn ! The monogram of Osiris is a *cross !*
On a medal of one of the Ptolemies is to be seen an
eagle conveying a thunderbolt with the *cross !* In
short, all through the ancient world this symbol was
to be encountered, and wherever it presented itself,
it was always the harbinger of sanctity and of peace.

Can we glean from their writings any confirma-
tion to my development as to the *origin* of the rite?
Plato asserts, that the form of the letter X was im-
printed upon the universe †. I know how this has
been interpreted as a reference to the Son of God,

* Basnage, b. iii. c. xix. s. xix.

† That phenomenon in the heavens, called the " Southern Cross,''
appears to me so associated with the *mystery* of redemption, in all ages,
that I cannot forbear drawing attention to the sign. The following is
Captain Basil Hall's description of this curious constellation.

" Of all the antarctic constellations, the celebrated *Southern Cross* is
by far the most remarkable; and must in every age continue to arrest
the attention of all voyagers and travellers who are fortunate enough to
see it. I think it would strike the imagination even of a person who
had never heard of the Christian religion; but of this it is difficult to

and the second power of the Divinity. I will not make use of it in any such light, preferring to avoid everything that may seem *equivocal,* yet am I well convinced that, under the philosopher's ratiocination, may be seen the twinkling trace of a previous incarnation of the λογος, and a crucifixion, likewise, as an atonement for the sins of humanity.

" Surely he hath borne our griefs and carried our sorrows : yet we did esteem him stricken, smitten of God, and afflicted.

" But he was wounded for our transgressions, he was bruised for our iniquities : the chastisement of

judge, seeing how inextricably our own ideas are mingled up with associations linking this sacred symbol with almost every thought, word, and deed of our lives.

" The three great stars which form the Cross, one at the top, one at the left arm, and one, which is the chief star, called Alpha, at the foot, are so placed as to suggest the idea of a crucifix, even without the help of a small star, which completes the horizontal beam. When on the meridian, it stands nearly upright ; and as it sets, we observe it lean over to the westward. I am not sure whether, upon the whole, this is not more striking than its gradually becoming more and more erect, as it rises from the east. In every position, however, it is beautiful to look at, and well calculated, with a little prompting from the fancy, to stir up our thoughts to solemn purposes.

" I know not how others are affected by such things, but for myself I can say with truth, that during the many nights I have watched the Southern Cross, I remember on two occasions, when the spectacle interested me exactly in the same way, nor any one upon which I did not discover the result to be somewhat different, and always more impressive than what I had looked for. This constellation, being about thirty degrees from the South Pole, is seen in its whole revolution, and accordingly, when off the Cape of Good Hope, I have observed it in every stage; from its triumphant erect position, between sixty and seventy degrees above the horizon, to that of complete immersion, with the top beneath, and almost touching the water. This position, by the way, always reminded me of the death of St. Peter, who is said to have deemed it too great an honour to be crucified with his head upwards. In short, I defy the stupidest mortal that ever lived, to watch these changes in the aspect of this splendid constellation, and not to be, in some degree, struck by them."—*Fragments of Voyages.*

our peace was upon him; and with his stripes we are healed *."

This is all in the past tense; bearing reference, irrefutably, to a *former* occurrence, but including, also, in the sequel, the idea of a *future* reappearance. And if you look back at the effigy, page 296, will it not sensitively prove him to have been " a man of sorrows and acquainted with grief † ?"

" The deity Harì," says an inscription at *Buddagaya*, in India, " the lord and possessor of all, appeared in this ocean of natural beings at the close of the Devapara and beginning of the Cali Yug. He who is omnipresent and everlastingly to be contemplated, the Supreme Being, the Eternal One, the Divinity worthy of mankind, appeared here, with a portion of his divine nature ‡."

There is no term so vernacular in the Irish language as that of *Budh-gaye*. It is familiar to the *ears* of every smatterer in *letters ;* and is in the *mouth* of every *cowherd*, from Cape Clear to the Giants' Causeway. Neither class has, however, had so much as a *glimpse* of what it means : nor did they busy themselves much in the pursuit, but acquiesced in that example of *commendable* resignation once practised by Strabo—when he failed to ascertain anything about the *Cabiri*—by declaring that " the name was mysterious ! "

A great personage, however, who was not only in his habits *wise*, but was in himself *wisdom*, has affirmed, that " there is nothing covered that shall not be revealed ; nor hid that shall not be known §." And as every sentence recorded as emanating from

* Isaiah liii. 4, 5. † Isaiah liii. 3.

‡ Asiatic Researches. § Matthew x. 26.

his lips has with me a value more than what could serve to illustrate a momentary topic, I flatter myself that the result of the confidence, thus humbly inspired, will be additionally verified in the instance before us.

Budh-gaye, then of the Irish, or *Budha-gaya* of the Hindoos, means *Phallus* * *telluris,* i. e., the *generativeness of the earth,* or *the earth's prolific principle.* This I have before demonstrated to have been the object of adoration to the ancients; and have furthermore shown, that one of the individuals, in whom this idea was personified, had suffered crucifixion as a mediator for sin.

A new disclosure suggests itself from this. *Budh* and *Phallus* being synonimous, if you add *Gaye* to each, then *Budh-gaye* and *Gaye-phallus* will be identical. But, as the character, who embodied the *abstract virtue* of the former, had been crucified, his name came to stand, not only for that *abstract virtue,* but also for a cross†, or a *crucified man;* and of course, *Gaye-phallus,* its equivalent, represented the same ideas.

Now, as well the *primary* as *secondary* meaning of those two words was liable to misconstruction; and they were sure to obtain such from ignorance and from depravity. The *pure* and the *sublime emotions,* which the religiousness of the *prolific principle* had

* This will explain a text in Scripture never before understood, viz., "Son of man, when the land sinneth against me by trespassing grievously, then will I stretch out mine hand upon it, and will break *the staff of the bread thereof,* and will send famine upon it, and will cut off man and beast from it." Ezekiel xiv. 13. *Fogh* is another term equivalent to this.

† This will at once appear from Varro, who, in Nonus Marcellinus, is made to say, "We are barbarians, because that we crucify (in gabalum suffigimus) the innocent; are you not barbarians, when you acquit the guilty?" Compare also Selden, Syntagm. ii. c. 1.

comprehended, were perverted by malice into *sen-suality* and *debauchery ;* while the idea of a *man cru-cified*, however innocent of charge, could not be separated, by grovelling and servile dispositions, from the ordinary accompaniments of *contempt* and of *crime*.

Hence *Budh-gaye* and *Gaye-phallus*, after a suc-cession of ages, when their *proper* acceptation was forgotten, were remembered only in their *perverted* sense. And accordingly we observe, that, when a Roman Emperor who had been brought up a priest in the East, assumed, on his being appointed to the Roman sceptre, the title of *Helio-ga-balus*, and thereby invested himself in all the attributes of *Gaye-phallus*, or *Budh-gaye*, that is, in other words, as the *Vicegerent of the Sun*, the licentiousness of his life, and the profligacy of his demeanour, having rendered him ob-noxious to his subjects, they amputated the *prefix* of his *Solar* majesty, and branded him with the *scorn* of *Ga-balus*.

The *disdain* intended in this latter abbreviation is now, therefore, already solved. *Gaye-phallus*, for sound-sake, having been made *Ga-phallus*, this latter was still further—by reason of the commutability of the letters *ph* and *b*—reduced into *Ga-balus*.

When the temple of Serapis, at Alexandria, was destroyed, we are told by Sozomon, that the mono-gram of Christ was discovered beneath the founda-tion. And, though neither party knew how to account for the sign, yet was it pleaded alike, by the Gentiles as by the Christians, in support of the heavenliness of their respective religions.

The early Roman *fathers*, very pious but very illite-rate men, unable to close their eyes against the proofs of the priority of the cross to the era of the advent,

did not scruple to assign it to the malicious fore-knowledge of the prince of the lower world *.

But if this gentleman had been the author of the early cross, is it likely that God would have embraced it, as the signal of his protection, when dealing destruction to the objects of his divine vengeance ?

" And the Lord said unto him, go through the midst of the city, through the midst of Jerusalem, and put a *mark* upon the foreheads of the men that sigh and that cry for all the abominations that be done in the midst thereof:

" And to the others he said, in my hearing, go ye after him through the city, and smite; let not your eye spare, neither have ye pity.

" Slay utterly old and young, both maids and little children, and women; but *come not near any man upon whom is the mark ;* and begin at my sanctuary†."

Now this " mark," in the ancient Hebrew original, was the *cross* X. St. Jerom, the most learned by far of those "*fathers*," has admitted the circumstance. And if this had been the device of the enemy of man, would the Author of all goodness so sanction *his* imposture, as to adopt it as the index of his saving love?

" Art thou a master of Israel, and knowest not these things ‡ ?"

But this was not the only *invention* which they attributed to the devil. Tertullian gravely assures us that he was the author of *buskins* also ! And why,

* Mithra signat illic in frontibus milites suos.—Tertullian, de Præscrip. cap. xi.

† Ezekiel ix. 4, 5, 6.

‡ John iii. 10. The omission of this *cross* from the text of our translation may afford some handle to the enemies of religion.

good reader, would you suppose?—in sooth, for no
other reason than because that our Saviour said, in
his sermon upon the mountain, " Which of you, by
taking thought, can *add one cubit unto his stature* ?*"

In him, also, did they find an adequate excuse for
those *apertures,* which I shall by and by notice, as
excavated in rocks and mounds of clay, calling them,
with some compliment, it must be admitted, to his
gallantry, by the monopolizing appellation of the
Devil's *Yonies* †.

But of all the *puerilities* which sully their zeal,
there is no one half so calculated to injure *vital
religion,* as the *low quibbles* and *dishonest quotations*
which Justin Martyr had recourse to, as *apologies* for
the *cross !*

Why, Sir, the greatest persecutor with which the
Christians had ever been cursed, namely, the emperor
Decius, had imprinted the *cross* upon some of his
coins !

Here, again, it is upon a medal, found in the ruins of
Citium, and proved, by Dr. Clarke, in his " Travels,"

* Matthew vi. 27. † *Cunni* Diaboli.

to have been Phœnician! It exhibits the *lamb*, the *cross*, and the rosary *!

When John the Baptist first saw Jesus beyond the Jordan, in Bethabara, he exclaimed, " Behold the Lamb of God, which taketh away the sins of the world †."

This he did not apply as a *novel* designation; but as the familiar epithet, and the recognised denomination of the Son of God, whose prescribed office it was, in *all the changes of past worlds*, as it was now in this present, to redress the broken-hearted, by taking away sin.

He adds, " This is he of whom I said, after me cometh· a man which is preferred before me; *for he was before me* ‡," not only in eternity, but on this earth.

" And I knew him not; but that *he should be made manifest to Israel* §," as he was before to other nations,—an event, which was but the fulfilment of a prophecy, ushered in, many years before, in these remarkable words—

" Behold, the former things are come to pass ||:" not that the *predictions* formerly delivered had taken place, but the *things*, the *events*, the *occurrences*, which had been *enacted* before, were now *re*-enacted! that a *renovation* of the world was at hand, which the mouth-piece of the Lord commences by saying— " New things do I declare; before they spring forth I tell you of them ."

On turning the leaf, you will see another of those

* The *rosary* was also anterior to Christianity.
† John i. 29. ‡ John i. 30.
§ John i. 31. || Isaiah xlii. 9.

pillars which grace a land of heroes, " where stones
were raised on high to speak to future times, with
their grey heads of moss* ;" and whose story, though
" lost in the mist of years," may yet be deciphered
from off themselves.

ꞏThis costly relic of religion, erected solely in
honour of the cross, is to be seen at Forres, in Scot-
land, and is thus described by Cordiner :—

" On the first division, under the Gothic ornaments
at the top, are nine horses with their riders, march-
ing in order; in the next division is a line of warriors
on foot, brandishing their weapons, and appear to be
shouting for the battle. The import of the attitudes
in the third division very dubious, their expression
indefinite.

" The figures which form a square in the middle
of the column, are pretty complex, but distinct; four
serjeants, with their halberts, guard a canopy, under
which are placed several human heads, which have
belonged to the dead bodies piled up at the left of
the division : one appears in the character of execu-
tioner, severing the head from another body; behind
him are three trumpeters sounding their trumpets;
and before him two pair of combatants fighting with
sword and target.

" A troop of horse next appears, put to flight by
infantry, whose first line have bows and arrows; the
three following, swords and targets. In the lower-
most division now visible, the horses seem to be
seized by the victorious party, their riders beheaded,
and the head of their chief hung in chains, or placed
in a frame : the others being thrown together beside
the dead bodies, under an arched cover."

* Temora.

With this compare the description given by Captain Head, of the devices sculptured upon one of the Egyptian antiquities.

" It would," says he, " far exceed the limits of this work, to attempt a description of the ornaments of sculpture in this temple. The most interesting are on the north wall, where there are battle-scenes, with innumerable figures of military combatants, using their arms, consisting of bows and arrows, spears and bucklers—of prostrate enemies, of war-chariots and horses. The fiery action and elegant shape of the steeds are remarkable. It would require a first-rate living genius to rival the variety of position, the power of effect, and fidelity of execution, in which men and horses are exhibited in the dismay of the flight, the agony of the death-struggle, and the exultation of the triumph."

Let us take a view, now, of the other side of this obelisk. " The greatest part of it," says Cordiner, " is occupied by a *sumptuous* cross, and covered over with an uniform figure, elaborately raised, and interwoven with great mathematical exactness ; of this, on account of its singularity, there is given a representation at the foot of the column. Under the cross are two august personages with some attendants, much obliterated, but evidently in an attitude of reconciliation ; and if the monument was erected in memory of the peace concluded between *Malcolm* and *Canute*, upon the final retreat of the *Danes*, these larger figures may represent the reconciled monarchs.

" On the edge, below the fretwork, are some rows of figures, joined hand-in-hand, which may also imply the new degree of confidence and security which took place, after the feuds were composed,

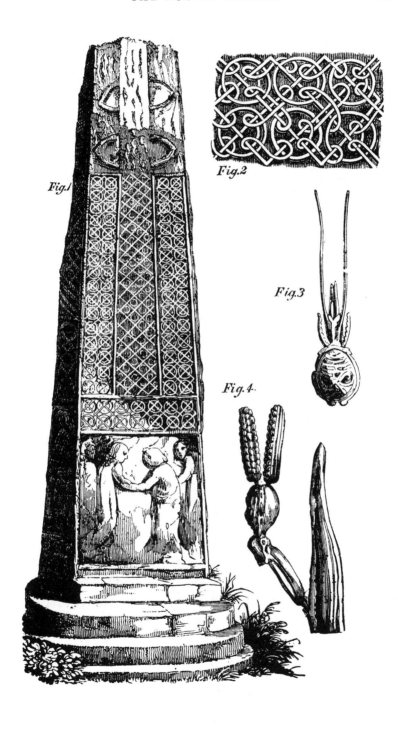

Fig.1

Fig.2

Fig.3

Fig.4

which are characterised on the front of the pillar. But to whatever particular transaction it may allude, it can hardly be imagined, *that in so early an age of the arts in Scotland as it must have been raised, so elaborate a performance would have been undertaken but in consequence of an event of the most general importance:* it is, therefore, surprising, that no distincter traditions of it arrived at the era when letters were known."

As to " the era when letters were known," I shall bestow upon that a sentence or two by and by. For the present I confine myself to the " surprise that no distincter traditions" of this *monolith* temple* has been handed down to us.

It was erected by the *Tuath-de-danaans* on their expulsion from Ireland. The inscriptions upon it are the irresistible evidence of their emblematic religion. After an interval of some centuries, the Picts poured in upon their quietude; and the barbarous habits of those marauders, being averse as much to the *ritual* as to the *avocations* of the Tuath-de-danaans, they effaced every vestige of the dominion of that people, and made them fly for shelter to the Highlands.

In the days of *Malcolm*, therefore, and of *Canute*, the history of this pyramid was as difficult of solution, as it was in those of *Pennant* and of *Cordiner*. And there is no question but that the two *monarchs* looked, with as much wonder, upon the hieroglyphics along its sides, as did the two *antiquarians*, who would fain associate them with them.

It is to me marvellous, how persons, in the posses-

* And this *stone*, which I have set for a *pillar*, shall be *God's house.* —Genesis xxviii. 22.

sion of common reason could, *contrary to all the evidence of observation and history*, look upon the Danish invasion as the epoch of all enlightenment! and the Danes, themselves, as the heaven-sent importers of its blessings! Yet, whatever may have been the case with *some hopeful* scions of this order, Mr. Cordiner, at all events, appears to have been honest, and if he missed the direction of historical verity, it was less his fault than his misfortune.

Who can say so much for Ledwich?

The following extract will justify the tribute here paid to the *sincerity* of Mr. Cordiner's investigations— " These monuments," says he, " are all said to have been erected in memory of defeats of the Danes, but there *does not appear any reference that the hieroglyphics on them can have to such events*. That they have been raised on interesting occasions there can be little doubt, perhaps in memory of the most renowned chieftains and their exploits who first embraced Christianity."

They who first " embraced Christianity" were no " chieftains;" or such as were, had no " exploits " to record. But it was not so with the professors of the *primeval* " cross," in the revelation of Budhism, the transmigrations of which were but typically pourtrayed on this enduring column. And in confirmation hereof, Mr. Gordon affirms that he has " distinguished upon it several figures of a *monstrous form*, resembling *fourfooted beasts* with human heads!"

Carnac, in Upper Egypt, retains a *monolith* of the same symbolic character. It is eighty feet high, composed of a single block of black granite, presenting a beautifully polished surface on each of its four sides. The hieroglyphics upon it represent the life-

time of *Thot*, or *Budda*, until you at last see him enthroned in heaven, at the top.

" He seems, indeed," says Hamilton, " to have been considered either by himself, his subjects, or his successors, as a peculiar favourite of heaven. He is frequently on his knees, receiving from Isis and Osiris, together with their blessing, the insignia of royalty and even of divinity. The hawk is always flying above him. Two priests are performing upon him the mysterious ceremony of pouring the *cruces ansatas*, or *crosses with rings*, over his head; at which time he wears a common dress and close cap. Hermes and Osiris are pointing out to him a particular line in a graduated scale, allusive it may be to the periodical inundation of the Nile, or the administration of strict justice: or, (combined with the preceding scene) to the ceremony of ' initiation into the religious mysteries *.' "

The number of feet in the pillar corresponds too, if I mistake not, with that of the years of his recorded pilgrimage.

Captain Head describes, in his splendid work, the avenue which leads to the temple to which this belongs, in the following terms : — " Fragments of sphinxes line the sides of the road at intervals of ten or twelve feet, and usher the visiter to the magnificent granite propylon, or gateway, whose grandeur for a time monopolizes the attention, and makes him who gazes on it at a loss to decide whether he shall remain adoring its fine proportions, or advance and examine the carvings which embellish its front. Is

* It is fit I should advertise that Mr. Hamilton spoke of the individual merely as a figure, without professing to identify him in name or history either with *Thot*, *Budha*, or *any body else*.

this ' the land made waste by the hand of strangers, who destroy the walls, and cause the images to cease ?' The fragments of desolation that lie scattered around are identified with the predictions of the inspired historians, by whom we are enabled to estimate the ' palmy state' of this once mighty kingdom, whose gigantic monuments fully verify all that has been said or sung of its pristine splendour."

After what has been said above, then, along with what may be added by and by, may I not safely proclaim that M'Pherson's prediction, that " the history of Caledonia, before the Roman eagles were displayed beyond the friths, must ever remain in impenetrable darkness *," has now been falsified ?

> What are *ages* and the lapse of time,
> Matched against *truths* as lasting as sublime ?
> Can length of years on God himself exact ?
> Or make that *fiction* which was once a *fact ?*
> No—marble and recording brass decay,
> And like the graver's *memory* pass away :
> The works of man inherit, as is just,
> Their author's frailty, and return to dust ;
> *But truth divine for ever stands secure,*
> *Its head is guarded, as its base is sure ;*
> *Fixed in the rolling flood of endless years,*
> *The pillar of the eternal plan appears,*
> *The raving storm and dashing wave defies,*
> *Built by that Architect who built the skies* †.

* Introduction, page xciii.
† COWPER.

CHAPTER XXIII.

A VERY industrious contributor to the " Asiatic Researches " has afforded scope for some jests at his expense, because of the attempt which he has made to identify the British islands with certain Western localities commemorated in the writings of the Hindoos. Had he but known, however, the coincidence of *our monuments* with those *mysteries* which the Puranas record ; how they mutually support and dovetail into each other, he could not only have laughed to scorn the traducers of his services, but fixed his fame upon a pinnacle of literary pride, which no *undergrowl* of envy could have subverted.

But as it is, unacquainted with the history of the places which he left behind him, and wading, therefore, through an ocean, in which he had no compass for his guide, he has, in his puerile endeavours to wrest the text of the Puranas to external prejudices, effected more himself towards the disparagement of his reputation, than what the combined influence of interest and of scepticism could otherwise accomplish.

" There are," say the Puranas, " many manifestations and forms of Bhagavan, O Muni, but the form which resides in the *White Island* is the primitive one. Vishnu," says the author, " recalling all his emanations into the *White Island*, went into the womb,

in the house of Vasu-devi; and on this grand occa-
sion he recalled all his emanations. Bama and
Nrisinha are complete forms O Muni; but Crishna,
the most powerful king of the *White Island*, is the
most perfect and complete of all Vishnu's forms. For
this purpose, Vishnu, from Potola, rejoins the body of
Radhiceswara, the lord of Radha, he who dwells in
the *White Island*, with the famous *snake*, a portion of
his essence. The gods sent there portions of their
own essences, to be consolidated into the person of
Crishna, who was going to be incarnated at Go-
cula *."

The gist of the foregoing, Mr. Wilford would neu-
tralize by this following extract, which he gives
as the substance of another notice in the same
documents, and which he considers, himself, as
incredible.

" *Bali*, an antediluvian, and in the fifth generation
from the creation, is introduced, requesting the god
of gods, or Vishnu, to allow him to die by his hand,
that he might go into his paradise in the *White Island*.
Vishnu told him it was a favour not easily .b-
tained; that he would, however, grant his request.
But, says Vishnu, you cannot come into my paradise
now; but you must wait, till I become incarnate in
the shape of a *boar*, in order to make the world
undergo a total renovation, to establish and secure it
upon a most firm and permanent footing: and you
must wait a whole yuga till this takes place, and then
you will accompany me into my paradise."

" Ganesa, who is identified with Vishnu, and has,
also, an inferior paradise in the *White Island*, and

* From the Brahma-vawartta, section of the Crishna-janma—c'hand'a.

another in the Euxine, or Jeshu sea, thus says to a king of Casi, or Benares, an antediluvian, and who, like Bali, wished much to be admitted into his elysium, " you cannot now enter my paradise, in the *White Island ;* you must wait 5000 years : but in the mean time you may reside in my other paradise, in the Euxine sea."

Now, all these monstrosities, as they presented themselves to Mr. Wilford, gaging them with the comparisons of dry rule and line, on the application of the true touchstone, vanish into ether.

The most *mysterious* and *religiously-occult* name given to *Ireland,* in the days of its pristine glory, was *Muc-Inis.*

This word has three interpretations—firstly, the *Boar Island*—secondly, the *White Island*—and thirdly, the *Sacred,* or rather, the *Divine,* and *Consecrated Island of God* *.

Is it necessary that I should say one syllable more to authenticate the Puranas, and identify this *hallowed* spot with the *paradise* of their encomiums ? No : I shall not affront your understanding by so supposing. The explanation of this *single term* has, more effectually than could a *ship load of folios,* set to flight the hobgoblins of ignorance and of scepticism, and reared the castle of truth on the ruins of prostrated error.

I would by no means, however, be understood as intending an ungenerous trophy over Mr. Wilford's mistakes. I respect the zeal with which he embarked in his undertaking; and, to speak over-board, the lapses, which he has committed, were to *him* ethically unavoidable.

* Much, mugh, mughsaine tra ainm sain delias do dheadh.—Cormac's Glossary.

The sting, therefore, of the above, if any it convey, must be directed exclusively to the *romancers* of
my own country : a specimen of whom I shall give
you in the Rev. Dr. Keating, who, venturing to unveil the mystery of the name *Muc-Inis,* and account
for its origin, tells us, with a serious face, that " when
the Danaans found the Milesians attempted to land,
by their magical enchantments they threw a cloud on
the island, by which it appeared no bigger than a
hog's back ! ! ! "

But Ireland, thank God, is rescued from the drivelling of such dotards. It will hold its place, now,
amongst the nations of the earth ; and the result is
inevitable, however tardy your compliance, but that the
truth will be *revived* from one pole of the universe to
the other, that, in the primeval world, all sanctity
and all happiness had here fixed their abode,—that
heaven was here personified,—and that the irradiating focus of all moral enlightenment was here
alone to be found *.

Look, Sir, what do you see before you ? The solution of that all-healing *arrow* which Abaris was
said to have brought with him from the island of the
Hyperboreans, on his visit of religion to Greece !

Should you ever chance to travel as far as the
county of Galway, inquire for the deserted village
of Knockmoy. Though now dreary, inconsiderable,
and forgotten, it was once the theatre of soul-stirring
impressions !

There, in the remnant of an ancient Tuath-de-danaan Temple, vaulted with stone, and transformed, in

* The *locale* of that *boar,* as well as the *mystery* of its meaning, which
Plutarch transmitted in his allegorical *war* between Osiris and Typhon,
is now, no longer, ambiguous.—See page 327.

after ages, to a Christian Abbey, you will find, after
a succession of, at least, three thousand revolving
years, this pathetic representation of the *youth Apollo
slaying with his arrow the serpent Python* *—in other
words, *overthrowing, by self-endurance, the dominion of
sin!* and, finally, *by immolation upon a tree,* to which
you perceive him pinioned, *establishing ascendancy
over the serpent and his wiles,* and pointing out the
road to eternity beyond the grave!

In an upper range, on the same compartment, you

can trace this other line, consisting of three kings with

* I have before explained that the *serpent Pyth-on* means the *seduc-
tion* of sensuality—*Pith* itself signifying *yoni,* the *boat,* or *serpent,* the
final *on* being nothing but a Greek termination.

their eastern *crowns*, their eastern *costume*, and the *dove*
of amity entwining all of them as they superintend
the spectacle, while the solemnity of the whole is
enhanced by the composure with which a Brehon
sits by, in his turban of state, after reading from the
Bana, or the Budhist gospel, the sentence of con-
demnation and of mysterious expiation, in one and the
same breath.

" He was oppressed and he was afflicted ; yet he
opened not his mouth : he is brought as a lamb to
the slaughter, and as a sheep before his shearers is
dumb, so he openeth not his mouth *."

But this is not the only incident which this trea-
sure of antiquity pourtrays. Beside the three mo-
narchs are skeleton delineations of the *three* other
divinities, who, before this *fourth*, assumed the form
of humanity, and went through the same ordeal of
atoning passion to reclaim our species, through ages
back in the distance † !

It will readily be believed, that descriptions so
mysterious, relating to events so momentous, must
have attracted the observation of subsequent years.
Generation after generation gazed upon them with
wonder ! Generation after generation spoke their
ignorance in wonder ! Mr. Ledwich, of course, must
have a snap at them : and it would make a *cat* laugh,
or Plutarch's *boar* dance a hornpipe, to hear the
contortions of history, the violations of nature, the
perversions of fact, of date, and of philosophy,

* Isaiah liii. 7.

† " The gods," said the Budhist priest to the Catholic bishop before
alluded to, " who have appeared in the present world, and who have
obtained the perfect state, niebau, or *deliverance from all the evils of
life*, are four, Chanchasam, Gonagom, Gaspa, and Godama."—Syme's
Embassy to the Court of Ava.

which this *blot* upon letters has strung together into a melange, as if an exposition of the above hieroglyphics!

And yet, this is he who boasts of his having been "*not sparing of ridicule*" in those moments which he tells us, "he could steal from *clerical* and domestic avocations,"—to tell lies of his country!

The speculation took, however, and he was fostered in his malice—riches and honours were showered upon him!

Well, he died—a monitory pause accompanies the sound—but the party must have a successor!

They "have found him" amongst themselves!—the author of the "Fine Arts in Ireland!"

This *fine* gentleman has really exhibited some degree of *tact,* which shows him not unworthy of his appointment. He begins by denouncing, hoof and horn, every position of his predecessor! Calls him, as a salvo, a "learned man!" but insists upon his being a "most unskilful antiquary;" and though "dogmatic," "altogether a visionary."

These, you would suppose, were great liberties to take with the foster-child of patronage. They were so, in *appearance ;* not *in reality :* for.

"Mutato nomine, de te fabula narratur—"

he is a *modern**, and though of a different *school,* it suits their purpose as well.

But let us see how he would decypher "the writing upon the wall."

"If we might venture a *conjecture,*" he says, "it would be that the living figures represent the most distinguished native princes, who warred with the

* I shall give you my *definition* for this word by and by.

adventurers in defence of their country ; and that
those of the deceased kings were the patriot monarchs
of earlier times!"

Pray, *what* adventurers ? *what ?*—But the farce is
too absurd to bestow discussion upon it.

Come, however, to the *crucifixion scene,* what would
" P——" make of this ?

" This *appears,*" he says, " to represent the death
of the young son of Dermod Mac Murrough, who was
delivered up to Roderick O'Connor, as a hostage for
his father's fidelity, and who, according to Cam-
brensis, and, we *believe,* to our own annalists, was
abandoned by that inhuman and ambitious parent to
his fate !"

After the flourish of trumpets, with which Mr. P——
had proclaimed *independence* of Dr. Ledwich, one
would have expected a *new* ascription, or, at least, a
different one, from him. This, however, is but a *servile
transcript from his predecessor's work,* and that too,
without having the candour to quote him as his
authority !

" But let us view those things with closer eyes."

Had Mac Murrough's son been put to death by
O'Connor, in that awful manner above delineated,
with such external parade, and such mysterious
pomp, think you that Cambrensis, who never omitted
even the most trivial feature of a narrative, would have
been blind to a particular, which must have inte-
rested all his readers ? Yet, as to the reality of this
—Mr. P——'s insinuation notwithstanding—Cam-
brensis is silent and mute as the grave !

A fact which was thought worthy to be commemo-
rated in *fresco* must have been equally eligible as a
phenomenon in *writing.* The O'Connors, therefore,

whom Mr. P——— would install as the authors of this
device, must have retained some *documentary* register
thereof : and, though it is well known, that there is
not a family in the kingdom, who have preserved the
records of their house with such industry or minute-
ness as *they* have, yet is there not so much as the
semblance of an allusion to be traced amongst them,
to this *mysterious representation !*

Nay, if O'Connor had put to death Mac Mur-
rough's son, with such circumstances of torture and
savage insensibility, is it probable that he would him-
self be the person to immortalize his disgrace, by,
depicting it upon such a chronicle? And if the vir-
tue of the nation were not previously outraged by
the *hellishness* of the crime itself, would it not now
blaze forth in holy indignation at the infatuated *vanity*
of the monster, who, not satisfied with the murder of
his innocent *victim*, must deluge his *country* also in
gore, by associating it, to forthcoming ages, with this
outline of his barbarity ?

Yes, Sir, if they were *silent* as to the *crime*, they
would be *eloquent* as to the *painting !*—And it is not
only that they would *demolish* the *structure* within
which it was *inscribed*, but every *quill* within the
realm would become a *pen*, every *liquid* be converted
into *ink*, and every *hand* be made that of a *writer*, to
rescue the *island's* fame from identity with the trai-
tor's *cause ;* and confine to his own and his loathed
head the withering execrations of posterity !

Instead of which, however, not a syllable is
uttered, on paper or on parchment, allusive to the
tragedy ! Not a *presage* is imparted by mournful
banshee ! nor *elegy* sung by familiar *mna-caointha !*
No *historian* records the heart-rending *tale !* nor does

gipsy retail it in itinerant *ditty!* But the *mystery* of sorrow, and the *sanctity* of *truth,* that *hallowed the scene which this temple commemorates,* has, still further, exerted its protecting instrumentality, and besides the *moving evidences imprinted* upon its *interior,* has added those also of *exclusion from without,* and prevented the iniquity of *profane* appropriation, by the occurrence of any equivocal record!

The devices upon places of worship are always of a religious kind.—Would the perpetration of a *faithless infanticide* be considered an act of religion? And if not, why emblazon it within the tabernacle of prayer, with all the circumstances of grace and of grandeur around it?—solemnized by kings! superintended by gods! and executed by judges!

Oh! Sir, a dire plague of astringent benightment has lain brooding over history! and spread, like the *upas,* its baneful emaciation·over everything of culture that fell within its shadow! But *truth* is *immortal :* and, however *momentarily suppressed,* will *ultimately* recover.

" It is a pleasure," says Bacon, " to stand on the shore, and to see ships tossed upon the sea ; a pleasure to stand in the window of a castle, and to see a battle, and the adventures thereof below; *but no pleasure is comparable to the standing on the vantage-ground of truth,* (a hill not to be commanded, and where the air is always clear and serene,) *and to see the errors, and wanderings, and mists, and tempests, in the vale below; so always that this prospect be with pity, .and not with swelling or pride.* Certainly it is heaven upon earth to have a man's mind move in charity, rest in Providence, and turn upon the poles of truth."

The very dresses, which adorn these venerable

delineations, are enough to redeem them from the turpitude which Mr. P—— would impute to them. O'Connor and Mac Murrough were, neither of them, on this earth, for at least *two thousand years after* these were in vogue! neither are they by any means the habits which P—— would persuade us that " laws were subsequently enacted to abolish as barbarous!"

Behold! I show you a mystery! *

What do you see here †? What do you make of

† It will be perceived, that I do not mean this to be an exact *copy* of the Knockmoy Crucifixion—or *vice versâ*.—The general idea is, what I mean to substantiate, and the identity of design cannot well be gainsaid. This remark applies also to the kings about to be introduced by and by.

this Mr. P——. Or do you think that O'Connor went over into Nubia, and got the impress of his enormity canonized there also, in the form of a cross, within the temples and sanctuaries of the adoring Egyptians?

I copy this image from a work of great value, lately published in Paris by Monsieur Rifaud; which he designates by the title of " Voyage en Egypte et en Nubie, et lieux circonvoisins." The plate under notice is but part of a larger one, which he describes as " Façade du petit temple de Kalabche (en Nubie) et ses détails intérieurs," and of which I shall, by and by, treat you to two more compartments, as the exact correspondents of the six crowned figures at Knockmoy.

Meanwhile I beg leave to introduce to you on the next page, some of the sculptures on the Tuath-de-danaan *cross,* at old Killcullen, in the county of Kildare, Ireland. Here you distinguish nine *Budhist* priests in the *Eastern* uniform, with *bonnet, tunic,* and *trowser*—nay, with their very *beards* dressed after the Egyptian fashion!

Other figures I shall leave to your own research to unfold. But let me particularly *fasten* upon your faculty of comparing, the *head-gear* of the standing figure, in the *second* division, and that of the crucifixion upon the Nubian temple. Are they not *critically, accurately,* and *identically* the same?

Look next at the brute *animals* that take part in this group! Mind the *grotesqueness* of their positions, and the *combination* of their character with that of *man!* then lay your hand upon your breast, and, with the light now streaming in upon you, can you conscientiously believe that the *cross* which exhibits

itself at the other side, was ever the work of Chris-
tianity *?

But as you cannot imagine that O'Connor had gone
over to Nubia, in the twelfth century of the Christian
era, to get his murdered hostage *deified* in a pagan
temple, built, perhaps, at the very lowest, three thou-

* " We saw," says Colonel Symes, alluding to the imperfect shell of
a *Budhist* temple, in the Burman empire, " several unfinished figures
of *animals* and *men* in *grotesque attitudes*, which were designed as
ornaments for different parts of the building."—*Embassy to the Court of
Ava.*

sand years before his time, so neither can you impose upon us, that the Budhists stole a march upon our Christian *supineness,* and, while our different sects were fighting for *who should have most,* and proclaiming, " I am of Paul, and I of Apollos, and I of Cephas, and I of Christ *," imprinted their complexity upon our boasted simplicity, and then suddenly again vanished without having been once seen, felt, heard, discovered, or understood ! ! !

What entanglements will not people plunge themselves into when supporting a bad cause ! And how easy is the road which rectitude follows !

The Hindoo Puranas corroborate, to an iota, this our Knockmoy crucifixion †. *Sulivahana* is the name which they give to the deity there represented. The meaning of the word is *tree-borne,* or, who suffered death upon a tree. He was otherwise called *Dhanandhara,* that is, the *sacred almoner.* And his fame, say the Puranas, reached even to the *Sacred Island,* in the sea of *milk,* that is, of *Doghda,* which signifies milk, and which was the title of the tutelar goddess of Ireland ‡.

Avaunt, then, *evermore* to the humbug of *back-reckoning,* and the charge of *imposture* upon the

* 1 Corinthians i. 12.

† Asiatic Researches.

‡ The name of *Sulivan* in Ireland, than which there is no one more common, is unquestionably but the perpetuation of the above *Sulivahana.* And I can give a proof of the fact, *independently of its derivation,* which will scare ridicule into defiance. It is that a particular branch of that family called the O'Sulivans, of Tomies, have been ever looked upon with a feeling of *reverence* by the natives, almost approaching to veneration. I have in vain strove to ascertain from them the origin of this indefinable sense of sanctity. It was like magic upon their minds : they half worshipped them, and knew not why. There were but *two individuals* of this stock remaining when I was a schoolboy, a few years ago, at Killarney.

Brahmins! I flatter myself, I have laid an *extinguisher*, for ever, upon that pretext.

As I have before presumed to offer a suggestion to the translators of oriental *manuscripts*, I shall take the additional liberty of intimating, which I do with profound submission and respect, to the decypherers of all *hieroglyphics*, whether in Ireland or in the East, that those *arrow-headed* characters, to be met with at Persepolis, and resembling in their formation our Irish Oghams, *bear reference, both of them, to this mysterious crucifixion!* And that if Mr. Champollion, and other gentlemen interested in the prosecution of those useful points, will attend to this my advice, they will find it a more *certain key to the attainment of their desired object, than all the labour and outlay of centuries heretofore!*

> " Knowing that Nature never did betray
> The heart that loved her; 'tis her privilege,
> Through all the years of this our life, to lead
> From joy to joy : for *she can so inform*
> *The heart that is within us, so impress*
> *With quietness and beauty, and so feed*
> *With lofty thoughts*, that neither evil tongues,
> Rash judgments, nor the sneers of selfish men,
> Nor greetings where no kindness is, nor all
> The dreary intercourse of daily life,
> Shall e'er prevail against us, or disturb
> Our cheerful faith, that all which we behold
> Is full of blessings."—WORDSWORTH.

CHAPTER XXIV.

THE regal figures, which I promised, as belonging to the *Nubian* temple, and corresponding to the *Knockmoy* frescoes, are the following :—

You will, furthermore, observe, how that they all wear the *philibeg*, like our crucified effigy at page 296, and our war-god, Phearagh, at page 138. Each

of them, also, is adorned with the *cross*, as the pass-
port of their redemption: while the three *divinities*,
delineated in the Irish scenes, have these as their
counterparts in the temple of Nubia.

Abbe Pluché states, that " the figures of those gods
brought from Egypt into Phœnicia, wore on their
heads leaves and branches, wings and globes, which,"
he adds, " appeared ridiculous to those who did not
comprehend the signification of these symbols, as
happened to Cambyses, king of Persia, but these
represented Isis, Osiris, and Horus."

" In the ' Gentleman's Magazine' for November,
1742, is an account," says Vallancey, " of two silver
images, found under the *ruins of an old tower*, which

had raised various conjectures and speculations amongst the antiquaries; they were about three inches in height, representing men in armour, with *very high helmets on their heads, ruffs round their necks,* and standing on a pedestal of silver, holding a small golden spear in their hands. The account is taken from the Dublin papers. The writer refers to Merrick's translation of Tryphiodorus, an Egyptian, that composed a Greek poem on the destruction of Troy, a sequel to 'Homer's Iliad,' to show that it was customary with the ancients, at the foundation of a fort or city, to consecrate such images to some titular guardians, and deposit them in a secret part of the building; where he also inserts a judicious exposition of a difficult text of Scripture on that subject."

The above extract was indited long before the publication of those Nubian antiquities; and, consequently, when neither the contributor to the Magazine, nor the quoter from its columns, had any knowledge of their existence. Its production, therefore, must be valuable here, as showing not only the connexion of the *idols* with the *Round Tower ceremonial,* but also that the helmets of the *Nubian* gods had been adopted in the effigies of some of those amongst us.

I terminate my proofs of the primeval *crucifixion,* by the *united* testimonies of the *Budhists* and the *Free-Masons.*

" Though the punishment of the cross," say the Asiatic Researches, " be unknown to the Hindus, yet the followers of Buddha have some knowledge of it, when they represent Deva *Thot* (that is, the god *Thot*) crucified upon an instrument resembling a

cross, according to the accounts of some travellers to Siam."

" Christianity," says Oliver, " or the system of salvation through the atonement of a crucified Mediator, was the main pillar of Freemasonry ever since the fall."

Let me point your notice now to some *consequences* of that mysterious fact. I begin by asking—

How happened it, that, of all places in the world, Ireland was that which gave the readiest countenance, and the most cheering support, to the Gospel of Christ, on its first promulgation?

This question you will consider of no trivial tendency. It is, in itself, worth a thousand other arguments. To solve it, I must premise, that, besides the many ancient appellatives, already given you, for this country, there was one, which characterised it, as anticipating that event!

*Crioch-na-Fuineadhach** was this name. Its meaning is, *the asylum of the expectants :* or, *the retreat of those looking forward.*

To what, you ask ?—To the consummation, I reply, of that prophecy, which was imparted to Israel through another source, saying, " the sceptre shall not depart from Judah, nor a lawgiver from between his feet, until *Shiloh* come †."

* " That is," says Keating, " the neighbouring country ! !! " as if a country would call itself by such a name ! Vallancey ridicules, but bungles himself still more. And while reminded by this circumstance, I had best note, that what this last-mentioned writer, elsewhere, translates as " the *topographical* names of Ireland," (*Ainim abberteach an n' Eirean,*) should have been " the *appellative* names of Ireland :" they are the *titles* of the *island* itself, not *descriptions* of the several *localities* within it.

† Genesis xlix. 10.

Numerous intimations have, from time to time, been conveyed to man, as harbingers of an event which was to crown their species with universal blessings. In the Puranas it was prophesied, that " after three thousand and one hundred years of the Caliyuga are elapsed, will appear King *Saca*, to remove wretchedness from the world *."

I have given an abstract of the history of this remarkable personage at pages 293 and 294; and, shortly after, at page 296, I presented you with the effigy of his crucifixion. As to the era of his appearance as deducible from the Yugas, I shall confine myself to the opinion advanced by Mr. Davis, in the " Asiatic Researches," vol. ix. page 243, where he states, " It may further with confidence be inferred, that *Mons. Anquetil du Perron's conclusion, with respect to the late introduction of Yugas*, which are the component parts of the Calpa into the Hindu astronomy, *is unfounded ; and that the invention of those periods, and the application of them to computations by the Hindus, must be referred to an antiquity which has not yet been ascertained*."

In another age was promised another Redeemer; and of him I copy what Mr. Wilford transmits, as follows, *viz.*—

" A thousand years before that event the goddess Cali had foretold him, that he would reign, or rather his *posterity*, according to several learned commentators in the Dokhin, as mentioned by Major Mackenzie, till a *divine child*, born of a virgin, should put an end both to his life and kingdom, or to his dynasty, nearly in the words of Jacob, in Genesis,

* Asiatic Researches.

chap. xlix. ver. 10. The Hindu traditions concerning
this wonderful child are collected in a treatise, called
the ' Vicrama Chastra ; or, History of Vicrama Ditya.'
This I have not been able to procure, though many
learned pundits have repeated to me by heart whole
pages from them. Yet I was unwilling to make use
of their traditions till I found them in the large
extracts made by the ingenious and indefatigable
Major C. Mackenzie, of the Madras establishment,
and by him communicated to the Asiatic Society."

In truth, it was to the *certainty* of this *manifesta-
tion,* that the first couplet of an Arabic elegy, pre-
served by Mons. d'Herbelot, in his account of Ibnu-
zaidun, a celebrated Andalusian poet, refers. In
Roman letters, the lines run thus—

> " Jekad heïn tenagikom dharmairna
> Jacdha alaïna alassa laula tassina."

That is, " The time will soon come when you will
deliver us from all our cares ; the remedy is assured,
provided we have a little patience."

The learned President of the Society of Bengal,
unaware of the *drift* of this beautiful stanza, and
without ever having so much as *seen* the original,
whence it was quoted, offers to alter its import to
the following, *viz.,* " When our bosoms impart their
secrets to you, anguish would almost fix our doom, if
we were not mutually to console ourselves ! " And
the only reason he assigns for this novel interpreta-
tion is, that *two* individuals, *neither of whom, he him-
self admits, knew any thing about its meaning,* hap-
pened, or rather pretended, to put it for him, *dif-
ferently,* into Arabic words !

On the pillar at Buddal, this emanation of the
godhead is thus characterised—" He did not exult

over the ignorant and ill-favoured : but spent his
riches among the needy : in short, he was the wonder
of all good men*." Isaiah's prophecy of the *future*
Messiah would appear a *verbatim*, though more *poeti-
cal* transcript of this inscription, *viz.*, " He shall not
cry, nor lift up ; nor cause his voice to be heard in
the street : a bruised reed shall he not break, and the
smoking flax shall he not quench : he shall bring
forth judgment unto truth†."

At page 110 of this volume, I have promised to
explain the origin of the word *Eleusinian*, as applied to
the celebration of certain religious rites. I have very
little doubt but that, when reading that declaration,
the reader looked upon its offer as, to say the least,
gratuitous—satisfied that the term could have no
possible other meaning, than as an adjective formed
from the substantive *Eleusis !*

Well, the rashness of that judgment I very freely
forgive ; and repay it now by the verification of my
contract.

Eleusis, the *place*, and *Eleusinian*, as descriptive of
the *mysteries* therein solemnized, were both denomi-
nated in honour of that *Advent*, which all nations
awaited ; and the fulfilment of which in the person
of one of the *Budhas*, made him to be recognised,
on one occasion, as the " source of the *faith* of the
three epochs of the world‡."

* Asiatic Researches.

† Chapter xlii. verses 2, 3.

‡ Retiring into a still more solitary place, *Gautama* and his disciples
sustained triumphantly an argument with two of their bitterest ene-
mies. But a severer trial exhibited his righteousness in a yet clearer
light. Four young and beautiful sisters, burning with unholy love, pre-
sented themselves naked before him, and besought him to comply with
their desires. " Who, O Gautame ! " said they, in the rage of their

I have already redeemed the character of those ceremonies from the sinister imputations which attached to their *secrecy*. An apprehension that their publication would subvert the popular belief, or a supposed indelicacy in their tenour, were the *mildest* constructions which the *unitiated* would afford them. Though secure in the sufficiency of my former proofs, I cannot avoid taking support from an article in a very talented publication of our day, in which the writer, *wholly uninstructed, while he evidently is, as to the nature* of those celebrations, yet confirms the fact of their worth and their purity.

" From the whole concurrent testimony of ancient history," says he, " we must believe that the Eleusinian mysteries were used for good purposes, for there is not an instance on record, that the honour of an initiation was ever obtained by a very bad man. The hierophants—the higher priests of the order— were always exemplary in their morals, and became sanctified in the eyes of the people. The high-priesthood of this order in Greece was continued in one family, the Eumolpidæ, for ages. In this they resembled both the Egyptians and the Jews.

" The Eleusinian mysteries in Rome took another form, and were called the rites of Bona Dea ; but she was the same Ceres that was worshipped in Greece.

disappointment, " who is the lying witness who dares attest that the virtues of all the former saints are concentrated in thee ? "—" Behold my witness," said the sage, striking the ground with his hand ; and at the moment Okintôngu, the tutelar genius of the earth, appeared, proclaiming with a loud voice—" It is I who am the witness of the truth !" The young women then fell upon their faces, and adored Gautama, saying, " O *pure* and *perfect countenance*, wisdom more precious than gold ! majesty impenetrable ! honour and adoration to thee, *thou source of the faith of the three epochs of the world !*"—*Abridged from Klaproth.*

All the distinguished Roman authors speak of these
rites and in terms of profound respect. Horace
denounces the wretch who should attempt to reveal
the secrets of these rites; Virgil mentions these mys-
teries with great respect; and Cicero alludes to them
with a greater reverence than either of the poets we
have named. Both the Greeks and Romans punished
any insult offered to these mysteries with the most
persevering vindictiveness. Alcibiades was charged
with insulting these religious rites; and although
the proof of his offence was quite doubtful, yet he
suffered for it for years in exile and misery; and it
must be allowed that he was the most popular man of
his age *."

Analogous to these were the solemnities at Car-
thage, designated by the name of *Phiditia;* and the
import of which, as well in term as in substance, has
been no less a riddle to antiquarians, than was
the sanctified commemoration which it disguises.
During the interval of their celebration, the youths
received lessons from the elders of the state, as to
the regulation of their conduct in after life; and the
lustre of truth, and the comeliness of virtue, as they
shone forth in *Budha,* (*which solves the mystery of the
name,*) were the invariable *ethics* they propounded.

Public feasts were the scene for the delivery of
those discourses. The found their way also to
Rome, but the *spirituality of Redemption* not going
hand-in-hand with its *doctrine,* or not duly compre-
hended, if accompanying, the *joyousness* of *hope,* was
there sunk into the *licentiousness* of *enjoyment,* and
the innocence of mirth and of moral hilarity was

* Chambers's Edinburgh Journal, October 12, 1833.

superseded by the uproar of riot and of vice! *Such were the Saturnalia.*

How different was their celebration in our "Sacred Ireland!" The very letters of the epithet, by which our forefathers had solemnized them, show the spirituality of purpose which actuated their zeal. *Nullog* was that epithet—it is compounded of *nua, new;* and *log* (for bullog), a *belly,* meaning *regeneration,* or the putting aside the old leaven of sin, and the assumption of the new investiture of righteousness, by justification.

As everything, however, in their religious procedure was transacted by symbols, so, in this instance, they did not content themselves with the *inner consciousness* of a *new birth* *, but they must go through the outer form of it by typification; and for this end it was that they excavated those *apertures* in the bodies of rocks, which I have noticed in page 314, as calling forth, from ignorance, the animadversion of the *devil's yonies,* in order that, by *passing themselves through them, they might represent the condition of one issuing, through the womb, to a new scope of life* †.

A nobler method of symbolisation, and confined solely to the *initiated,* was that which characterised the construction of their subterranean temples. Here the sublimity of their worship breaks out in all the

* This is the exact rendering of the name by which they called it: viz. *nua vreith,* or *the being born anew* by the operation of grace.

† It is still practised in the East.—" For the purpose of regeneration it is directed to make an image of pure gold of the *female* power of *nature,* in the shape either of a woman or of a cow. In this statue the person to be regenerated is inclosed, and dragged out through the usual channel. As a statue of pure gold, and of proper dimensions, would be too expensive, it is sufficient to make an image of the sacred *Yoni,* through which the person to be regenerated is to pass."—WILFORD.

grandeur and the majesty of awe *. The narrowness of the entrance, never larger than the girth of the ordinary human body, portrayed, as well the *circular passage* in their regenerating *type* †, as the *circumvention* of temptation by which the faithful are ever beset ‡; while *the model* of the *cross, which regulates their architecture withinside, attests the mystery and the form of their master's death.*

The Mithratic temple, at New Grange, is exactly so constructed. After squeezing yourself, with much labour, through a long *emblematic* gallery, you arrive at a *circular room*, or rather an *irregular polygon, or octagon*§; whence, at measured intervals, three other

* See page 3—78, and 162.

† Be it remembered, that it was in consequence of his ignorance of the principle of regeneration that our Saviour addressed Nicodemus in these cutting words, *viz.* " Art thou a master of Israel, and knowest not these things?" thereby recognising the existence of the doctrine before his own manifestation to that people.

‡ Enter ye in at the *strait gate:* for *wide* is the gate and broad is the way that leadeth to *destruction,* and *many* there be which go *in* thereat : because *strait* is the *gate* and narrow is the way which leadeth unto *life*; and *few* there be that find it.—Matthew vii. 13, 14.

§ " The dome (of this, what he calls a cemetery) springs at various unequal heights, from eight to nine and ten feet on different sides, forming at first a coving of eight sides. At the height of fifteen or sixteen feet, the north and south sides of this coving runs to a point like a gore, and the coving continues its spring with six sides; the east side coming to a point next, it is reduced to five sides, the west next; and the dome ends and closes with four sides; not tied with a keystone, but capped with a flag-stone of three feet ten inches, by three feet five. The construction of this dome is not formed by key-stones, whose sides are the radii of a circle, or of an ellipsis converging to a centre. It is combined with great long flat stones, each of the upper stones projecting a little beyond the end of that immediately beneath it; the part projecting, and weight supported by it, bearing so small a proportion to the weight which presses down the part supported; the greater the general weight is which is laid upon such a cove, the firmer it is compacted in all its parts."—POWNALL.

apartments diverge, forming, with the in-leading gut, a perfect *cross ;* and presenting, altogether, to a susceptible mind, *the most solemn combination of symbolical mysteries* * !

I wonder why do not our *moderns* confer these *subterraneous cruciform* edifices upon the industry of the early Christians, as they have strove to claim for them the *corresponding* structures *above-ground!* and without half the probability of success! For if it may be stated, that the *crucifixions* upon the *towers* were an *interpolation,* with a view to *Christianise* what before was devoted to *Paganism, no one,* at all events, would maintain that the *monks* had gone down into the bowels of the earth, and after ejecting the inmates of old *Alma Mater,* converted their tabernacles into a magical cross !

Nay, a greater difficulty would still attach to this adventure. The *Pagodas* † of Benares and Mathura, the two principal ones in all India, are *cruciformly* built! and, in order to make both worlds harmonize, the *advocates* for the monks, or rather their *beliers,* would have to transport their mechanics to those regions also, and turn upside-down, and sideways, and every way, whatever was the shape of the ori-

* " The eight sides of this polygon are thus formed : the aperture which forms the entrance, and the three niches, or tabernacles, make four sides, and the four imposts the other four."—POWNALL.

† This word I have already derived, after the example of other writers, from *peutgeda,* or *house of idols,* so misnamed by Europeans. I must state, however, that another explication is also assigned thereto, and that is, a perversion of the term *bhaga-vati,* or *holy house.* But with great respect to the gentlemen who incline to the latter opinion, I have to observe that *bhaga-vati,* properly signifies the *sacred Yoni ;* and, therefore, that however applicable to a *subterraneous temple,* or *cave,* it could by no means represent an *erect building.*

ginal structures, until they moulded them, at last, into this mysterious cross !

Some blame, however, would seem attachable to the *superintendents* of this vision: and it is, that, while imprinting this *mark* over the head of the principal figure, in the cave, or Mithratic temple, at Elephanta *, they neglected to demolish the *Lingam*, appertaining to the previous worship; and which actually presents itself but a little from it in the front ! ! !

To be grave—There was nothing more *natural* than that those different symbols should be thus united. I have shown, that in the various copies of our annals, the *Round Towers,* or over-ground temples, are designated by the name of *Fidh-nemead,* the meaning of which I have elucidated to be, the *consecrated Lingams :* the *Mithratic caves,* or under-ground temples, their *correspondents,* it was to be expected, should be known by a *suitable* denomination ; and, accordingly, you will find this very one at New Grange, mentioned in the " Chronicon Scotorum," by the title of *Fiodh Aongusa ;* that is, the *Myste-*

* "The entrance into this temple, which is entirely hewn out of a stone resembling porphyry, is by a spacious front supported by two massy pillars and two pilasters forming three openings, under a thick and steep rock, overhung by brushwood and wild shrubs. The long ranges of columns that appear closing in perspective on every side ; the flat roof of solid rock that seems to be prevented from falling only by the massy pillars, whose capitals are pressed down and flattened as if by the superincumbent weight; the darkness that obscures the interior of the temple, which is dimly lighted only by the entrances; and the gloomy appearance of the gigantic stone figures ranged along the wall, and hewn, like the whole temple, out of the living rock,—joined to the strange uncertainty that hangs over the history of this place,—carry the mind back to distant periods, and impress it with that kind of uncertain and religious awe with which the grander works of ages of darkness are generally contemplated."—ERSKINE.

rious Cavern of *Budh;* while the *crucifixions* upon the *former,* and the *cruciform shape* of the *latter,* are the reverential memorials of his atoning dissolution.

The mysteries celebrated within the recesses of those caverns were precisely of that character which are called *Free-masonic,* or *Cabiric.* The signification of this latter epithet is, as to written letters, a desideratum. Selden has missed it; so has Origen, and Sophocles. Strabo too, and Montfaucon, have been equally astray. Hyde was the only one who had any *idea* of its *composition,* when he declared " it was a *Persian word,* somewhat altered from *Gabri,* or *Guebri,* and signifying fire-worshippers."

It is true that *Gabri* now stands for *fire-worshippers,* but that is only because that they assumed to themselves this title, which belonged to another order of their ancestors. The word is derived from *gabh,* a smith, and *ir,* sacred, meaning the *sacred smiths;* and *Cabiri,* being only a perversion of it, is, of course, in substance, of the very same import.

Mount *Caucasus*,* also, which still, in our language, retains its original pronunciation, of *Gaba-casan,* or the Smith's Path, was named from the same root; nor is the tradition of the *reason* altogether obliterated from those who dwell beside it, if we may judge from a ceremony described by a recent traveller, as performed by them, as follows :—

" The original founders of the Tartarian Mungalian Scythians, called Cajan and Docos, got embarrassed amongst those mountains, then uninhabited.

* " This appellation, Caucasus, at least in its present state, is not Sanscrit; and as it is not of Grecian origin, it is probable that the Greeks received it through their intercourse with the Persians."— WILFORD.

After a sojourn there of 450 years, having become so numerous as to require other settlements, they were at a loss to find a passage through the mountains, when a *smith*, pointing out to them a place very rich in iron ore, advised them to make great fires there, by which means the ore melted, and a broad passage was opened for them. In commemoration of which famous march, the Monguls, to this day, celebrate an annual feast, and observe the ceremony of heating a piece of iron red hot, on which the Ceann (that is the chief) strikes one blow with a hammer, and all the persons of quality do the same after him."

I shall close this chapter by the description given of the destruction of Cambyses's army in the Nubian desert, *after the insults offered by him to the Cabiri priests.*

> " Gnomes, o'er the waste, you led your myriad powers,
> Climb'd on the whirls, and aim'd the flinty showers ;
> Onward resistless rolls the infuriate surge,
> Clouds follow clouds, and mountains mountains urge ;
> Wave over wave the driving desert swims,
> Burst o'er their heads, inhumes their struggling limbs ;
> Man mounts on man, on camels camels rush,
> Hosts march o'er hosts, and nations nations crush :
> Wheeling in air, the winged islands fall—
> And one great sandy ocean covers all*."

> * Darwin.

CHAPTER XXV.

On the east side of the river Shannon, about ten miles distant from Athlone, in the barony of Garry-castle, and King's county, is situated the *Sanctuary* of Clonmacnoise. Within the narrow limits of two Irish acres, are here condensed more *religious* ruins, of antiquarian value, than are to be found, perhaps, in a similar space in any other quarter of the habitable world.

Nine churches, built respectively by the individuals whose names they bear, *viz.*, 1. that of Macarthy More; 2. that of Melaghlin; 3. that of Mac Dermott; 4. that of Hiorphan; 5. that of Kieran; 6. that of Gawney; 7. that of O'Kelly; and 8. that of O'Connor;—independently of the *cathedral*,—here moulder, in kindred mortality, with the ashes of nobles, of princes, and of kings, entombed beneath their walls; and who, at feud, mayhap, in life, are now content to sleep, beside each other, " their warfare o'er," in the levelling indistinction of death ?

Your curiosity is, no doubt, excited to know, how so circumscribed a little spot could have been chosen as the nucleus of such ecclesiastical ambition? The answer is found in the circumstance of this having

been one of the strongholds of *Budhism,* in the days of its corruscations, which made it now be singled out, in common with other places memorable for that creed, as the appropriate locality for Christian super-incumbency.

Two Round Towers, *the chief object of emulation,* are, as you may have supposed, here to be encountered : and *these are the very ones, which the reader may recollect have been alluded to at* page 38, as ridiculously claimed by Montmorency for *Christian*—because, forsooth, in the vagueness of popular titles, they are *recently* distinguished by the names of *Mac Carthy* and *O'Rourke !*

The *eastern columns,* denominated after *Pompey* * and *Cleopatra* †, have been equally productive of historical mistakes ; until, at last, it has appeared, that those celebrated lovers have had no more to do with such erections, than have had the *O'Rourkes* or *MacCarthys* with our *Round Towers !*

Here also are *three crosses,* belonging to the same religion, to *one* of which only shall I now direct your observation. It is fifteen feet high, composed of a single stone, and sculptured with imagery of the most elegant execution.

The devices upon this sculpture are such as you would have expected from the *authors of the Alle-*

* " If perfection in art consist in affording continued pleasure, its achievements, when contemplating this column, must be deemed insurpassable. A Corinthian capital of 10 feet is poised on a shaft of 67½ feet, the latter resting on a base of 21½ feet ; the whole rises to a height of nearly 100 feet."—HEAD.

† " Of the obelisks, commonly called Cleopatra's Needles, one alone is now standing ; the other, lying down, measures seven feet square at the base, and 66 feet in length. They are so well known, that it is not necessary to give a very particular description of them."—CLARKE.

gory of the Paradisiacal Fall: and here, accord-
ingly, it presents itself, just as in *language* they had
clothed it, in all the mysteriousness of the figura-
tive *tree.*

Immediately over the equestrian and chariot sports,
which decorate the pedestal, you see Adam and Eve

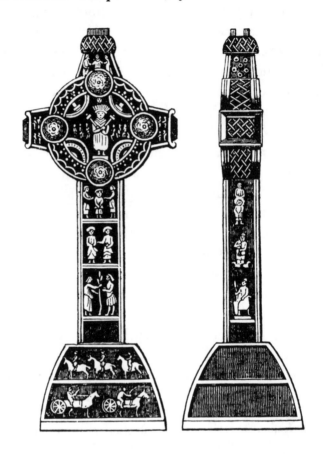

conversing at each side of this *symbol* of their dearly-
bought *knowledge!* Farther up are other emblems of
mythological allusion: while, in the centre above,
you observe a *Cabir* priest, alias, a *Free-mason,* hold-
ing the implements of his craft—a high honour—in

his hand *; and encompassed by a retinue of several more persons, all in the glow of joy!

The other sides, though less complex, are not less graceful, nor less significant, than the two which I have introduced. In them, also, everything bears reference to the *Budhist* ceremonial. Nor are the *mouldings* and the *flowerings*, the *net-works*, and other ornaments which figure upon them, the *least essential* constituent of that fruitful code †,—while the personation of a *dog*,—an invariable accompaniment, as it is also amongst the sculptures at Persepolis, and other places in the east,—*would, in itself, be sufficient to fix the appropriation of those crosses*, as that animal can have no possible relation to Christianity, whereas, by the Tuath-de-danaans, it was accounted *sacred*, and its maintenance enjoined by the ordinances of the state, as it is still in the Zend books, which remain after Zoroaster.

To Clondalkin Tower, represented at page 101, there belongs also a stone cross, and bearing its own history upon its *Tuath-de-danaan* countenance. In Armagh is another. I cannot afford time to point out any more, but that at *Finglas* is too remarkable to be quite neglected.

Every body is acquainted with the legendary tale

* In confirmation of this, you will find at page 14 of Seguin's " Thessalonian Coins," the impression of a man with a hammer, as above, in one hand, and a key in the other, and the word *Cabeiros* as the inscription.

† On all public occasions displays of this kind are still indulged in the east. The *floralia* of the Romans were adopted from the easterns. " Every person, male and female, had *festoons* depending from the top of the cap down one side of the head. These were composed of the flowers of the *wild rose* and hawthorn, and other beautiful kinds, which, while they set off the head-piece of the lieges, literally perfumed the air wherever they went."—ARCHER.

of *St. Patrick having banished all venomous reptiles from this* island. Now, I am very willing, as has been shown, to give this apostle all the credit which he deserves; but I am a chronicler of *truth*, and from me he shall have no romances. Solinus, who flourished A.D. 190, that is, above two centuries before St. Patrick was born, has noticed the phenomenon of there being no vipers here. Isidore has repeated it in the seventh century; as has Bede in the eighth; and, in the ninth, Donatus, the famous Bishop of Fesula. This exemption, therefore, cannot be attributable to St. Patrick, whose honour would be better consulted by his religious admirers, in confining themselves to *facts*, which are numerous enough, than in shocking credibility by their *pious frauds*.

As to the *local* phenomenon, to which you perceive *he* can have no pretensions, I cannot resist bestowing upon it a passing observation. Bede, I think, has gone so far as to say, that not only are there no snakes to be found in Ireland, but that they would not live, if imported: nay, that, when brought within sight of the shore, they expire! I should like to see this ascertained; if the fact be such, then the question is solved, the air or the soil is the cause.

But if the case be otherwise, then must we ascribe it to some *human* instrumentality; and, as there occur various texts in Scripture, allusive, it would seem, to a very prevailing opinion in the *east*, as to the manageableness of that species, by the power of charms,—such as, " I will send serpents, cockatrices, among you, which will not be charmed"—(Jeremiah viii. 17); and " the deaf adder that stoppeth her ear, which will not hearken to the voice of charmers, charming never so wisely"—(Psalm lvii. 4, 5) ;—and

as our Tuath-de-danaans, who were an eastern people, are recorded by all our early ecclesiastical writers, and with no view to encomium, as so eminent for incantations, that the island seemed, during their sway, to have been one continuation of enchantment, it is past doubt, that, if practicable by man's efficacy at all, the merit of extinction belongs solely to them.—And it is well worth notice, that the island of Crete, where a colony of them also had settled, is said to be gifted with a similar exemption. " The professed snake-catchers in India," says Johnson, " are a low caste of Hindoos, wonderfully clever in catching snakes, as well as in practising the art of legerdemain; they pretend to draw them from their holes by a song, *and by an instrument resembling an Irish bagpipe, on which they play a plaintive tune**."

Every *legend*, however, is founded upon *reality*, and I will unfold to you from what has Joceline concocted *this about St. Patrick*. All the *crosses* of the Tuath-de-danaans had *snakes* engraved upon them. Look back at that at Killcullen†, and you will see them there still, and more plainly, by and by, upon that at Kells. These to the Irish were objects of reverence, because of the *passions* which they symbolized; and accordingly the Saint, in order to obviate the recurrence of such contemplations, effaced them, when practicable, from off the stones ‡.

* Sketches of India Field-sports. Dr. Shaw and Mr. Forbes are even more conclusive.

† Page 338.

‡ If you examine the Tuath-de-danaan crosses with a minute eye, you will find this exposition irrefutably verified. Though they all have the traces of the Budhist sculpture, they have also the marks of *obliteration;* and no one of them to a greater extent than this at Finglas,

The same precisely was the course, but with a less
hallowed intention, which the Moslems had pursued
in the dissemination of their creed. " Whenever,"
says Archer, " these figures were introduced, the
fanatic Moslem had hammered away all those within
his reach ; and when this process was too slow for
the work of demolition, another mode of obliteration
was requisite. Whole compartments of sculpture
were plastered over to hide the profane imagery ! In
clearing away the rubbish, to bring these beautiful
remains to light, the engineer stumbled on a long
frieze, part of which had had the destroying mallet
passed over it; but this method of despatch was not
active enough, and that portion which had escaped
violence, had been plastered over with a composition
of the colour of the stone *."

We read also in the Puranas, as an historical
circumstance, that the whole *serpent* race had been
destroyed by Janamijaya, the son of Parieshit, which,
in truth, only implies, as the talented professor of
Sanscrit in Oxford University has already remarked,
" the subversion of the local and original supersti-

where it is known that St. Patrick principally resided. Yet even this
retains indistinct evidence of snakes, &c. &c. &c.

" The body of the snake is not only capable of flexion, but of close
and intimate application to every rugged inequality of a tree on the
earth ; and this faculty is the result of its minute subdivisions. The
body of the snake is never bent in acute angles, but always in flowing
easy curves or circles. From each of those distant bones, so multitu-
dinous in their number, which form the vertebral column, (and in one
species of Pythra we have counted 256, exclusive of those composing the
tail,) a rib arises from each side, and both together form a great portion
of a circle, so as to embrace nearly the whole circumference of the body.
These ribs are restricted to the vertebræ of the body only ; they do not
arise from those of the tail.''

* Travels in Northern India.

tion, and the erection of the system of the Vedas upon its ruins."

St. Patrick, in like manner, having established Christianity *here*, in supercedence of a religion, the most prominent symbols of which were *snakes, cockatrices,* and *serpents,* may be truly said to have *extirpated* their race from the country, but, as you see, in an acceptation heretofore unexplained.

The *statement* given by Major Archer of the *symbolic representations* upon one of the Indian temples, as well as the particulars of its *fate,* are so perfectly in unison with what I have been describing, that I must be excused if I give it a place here.

" Reached Burwah-Saugor," says he.—" Immediately on the right is a Hindoo temple, which I think one of the rarest sights, on the score of architecture and sculpture, which have gratified our curiosity. The work of the chisel would have immortalised the artist had he lived in the present day. I have never seen its execution rivalled, although tolerably conversant with similar objects of art. The elegance of design—the arrangement of the figures, which were too numerous to be computed—the position of them —the sharp and bold relief—and the elaborate ornaments of *foliage* and *animals,* render it one of the *most remarkable monuments* of art it is possible to conceive. There are compartments on the lintels of the doors and the entablature, four deep; *figures of the subordinate deities in the voluminous code of Bramah, symbols of their attributes, sacred utensils,* and *animals.* Two vases are on the threshold, which, for shape and execution, would compete the palm of excellence with Grecian art. *Wreaths of snakes,* and groups of *men* and *women,* are on the *columns,*

which also have *their* ornaments, and are well pro-
portioned.

" I could not resist a second visit to this edifice,
which, at the risk of appearing opinionative, I can
seriously aver, I never saw equalled for richness and
taste; but the hand of intolerant bigotry has marred
the work of fair proportion. The fanatical Moslems,
who over-ran the country in the time of Acbar, broke
and defaced every image they saw; and, with few
exceptions, the head of every figure, of any size or
importance, has been demolished; and nothing re-
mains but relics, which attest the advance of the arts
at the time the structure was reared."

The effects of fanaticism are the same in all ages.
It desecrates alike human and divine laws. St. Pa-
trick was no fanatic; and accordingly, in *his* course,
what he could not himself comprehend, he was
resolved, at all events, to have respected. Those
crosses, therefore, which had previously been looked
upon with an eye of veneration, *though the cause had
long ceased to be transmitted*, he literally *Christianised*,
by removing the sculpture; and thus were they made,
in the ritual of the new religion, as hallowedly
expressive as they were ever before.

Precisely similar was the system pursued by the
missionaries in India.

" The island of Salsette," says Captain Head,
" abounds in mythological antiquities and pagan
temples—two gigantic figures of Buddha, near twenty
feet high, of complete preservation, which they owe
to the zeal of the Portuguese, who painted them red,
and converted the place they ornamented to a Catholic
chapel."

The Pantheon at Rome was new modelled in the

same manner. In a word, as Grotius has before affirmed, " infinite appropriations have been made."

But, independently of this conversion, the conformity itself between the Christian and the Budhist religion was so great, that the Christians, who rounded the Cape of Good Hope with Vasco de Gama, performed their devotions in an Indian temple, on the shores of Hindostan ! Nay, " in many parts of the Peninsula," say the Asiatic Researches, " Christians are called, and considered as followers of Buddha, and their divine legislator, whom they confound with the apostle of India, is declared to be a form of Buddha, both by the followers of Brahma and those of Siva ; and the information I had received on that subject is confirmed by F. Paulino."

It was not so with those who made religion a trade, and only the auxiliary pass-word to their selfish aggrandisement ! When the " abomination of desolation * " swept over this country, and strewed the verdure of its surface with the indiscriminate fragments of cathedrals, of castles, and of towers, the crosses but as little escaped the scourge !

Having had occasion to pass through Finglas, on their march to the siege of Drogheda, and fancying the cross, which stood there, to have been *necessarily* the erection of obnoxious *Romanism*, they gave it an *iconoclast* blow, which broke its shaft into two ! Thus decapitated, it fell. But the citizens, wishing to avoid further profanation, soon as ever the army evacuated the town, took the disjointed relic, and buried it, very decorously, within the confines of the churchyard !

Here it remained, in consecrated interment, until

* Oliver Cromwell with his army of locusts.

the beginning of the year 1816, when an old man of
the parish, recounting anecdotes of by-gone times,
mentioned, amongst others, the particulars of this
tradition, and excited some curiosity by the narrative.

The Rev. Robert Walsh was then curate of Finglas,
and this mysterious history having reached his ears,
he determined forthwith to ascertain its evidences.
His first step was to see the chronicler himself.—

This personage's name was Jack White. Jack, who
was himself well stricken in years, told him, that he

had learned, a long while ago, from his father, who was then himself rather elderly, that he had been shown, by his still older grandfather, the identical spot where the cross had been concealed, and could point it out now to any one with certainty and preciseness.

The proposal was accepted; workmen were employed; and, after considerable perseverance, the cross was *exhumed!* its parts *re-united* by iron cramps! and *re-erected,* as opposite, within a short distance of the scene of its subterranean slumbers! as if in renascent triumph over the destroyer!

> Let such approach this consecrated land
> And pass in peace along the magic waste:
> But spare its relics—let no busy hand
> Deface the scene, already how defaced!
> Not for such purpose were those altars placed:
> Revere the remnants nations once revered;
> So may our country's name be undisgraced,
> So mayst thou prosper where thy youth was reared,
> By every honest joy of love and life endeared *.

 * Byron.

CHAPTER XXVI.

IT will be borne in mind, that everything hitherto advanced, on the various topics, which we have been discussing, was the sheer result of internal reasoning, and of personal circumspection—that, wherever extrinsic aid was brought forward in support of this unbeaten track, it was uniformly in the shape of *conclusions*, deduced from the premises of reluctant witnesses. I rejoice, with delight unspeakable, that I have it, at last, in my power, to range myself, side by side, with an author, whose testimony in this matter must be considered decisive, but which, however, by some strange aberration of intellect, has never before been understood!

Cormac*, the celebrated bishop of Cashel, and one of the first scholars who ever flourished in any country, when defining the Round Towers, in his Glossary of the Irish Language, under the name of *Gaill* †, says, that they were " *Cartha cloacha is aire bearor gall desucder Fo bith ro ceata suighedseat en Eire*,"—that is, stone-built monuments, within which noble judges used to inclose vases containing the relics of Fo (i. e. Budh), and of which they had erected hundreds throughout Ireland!

* Some say he belonged to the *fifth* century. All agree that it was not later than the *ninth*.

† See page 61.

Knowing that the Ceylonese *Dagobs*, a name which literally signifies *houses of relics*, were appurtenances of Budhism, I intreated of a very intelligent native of that island, who attended the Vihara, at Exeter Hall, some time ago, that he would favour me with a written outline of his views of those structures. After a few days he very civilly obliged me with the following :—

" Travellers to the eastern countries often have their notice attracted by numerous buildings of a singular form and of enormous sizes, both in ruins and in preserved states, about the origin and objects of which, many inquiries have been made, and various conclusions drawn. These are monuments raised in ancient times to the memory of deified persons, and called *Chaityas*, to which places devotees used to resort for meditation, especially those who had any particular veneration for the deceased, whose relics are supposed to be deposited within, and on whose virtues they quietly reflect, availing themselves of the solitude of such places ; and if in their own imaginations the personages are deified, they make offerings of lamp-light, &c.

" In exploring the ruins of these pyramids, the inside of the globes are found to contain loose earth, merely filled up after the arches had been raised ; in such loose earth are found ancient coins of various metals, supposed to be thrown in, in token of respect or veneration, whilst building ; but in the very centre of the globe is always found a square well, paved with bricks, and the mouths covered by hewn granite, borne on granite supporters, standing in the four corners of the square (sometimes triangular). In this well, if the monument of a king, (and if not robbed by

ancient invaders,) will be found the urn, containing
the relics of the deceased, and treasure to a consider-
able worth. Sometimes there may be discovered a
piece of beaten gold, or other metal, with engravings,
mentioning the name and other circumstances of the
deceased. If a Buddhist king, idols of Buddha
might be found in it—but in others, sometimes
earthen or metallic lamps, and heads of *cobra de
capellas.*

" In similar monuments, erected for the relics of
Buddha, are three different compartments or depo-
sitories ; one in the bottom of the foundation, one in
the heart of the globe, and one at the top of the
globe within the column. This column always has
its basis upon the granite covering of the well. In
monuments of this description are supposed to be
much buried treasure, especially in the foundations.
The Paly book, *Toopahwanse,* gives account of the
distribution of the Buddha's relics to the different
parts of the world, and the erection of such monu-
ments over them.

" Monuments of eminent Buddhist high priests are
sometimes erected very high, but no treasure is to be
expected in them, excepting sometimes books en-
graved on metal ; but the tomb of the poorest prince
is never without (at least in models) a golden crown,
a sword of the same metal, a pair of metallic shoes,
and a similar parasol.

" Besides having learnt from tradition and ancient
documents, the writer has seen the discovery of the
tomb of a prince, in which these articles were found,
with a plate of gold, stating the name of the prince,
his age, death, &c., which he had the pleasure to

transcribe; the characters were in a different form from those now used in the same language, and hardly intelligible.

" The writer also had the pleasure of exploring the ruins of a very lofty Dagob that stood opposite to the establishment of the Church Missionaries in Ceylon. It was found to have been the tomb of a monarch, and had the appearance of having been robbed of the wealth it very likely contained, upwards of a century ago, as the trees that were growing on it indicated. A large quantity of ancient coins, and metal of different kinds, melted into various shapes, (perhaps with burning of the corpse,) were however collected.

" Ceylon contains many ancient pyramids of the kind in a preserved state, and protected by the people, which are supposed to contain much wealth, but the superstitious do not dare to explore, and others fear the laws, which will permit violence to no man's feelings *."

Having before shown how that the religion of the ancients was interwoven with their funeral observances, this ocular testimony was alone requisite to gain credence for my proofs. I can still further adduce the authority of Dr. Hurd †, to show that the Gaurs of India, to this day, make use of the *Round Towers* ‡ in their neighbourhood, as places of burial, lifting up the dead bodies to the elevated door by means of ladders and pullies. None of those three writers have attempted anything more than a

* " July, 1833."—This gentleman's name was Pareira.

† Religious Rites and Ceremonies.

‡ The Gaurs themselves did not build those towers, but finding them to their hand, and knowing them to have been formerly reverenced, they converted them to this purpose.

statement of the actualities, therefore will I be
excused if, in addition to what has been already
detailed, I observe that, sublime and philosophic as
was the intent of the *phallic* configuration of those
edifices, applied to *religion*, it was incomparably more
so, considered in reference to *sepulture ;* for while,
in the former, it merely typified the progress of
generation and *vitality*, in the latter it suggested the
more ennobling hope of a future *renasccnce* and a
resurrection.

That the reader, now aware of the " *secret*" which
directed the form and elevation of our Sabian Towers,
should not be surprised at the affinity which I have
before pointed out between them and the two "pillars"
which stood at the door of Solomon's Temple*, I
shall tell him that the whole internal construction of
this latter edifice, as well as those outer and partial
ornaments, bore direct relation to the anatomical
organism of man himself.

* One called *Jachen*, that is, *he shall establish ;* and the other *Boaz*,
or in it is strength. This was all emblematical, which, without giving
Solomon any participation therein, may be accounted for on the prin-
ciple, that the building was conducted under the superintendence of
Hiram, a Sidonian, who naturally had exercised the taste of his own
country in the discretion here allowed him. Nor will the circumstance
of those pillars having been made of *metal* oppose any barrier—the
design is the thing to be considered, not the *material.* And besides, we
find them of metal elsewhere also.

" An iron pillar," says Archer, " stands in a sort of court-yard, having
the remains of cloisters on the four sides. Its history is *veiled in darkest
night.* There is an inscription on it, which nobody can decipher : nor
is there any account, historical or traditional, except we may refer to the
latter class, a prevalent idea of all people, that the pillar is on the
most sacred spot of the old city, which spot was also its centre. It is
also said, that as long as the pillar stood, so long would Hindostan
flourish. This was the united dictum of the Bramins and astrologers of
the day. The pillar is fifteen or sixteen inches in diameter."

To instance only the most prominent of those ana-
logies, you will find the " holy" and the " most
holy" bear the same relation to each other, as the
cerebrum and cerebellum of the human mechanism.
Nor need this at all be wondered at, seeing that,
from the very faintest reflection, it must suggest itself
to the most indolent, that the divine ingenuity most
prominently shines forth in the human anatomy ; and
that, therefore, from the exalted sentiments which this
is calculated to inspire of the Godhead, " the noblest
study of mankind is man *."

Viewing it in this light, and coupling it with that
piety which is known to have animated the bosom
of David's anointed son, I cannot pass on without
participating in that sublime exclamation, which
bespoke at once his gratitude and his humility,
after the consummation of his mighty task. " But
will God," said he, " indeed dwell on earth? Be-
hold! the heaven and the heaven of heavens cannot
contain thee, how much less this house that I have
builded † !"

Now to the *era* for the erection of our Round
Towers. " As they have neither dates nor inscrip-
tions," says Sir John Ware, " and as history is silent
on that head, it cannot be expected that I should
point out the time when they were erected in this
country ‡."—A very cheap way, certainly, of getting
over a difficulty ! The same was the mode adopted
by him, and with equal candour, a few pages earlier,
as to the development of their *destination*, when he
says—" I confess it is much easier to combat and

* ανθρωπος εστι των παντων μετρον.—PROTAGORAS.
† 1 Kings viii. 27.
‡ Antiquities of Ireland, vol. ii. p. 134.

overthrow everything that has been hitherto advanced by writers in favour of the *Danish claim* to these monuments of antiquity and the *uses* of them, than to *substitute anything solid and satisfactory in their room* *." But inasmuch as the latter problem has been solved, one is led to conclude, that the obstacles to the former are but imaginary also.

To begin then—Camden, speaking of them, in the thirteenth century, says, he believes them to have been erected in the seventh, but does not know by whom! But I put it to any rational thinker to say, whether, if they had been a creation of the seventh century, it would be possible for a writer of the thirteenth to have been ignorant of their origin, and that too at a time when *tradition* was universal? and every father made it a point to instil into his son the events and circumstances that happened in his own day? This writer's testimony is sufficient, at all events, to show that they existed in the seventh century.

Bishop Cormac, we have seen before, has recorded them as objects of antiquity in his own time; and this being, at the latest, within the ninth century, they must have had existence before the seventh; else they could not well be deemed *ancient* two centuries after.

The Ulster Annals record the destruction of fifty-seven of them by an earthquake, A.D. 448; they must, therefore, have existed before that century also. But the Royal Irish Academy say *no;* because that tradition connects a person called the *Goban Saer,* and " the historical notices relative to whom

* Antiquities of Ireland, vol. ii. p. 129.

have been collected into Mr. Petrie's Essay.....with the erection of this (the Antrim Tower), as well as others in the north of Ireland*!" As every notice, therefore, respecting so important a character, must be eagerly sought after, I shall take leave to transcribe what the same high authority tells us of him, in the following words, viz.—

"*I have not learned the particular period at which he flourished,* but tradition says, that he was superior to all his contemporaries in the art of building; even in that dark age when so little communication existed between countries not so remotely situated, his fame extended to distant lands. A British prince, whose possessions were very extensive, and who felt ambitious of erecting a splendid palace to be his regal residence, hearing of the high attainments of the Goban Saer, in his sublime science, invited him to court, and by princely gifts, and magnificent promises, induced him to build a structure, the splendour of which excelled that of all the palaces in the world. But the consummate skill of the artist had nearly cost him his life, for the prince, struck with the matchless beauty of the palace, was determined that it should stand unrivalled on the earth, by putting the architect to death, who alone was capable of constructing such another, after the moment the building received the finishing touches of his skilful hand.

" This celebrated individual had a son, who was grown up to man's estate; and anxious that this only child should possess, in marriage, a young woman of sound sense and ready wit, he cared little for the factitious distinctions of birth or fortune, if he found her

* Dublin Penny Journal, July 20, 1833.

rich in the gifts of heaven. Having killed a sheep, he
sent the young man to sell the skin at the next market
town, with this singular injunction, that he should
bring home *the skin and its price* at his return. The
lad was always accustomed to bow to his father's
superior wisdom, and on this occasion did not stop to
question the good sense of his commands, but bent
his way to town. In these primitive times, it was
not unusual to see persons of the highest rank en-
gaged in menial employments, so the town-folk were
less surprised to see the young Goban expose a
sheep-skin for sale, than at the absurdity of the term,
' *the skin and the price of it.*' He could find no chap-
man, or rather chapwoman (to coin a term), for it was
women engaged in domestic business that usually
purchased such skins for the wool. A young woman
at last accosted him, and upon hearing the terms of
sale, after pondering a moment agreed to the bargain.
She took him to her house, and having stripped off
all the wool, returned him the bare skin, and the price
for which the young man stipulated. Upon reach-
ing home, he returned *the skin and its value* to his
father, who learning that a young woman became the
purchaser, entertained so high an opinion of her
talents, that in a few days she became the wife of his
son, and sole mistress of Rath Goban.

" Some time after this marriage, and towards the
period to which we before referred, when the Goban
Saer and his son were setting off, at the invitation of
the British prince, to erect his superb palace, this
young woman exhibited considerable abilities, and
the keenness of her expressions, and the brilliancy of
her wit, far outdid, on many occasions, the acumen
of the Goban Saer himself ; she now cautioned him,

when his old father, who did not, like modern archi-
tects, Bianconi it along Macadamized roads, got tired
from the length of the journey, *to shorten the road;*
and secondly, not to sleep a third night in any house
without securing the interest of *a domestic female
friend.* The travellers pursued their way, and after
some weary walking over flinty roads, and through
intricate passages, the strength of the elder Goban
yielded to the fatigue of the journey. The dutiful
son would gladly *shorten the road* for the way-worn
senior, but felt himself unequal to the task. On
acquainting his father with the conjugal precept, the
old man unravelled the mystery, by bidding him com-
mence some strange legend of romance, whose delight-
ful periods would beguile fatigue and pain into
charmed attention. Irishmen, I believe, are the
cleverest in Europe at ' *throwing it over*' females in
foreign places, and it is pretty likely that the younger
Goban did not disobey the second precept of his be-
loved wife. On the second night at their arrival at
the king's court, he found in the person of a female
of very high rank (some say she was the king's daugh-
ter), a friend who gave her confiding heart to all the
dear delights that love and this Irish experimentalist
could bestow. As the building proceeded under the
skilful superintendence of the elder Goban, the son
acquaints him with the progress of his love, and the
ardent attachment of the lady. The cautious old man
bade him beware of one capable of such violent passion,
and take care lest her jealousy or caprice might not
be equally ungovernable, and display more fearful
effects. To discover her temper, the father ordered
him to sprinkle her face with water as he washed
himself in the morning—that if she received the

aspersion with a smile, her love was disinterested, and
her temper mild ; but if she frowned darkly, her love
was lust, and her anger formidable. The young man
playfully sprinkled the crystal drops on the face of
his lover—she smiled gently—and the young Goban
rested calmly on that tender bosom, where true love
and pitying mildness bore equal sway.

" The wisdom of the Goban Saer and his sapient
daughter-in-law was soon manifested ; for, as the
building approached its completion, his lady-love com-
municated to the young man the fearful intelligence,
that the king was resolved, by putting them to death
when the work was concluded, that they should erect
no other such building, and, by that means, to enjoy the
unrivalled fame of possessing the most splendid palace
in the world. These tidings fell heavily on the ear
of the Goban Saer, who saw the strong necessity of
circumventing this base treachery with all his skill.
In an interview with his majesty, he acquaints him
that the building was being completed ; and that its
beauty exceeded everything of the kind he had done
before ; but that it could not be finished without a cer-
tain instrument which he unfortunately left at home,
and he requested his royal permission to return for
it. The king would, by no means, consent to the
Goban Saer's departure ; but anxious to have the edi-
fice completed, he was willing to send a trusty mes-
senger into Ireland for that instrument upon which
the finishing of the royal edifice depended. The
other assured his majesty, that it was of so much
importance that he would not entrust it into the
hands of the greatest of his majesty's subjects. It
was finally arranged that the king's eldest son should
proceed to Rath Goban, and, upon producing his cre-

dentials to the lady of the castle, receive the instru-
ment of which she had the keeping, and which the
Goban Saer named ' *Cur-an-aigh-an-cuim.*' Upon his
arrival in Ireland, the young prince proceeded to
fulfil his errand; but the knowing mistress of Rath
Goban, judging from the tenor of the message, and
the ambiguous expressions couched under the name
of the pretended instrument, that her husband and
father-in-law were the victims of some deep trea-
chery, she bade him welcome, inquired closely after
her absent friends, and told him he should have the
object of his mission when he had refreshed himself
after the fatigues of his long journey. Beguiled by
the suavity of her manners and the wisdom of her
words, the prince complied with her invitation to
remain all night at Rath Goban. But in the midst
of his security, the domestics, faithful to the call
of their mistress, had him bound in chains, and led
to the dungeon of the castle. Thus the wisdom of
the Goban Saer, and the discrimination of his daugh-
ter, completely baffled the wicked designs of the
king, who received intimation that his son's life
would surely atone for the blood of the architects.
He dismissed them to their native country laden with
splendid presents; and, on their safe arrival at Rath
Goban, the prince was restored to liberty *."

Gentlemen of England, where is your knowledge of
history? which of your famed monarchs was it that
was going to play this scurvy trick upon our *Goban,*
and earn for himself the infamous notoriety of a
second *Laomedon,* by defrauding this *architect,* who
no doubt was a *Hercules,* of his stipulated salary?

* Dublin Penny Journal, June 10, 1833.

Ye shades of Alfred and of Ethelbert, I pause for a reply!

But this indignity, if offered to *Goban*, would be even greater than that offered by Laomedon to Hercules; for in the latter case the crime was only that of *dishonesty*—which is not uncommon in any age—superadded to a spice of *impiety*, in cheating a god; but in the former case, over and above all these, would weigh a consideration which our people would never forgive—namely, a violation of the laws of *gallantry*, this same Goban " having been believed in this part of this country to have been a *woman**!" And yet the same vehicle that puts forth this trash has told us, in the preceding extract, that he was a *father* and a *husband!* (I do not believe in hermaphrodites,) and, to crown the climax of absurdity, gives us the following specimen of the *heroism* of his *wife:* viz.—

" The Goban Saer having been barbarously murdered, together with his journeymen, by twelve highwaymen, the murderers proceeded to his house, and told the Goban's wife, with an air of triumph, that they had killed her husband. She appearing nowise concerned, asked them to assist her in drawing open the trunk of a tree, which the Goban had been cutting up into planks. They put in their hands for the purpose, when, drawing out a wedge, she left them literally in a cleft stick, and taking up an axe, cut off all their heads at a blow † !"

But this is ludicrously trifling with the time of my readers. I am alive to the fact, and I most submis-

* Dublin Penny Journal, July 20, 1833.
† Ibid. October 5, 1833.

sively crave forgiveness, which I doubt not I shall
receive, when I state that my sole object was to ex-
pose the *flimsiness* of that subterfuge, by which the
Royal Irish Academy, or rather their council! had
hoped that they could blindfold the public, as well
as they had succeeded in sequestrating my prize!

I do not deny indeed but that there may have been
in Ireland, at one time, such a person as the Goban
Saer: but if ever he did belong thereto, it must have
been at least *sixteen hundred* years before the epoch
which the Academy sanction—and so sanction, be it
observed, because that a weak-minded poor monk,
when writing the biography of St. *Abhan,* and tor-
turing his invention, in all quarters, for the purpose
of conjuring up miracles to lay to his score, thought
the similarity of sound between *Abhan* and *Gobhan* so
inviting, that he must contrive an interview between
the parties ;* and so, with " one fell swoop," alias, *dash
of the pen,* cutting off the centuries of separation, he
treats himself and his pupils to the following bur-
lesque :—

" *Quidam* famossissimus in omni arte lignorum et
lapidum *erat* in Hibernia nomine Gobbanus, cujus
artis fama usque *in finem sæculi* erit in ea. Ipse jam
postquam, aliis sanatis, in superflua artis suæ mercede
lumen oculorum amisit, et erat cæcus. Hic vocatus
est ad S. Abbanum et dixit ei: Volo ædificium in
honorem Dei ædificare, et tu age illud. Et ille ait:
Quomodo possum agere cum sim cæcus? dixit ei
sanctus, Quamdiu illud operaberis lumen oculorum
habebis, sed tibi postea non promitto. Et ita factum
est, nam ille artifex apud sanctum Dei in lumine suo
operatus est, et cum esset illud perfectum lumen ocu-

lorum amisit * "—that is—in the true spirit of what
my countrymen call a *Sceal Feeneechtha,* or *Phœnician
story,* i. e., an *entertaining lie,* (a proof, by the way,
that they claim no kindred with the Phœnicians, else
they would not thus confirm the well-known epithet
of *Punica fides*); however to put this *sceal Feeneech-
tha* into English, it runs thus :—" *Once upon a time,*
there lived in Erin, a man most celebrated for his uni-
versal mastery over wood and stone ; and whose fame,
accordingly, will live therein, as long as *grass shall
grow* or *purling streams flow in its enchanting scenery.*
This good man's name was *Gobhan,* who, wallow-
ing in wealth from the meritorious exertions of his
abilities, yet incapacitated from enjoying it by the
deprivation of his sight, was summoned before St.
Abhan, who had already healed the rest of the world
by his miraculous gifts, and who thus addresses
him :—' I wish to build a house to the honour of God ;
and set you about it. ' How can I,' says *Gobhan,*
' *seeing* that I am *blind?*' ' O very well,' says *Abhan,*
' I will settle that ; long as ever you are engaged in
the business, you shall have the use of your eyes ;
but I make no promises afterwards !' And verily it
was so, for long as ever he did work with the saint, he
had the use of his sight, but soon as ever the work
was done, he relapsed into his former blindness! "

Well, you may laugh if you chuse, in future, at the
simplicity of the *monks ;* but here is one for you,
who, in the very extravagance of his simplicity, and
that while bursting, almost, with risibility, himself, at
the speciousness of his conceit, has contrived to
bamboozle a jury of *umpires,* who pique themselves

* Colgan.

upon their contempt for everything *monkish*, and who,
actually, in any other case, had they the *sworn* evi-
dence of a monk, would go counter thereto; but here,
where an old doting friar is drawing upon his inge-
nuity, every syllable that escapes him is taken for
gospel!

Now, *I* as readily believe, as they would fain per-
suade me, that " long as *Gobhan* did work with *Ab-
han* he had the use of his sight," and that " soon as
ever the work was done, he relapsed into his former
blindness." And why? because the two men, living
in different ages, never laid eyes upon each other at
all, and thus were they *both, morally and literally, blind
to each other!*

The Scythians, who were masters of this country
at the Christian era, and for many centuries pre-
ceding, had a sovereign contempt for everything like
architecture. " They have no towns," says Herodo-
tus, " no fortifications; their habitations they always
carry with them *. The principle which actuated
them, in this indifference to *houses*, was precisely that
which governed the Britons in a similar taste—they
were a race of *warriors*, and dreaded the imputation
of *cowardice* more than they did the inclemency of the
weather. It is not without reason, therefore, that we
find Hollingshed, who wrote his Chronicles in Queen
Elizabeth's reign, complaining that " three things
were altered for the worse in England—the multi-
tude of chimneys lately erected, the great increase of
lodgings, and the exchange of treen platters into
pewter, and wooden spoons into silver and tin.
Nothing but oak for building houses is now regarded:
when houses were built with willow, then had we

* Melpomene, ch. 46.

oaken men ; but now our houses are come to be built of oak, our men are not only become willow, but a great many altogether of straw *."

St. Bernard, also, in reference to the Irish, having mentioned that Malachy O'Morgan, archbishop of Armagh, was the first (of the Scythian race) who had erected a stone house in the island, introduces a native upbraiding him with it, in these terms :— " What wonderful work is this? why this innovation in our country? we are Scots, and not Gauls, what necessity have we for such durable edifices?"

St. Abhan, therefore, who belonged to the sixth century, at which time the Scythians had here absolute sway, never once dreamt of erecting a stone edifice, or of evoking from the grave the manes of *Gobhan*, who, if he ever existed, must have been a member of the former dynasty.

Those *pious* fabrications which the biographers of early saints had concocted, with a view to magnify the reverence due to their subjects, remind me of one which was invented for the benefit (but in reality to the detriment) of St. Patrick, and which, even at the risk of appearing tedious, I must detail.

" Whereas,"—you perceive the record begins with all the formalities of office,—" in the year of the world 1525, Noah began to admonish the people of vengeance to come by a generall deluge for the wickednesse and detestable sinne of man, and continued his admonition for 120 years, building an arke for the safeguard of himself and his family ; one Cæsarea (say they), according unto others, Caisarea, a

* Oppidum vocant Britanni cum silvas impeditas vallo atque fossâ munierunt. The Britons call a town an encumbered wood, fenced in with a rampart and a ditch.—Cæsaris Comment. lib. 5.

a niece of Noah, (when others seemed to neglect this warning,) rigging a navy, committed herself, with her adherents, to the seas, to seeke adventures and leave the plagues that were to befall. There arrived in Ireland with her three men, *Bithi, Largria,* and *Fintan,* and fifty women. Within forty days after her arrivall the universal flood came upon them, and those parts, as well as upon the rest of the world, and drowned them all; in which perplexity of mind and imminent danger, beholding the waves overflowing all things before their eyes, *Fintan* is said to have been *transformed into a salmon,* and to have swoome all the time of the deluge about Ulster; and after the fall of the water, recovering his former shape, to have lived longer than *Adam,* and to have delivered strange things to posterity, so that of him the common speech riseth, 'If I had lived Fintan's years I could say much.' "

Well, " to make a long story short," this same Fintan, who was converted into a *salmon,* for the sole purpose of accounting for his appearance on the same theatre with St. Patrick, is introduced to the saint, when, after a very diverting episode upon his *submarine* adventures, a miracle, of course, is to be wrought, and, anon, we have the contemporary of *Noah,* and of *Patrick,* at once a *salmon,* a *dolphin,* and a *man,* renouncing his attachment to the *waters* and to the *boat,* and devoutly embracing Christianity ! ! !

The anachronism committed in the instance of the *Goban Saer* was precisely of the same character ! and the very name assigned him, which is that of a *class,* not of an individual, exposes the counterfeit !

Gobhan Saer means, the *Sacred Poet,* or the *Free-*

mason Sage, one of the *Guabhres,* or *Cabiri,* such as
you have seen him represented upon the Tuath-de-
danaan cross at Clonmacnoise. To this colony, there-
fore, must he have belonged, and therefore the *Towers,*
traditionally associated with his erection, must have been
constructed anterior to the Scythian influx.

But we are not left to such inferences to determine
the point. A more substantial ally, the imperishable
landmarks of history stand forward as my vouchers.

To this hour the two localities—whereon the
Tuath-de-danaans had fought their two decisive
battles with the *Fir-Bolgs,* their immediate prede-
cessors in the occupation of this island—one near
Lough Mask, in the county Galway, and the other
near Lough Arran, in the county Roscommon, are
called by the name of *Moy-tura,* or more correctly, in
Irish, *Moye-tureadh!*

The meaning of this compound, beyond the pos-
sibility of disputation, is *The field of the Towers!*
And when, in both those places, are still traced the
ruins of such edifices, are we not inevitably forced to
connect, as well their *erection* as the imposition of the
name, with the fortunes or with the feelings of some
side of the above combatants?

You will say, then, that the *Fir-Bolgs* were as likely
to have originated the name, and built those struc-
tures upon the site, in *reliance* upon *their* divinities,
as that the *Tuath-de-danaans* should have been the
authors in *gratitude* to *theirs?*

Our only mode, therefore, is to consider the vestiges
of their respective religions : and when we perceive
that, in the isles of Aran, whither the Fir-Bolgs betook
themselves after their *first* defeat, for the period in-

tervening between those two battles, commemorated
by the above name, there appears not a *vestige* of
architectural masonry, approaching in character to a
Columnar temple, while, on the contrary, they abound
in specimens of *Druidical* veneration, is it not evident,
that they, at all events, have no claim thereto?

The worship, therefore, of the Fir-Bolgs differed
altogether from that of the Tuath-de-danaans, and
so *they* are excluded from those immortal memo-
rials. Indeed the avidity with which they hailed the
approach of a new conqueror, and tendered him their
assistance for the reduction of the island, arose not
so much from any fondly-cherished hope of their
being themselves restored to the throne they had
lost, or even allowed therein a participation, as from
an illiberal aversion to the emblematic ritual of their
temple-serving superiors, which their ignorant pre-
judices could not allow them to appreciate !

We are warranted, then, I presume, in assigning
solely to the Tuath-de-danaans the affixing of the
name *Moy-tureadh* to those *two scenes of their success.*
And did there even a *doubt* remain on the mind of the
most incredulous, as to the accuracy of the inference,
or the correctness of that reasoning, which would
identify this people with the erections *in general* of
those rotundities, it will hide its diminished head,
and vanish with self-abasement, when I bring forward
the testimony of Amergin, brother to Heremon and
Heber,—the immediate victors of this religious order,
—in the following graphic and pictorial treasure, as
still religiously preserved in the Book of Leccan, viz.

" Aonoch righ Teambrach
Teamor *Tur Tuatach*
Tuath Mac Miledh
Miledh Long Libearne.''

That is,

> " Noble is the king of Teamor,
> Teamor the *Tuathan Tower*,
> Tuaths were the sons of Miledh,
> Miledh of the Libearn vessels."

Here, then,—*a circumstance which I cannot imagine how it could have escaped all before me!*—we have this disputed question at length settled, and incontrovertibly adjudicated by the very head of *that body*, which Montmorency had assured us, never alluded to those edifices as a subject of national boast—I mean the *Bards*. For, whether we admit this Amergin to have been the person above described *, the actual contemporary and successor of the Tuatha-de-danaans, or as the other, of that name, who belongs to the Christian age, and the time of St. Patrick, the supposition is equally valid, to prove the existence of those structures anterior to *their* respective eras! and the ascription, in either case, remains unshaken, and irrefragable, which, in the word *Tuathan Tower*, unites the *Tower* erectors with the colony of the *Tuatha!*

* Of whom O'Flaherty gives this character from an Irish poem, writ by one G. Comdeus O' Cormaic, which he thus translates into Latin.

> Primus Amerginus genu candidus anthor Jern
> Historicus, judex lege, poeta, sophus.

That is,

> Fair-limbed Amergin, venerable sage,
> First graced Ierne's old historic page ;
> Judge of the laws, for justice high approved,
> And loving wisdom by the muse beloved.

And he quotes this hemistich as another fragment of his poetry,

> Eagna la heagluis aidir
> Agus feabtha la flaithibh.

That is,

> Let those, who o'er the sacred rites preside,
> Take wisdom for their guardian and their guide ;
> Let those, whose power the multitude obey,
> Support by conduct their imperial sway.

My opponents may now demolish, if they can, all my foregoing deductions, as speedily as they please,—nay, did the destructiveness of fire or other untoward accident, deprive me of the deductions of my preceding labours, to *this one stanza* would I cling, as the palladium of my truth ; to this landmark would I adhere as my " ne plus ultra " against error, in its encroachments upon history * !

In the whole catalogue of Irish deposits, there exists not one of more intrinsic value to the lover of antiquities, so far as the right settlement of history is concerned, than what those four lines present. For, in the first place, we learn that the celebrity of Teamor† arose not from any gorgeous suit of palaces of a castellated outline. Its renown consisted in being the central convention for religious celebration to all the distant provincials once in every year; who, after attending the games in the adjoining district of *Tailtine*, now Telltown, adjourned, for legislative deliberations, to the Hill of Tarah, where they propounded their plans, not within the confined enclosures of any measured dome, but under the open canopy of the expanded firmament.

Teamor, then, was not a Palace at all, but one of the " Round Towers," or Budhist Temples, belonging to the Tuath-de-danaans ; and this is further proved by the result of researches, made to explore the foundation of an edifice, confirmatory of a regal mansion, having all ended in the most confuting disap-

* The above stanza, I should observe, belongs to that species of poetry called in Irish *con-a-clon*, wherein the final word of each line is the initial one of the following.

† Or " Tarah," says the Dinn Seanchas, compiled by Amergen Mac Amalgaid, in the year 544, " was so called from its celebrity for melody."

pointment—no vestiges could be found save those of the Round Tower!

The importance which attaches to the *Tailtine* games above noticed, makes it necessary that I should bestow upon them something more than a cursory glance. Let me, therefore, first state what other writers have said respecting them.

" We attribute," says Abbé Mac Geoghegan, " to Lugha Lamh Fada, one of their ancient kings, the institution of military exercises at Tailton in Meath ; those exercises consisted in wrestling, the combats of gladiators, tournaments, races on foot and on horseback, as we have seen them instituted at Rome a long time after by Romulus, in honour of Mars, which were called ' Equitia.' These games at Tailton, which Gratianus Lucius and O'Flaherty call ' ludi Taltini,' were celebrated every year, during thirty days, that is, fifteen days before, and fifteen days after, the first of our month of August. On that account, the first of August has been, and is still called in Ireland, ' Lah Lugh-Nasa,' which signifies a day in memory of Lugha. These olympiads always continued amongst the Milesians until the arrival of the English. We discover to this day some vestiges of them, without any other change than that of time and place. Wrestling, which we call in France ' le tour du Breton,' the exercises of gladiators and races on foot, are still on festival days their common diversion, in various districts of Ireland, and the conquerors generally receive a prize."

" *Tailtean*," says Seward, " a place in the county of Meath, where the Druids sacrificed in honour of the *sun* and *moon*, and *heaven* and *earth*, on the first of August, being the fifth revolution of the moon

from the vernal equinox. At this time the states assembled, and young people were given in marriage, according to the custom of the eastern nations. Games were also instituted, resembling the Olympic games of the Greeks, and held fifteen days before and fifteen days after the first of August. This festival was frequently denominated Lughaid Naoislean, or the Matrimonial Assembly."

"This chapter," says Vallancey, "might have been lengthened many pages, with the description and etymology of the various ornaments of female dress, but enough has been said to convince the reader, that the ancient Irish brought with them the Asiatic dress and ornaments of their ancestors, for they could not have borrowed these names of Spaniards, Britons, Danes, or Norwegians.

"Thus dressed and ornamented, the youthful females of Ireland appeared at *Tailetan*, or the mysteries of the sun, on the first day of August in each year, when the ceremony of the marriage of the sun and moon took place, and the females were exposed to enamour the swains. The day still retains the name of *Luc-nasa*, or the Anniversary of the Sun. And the name of the month of August, in Sanscrit, is Lukie, whom they make the wife of Veeshnu, the preserver and goddess of plenty. So the Irish poets have made this festival, named Lucaid-lamh-fada, i. e., the Festival of Love, the consecration of hands, to be the feast of Luigh-lamh-fada, or Luigh-longumans, to whom they have given Tailte for wife, who, after his death, was married to Duach."

"The Taltenean sports," says Sir James Ware, "have been much celebrated by the Irish historians. They were a sort of warlike exercises, something resembling the Olympic Games, consisting of racing,

tilts, tournaments, or something like them, and other exercises. They were held every year at Talten, a mountain in Meath, for fifteen days before, and fifteen days after, the first of August. Their first institution is ascribed to Lugaid-lam-fadhe, the twelfth King of Ireland, who began his reign A.M. 2764, in gratitude to the memory of Tailte, the daughter of Magh Mor, a prince of some part of Spain, who having been married to Eochaid, King of Ireland, took this Lugaidh under her protection, and had the care of his education in his minority. From this lady both the sports and the place where they were celebrated took their names. From King Lugaidh the first of August was called Lugnasa, or the memory of Lugaidh, nasa signifying memory in Irish."

The truth is, that those games were called *Tailtine* (whence the English *Tilts*), and the place *Tailton*, from *Tailte, which, in our language, signifies a wife ;*—and the sports, there exhibited, made but a representation of the victory which Budha gained over *Mara*, the great Tempter, who had attacked him on the day of his attaining to perfection, with an innumerable host of demons. The conflict is said to have lasted for fifteen days, at the end of which Budha reduced them to submission, and to the acknowledgment of his pretensions as the Son of God.

The *battle-scenes*, therefore, with which the *Tuath*-dedanaan crosses and obelisks are decorated, bear reference, all of them, to this religious achievement : and to this hour you will find those identical games celebrated in various parts of the east, and for the same number of days ! In Egypt, also, there was a place called Tailtal *, and named from the same cause. Nay, the

* Once occupied by a celebrated queen !—*Asiatic Researches.*

name of the Eleusinian mysteries was *Tailtine!* but
this the Greeks not comprehending, they bent it, as
usual, to some conformity to their own language,
and made *Teletai* of it! and then they were at no loss
in making a *reason* for it in like manner, viz., that
no one could be *finished* until *initiated* therein!

But it is not alone as assigning those edifices to
their real proprietors that this "stanza" is of value; but
as giving us an insight into that mysterious personage
whom our modern chroniclers would fain represent as
the father of Heber and Heremon. A greater error,
whether voluntary or accidental, was never incurred.
Heber and Heremon were the sons of Gallamh, and
invaded this island at the head of a Scythian colony *,
distinct in all respects, save that of language †, from
their Tuathan predecessors.

These predecessors were headed by three brothers,
Brien, Iuchordba, and Iuchor, the sons of King
Miledh, a Fo-morian, by a queen of the Tuath-de-da-
naan race, agreeably to this record in the book of
Leccan: viz.—

" D'Hine fine *Fo-mora* dosomh de shaorbh a athor,
agus do *Tuathabh Dadanann* a mhathar"—that is, the
father was of the race of the Fo-morians, and the
mother a Tuath-de-danaan.

Again, in the Seabright Collection, this genealogy
is prosecuted farther, and from it, General Vallancey
translates some lines, which are by no means irrele-
vant, as follows, viz. :—" Cuill, Ceacht, and Grian,

* Heremon was the first of the *Scots* who held the dominion over all
Ireland.—*Psalter of Narran.*

† For, in the first place, the general tradition of the old Irish handed
down to us by all our historians and other writers, imports that when
the Scots arrived in Ireland, they spoke the same language with that of
the Tuath-de-danaans.—*Preface to O'Brien's Irish Dictionary.*

were the children of little Touraine—and their de-
scendants, Uar, Jurca, Jurcatha ; and, from Uar was
descended *Brian*, who was named Touran ; and many
others not here enumerated."

But the history of those events having been de-
stroyed by time, the degenerate *Pheeleas*, wishing to
flatter the vanity of the existing powers, did not hesi-
tate to ascribe to the *Scythian*, or *modern* Irish, fol-
lowers of Heber and Heremon, those brilliant fea-
tures of primeval immortality which appertained
exclusively to the Irish of another day—the Hyper-
borean or Iranian Irish !

The Tuath-de-danaans having been proved the
authors of the Round Towers, my ambition in the inves-
tigation is already attained. But since we are told,
that this people had claimed possession of the island
as inheritors of an antecedent and pre-occupying
eastern colony, it may be worth while to inquire
whether we can discover any traces to connect
those predecessors with any of these edifices. With-
out bestowing upon it, however, more considera-
tion than what the exigency demands, I will briefly
observe, that we are likely to find such in the history
of the *Fo-moraice*, who are represented in our chro-
nicles, *by the party who had ejected them,* under the
obnoxious character of *monsters* and *giants* * !

It is high time to give up those abuses in the im-
port of words. *Fo-moraice* means literally, the ma-

* The Egyptian epithets are not very dissimilar,—" Besides these first
inhabitants of Sancha-dwipa, who are described by the mythologists,
as *elephants, demons,* and *snakes,* we find a race called Shand-ha-yana,
who are the real Troglodites ; they were the descendants of Abri,
before named, whose history, being closely connected with that of the
Sacred Isles in the West, deserves peculiar attention."—*Asiatic Re-
searches.*

riners of *Fo*, that is, of *Budh :* and their *religion* being thus identified with that of the *Tuath-de-danaans*, what could be more natural than, that they should have erected *temples* of the same shape with theirs ?

This deduction will appear the more credible from the unanimity of all our historians, on the subject of this people having been perfect masters of *masonry*,—as well as from the universally credited report in the days of Cambrensis, of some of the Towers being then visible beneath the inundation of Lough Neagh *.

I confess I am one of those persons who give faith to this tradition ; for even my experience of the vicissitudes of all things earthly has enabled me to say, in the words of the philosophic poet, that,

> " Where once was solid land seas have I seen,
> And solid land where once deep seas have been,
> Shells far from seas, like quarries in the ground,
> As anchors have in mountain tops been found.
> Torrents have made a valley of a plain,
> High hills by floods transported to the main,
> Deep standing lakes sucked dry by thirsty sand,
> And on late thirsty earth now lakes do stand."

* Nearly similar things, we find, have occurred in the East. " The natives of the place (Mavalepuran, in India) declared to the writer of this account, that the more aged people among them remembered to have seen the tops of several pagodas far out in the sea ; a statement which was verified by the appearance of one on the brink of the sea, already nearly swallowed up by that element."—*Asiatic Researches.*

CHAPTER XXVII.

HAVING promised early in this volume to identify
our island with the Insula Hyperboreorum of anti-
quity, I shall, without further tarrying, produce the
extract referre dto, from Diodorus; and, lest I may be
suspected of adapting it to my own peculiar views,
it shall appear minutely in Mr. Booth's transla-
tion—viz.,

"Amongst them that have written old stories much
like fables, Hecatæus and some others say, that there
is an island in the ocean, over against Gaul, as big
as Sicily, under the arctic pole, where the Hyper-
boreans inhabit, so called because they lie beyond
the breezes of the north wind. That the soil here
is very rich and very fruitful, and the climate tempe-
rate, insomuch as there are two crops in the year.

"They say that Latona was born here, and there-
fore that they worship Apollo above all other gods;
and because they are daily singing songs in praise of
this god, and ascribing to him the highest honours,
they say that these inhabitants demean themselves as
if they were Apollo's priests, who has here a stately
grove and renowned temple of round form, beautified
with many rich gifts. That there is a city like-
wise consecrated to this god, whose citizens are most
of them harpers, who, playing on the harp, chant
sacred hymns to Apollo in the temple, setting forth

his glorious acts. The Hyperboreans use their own natural language, but, of *long* and ancient time, have had a special kindness for the Grecians; and more especially for the Athenians, and them of Delos; and that some of the Grecians passed over to the Hyperboreans, and left behind them divers presents *, inscribed with Greek characters; and that Abaris formerly travelled thence into Greece, and renewed the ancient league of friendship with the Delians.

" They say, moreover, that the moon in this island seems as if it were near to the earth, and represents, on the face of it, excrescences, like spots on the earth; and that Apollo, once in nineteen years, comes into the island; in which space of time the stars perform their courses, and return to the same point; and therefore the Greeks call the revolution of nineteen years, the Great Year. At this time of his appearance they say that he plays upon the harp, and sings and dances all the night, from the vernal equinox † to the rising of the Pleiades‡, solacing himself with the praises of his own successful adventures. The sovereignty of this city, and the care of the temple, they say, belong to the Boreades, the posterity of Boreas, who hold the principality by descent, in the direct line from that ancestor."

When copying this narrative from the writings of Hecatæus, it is evident that Diodorus did not believe one single syllable it contained. He looked upon it as a romance:—and so far was he from identifying it with any actual locality, that he threw over the whole an air of burlesque. We are, therefore, not at all obliged for the services he has rendered—yet shall we

* Αναθηματα,—things dedicated to the gods.

† In March. ‡ In September.

make his labours subservient to the elucidation ot
truth. Little did he dream that Ireland,—which he,
by and by, expressly mentions by the name of Irin,
and which he calumniates as cannibal,—was one and
the same with that isle of which he read such enco-
miums in the writings of former antiquaries ; and,
most unquestionably, it did require no small portion
of research to reconcile the contradiction which the
outline involves, and which is now further enhanced
by his scepticism.

Unable to solve this difficulty, Mr. Dalton,—wishing
to retain, by all means, the *Hyperborean isle,*—which,
indeed, he could not well discard—yet not bring it in
collision with the *Iranian libel,*—does not hesitate to
throw, at once, overboard, into the depth of the Atlantic,
the island of Irin, (alias *Ireland,*) and affirm, that it
never was the place which the historian had specified.
" It is not quite certain," says he, " what place Dio-
dorus means by Iris * ; from the turn of the expression
it would *rather appear to be a part of Britain*—per-
haps the Erne, for which Mr. James M'Pherson
contends in another place,—while the island which
Diodorus does mention in the remarkable pages cited
above, and which so completely agrees with Ireland,
is never called Iris by him, nor does the name occur
again in all his work, nor is it by any other author
applied to Ireland †."

Mind, now, reader, how easily I reconcile the con-
flicting fact of Diodorus's incredulity with his positive
defamation.

At the period when he flourished as an accredited
historian, the occupancy of Ireland had passed into new

* See page 120.
† Trans. Roy. Ir. Acad., vol. xvi. p. 166.

hands. The Scythians were the persons then possessed of the soil; and they being a warlike tribe, averse to letters, to religion, and to refinement*,—but overwhelming in numbers,—obliterated every vestige of that primeval renown, in which the island had once gloried, and which afforded theme and material, to the learned of all countries, for eulogy and praise.

Hecatæus was one of those, who depicted in glowing colours the primitive splendour and the ethereal happiness of Ireland's first inhabitants. He belonged to an age which was well called antiquarian, even in the day in which Diodorus wrote, viz., B. C. 44; and when, therefore, this latter, looking over the pages of his venerable predecessor, saw them so replete with incidents,—at variance with our condition in his own degenerate day,—he did not only not dream of considering Ireland as the place described, but looked upon the whole story as the fiction of a dotard.

Let us, however, despite of Diodorus, establish the veracity of the antiquarian Hecatæus. Then behold the situation of this island, just opposite to France—in size as large as Sicily—at once corresponding to the locality and size of Ireland, and subversive of the claims of those who would fain make England, Anglesea, or one of the Hebrides, the island specified.

Consider further the prolificacy of its soil, and with that compare what the old poet has affirmed,—

* Procopius calls them αγηχοι και αμιλιτητοι, that is, heedless and indifferent to all culture.

Bishop Cormac also says, that he " cannot sufficiently express his astonishment at the indifference which the Scottish nation evinced in his day to literature."

Strabo calls them, Αγριων τιλιως ανθρωπων, while Mac Pherson asserts of their brethren, that " nothing is more certain than that the British Scots were an illiterate people, and involved in barbarism, even after the Patriarch's mission to the Scots of Ireland."

and what we know to be true,—of our own country, viz. :—

> " Illic bis niveum tondetur vellus in anno
> Bisque die referunt ubera tenta greges."

Then bring its propinquity to the " arctic pole," and the high northern latitude which Strabo[*] and other ancients have assigned to Ireland, into juxtaposition with " Hyperborean," the name given to its inhabitants from the very circumstance of their lying so far to the north,—and the identity of the isle with that in which each true Irishman exults is infallibly complete, when I quote from Marcianus Heracleotes—who wrote in the third century, and who, as he himself avows, only drew up a compendium from the voluminous works of Artemidorus, who flourished in the hundred and sixty-ninth Olympiad, or 104 years before Christ—the following description of this sacred island, viz.: " Iuvernia, a British isle, is bounded on the north (ad Boream) by the ocean called the Hyperborean; but on the east by the ocean which is called the Hibernian; on the south by the Virginian ocean. It has sixteen nations and eleven illustrious cities, fifteen remarkable rivers, five remarkable promontories, and six remarkable islands."

Here the sea, encompassing Ireland on the north, is called the Hyperborean Ocean[†]; and when we are told that the priests officiating at the round temples of

[*] In fact this writer had no other reason for this *mistake* which he has committed, in describing it as " scarce habitable for cold,"—than his knowledge of its Hyperborean situation. " The most remote navigation northward from the Celtic coast, in our days," says he, " is said to be into Ireland (Ierné), which being situated beyond Britain, is scarce habitable for cold, so that what lies beyond that island is thought to be not at all habitable."—Geog. lib. 2, ex vers. Gul. Xylandri.

[†] Orpheus, also, calls the sea dividing the north of Scotland from Ireland, " Mare Cronium, idem quod mare saturninum et oceanus septentrionalis."—VALLANCEY.

Apollo were called Boreades, we can readily under-
stand the origin of the name, as derived from *Boreas*,
the deity who presided over the north-east wind, to
which they offered their vows,—just as we find the
emperor Augustus erecting a temple at Rome, many
centuries after, to the wind called Circius.

To this deification of the energies of nature, which,
as before affirmed, was but part and parcel of that
form of worship called Sabaism, the author of the
Book of Enoch has alluded in the following mys-
terious episode :—

" Then another angel, who proceeded with me,
spoke to me ; and shewed me the first and last secrets
in heaven above, and in the depths of the earth : in
the extremities of heaven, and in the foundations of
it, and in the receptacle of the winds. *He shewed
me* how their Spirits were divided; how they were
balanced; and how both the springs and the winds
were numbered according to the force of their Spirit.
He shewed me the power of the moon's light, that its
power is a just one ; as well as the divisions of the
stars, according to their respective names ; *that* every
division is divided; that the lightning flashes ; that
their Host immediately obey ; and that a cessation
takes places during thunder, in the continuance of its
sound. Nor are the thunder and the lightning sepa-
rated ; neither do both of them move with one Spirit ;
yet are they not separated. For when the lightning
lightens, the thunder sounds, and the Spirit, at a
proper period, pauses, making an equal division be-
tween them ; for the receptacle of their times is what
sand is. Each of them at a proper season is re-
strained with a bridle, and turned by the power of

the Spirit; which thus propels them according to the spacious extent of the earth."

Yet beautiful as is the above, it is not much more so than an almost inspired little poem, which appeared some time ago, in one of the public prints, as emanating from the pen of an American lady, named Goold, personifying this element, viz.—

> " We come ! we come ! and ye feel our might,
> As we're hastening on in our boundless flight ;
> And over the mountains and over the deep,
> Our broad invisible pinions sweep.
> Like the Spirit of Liberty, wild and free !
> And ye look on our works, and own 'tis we ;
> Ye call us the *winds ;* but can ye tell
> Whither we go, or where we dwell?
>
> Ye mark as we vary our forms of power,
> And fell the forest or fan the flower,
> When the hare-bell moves, and the rush is bent,
> When the tower's o'erthrown and the oak is rent,
> As we waft the bark o'er the slumbering wave,
> Or hurry its crew to a watery grave :
> And ye say it is we ! but can ye trace
> The wandering *winds* to their secret place?
>
> And whether our breath be loud and high,
> Or come in a soft and balmy sigh,
> Our threat'nings fill the soul with fear,
> As our gentle whisperings woo the ear
> With music aërial, still 'tis we,
> And ye list, and ye look ; but what do ye see?
> Can ye hush one sound of our voice to peace,
> Or waken one note when our numbers cease?
>
> Our dwelling is in th' Almighty's hand,
> We come and we go at his command ;
> Though joy or sorrow may mark our track,
> His will is our guide, and we look not back ;
> And if, in our wrath, ye would turn us away,
> Or win us in gentlest air to play,
> Then lift up your hearts to Him who binds,
> Or frees, as he will, the obedient *winds !*"

And now, as to those " tempies " themselves, " of
round form," sacred to Apollo, where will Borlasse
in his championship for England, or Rowland in his
claims for the island of Anglesea, or Toland and
Carte for the little Hebrides isles, find a single ves-
tige of a *rotund edifice* of antiquated consecration, ap-
pertaining to the age which Hecatæus described ?—
whereas, in Ireland, of the two hundred and upwards,
with which its surface was, at one time, adorned, we
have not only *vestiges* of each and all to this day ;
but, out of the sixty that *survive*,—after an interval of
more than three thousand years standing,—about
twenty still display their Grynean devotion and their
Hyperborean tranquillity, and are likely so to do for
three thousand years more, should this world, or our
portion of it, but last so long!

To give soul to the solemnization of this religious
pomp, the Irish have ever cultivated the mysteries of
music. The harp more particularly had enlisted the
energies of their devotional regard, and their eminence
in its management made Hecatæus well observe, that
" the inhabitants were almost exclusively harpers."
This was a very suitable accompaniment to their wor-
ship of Apollo, who was himself the reputed inventor
of this instrument ; and accordingly we find that, even
in the twelfth century, broken down and obliterated
as every vestige of the *real Irish* then was, by the un-
genial amalgamation of the Scythian and Danish
intruders, the *harp* was still preserved as the last
remnant of their glory ; while the elegance of their
compositions and performance upon it extorted this
reluctant acknowledgment from the prejudiced Cam-
brensis :—

" The attention," says he, " of this people to

musical instruments, I find worthy of commendation ; their skill in which is, *beyond comparison, superior* to that of *any nation* I have seen. For in these the modulation is not slow and solemn, as in the instruments of Britain, to which we are accustomed, but the sounds are rapid and precipitate, yet, at the same time, sweet and pleasing. It is wonderful how, in such precipitate rapidity of the fingers, the musical proportions are observed, and, by their art, faultless throughout.

" In the midst of their complicated modulations and most intricate arrangement of notes, by a rapidity so sweet, a regularity so irregular, a concord so discordant, the melody is rendered harmonious and perfect, whether the chords of the diatesseron or diapente are struck together. Yet they always begin in a soft mood, and end in the same, that all may be perfected in the sweetness of delicious sounds. They enter on, and again leave, their modulations with so much subtlety, and the tricklings of the small notes sport with so much freedom under the deep note of the bass ; they delight with so much delicacy, and soothe so softly, that the excellency of their art seems to be in concealing it *."

Clarsech and Cruit were both names which the Irish gave their harp, from the musical board and the warbling of the strings respectively. But the favourite designation was that of Orphean, an evident derivation from Orpheus, the divine musician of the ancients, who is said to have stayed the course of rivers, and lulled the listening woods,—to have moved the stones into prescribed positions, and tamed the savage propensities of man—all by the instrumentality of his speaking lyre !

* Gerald. Cambr., Hist. i. cap. 19.

" As regards Orpheus himself," says the learned Barker, " he is stated, by some ancient authorities, to have abstained from eating of flesh, and to have had an abhorrence of eggs, considered as food, from a persuasion that the egg was the principle of all being. Many other accounts are given of him, which would seem to assimilate his character to that of the ancient priests of India, or Brachmani. The ancients, however, unable to discover any mode by which he could have obtained his knowledge from any other source, pretended that he had visited Egypt, and had there been initiated in the mysteries of Isis and Osiris. This appears, however, to be a supposition purely gratuitous, on the part of the ancient writers, since a careful examination of the subject leads directly to the belief, that Orpheus was of Indian origin; that he was a member of one of those *Sacerdotal Colonies, which professed the religion of Buddha;* and who being driven from their home, in the northern parts of India, and in the plains of Tartary, by the power of the rival sect of Brahma, moved gradually onwards to the west, dispensing, in their progress, the benefits of civilization and the *mysterious tenets of their peculiar faith.*"

We know little or nothing at this remote day of the ancient music of the Bardic order; that it was eminent, however, and transcendently superior to that of all other countries, is evident from the fact of its having maintained its character when all our other attributes had notoriously vanished. Caradoc admits that his countrymen, the Welsh, borrowed all their instruments, tunes, airs, and measures, from our favoured island. Carr additionally says, that " although the Welsh have been for ages celebrated for

the boldness and sweetness of their music, yet it
appears that they were much indebted to the superior
musical talents of their neighbours, the Irish." Sel-
den asserts, " that the Welsh music, for the most
part, came out of Ireland with Gruffydh ap Tenan,
Prince of North Wales, who was cotemporary with
King Stephen." I know not whether our brethren of
Scotland will be so ready to acknowledge the loan.
But if any one will compare the spirit of their music,
with that which pervades the melodies of our country,
the identity will be as obvious, as the inference is irre-
sistible.

Fuller, in his account of the Crusade, conducted
by Godfrey of Boulogne, says, " Yea, we might well
think that all the concerts of Christendom in this war
would have made no music, if the *Irish harp* had been
wanting."

And *this* is the instrument which Ledwich asserts
we borrowed from the Ostmen!—Insolent presumption!
—Neither Ostman or Dane ever laid eyes upon such,
until they saw it in the *sunny* valleys of the Emerald
Island. And had they the shadow of a claim either
to it or to the " Round Towers,"—to which its services
were consecrated,—Cambrensis could not fail ascer-
taining the fact from any of the stragglers of those
uncouth marauders, who—having survived the car-
nage inflicted upon their army, in the plains of Clon-
tarf, under the retributive auspices of the immortal
Brien—were allowed to cultivate their mercantile
avocations in the various maritime cities, where they
would naturally be proud to perpetuate every iota of
demonstrative civilization which they could pretend
to have imported. Alas! they *imparted* none, but
exported a great deal; and, what is more to be
lamented, annihilated its evidences!

But it is not alone of the *property* of this national organ that the *moderns* would deprive us, but the very *existence* of the instrument they affirm to be of recent date! Why, Sir, it is as old as the hills. Open the fourth chapter of the book of Genesis, and you will find it there recorded, that " Jubal was the father of all such as handle the *harp* and organ."

And now to the empirics of the " Fine Arts *," and the deniers of their antiquity, I shall quote the next verse, viz., " Zillah, she also bare a son, Tubal-Cain, an instructor of every artificer in brass and iron†." And in Job xxviii. 2, it is said, that " iron is taken out of the earth, and brass is molten out of the stone."

" In the *north of Europe*," says Herodotus, " there appears to be by far the greatest abundance of gold: where it is found I cannot say, except that *the Arimaspians, a race of men having only one eye*, are said to purloin it from the griffins‡. I do not, however, believe that there exists any race of men born with only one eye !"

Had this esteemed author known the allegorical import of the word Arimaspians, (from *arima*, one, and *spia*, an eye,) such as it has been explained at page 86, he would not have committed himself by the observation with which the above extract has termi-

* A series of articles written under this head, in the columns of the Dublin Penny Journal, by Mr. Pebrie, antiquarian high-priest to the Royal Irish Academy !

† This Tubal-Cain was evidently the person from whom the Greeks manufactured their mythological Vul-can.

‡ " The griffin," says Shaw, copying Ctesias, " is a quadruped of India, having the claws of a lion, and wings upon his back. His fore-parts are red, his wings white, his neck blue, his head and his beak resemble those of the eagle ; he makes his nest among the mountains, and haunts the deserts, where' he conceals his gold."

nated. No doubt, he thought it extremely *philoso-phical*, because it is *sceptical!* but let us see if another instance of his *scepticism* will redound more to his *philosophy :*—" I cannot help laughing," says he elsewhere, " at those who pretend that the ocean flows round our continent: no proof can be given of it.....I believe that Homer had taken, what he believes about the ocean, from a work of antiquity, but it was without comprehending anything of the matter, repeating what he had read, without well understanding what he had read*!"

Now, without disputing with Siberia the honour of possessing all this *ancient* gold, I will take the liberty of inserting an extract from one of Mr. Hamilton's letters on the Antrim coast, which will show, at all events, the antiquity of our mining.

" About the year 1770," says he, " the miners, in pushing forward an adit toward the bed of coal, at an unexplored part of the Ballycastle cliff, unexpectedly broke through the rock into a narrow passage, so much contracted and choked up with various drippings and deposits on its sides and bottom, as rendered it impossible for any of the workmen to force through, that they might examine it farther. Two lads were, therefore, made to creep in with candles, for the purpose of exploring this subterranean avenue. They accordingly pressed forward for a considerable time, with much labour and difficulty, and at length entered into an extensive labyrinth, branching off into numerous apartments, in the mazes and windings of

* " The ignorance of the European Greeks in geography was extreme in all respects during many ages. They do not even appear to have known the discoveries made in more ancient voyages, which were not absolutely unknown to Homer."—Mr. Gouget, *Origin of Arts and Sciences*, tom. 7. b. 3.

which they were completely bewildered and lost.
After various vain attempts to return, their lights were
extinguished, their voices became hoarse, and ex-
hausted with frequent shouting; and, at length,
wearied and spiritless, they sat down together, in
utter despair of an escape from this miserable dun-
geon. In the meanwhile, the workmen in the adit
became alarmed for their safety, fresh hands were
incessantly employed, and, in the course of twenty-
four hours, the passage was so opened as to admit
some of the most active among the miners; but the
situation of the two unhappy prisoners, who had sat
down together in a very distant chamber of the cavern,
prevented them from hearing altogether the noise
and shouts of their friends, who thus laboured to
assist them.

" Fortunately, it occurred to one of the lads, (after
his voice had become hoarse with shouting,) that the
noise of miners' hammers was often heard at consi-
derable distances through the coal works; in conse-
quence of this reflection, he took up a stone, which
he frequently struck against the sides of the cavern;
the noise of this was at length heard by the workmen,
who, in their turn, adopted a similar artifice; by this
means each party was conducted towards the other,
and the unfortunate adventurers extricated time
enough to behold the sun risen in full splendour, which
they had left the morning before just beginning to
tinge the eastern horizon. On examining this subter-
ranean wonder, it was found to be a complete gallery,
which had been driven forward many hundred yards
to the bed of coal : that it branched off into numerous
chambers, where miners had carried on their different
works : that these chambers were dressed in a work-

manlike manner: that pillars were left at proper intervals to support the roof. In short, it was found to be an extensive mine, wrought by a set of people at least as expert in the business as the present generation. Some remains of the tools, and even of the baskets used in the works, were discovered, but in such a decayed state, that on being touched, they immediately crumbled to pieces. From the remains which were found, there is reason to believe that the people who wrought these collieries anciently, were acquainted with the use of iron, some small pieces of which were found; it appeared as if some of their instruments had been thinly shod with that metal."

There is no question but that the era when those collieries were before worked, was that in which the Tuath-de-danaans were masters of this island. *Had it been at any latter period, we could not fail having some traditions relating thereto.* Iron, therefore, the last discovered of the metals, as stated at page 115, must have been known to this people: and the absence of any name for it in our vernacular language, is accounted for on the same principle as that, by which those excavations themselves had been so long concealed, viz., the distaste of their successors to such applications, or the reluctance entertained to make them acquainted with their worth.

It is probable, however, that the little minikin fineries of life were not then in fashion—that our loaves were not baked in tin shapes, as at present,— nor our carriages constructed in so many different varieties of form, excluding altogether those worked by steam,—that our gunlocks were not prepared with percussion caps; nor our sofas furnished with air-blown cushions,—that the routine of etiquette was differ-

ently negotiated,—and that twenty, or more, several
hands were not employed in the finish of a common
pin, before it could be dignified with the honour of
acting a useful part in adjusting the habiliments of a
modern dandy :—but in all the grand essentials of
life—in all its solid refinements and elegant utilities,
the scholar will confess that those who have gone
before us have been fully our equals ; and traces, too,
are not wanting to countenance the belief, that even
those knick-knack frivolities, on which we so pique
ourselves in the present day, have not been at some
period without a prototype,—so that the majority of
those boasted patents for what are considered *disco-
veries* or inventions of something new, should more
properly be for *recoveries*, or unfoldings of something
old, and illustrative of the adage, as remarkable as
it is correct, " that there is nothing new under the
sun *."

* " L'existence *de ce peuple antérieur* est prouvée par le tableau qui
n'offre que des débris, astronomie oubliée, philosophie mêlée à des absur-
dités, physique dégénérée en fables, religion épurée, mais cachée dans
une idolatrie grossière. Cet ancien peuple a eu des sciences perfec-
tionnées, une philosophie sublime et sage."—BAILLY.

CHAPTER XXVIII.

You ask me for the proofs of this early grandeur? I point you to the gold crowns—the gold and silver ingots—the double-headed pateræ or censers—the anklets, lunettes, bracelets, fibulæ, necklaces, &c., which have been repeatedly found throughout all parts of Ireland, evidently the relics of that "Sacred" colony who gave their name to this island, and who, to the refined *taste* which such possessions imply, united also the science which appears in their workmanship *.

But these are scanty and insufficient memorials? Pray, what greater can you produce of ancient Egypt? Her Pyramids? Our "Round Towers" are as *old;* are likely to be as *permanent;* and are really more *beautiful.* What are the vestiges of ancient Etruria? of Assyria? Troy? Chaldea? nay, of Babylon the Great, the queen of the world? A few consolidations of stone and mortar—disjointed rubbish—and incrusted pottery. All these *we* retain, in addition to the thousand other evidences which crowd upon the historian. And, while Britain can adduce no single vestige of the Romans—who subjugated

* Amongst our antiquities also are found *nose-rings* (nasc-sroin) which, stronger than any other demonstration, shows the orientalism of our Tuath-de-danaan ancestors. Their ear-rings, also, are thus defined in Comrac's Glossary, " Arc nasc—vel, a-naisc, bid im cluas—aibh na saoreland," i. e., a ring worn in the ears of our gentry.

that country at their highest period of civilization—but what, in the words of my adversaries themselves, are " only monuments of barbarism," I answer—*no wonder*—for the Romans were never to be compared to the Iranian Buddhists, who brought all the splendour of the East to the concentrated locality of this Hyperborean Island.

" Infant colonies, forsooth, do not carry a knowledge of the ' Fine Arts' along with them ; they are only to be found where wealth, luxury, and power have fixed their abode *." Most sapient remark ! but unluckily out of place ; for the authors of our Round Towers were not " an infant colony" at all ; but the very *heads* and *principals* of the most polished and refined people on the bosom of the habitable earth—the Buddhists of Iran. And, accordingly, in their train not only did " wealth, luxury, and power" abound, but they seemed *exclusively* to have taken up their abode amongst them †.

Analogous to the above was the rhodomontade of another pillar of the same order. " I, nevertheless," says Montmorency, " am disinclined to believe that those same persons, had they to choose a residence between Syria and Ireland, would have taken the *wintry* and *uncultivated wilds* of *Fidh-Inis*, in preference to the sunny plains which gave them birth‡."

In both those cases, of which the former is but the *echo*, in all opinions, of the latter, our eastern extraction is only objected to, *considered as Phœnician ;*

* Dublin Penny Journal.
† Si j'ai bien prouvé que Butta, Thoth, et Mercure ne sont egalement que le même inventeur des sciences et des arts.—BAILLY.
The Buddhists insist that the religion of Buddha existed from the beginning.—*Asiatic Researches.*
‡ Gentleman's Magazine, Nov. 1822.

and there, I admit that the Colonel and his pupil may get an easy triumph over their adversaries. For had the *Phœnicians* been the erectors of those " Round Towers," *what was to prevent their raising similar structures in Cornwall ?*—where it is indisputable that they had trafficked for tin. In Spain, we are certain that they had established *a home ;* and *why does this appear as free from every evidence of columnar archi- tecture, as does the former place?* The same may be said of other countries whither this people resorted, Citium, Crete, Cadiz, and all the islands in the Mediterranean. *In no one of them is there to be found a single edifice approaching, either in design or form, the idea of a Round Tower* * !

The Phœnicians, therefore, can have no pretensions to the honour of those memorials : nor, indeed, can their connexion with Ireland be at all recognized, further than that, as having been, at one time, masters of the sea, *it is merely possible* that the Tuath-de-danaans may have availed themselves of their geographical information, and even consigned themselves to their pilotage for a secure retreat, aloof from the persecu- tion of intolerance.

But as we see from the stanza quoted at page 396, that the Tuath-de-danaans were themselves possessed of a navy ; and as it is indisputable that, long before the Phœnicians, the dynasty of the Persians had swept the ocean in its widest breadth, there is no need for our giving the Phœnicians credit even *for this service,* which it now appears could be dispensed with.

An effort, however, has been advanced, to identify

* In the entire land of Phœnicia there was but one, and that com- paratively a modern one, erected no doubt after their intercourse with the Tuath-de-danaans.

their language with ours, by the analysis of the fragment of a speech which occurs in one of the plays of Plautus *. The idea was ingenious, but totally unfounded. *Affinity*, undoubtedly, there does appear, —as there does between all the ancient languages,— but nothing like *identity ;* and the very circumstance of its having a *distinct* denomination assigned to it in Ireland, viz., *Bearla-na-Fene,* or dialect of the Phœnicians, (who traded here, it is admitted) proves it to be different from our *local* phraseology—the Iranian *Pahlavi,* the polished elocution of the Tuath-dedanaans.

The Phœnicians, besides being a mercantile people, never had any monuments of literary value, whereas the Irish are known to have abounded in such from the earliest era †.

* The play above alluded to is that of the Pænulus, or Carthaginian, in which Hanno is introduced in quest of his two daughters, who, with their nurse, had been stolen by pirates, and conveyed to Calydon, in Ætolia. Thither the father repairs on receiving intelligence of the fact, and addresses a supplication to the presiding deity of the country, to restore to him his children unstained by pollution. He is made to speak in his vernacular tongue, just as natives of France are represented in our drama by Shakspeare : and so *interesting* is the whole—independently of the curiosity attaching to so rare a production—that I shall subjoin a portion of it for the reader.

1.

Nith al o nim, ua lonuth secorathessi ma com syth.

An iath al a nim, uaillonac socruidd se me com sit.

O mighty splendour of the land, renowned, powerful; let him quiet me with repose.

2.

Chin lach chunyth mumys tyal mycthii barii imi schi.

Cim laig cungan, muin is toil, mo iocd bearad iar mo sgil.

Help of the weary captive, instruct me according to thy will, to recover my children after my fatigue.

N.B. The first line in each of these triplets is Phœnician, the second Irish, and the third, their import in English.

† " How comes it then that they are so unlearned—still, being so old scholars ? for learning (as the poet saith) *emollit mores* nec sinit esse

It is true that we have been denied the possession
of alphabetic characters before the time of St. Pa-
trick : but by whom? By Bolandus ; on a false de-
duction from the writings of Ward, Colgan, Nennius,
&c., who state that this Apostle was the first who
gave the " abjectoria," or alphabet to our nation.
Who says otherwise? But what alphabet was here
meant? The Latin, certainly, and no other. Until
then the Irish were strangers to the *Roman* letters*;
but that they were not to *written characters,* or the
cultivation of them in every variety of literature, is
evident from the very fact, of St. Patrick himself
having committed to the flames no less than one hun-
dred and eighty volumes of our ancient theology † ;
as well as from the recorded instance of his disciple,
Benignus,—his successor also in the see of Armagh,—
having, according to Ward, written a work on the
virtues of the Saint, half Latin and half Irish, and
which Jocelyne afterwards availed himself of, when
more fully detailing his biography.

It has been the custom in all ages with those who

feros; whence then, I pray you, could they have those letters?" He
answers, " It is hard to say, for whether they at the first coming into the
land, or afterwards by trading with other nations, learned them of them,
or devised them amongst themselves, is very doubtful, *but that they had
letters anciently is nothing doubtful, for the Saxons of England are
said to have their letters and learning, and learned men, from the Irish.*
And that also appeareth from the likeness of the character, for the
Saxon's character is the same with the Irish.—SPENSER.

* Having been always free and independent of the empire of the
Romans, they were unacquainted with the Roman language and its
characters : there were, therefore, but two courses to adopt; either to
translate the holy books into the language of the country, and celebrate
the divine mysteries in it, which would have been contrary to the cus-
tom of the church, or to teach the characters of the Roman language to
those who were to instruct others ; the holy apostle adopted the latter
course.—*Abbé Mac Geohigan.*

† Book of Cashel.

would pass as the luminaries of their respective generations, to maintain that *letters* and their application were but a *recent* discovery! Their antiquity, however, is an historical fact, than which there can be no other better authenticated. The Bible makes frequent allusion to the cultivation of alphabetic cyphers—thus in Exodus xxiv. 4, it is said, " And Moses *wrote* all the words of the Lord." And in Joshua xxiv. 26, "And Joshua *wrote* these words in the book of the law of God."

Nor is it only to the *elementary* part of literature, but to the very highest and noblest department of literary research that we find the ancients had arrived. In the history of Job, an acquaintance with astronomy is quite apparent. The names of Arcturus, Orion, and the Pleiades *, are distinctly notified in that elaborate composition †. Could this have been without the aid of written characters? Could the abstruse calculations involved in that pursuit be possibly carried on without an intimate knowledge of notation and of numbers? Or, if superior memory may effect it in a few cases, without such characters or legible marks, how could the *results* arrived at, and the steps by which they had been attained, be for any length of time preserved, and their value handed down to successive experimentalists, unless by the instrumentality of expressive signs?

We find accordingly in the same treatise ‡, the art

* Job viii. 8, and xix. 23.

† " There is no Mahomedan of learning in Persia or India who is not an astrologer : rare works upon that science are more valued than any other; and it is remarkable that on the most trivial occasions, when calculating nativities and foretelling events, they deem it essential to describe the planets in terms *not unsuited to the account which the author of the Dabistan has given of these deities.*"—Sir JOHN MALCOLM.

‡ Job xix. 23, 24.

of writing expressly named, thus, " O that my words were now written! Oh! that they were printed in a book : that they were graven with an iron pen, and laid in the rock for ever!" And that it was of long-continued usage is evident from a preceding chapter[*], where it is said, " *Enquire,* I pray thee, of the *former age,* and prepare thyself for the *search* of their fathers !"

The alphabet which we had here, before the Roman abjectorium, is still preserved, and called *Beth-luis-nion*[†], from the names of its three first letters, just as the English is denominated *A B C,* from a similar cause; and the Greek *Alpha-bet* from a like consideration.

			Irish.	Latin.	English.
1	B	ƀ	Beithe,	Betulla,	Birch.
2	L	ʟ	Luis,	Ornus,	Wild ash.
3	N	N	Nion,	Fraxinus,	Ash.
4	S	s	Suil,	Salix,	Willow.
5	F	ſ	Fearn,	Alnus,	Alder.
6	H	h	Huath,	Oxiacanthus,	White thorn.
7	D	ð	Duir,	Ilex,	Oak.
8	T	ꚍ	Timne,	Genist. Spin.	Furze.
9	C	c	Coll,	Corylus,	Hazel.
10	M	ɱ	Muin,	Vitis,	Vine.
11	G	ʒ	Gort,	Hedera,	Ivy.
12	P	p	Peth-bhog,	Beite, or B mollified,	
13	R	ɾ	Ruis,	Sambucus,	Elder.
14	A	ɑ	Ailm,	Abies,	Fir tree.
15	O	o	Onn,	Genista,	Broom.
16	U	u	Ur,	Erix, or Erica,	Heath.
17	E	e	Eghadh,	Tremula,	Aspen.
18	I	ɉ	Iodha,	Taxus,	Yew.

[*] Job viii. 8.

[†] Since I have commenced this work, a very ancient manuscript of the abbey of Icolm kill has fallen into my hands; it was written by

This, you perceive, *falls short, by eight letters, of the number of the Latin cyphers,* which could not have occurred if borrowed from that people; and will, therefore, *stand,* independently and everlastingly, a self-evident proof of the reverse.

It is well known, that long prior to the arrival of Cadmus, the Greeks were in possession of alphabetic writing *. Diodorus states so; but adds, that a *deluge* had swept all away. One thousand five hundred and fifty, before the era we count by, is agreed

Cairbre-Liffeachair, who lived *six generations before St. Patrick,* and about the time of our Saviour: an exact account is given in it of Irish kings, from whence I infer, that as the Irish had manuscripts at that period, we must certainly have possessed them likewise.

* Æschylus would seem to refer to this, when he makes Prometheus say, " I invented for them the array of letters, and fixed the memory, the mother of knowledge, and the soul of life."—*Bloomfield's edition,* v. 469.

upon as the year, in which Cadmus visited Greece; and you have the authority of Pausanias, that he himself had read an inscription upon a monument at Megara, the date of which was 1678 before our epoch, that is, one hundred and twenty-eight years before Cadmus's time.

Besides those ordinary letters of the *Beth-luis-nion,* the Irish made use of various other *occult* and secret forms of writing, which they called *ogham* *, and of which I insert some specimens.

Among these you perceive the *arrow-headed figures* whereof I have already advertised you; and the *mysterious import* of which reminded the *initiated* of the *solemn purchase of salvation by the cross.*

These are all peculiar, and totally separate from any Phœnician alliance. Instead, therefore, of my being *adverse* to the *moderns* as to the Phœnician *bubble,* I am their *auxiliary.* But, Mr. Montmorency, are there not other places in the east besides Phœnicia? And may not a people leave the " sunny plains that gave them birth," from other motives than those of " choice?" And may not " Fidh Inis," instead of being a name of reproach, such as you affected, by associating it with " wintry and uncultivated wilds," be one of distinction and of renown? And though to you its *authors,* as well as the *mystery of its import,* were an *impenetrable* secret, may it not, notwithstanding—*what you see verified* now—be made one of the engines exercised, in the recovery of truth, to prove the splendour and the refinement of our venerable ancestors?

It is to be hoped, therefore, that, after this expla-

* Τον Ἐραχλια ὁι Κελτοι ΟΓΜΙΟΝ ονομαζουσι φωνη τη ιπιχωριω.

LUCIAN.

nation, we shall hear no more sarcasms upon this *favoured* spot. Nor would the anticipåtion be too great, that the whole *infidel* host, with the gallant colonel himself at their head, *becoming* alive to the injustice of their former disbelief, would now slacken their virulence, and if they will not *join* in the acclamations of regenerated history, at least decently *withdraw*, and let the lovers of truth, in security and happiness, celebrate its triumph.

" The appellation of Britain," says another *goodly*(?) champion of this *order*, " has been tortured for ages by the antiquarians, in order to force a confession of origin and import for it. And erudition, running wild in the mazes of folly, has eagerly deduced it from every word of a similar sound, almost in every known language of the globe. But the Celtic is obviously the only one that can lay any competent claim to it—and the meaning of it may as easily be ascertained as its origin."—And so, accordingly, he proceeds to show, that " Breatin, Brydain, or Britain," is derived from a " Celtic word," which signifies " separation or division*!"

It is more than probable that I should have left Mr. Whittaker to his vagaries, or rather his *clerical* recreations, if he had not been propelled by his all-illuminating reforms, to glance a ray upon us, here, across St. George's Channel.—" This," says he, " has *equally* given denomination to the *tribes* of *Ireland*, the nations of Caledonia, and two or three islands on our coasts!"

" The original word is still retained in the Welch, Britain; and the Irish, Breact,—anything divided or

* Whittaker's Manchester.

striped; in the Irish Bricth, a fraction; the Irish
Brisead, a rupture; and, the Welch Brig, a breach.
And it was equally pronounced Brict, or Brit, (as the
Icitus of Cæsar, or the Itium of Strabo,) Bris and
Brig; and appears, with this variety of terminations,
in the usual appellation of the islanders, Britanni, in
the present denomination of the Armorican Britons,
and their language, Brez and Brezonic, and in the
name of Brigantes. Brit is enlarged into Briton, or
Brit-an in the plural, and Britan-ec in the relative
adjective. And so forms the appellation Britones,
Britani, and Britanici; as Brig is either changed
into Briges, in the plural, and makes Allobroges, or
Allo-broges, the name of a tribe on the continent, and
of all the Belgæ in the island, is altered into Brigan
and Brigants, and forms the denomination of Bri-
gantes." And again, " the original word appears to
have been equally pronounced Brict, Brits, and
Bricth, Breact, Breac, and Brig; and appears to be
derived from the Gallic Bresche, a rupture, the Irish
Bris, to break, and Brisead, a breach. And the word
occurs with all this variety of termination in the Irish
Breattain or Breatin, Bretam, and in Breathnach,
Briotnach, and Breagnach, a Briton; in the Armori-
can names of Breton, Breiz, and Brezonnec, for an
individual, the country, and the language of Armo-
rica; in the Welch Brython and Brythoneg, the Bri-
tons and their language; and in the ancient synony-
mous appellations of Brigantes and Britanni."

Doubtless, the reader has been highly edified by
this Britannic dissertation! He is, I am sure, as
thorough master of the subject, now, as Mr. Whit-
taker himself!—can tell how many fractures, cross-
lines, and diagonals have been made upon *Britain*

ever since Noah's *flood!* And as he cannot fail, in consequence, being in love with the Reverend Author, I will indulge his fondness by another *spark* of enlightment.

"At this period," he resumes, (three hundred years before Christ,) "many of the natives, relinquishing their ancient seats to the Belgæ, found all the central and northern parts of England already occupied, and transported themselves into *the uninhabited isle* of Ireland!"

I will now be understood as to the promise made some while ago *, in reference to a definition for the word *modern.* A *modern* then, be it known, *is a philosopher(?), who fancies that until three hundred years before Christ, the whole world was in darkness! physical as well as metaphysical! that it was even, in a great measure, uninhabited! by other than the brute creation!—but that, suddenly, whenever any mighty feat was to be achieved,* (in other words, whenever a modern theory was to be bolstered up) *innumerable myrmidons, armed cap-à-pié!—full accoutred, booted and spurred! used to gush forth from some obscure corner of the earth!* A miracle of production, to which even *Cadmus's soldiers* can bear no parallel; for, while the latter are located to a particular *place,* and stated to have been generated by regular *seed,* even though that was nothing more than the *tooth* of a *dragon* †, the former burst forward, nobody knows *whence,* nor will their *machiners* condescend to tell even so much as what may have been the *elements* of their composition!

* See page 332.

† An allegory, by the way, which I could explain satisfactorily, were it not that it would detain me.

To whom, however, is Mr. Whittaker beholden for
this intellectual idea? Verily, to a half-senseless
poor friar*, a few centuries deceased, who was no
more competent—and no blame to him from his
resources—to analyse this question, than he was to
stop the revolutions of the celestial orbs!

Yet *jejune* and abortive as were Cirencester's cere-
bral conceptions, he was not less dogmatic in the
utterance of them than was his imitator. " *It is most
certain*," says he, " that the Damnii, Voluntii, Bri-
gantes, Cangi, and other nations, were descended
from the Britons, and passed over thither after Divi-
tiacus, or Claudius, or Ostorius, or other victorious
generals had invaded their original countries. Lastly,
the ancient language, which resembles the old British
and Gallic tongues, affords another argument, as is
well known to persons skilled in both languages."

Now, by what authority, may I ask, is all this
" most certain?" And by authority I do not mean
any quotation from previous historians. That I
waive, and should not here require it, if either *proof*
or *probability* were tendered of the *occurrence*. But
as none such is vouchsafed—as all is mere *assertion*—
and as I can *prove the exact contrary to have been the
actual fact*, is not *dogmatism* too *mild* a name to apply
to the *scribbler* who *propounds* such nonsense? And
is not *servility* too *dignified* an epithet to brand upon
the *copyist*, who takes such *ipse dixit* evidence upon
so intricate a proposition as gospel truth? and that
too when he must have absolute *demonstration*, and

* Oh! Richard of Cirencester, oh! what pleasure it affords me to see
the *moderns* running after the chariot wheels of the *monks*, whenever
they can pick out amongst their lucubrations any stray sentences to sup-
port their own fantasies!

canvas every other statement, emanating from that fraternity, with *the very eye of a Lynceus !*

In the first place, then, the name *Damnii* (to begin with the beginning) is but a monkish Latinisation for *Danaans ;* and *these I have established to have been* an eastern race, totally and universally distinct from Britain, until upon their overthrow in Ireland, they fled for shelter to Scotland, whither on their way, some straggling parties, reduced and humiliated, took up their residence in the northern parts of England ; where, accordingly, to this hour we find evidences of their worship, such as sculptured *crosses* *, and other *emblematic devices,* but *never* a *Round Tower,* their impoverished circumstances not being now adequate to such an expense.

The Brigantes, again, is another Latin metamorphosis for the inhabitants of *Breo-cean,* in Spain, where the Phœnicians had fixed a colony, and whence they doubtless had brought some portion with them to work the mines at Cornwall. This *Breo-cean* the Romans, in conformity with the genius of their language, changed into *Bri-*gantia, which, however, was a very allowable commutation, the letters *c* and *g* being always convertible, and *tia* nothing more than an ordinary termination.

Seneca well knew that the *Brigantes* thus imported were a very different extraction from the native *Britons.*

> " Illi *Britannos* ultra noti littora ponti,
> Et cœruleos *Scuto-Brigantes* dare Romuleis,"

* " Near the road (at a place called Margan) is an *old cross,* bearing an *inscription,* which has been doomed to serve as a bridge for foot passengers over a little rivulet ; and in the village are fragments of a *most beautiful cross richly decorated with fretwork.*"—CAMBRENSIS.

says he, in his satirical invective upon the death of
Claudius. Here, you will observe, that the *Britons*
and the *Brigantes* are *opposed to one another,* and
marked out as *distinct* races. And to specify still
further the origin of the Brigantes is the epithet
Scuto * prefixed thereto, from *Scuitte,* the ancient mode
of spelling *Scythia.*

Those Scoto-Brigantes were the persons who, hav-
ing been driven from Spain by the conquests of Sesos-
tris, poured in with multitudinous inundation upon the
quietude of our *Tuath-de-danaans,* and wrested from
them an island which, during their blissful reign, had
eclipsed in sanctity even their *former* Iran †.

The language which they spoke differed in nothing
from the Tuath-de-danaan, but that it was not quite
so refined ; and this feature of similarity silences at
once, the *conjectures* of *Stillingfleet,* Innes, and their
followers, who would make those *Scythians* to, be
Scandinavians, merely because the letter *S* occurs as
the *initial* and *final* of either name !

Why, sir, when the *Scandinavians* did *really* invade
Ireland, which was not until the early centuries of the
Christian era, the great obstruction to their progress
was their *ignorance* of our tongue ; whereas, when the
Scythians arrived here, many ages earlier, our legends,
our traditions, our histories, and our annals, *unani-*

* Some copies read *Scoto,* the meaning, however, is the same; tho
only difference being that the latter partakes of the modern enunciations
of the word, as *Scots,* instead of *Scuits* or *Scythians.*

† In the anxiety with which my translation of " Phœnician Ireland"
was hurried through the press, it inadvertently escaped me that the
Scythians had only *touched at Spain.* The above will correct the over-
sight; to which I shall add that, " as for entitling the *Spanish-Irish
Scots,* there wants no authority, the Irish authors having constantly
called the Spanish colony Kin-Scuit, or the Scottish nation."—LHUYDH.

mously and *universally* attest, that they used the same conversable articulation with that of the established dynasty *.

Where is the wonder, then, that we should find all the ancient names in the north of England, correspond to a nicety with those of the Irish ? And which made Lhuydh, the author of the Archæologia, himself an Englishman, declare, " *how necessary the Irish language is to those who shall undertake to write of the antiquity of the isle of Britain.*"

But if Lhuydh was thus *candid* in the avowal of his conviction, he was not equally *successful* in the discovery of the relationship. From want of the true *touchstone*, he went on *hypothesising !* and came at last to the *supposition !* " that the Irish must at one time have been in possession of those English localities, and thence removed themselves into Ireland !" *the exact opposite having been the fact.*

To atone for my long digression from Mr. Whittaker, and his *breakages,* I will supply to you the derivations, as well of Britain as of Brigantia. The former is compounded of *Bruit, tin ;* and *tan,* a country abounding in that metal, and corresponding to *Cassiteris,* assigned to it by the Greeks : and Brigantia, as before explained, being but a formative from Breo-cean, is compounded of *Breo,* which signifies fire ; and *cean,* a head or promontory, meaning the *head-land of fires ;* or that whereon such used to have been lighted for the convenience of mariners lying out at sea †.

* " Every argument of the origin of emigrant nations must, after all, be referred to language."—CAMDEN.

† The derivation of those two terms is not exclusively mine. It is but the repetition of the received interpretation of all men of letters.

Neither the Scythians, therefore, nor the Celts, had connexion whatsoever, either of them, with the once-envied celebrity of this " island *." The latter were the persons who, under the name of Fir-Bolgs, erected all the cromleachs spread over the country, the accomplishment of which bespeaks, it is true, an acquaintance with *mechanics*, of which the present artisans are altogether ignorant. And as the original of their denomination has never been elucidated, I embrace this opportunity of supplying the omission. It comes from *bolog*, which, in the Irish language, signifies a *paunch;* and *fir*, a *man;* so that Fir-Bolg means the *big-bellied man*, being an evident allusion to their bodily configuration: and to this day Bolcaig is the epithet applied, vernacularly, to individuals of large girth or corpulent robustness, exactly corresponding to what we are told by Cæsar, when describing the tripartite division of Gaul, viz., that the Belgæ, who, in fact, were of the same stock as our Fir-Bolgs, were the *stoutest bodied,* and the *bravest otherwise,* of all its inhabitants.

The Scythian religion, which was Druidical, accorded with that of the Fir-Bolgs, which was Celtic, —not less as to modes of worship, than in mutual aversion to that of the Iranians; and, accordingly, we find, that when both conspired for the recovery of this country from the Iranians, who had themselves wrested it from the Fir-Bolgs, antecedently, these latter branching out into the septs of Cauci and Menapii, corre-

* " For it is to be thought, that the use of all England was in the raigne of Henry the Second, when Ireland was planted with English, very rude and barbarous, so as if the same should be now used in England by any, it would seem worthy of sharpe correction, and of new lawes for reformation, for it is but even the other day since England grew civill."—SPENSER.

sponding to the kindred and cognominal tribes on the continent; and who, during the occupancy of the Iranians,—the interval of Ireland's Hyperborean renown, —had retired to Arran* and the northern isles,—were restored to a partnership in the possession of the island, in return for the assistance they lent the Scythians for its conquest:—and this accounts for that diversity of races which Ptolemy records, but which antiquarian luminaries, unable to comprehend, took upon them to reject as altogether a chimera.

As to the Iranians—the real Hibernians,—the true Hyperborean Tuath-de-danaans, or Magic-god Almoners—they were hurled from the throne—their sanctified ceremonials trampled in the dust—their sacred harps, which before used to swell to the praises of their Divinity, were now desecrated for the inspiration of the Scythian warriors,—and their divine *Boreades*, who ere now composed canticles in adoration of Apollo, were degraded to the secular and half-military occupation of Scythian *Bards*.

The name of the island itself, from " Irin," or the " Sacred island," was changed into Scuitte, that is, Scotia or Scythia, or the Land of the *Scythians*. Nor was it until the eleventh century of the present era, that, *to remove the ambiguity which arose from the circumstance of there being another country also called by this name*, Ireland resumed its former name, Irin, as its people did Irenses, instead of Scoti †.

* The name of *Arran* was given to this island as expressive of *the land of the unfaithful*, in opposition to our *Iran*, or *the land of the unfaithful*: both corresponding to the *Iran* and *An-Iran* of the Persians.

† This, however, did not happen at first; for the name of Ireland was not yet generally used among strangers, as Adam de Breme, who lived in the eleventh century, and Nubigensis, in the twelfth, were the first who mentioned it: the name of Scotland was by degrees appropriated

Yet in the general transmutation which so great a revolution bespeaks, we behold the strictest regard paid to the literary fame and the mental acquirements of those sages who had been ejected. They were retained as the *instructors* of the new establishment; and their refined precepts tending gradually to soften the warlike propensities of this ferocious group, the amalgamation became so complete, and the aristocracy of intellect so recognised, that when religious dissensions were all cancelled in the grave, many of them were able to trace their steps backwards to the forfeited monarchy.

Of this number was Connachar-mor-mac-Nessan, that is, Connor the-great-son-of-Nessan, styled indifferently *Feidlimidh* and *Ollamh Fodlah*, i. e., the *Erudite man* (the *Budhist*) and the *Doctor* of *Budland;* and Brien, who ascended the Irish throne, A. D. 1014; and who, after a succession of two thousand two hundred years, was the lineal descendant of Brien, head of the Tuath-de-danaans; and this very extraction, in the confusion of the names, was the circumstance which occasioned the popular belief, not yet exploded, of his having been the founder, by magic creation, in one single night, of those Round Towers of his inheritance! The mistake, however, is of value,

to Albania, which was for some time called Little Scotland, " Scotia Minor," to distinguish it from Ireland, which was called " Scotia Major," whose inhabitants did not lose all of a sudden the name of Scots; they are so called in the eleventh century by Herman, in the first book of his chronicle; by Marianus Scotus, Florentius Wigorniensis, in his annals, in which, having inserted the chronicle of Marianus, in mentioning the year 1028, he says, " in this year was born Marianus, probably a Scot from Ireland, by whose care this excellent chronicle has been compiled from several histories." We discover the same thing in a chronicle in the Cottonian library.—*Abbé Mac Geoghegan.*

as it is a collateral evidence that those edifices have been attributed to their real authors ; and the anachronism will be excused, seeing that there is nothing more common than to assign to one Hercules the exploits of another.

Others of this colony, who could not brook the yoke, betook themselves on their downfall to Scotland, and built there the two round temples of Brechin and Abernethy, besides others that have disappeared ; from thence, however, they were again dislodged by the barbarous Picts, and obliged to fly for shelter to the Highland fastnesses. These are they whom Macculloch and others have misrepresented as Celts. During their sway in that country, they called it also by the name of Iran or Eran, as the Scotch language is, to this day, called Irish, or Erse. The name of Scoitte, *i. e.*, Scotia, was given it afterwards by the Picts, in compliment to *this* island, which had furnished them with wives, and otherwise joined their fraternity *.

* The Picts, confiding in the happy omen of future friendship from the Scots, obtained wives from them, and thereby contracted so close an alliance, that they seemed to form but one people ; so that the passage between the two countries being free, a number of Scots came and settled amongst the Picts, who received them with joy.—BUCHANAN.

Britannia post Britones et Pictos tertiam Scotorum nationem in Pictorum parte, recepit, qui, duce Reuda, de Hiberniâ progressi, vel amicitiâ vel ferro, sibimet inter eos sedes quas hactenus habent, vindicârunt, à quo scilicet duce usque hodiè Dalreundini vocantur.—Beda, Hist. Eccles. lib. i. cap. 1.

Cambrensis says, that in the reign of Niall the Great in Ireland, the six sons of Muredus, king of Ulster, with a considerable fleet, seized on the northern part of Britain, and founded a nation, called Scotia.—Topog. Hib. dist. 3. cap. 16.

" It is certain," says Camden, "that the Scots went from Ireland into Britain. Orosius, Bede, and Eginard, bear indisputable testimony that Ireland was inhabited by the Scots." Elsewhere he calls the Irish the ancestors of the Scotch. " Hiberni Scotorum atavi."

CHAPTER XXIX.

" THE Scoto-Milesians," says Dr. Hales *, " reckon twenty-three generations from Feni an fear soid, ' the Phœnician wise man,' their ancestor, to Heber and Heremon, who established the last settlement from Spain, as observed before; which, at the usual computation of three mean generations to a century, would give 766 years from Fenius to Heber. But we learn from Coemhain, that the sons of *Milesius* (this should have been *Gallamh* †) were coeval with Solomon, and that the Gadelians ‡ came to Ireland in the middle of the reign of this illustrious prince," B.C. 1002, according to the Irish chronology. Counting backwards, therefore, from this date, 766 years, we get the time of Fenius about B.C. 1768. And this agrees with sacred and profane history; for Joshua, whose administration began B.C. 1688, according to Hales's Chronology, notices " the strong city of Tyre," Josh. xix. 29; which maintained its independence even in David's days, 2 Sam. xxiv. 7; and in Solomon's, 1 Kings ix. 11—14. And Herodotus, that inquisitive traveller and intelligent historian, who visited Tyre about B.C. 448, saw there the temple of the Thasian Hercules; and another erected to him by the

* Author of the New Analysis of Chronology, and late fellow of Trinity College, Dublin.
† See page 376.
‡ This should have been Scythians.

Phœnicians at Thasus itself, an island on the coast of Thrace, while they were engaged in search of Europa, the daughter of Agenor, king of Tyre, who had been carried off by some Greeks ; an event, says Herodotus, which happened five generations before the Grecian Hercules, the son of Amphitryon, B. ii. § 44; who flourished about 900 years before he wrote, § 145, or about B.C. 1348, to which adding 166 years for the five generations, we get the rape of Europa about B.C. 1514.

" But the deification of the Thasian Hercules must have been after his death, which may make him contemporary with Joshua, or even earlier. Herodotus relates that the Tyrians themselves boasted of the remote antiquity of their city, founded, as they said, 2300 years before, (B. xi. 44.) which would carry it higher than the deluge. The high antiquity, however, of Sidon and her daughter Tyre, was acknowledged by Xerxes, king of Persia, when he invaded Greece, B.C. 480 : and in a council of his officers allowed her ambassadors the honour of precedence." (§ 11.)

He adds—" In order to determine the cardinal data of ancient Irish history, it is necessary to premise a synopsis of Coemhain's System of Chronology.

	Y.	B.C.
Creation . . .	1656	3952
Deluge . . .	292	2296
Abraham born . .	942	2004
David, king . . .	473	1062
Babylonish Captivity .	589	589
	———	
Christian Era . .	3952	1

" In this table, the first column contains the years elapsed between the succeeding events : thus, from

the creation, 1656 years to the deluge; from the
deluge, 292 years to the birth of Abraham, &c.; and
their amount, 3952 years, gives the basis of the sys-
tem, or the years elapsed from the creation to the
vulgar Christian era. The second column gives the
dates of these events before the Christian era.

" David began to reign B.C. 1062; from which
subducting 60 years for the amount of his whole
reign, 40 years, and 20 years, the half of Solomon's,
we get B.C. 1002, for the date of the expedition of
Heber and Heremon to Ireland.

" This same number has been noticed by two
earlier chronologers, Marcus Anchoreta, A.D. 647;
and Nennius, A.D. 858; who both date the arrival
of the Scoti in Ireland, ' 1002 years after the passage
of the Red Sea by the Israelites, in which the Egyp-
tians were drowned.' *O'Connor, Proleg.* ii. pp.
15—45. The identity of the number 1002 proves
the mistake in the reference to the exode of the
Israelites, instead of to the Christian era, which
depresses the arrival of the Scoti five centuries too
low. For Coemhain reckons the exode 502 years
after the birth of Abraham, or B.C. 1502; from which
subtracting 1002 years, the arrival of the Scoti would
be reduced to B.C. 500; or, following Usher's date
of the deluge, B.C. 1491. O'Connor reduces it still
lower, to B.C. 489.—*Proleg.* ii. p. 45. Upon the
superior authority of Coemhain, therefore, as a chro-
nologer, we are warranted to rectify this important
error of Nennius and Marcus Anchoreta, which
even Dr. O'Connor has failed to correct; not ad-
verting to the foregoing inference from Coemhain.
But he has happily furnished himself the materials
for proving the error.

" He states, that one hundred and eighteen kings of the Scoti reigned, till the arrival of St. Patrick, B.C. 489 + A.D. 432 = 921 years in all, which, divided by 118, would give too short an average of reigns, only $7\frac{9}{11}$ years a-piece ; whereas the true interval, B.C. 1002 + A.D. 432 = 1434 years, would give the average of reigns above twelve years a-piece; which he justly represents as the standard, from Patrick to Malachy ii. viz. forty-eight reigns in 590 years.—*Proleg.* ii. p. 45 *."

The date of the Scythian invasion, then, being fixed as B.C. 1002, it is agreed on all hands that that of the *Tuath-de-danaans* was but two hundred years anterior, or B.C. 1202 †, with this *exactly corresponds the time at which Marsden, Kæmpfer, and Loubere date the arrival of the Buddists at Siam,* viz., B.C. 1202. Among the Japanese also, they are stated by Klaproth to have arrived not very distant from that era, or B.C. 1029. Dé Guignes and Remusat suppose 1029 as the epoch at which they invaded China. B.C. 1000 is the epoch assigned by Symes for their descent upon the Burman empire; and B.C. 1029 is that fixed by Ozeray for their entrance into Ceylon ; while the Mogul authors and the Bagwad Amrita (Sir W. Jones) recognise their appearance respectively at B.C. 2044 and B.C. 2099.

Now, the extreme concordance amongst the calculations of those various countries, one with the other, and their almost universal coincidence, nay, *in the Siamese authorities,* almost *miraculous identifications, with our Irish registries,* as to the influx, amongst all,

* Origin and Purity of the Primitive Churches of the British Isles.

† Various colonies of the Tuath-de-danaans had settled here : but I talk now of the last one, immediately preceding the Scythians.

of this singular people, and their extraordinary ritual, makes us associate the phenomena with one common cause, and that was the *expulsion* of the Budhists from India, the Rajas having proclaimed, at the instigation of the rival Brahmins, that " from the bridge of Rama, even to the snow-capped Himala, no man should spare the Budhists, young or old, on pain of death."—*Guigniaud's Creuzer.*

As to the Mogul dates, and those of the Bagwad Amrita, they evidently bear reference to former colonies ; nor are *we*, in Ireland, without similar chronicles of an antecedent arrival, and precisely answering to the time of the *first departure* of the Tuath-de-danaans from the borders of Persia *.

It was, indeed, the tradition of this early invasion, long mystified by age, that we have seen so perverted at page 385, for the sole purpose of effecting a miracle ! Nor is this the only fable that fastens upon that narrative : we have that of Partholan and of Nemedius, and a thousand other reminiscences, all directing towards the centre of a common nucleus. The *East* is the point whither they all aim, and the era they assign is invariably that of the *deluge!* Is it not, therefore, inevitable, but that the object recorded is our reception of the Tuath-de-danaans when ejected by the arms of their Pish-de-danaan rivals † ?

Amongst the Easterns themselves we find corresponding traditions, wrapt up, as usual, in allegory, of this primordial departure. The Phrygians, who were one of the most ancient and considerable nations of Asia Minor, complain of Apollo having wandered from them, in company with Cybele, to the land of

* See pages 259, 264, 5.
‡ See pages 385, 282, and 259.

the Hyperboreans *. The costume of the archers upon our Knockmoy frescoes is strictly Phrygian, and confirms their testimony better than any written memorial! " Hercules," says Cedrenus, " first taught philosophy in the *western* parts of the world." This was our Ogham, which the Gauls had borrowed from us, as you will see by note, page 420. " In Egypt," says Ausonius, " they called him Osiris, but in the *island* of Ogygia they gave him the name of Bacchus." If we will remember the form under which *Osiris* was worshipped, viz., that of our *Round Towers* †, and then recollect that the name of *Bacchus* is still found amongst our ancient inscriptions ‡; and in addition to all these, bear in mind that Plutarch § expressly designates *this island,* from its extreme antiquity, as *Ogygia,* all qualms as to the situation alluded to by Ausonius must for ever evaporate !

Let us now glance at the institutions of this island, the personal appearance of its inhabitants, and their popular customs, as compared with ancient Persia.

To begin with the *aspect,* which often proves decisive in more *interesting* applications, I refer you to our regal figures at page 330, as a fair outline of Irish contour; with this, if you will compare what Captain Head affirms, in reference to the settlers at Bombay, viz., that " the *ancient* inhabitants of Persia were superior, not inferior, in looks, to the *present,*

* Euseb. Præpar. Evang. l. ii. 4.

† Πανταχοῦ δὲ καὶ ἀνθρωπομορφον Ὀσιρίδος ἄγαλμα δεικνύουσιν, ἐξορθιαζον τῶ αἰδοιω, διὰ το γόνιμον καὶ τὸ τρόφιμον.—Plut. de Isid. et Osirid.

‡ See page 265.

§ De facie in orbe lunæ. Slatyr, also, an English poet, in his " Pale Albeone," calls our island Ogygia. Rhodoganus explains the propriety of the word when he says, " Ogygium appellant poetæ tanquam pervatis dixeres."

who belong to a hundred mixed races, which have
poured upon that kingdom since the overthrow of
Yezdijerd," no disparity will present itself, at least in
that quarter.

As to *institutions*, I will instance that of our ancient
clans*, and place by them in juxtaposition what Sir
John Malcolm delivers on the subject of Persia.
"Jemsheed" (a prince of the Pish-de-danaan dynasty,
founder of Persepolis, called after him, Tucht-e-jem-
sheed, which, in Irish, signifies the Couch-of-Jem-
sheed) divided," says he, " according to Persian
authors, his subjects into four classes. The first was
formed of learned and pious men, devoted to the wor-
ship of God; and the duty ascribed to them was to
make known to others what was lawful and what other-
wise. The second were writers, whose employment
was to keep the records and accounts of the state. The
third soldiers, who were directed to occupy themselves
in military exercises, that they might be fitted for war.
The fourth class were artificers, husbandmen, and
tradesmen. The authorities on which we give the
history of Jemsheed make no mention of Mah-abad;
but, if we are to give credit to the Dabistan, the *in-
stitution of Jemsheed can only be deemed a revival of that
lawgiver* †."

* The original, in fact, of the *Feodal System*.

† An act of daring impiety (not requiring to be added) disgusted
Jemsheed's subjects, and encouraged the Syrian prince, Zohauk, to in-
vade Persia. The unfortunate Jemsheed fled before a conqueror, who
was deemed by all, the instrument of divine vengeance. The wander-
ings of the exiled monarch are wrought into a tale, which is among the
most popular in Persian romance. His first adventure was in the
neighbouring province of Seistan, where the only daughter of the ruling
prince was led, by a prophecy of her nurse, to fall in love with him, and
to contract a secret marriage; but the unfortunate Jemsheed was pur-
sued through Seistan, India, and China, by the agents of the implacable

In respect to *religion*, Herodotus states that, "*from his own knowledge,* the Persians had neither statues, temples, nor altars, but offered on the tops of the highest mountains, sacrifices to Jove, by which they meant the deity of the air; that they adored the *sun, moon, earth, fire, water, and the winds,* but that they sacrificed to these *only from of old, according to ancient custom,* and that they gave the preference to Trefoil, whereon they laid their offerings * ."

Now, two considerations are to be observed, as involved in this last quotation : one is, that the historian attributes the usages of this nation to two distinct periods of time. From ocular inspection, he avows that they had no *temples,* &c., *because such were long exploded.* And *he knew not what to make of the Round Towers.* Part, however, of the ceremonial appertaining to those edifices still remained, such as the worship of the sun, moon, earth, fire, water, and the winds; and " to these," he frankly acknowledges, " they sacrificed *only from of old,*" or in deference to the practice of their predecessors—I will not say forefathers.

Contemplate now the reverence shown to the herb *Trefoil,* our *national shamrock,* and will you not see another link of that great concatenation uniting the two Irans, and triumphing at once over *supposition* and over *scepticism ?* I have already deplumed St. Patrick of the *serpent* expulsion; or, rather, I have done honour to his memory, by saving it from the

Zohauk, by whom he was at last seized, and carried before his cruel enemy, like a common malefactor. Here his miseries closed; for after enduring all that proud scorn could inflict upon fallen greatness, he was placed between two boards, and sawn asunder with a bone of a fish.— SIR JOHN MALCOLM.

* Clio, chap. 130.

fabrications of *pious* impostors. I now continue my course of justice, by showing that he had as little to do with the veneration paid to this plant. It was worshipped in the Emerald Island, and imported, you perceive, by the Tuath-de-danaans, centuries upon centuries before the apostle was born : and the cause of this devotion was, not alone that it symbolized the *Trinity*, which was an article of Budhist doctrine, even before the incarnation of Christ, but because that it *blended with* it, in mystery as well as in gratitude, the *Alibenistic cross*, the seal of their redemption, and their passport to eternity ! Here then are the *shamrocks*, or *Free-masonic devices*, upon the crowns of our *Irish* kings explained ; and those upon the *Persian* crowns, by and by to be inserted, are similarly expounded * !

Lastly, the *funerals* of the Persians—after the soul's liberation from its tenement of clay, at the summons of its God—are described by Herodotus † with so striking a similitude, that you would imagine he had witnessed, and expressly referred to, the like scenes in Ireland ‡.

* " Now these *heathens* in India, believe that an *atonement* has been made for their sins," says Dr. Hurd, in his " Religious Rites and Ceremonies." Had the Doctor, or whoever he was that assumed his name, known that this was their reliance upon the *expiation* " of the Lamb slain from the beginning of the world," he would have spared his *heathens*, and spoken less irreverently.

† Clio, chap. 193.

‡ Cambrensis, in the twelfth century, says, the Irish then musically expressed their griefs ; that is, they applied the musical art, in which they excelled all others, to the ordinary celebration of funeral obsequies, by dividing the mourners into two bodies, each alternately singing their part, and the whole, at times, joining in full chorus.

" The body of the deceased, dressed in grave clothes, and ornamented with flowers, was placed on a bier, or some elevated spot. The relations and *keeners* (singing mourners) then ranged themselves in two divisions,

Oh! " if the human mind can ever flatter itself with having been successful in discovering the truth, it is when many facts, and these facts of different kinds, unite in producing the same result *."

In truth, the island was altogether an *Oriental Asylum* †, until, for a moment, broken in upon by the

one at the head, and the other at the foot of the corpse. The bards and croteries had before prepared the funeral caoinan. The chief bard of the head chorus began by singing the first stanza in a low doleful tone, which was softly accompanied by the harp : at the conclusion, the foot semichorus began the lamentation, or *ullaloo*, from the final note of the preceding stanza, in which they were answered by the head semichorus ; then both united in one general chorus. The chorus of the first stanza being ended, the chief bard of the foot semichorus began the second gol, or lamentation, in which they were answered by that of the head, and as before, both united in the full chorus. Thus, alternately, were the song and the choruses performed during the night. The genealogy, rank, possessions, the virtues and vices of the dead were rehearsed, and a number of interrogations were addressed to the deceased : as, Why did he die? If married, whether his wife was faithful to him, his sons dutiful, or good hunters or warriors? If a woman, whether her daughters were fair or chaste? If a young man, whether he had been crossed in love? or if the blue-eyed maids of Erin had treated him with scorn?"— *Transactions of the Royal Irish Academy*, vol. iv. note 9.

* Baillie.

† A particular anecdote in the Persian history has such claims upon the feelings, and is otherwise so interesting, *as being, in fact, the elucidation of the origin and era of the Tyrrhenians, Etrurians, or Tuscans, in Italy*, that I am forced to transcribe it here at full length.

" Feridoon was the son of Ablen, an immediate descendant of Tahamurs. He had escaped, in almost a miraculous manner, from Zohauk, when that prince had seized and murdered his father. At the age of sixteen he joined Kâwâh, who had collected a large body of his countrymen : these fought with enthusiasm under the standard of the blacksmith's apron, which continually reminded them of the just cause of their revolt; and the presence of their young prince made them invincible. Zohauk, after numerous defeats, was made prisoner, and put to a slow and painful death, as some punishment for his great crimes.

" Feridoon's first act was to convert the celebrated apron into the royal standard of Persia. As such, it was richly ornamented with jewels, to which every king, from Feridoon to the last of the Pehlivi monarchs, added. It was called the Derush-e-Kawanee, the standard of Kawa, and continued to be the royal standard of Persia, till the Ma-

Fir-Bolgs, or Celts. Their usurpation, however, was only that of a day, amounting, by all records, but to

hometan conquest, when it was taken in battle by Saad-e-Wukass, and sent to the Caliph Omar.

" A Persian poet, alluding to the victories which the youthful Feri-doon obtained over Zohauk, and to those enchantments by which the latter was guarded, and the manner in which they were overcome by his virtuous antagonist, beautifully exclaims, ' The happy Feridoon was not an angel ; he was not formed of musk or of amber ; it was by his justice and mercy that he gained good and great ends. Be then just and merci-ful, and thou shalt be a Feridoon.'

" The crimes of his elder sons, which embittered the latter years of Feridoon, have given rise to one of the most affecting tales in Persian romance ; and it is, indeed, only in that form that there remains any trace of these events. This virtuous monarch had, we are told, three sons, Selm, Toor, and Erii. The two former were by one mother, the daughter of Zohauk ; the latter by a princess of Persia. All these three princes had been united in marriage to three daughters of a king of Arabia. Feridoon determined to divide his wide dominions among them. To Selm he gave the countries comprehended in modern Tur-key ; to Toor, Tartary and part of China ; and to Erii, Persia. The princes departed for their respective governments, but the two elder were displeased that Persia, the fairest of lands, and the seat of royalty, should have been given to their junior, and they combined to effect the ruin of their envied brother. They first sent to their father to reproach him with his partiality and injustice, and to demand a revision of his act, threatening an immediate attack if their request was refused. The old king was greatly distressed ; he represented to them that his days were drawing to a close, and intreated that he might be allowed to depart in peace. Erii discovered what was passing, and resolved to go to his brothers and to lay his crown at their feet, rather than continue to be the cause of a dissension that afflicted his father. He prevailed upon the old king to consent to this measure, and carried a letter from their com-mon parent to Selm and Toor, the purport of which was, that they should live together in peace. This appeal had no effect, and the unfor-tunate Erii was slain by his brothers, who had the hardihood to embalm his head, and send it to Feridoon. The old man is said to have fainted at the sight. When he recovered, he seized, with frantic grief, the head of his beloved son, and holding it in his raised hands, he called upon heaven to punish the base perpetrators of so unnatural and cruel a deed. ' May they never more,' he exclaimed, ' enjoy one bright day! May the demon remorse tear their savage bosoms, till they excite compassion even in the wild beasts of the forest! As for me,' said the afflicted old man, ' I only desire from the God that gave me life, that he will continue it till a

fifty-six years*; after which, a new army of the Tuath-de-danaans, driven now, not from Persia, but from India, by the Brahmins, laid claim to the sceptre to which their brethren had invited them, and reinstated themselves afresh in our kindred Iran.

It is not, therefore, you perceive, our individual history alone that is rectified by this investigation. It supplies a vacuum in the history of the world : which could not be said to have been correct, *so long as there was nothing known on the various topics now explained* †.

Professor Müller ‡, in a very elaborate treatise upon the Antiquities of the Dorians, has been pleased

descendant shall arise from the race of Erii to avenge his death; and then this head will repose with joy on any spot that is appointed to receive it.'

" The daughter of Erii was married to the nephew of Feridoon, and their young son, Manucheher, proved the image of his grandfather; this child becoming the cherished hope of the aged monarch; and when the young prince attained manhood, he made every preparation to enable him to revenge the blood of Erii. Selm and Toor trembled as they saw the day of retribution approach; they sent ambassadors with rich presents to their father, and intreated that Manucheher might be sent to them, that they might stand in his presence, like slaves, and wash away the remembrance of their crimes by tears of contrition. Feridoon returned their presents; and in his reply to their message, expressed his indignation in glowing terms. ' Tell the merciless men,' he exclaimed, ' that they shall never see Manucheher, but attended by armies, and clothed in steel.'

" A war commenced; and in the very first battle Toor was slain by the lance of Manucheher. Selm retired to a fortress, from whence he was drawn by a challenge from the youthful hero, who was victorious in this combat, and the war restored tranquillity to the empire."—SIR JOHN MALÇOLM.

* " Fifty-six years the Fir-Bolgs royal line were kings, and the sceptre they resigned to the Tuath-de-danaans."—KEATING.

† We have, as yet, no accounts of the persecution and expulsion of the Budhists from India; and this circumstance, of itself, would allow us to infer, with great probability, that those events must have taken place at a very remote period of antiquity.—*Asiatic Researches.*

‡ Göttingen University.

to affect astonishment, through one of his notes, that
Hecatæus should have believed in the existence of
the Hyperboreans! It became him, unquestionably,
so to do, because that the proofs of their existence
were beyond his own reach. But though their *reality*,
as well as *locality*, have been already put beyond
disputation, I will, to justify the exclusiveness here
proclaimed, enter again upon the subject, and, with-
out following in detail, show, by the reverse of his
positions, that his whole system of mythology is
equally erroneous.

In this determination I will, of course, be acquitted
of any intentional slight. Who could read Professor
Müller's work, and not be struck with the labour and
the ingenuity which distinguish its every page? I
yield to no man in my respect for his abilities, but I
weep, from my soul, that his classic care was not
bequeathed upon some other subject, rather than be
split upon a rock by an *ignis fatuus*. I never saw
such a waste of letters as his book exhibits! I never
saw such learned research so miserably thrown
away! And how could it be otherwise, his great
object having been to make everything square to the
reveries of the Grecians!—taking them, as his clue,
into a labyrinth of inextricability, through one inch
of which neither conductor nor traveller could see
their way!

Sweet *pahlavi* of the Hyperboreans, I will take *you*
as my guide!

——— ——— Nor be my thoughts
Presumptuous counted, if amid the calm
That soothes the vernal evening into smiles,
I steal, impatient, from the sordid haunts
Of strife and low ambition, to attend
Thy sacred presence, in the sylvan shade,
By their malignant footstep ne'er profaned *.

* Thomson.

CHAPTER XXX.

BEFORE we descend to language, I shall collect the historical concordances that bear upon this investigation.

Beo, a poetess of Delphi, mentions in the fragment of a poem, quoted by Pausanias, that three individuals, sons of Hyperboreans, and named *Olen*, *Pagasus*, and *Agyeus*, had founded the oracle of Delphi. Will it be credited that those three names are but representatives of three several orders of our Irish priests, viz., Ollam, Pagoes, and Aghois *?

At Delos the same tradition is to be encountered, with but a few local alterations : such as that of Latona having arrived there from the Hyperboreans, in the form of a *she wolf;* Apollo and Diana, with the virgins Arge and Opis, following afterwards. Two other virgins, viz., Laodice and Hyperoche, succeeded, and with them five men, who were called *peripherees,* or carriers, from their bringing with them offerings of first fruits, wrapt in bundles of wheaten straw.

But is this embassy altogether a fiction ? " There is not a fact in all antiquity," says Carte, " that made a greater noise in the world, was more universally known, or better attested by the gravest and most ancient authors among the Greeks, than this of the sacred embassies of the Hyperboreans to Delos, *in*

* Vallancey, Coll. vol. iii. p. 163.

times preceding, by an *interval of ages*, the voyages of the Carthaginians to the north of the Straits of Gibraltar." " No argument to the contrary," says Müller, " can be drawn from its not being mentioned either in the Iliad or Odyssey, these poems not affording an opportunity for its introduction: moreover, the Hyperboreans were spoken of in the poem of the Epigoni, and by Hesiod Stephanus quotes here a supposed oracle of a prophetess named *Asteria*, that the inhabitants and priests of Delos came from the Hyperboreans." So that we are by no means dependent, as implied before, upon Diodorus Siculus, for the narrative.

On this subject Herodotus says that " the suite of this Hyperborean embassy having been ill-treated by the Greeks, they took afterwards another method of sending their sacred presents to the temples of Apollo and Diana, delivering them to the nation that lay nearest to them on the continent of Europe, with a request that they might be forwarded to their next neighbour : and thus they were transmitted from one people to another, through the *western* regions, till they came to the *Adriatic*, and there, being put into the hands of the Dodoneans, the first of the Greeks that received them, they were conveyed thence by the Melian Bay, Euboea, Carystus, Andras, and Tenos, till at last they arrived at Delos."

Could he, I ask, more geographically portray their route from Ireland ?

Alcæus, in a hymn to Apollo, says that " Jupiter adorned the new-born god with a golden fillet and lyre, and sent him, in a chariot drawn by swans, to Delphi, in order to introduce justice and law among the Greeks. Apollo, however, ordered the swans first

to fly to the Hyperboreans. The Delphians, missing
the god, instituted a pæan and song, ranged choruses
of young men around the tripod, and invoked him to
come from the Hyperboreans. The god remained an
entire year with that nation, and at the appointed
time, when the tripods of Delphi were destined to
sound, he ordered the swans to resume their flight.
The return of Apollo takes place exactly in the middle
of summer; nightingales, swallows, and grasshoppers
sang in honour of the god; and even Castalia and
Cephisus heave their waves to salute him."

Now Mr. Bryant assures us that—

> The Celtic sages a tradition hold,
> That every drop of amber was a tear
> Shed by Apollo, *when he fled from heaven,*—
> *For sorely did he weep,*—and *sorrowing passed*
> *Through many a doleful region,* till he reached
> The sacred Hyperboreans [*].

Words could not convey a more direct delineation
of the first arrival of the Tuath-de-danaans amongst
us, with their mysterious worship, after their eject-
ment from *Iran,* their paradise, or earthly *heaven,* for
the loss of which they " sorely wept " until at length
they found a substitute in *Irin.* The *lyre* or *harp*
which they brought with them, and solely for cele-
brating the praises of Apollo, continues still our
national emblem; and those swans which are said to
have drawn his chariot formed so essential a part of
our ceremonial, that you shall be presented by and by
with one of his magic implements, to which they are
still attached, as they are similarly figured upon the
painted vases, remaining after our allied Etrurians, in
the south of Italy.

As to the embassy of Abaris, the direct fact is so

[*] Bryant's Anal. vol. iii. 491—3.

completely authenticated by our ancient records,
which narrate the circumstance, with no view to
decide an historical controversy, but with indiffer-
ence thereto, and as in ordinary course,—that it is
inevitable but that, when the Greeks say that this
philosopher had gone to them from the *Hyperboreans*,—
and when we produce proofs to show that a man of
the *same name* had repaired on the *errand* alluded to,
from *our* country to *Greece*, it is inevitable, I say, but
that, when both statements so perfectly tally, the
island of the *Hyperboreans* and that of the *Hibernians*
must be one and the same.

I shall now subjoin from General Vallancey's
works, as he translates it from an old Irish poem, the
authentic narrative of this our Hyperborean embassy.

" The purport of the Tuath-de-danaans journey was in quest of know-
 ledge,
And to seek a proper place where they should improve in Druidism.
These holy men soon sailed to Greece. The sons of Nirned, son of
 Adhnam,
Descendant of Baoth, from Bœotia sprung. Thence to the care of
 skilful pilots,
This Bœotian clan, like warlike heroes, themselves committed,
And after a dangerous voyage, the ships brought them to Loch Luar.
Four cities of great fame, which bore great sway,
Received our clan, in which they completed their studies.
Spotless Taleas, Goreas, majestic Teneas and Mhuiras,
For sieges famed, were the names of the four cities.
Morfios and Earus-Ard, *Abhras*, and Lemas, well skilled in magic,
Were the names of our Druids; they lived in the reign of Garman the
 Happy.
Morfios was made Fele of Falias, Earus the poet in Gone dwelt,
Samias dwelt at Mhurias, but *Abhras*, the Tele-fionn, at Teneas."

A quarrel, it should seem, ensued between them
and the Fir-Bolgs on their return : and the Sean-
neachees, in their incapacity to separate any two
events of a similar character from each other, con-

founded the differences which arose herefrom with
the battles fought *six hundred years before,* between
the ancestors of both parties, on the plains of *Moye-
tureadh!*

At page 67 I have stated that this event took place
about B.C. 600. And this very circumstance it was—
I mean the lateness of the date—which rendered the
expedition at all needful.

The Tuath-de-danaans having been for a long time
humiliated, and allowed but a mere nominal exist-
ence, in a remote canton of the realm, their ritual got
merged into that of the Druids. A corresponding
decay had vitiated their taste for letters, while the
Greeks, in proportion, rose in the scale.

Pythagoras had by this time returned from his tour
to Egypt, and the fame of his acquirements had
reached the Tuath-de-danaans. Naturally solicitous
to court the acquaintance of an individual who had
derived his information from the kindred of their
ancestors *, they had address enough to obtain leave
from the several states of the kingdom to repair to
Greece, on the alleged plea of returning the visit † of

* "The first origin of the *Danavas,*" says Wilford, talking of the primeval
inhabitants of Egypt, " is as little known as that of the tribe last men-
tioned. But they came into Egypt from the west of India, and are fre-
quently mentioned in the Puranas, amongst the inhabitants near Cali."
Is it not manifest that they were a colony of our Danaans? And is
not this still more undeniable from the circumstance of a part of Egypt
—doubtless that wherein the Danaans resided—having been called of
old, as you will find by the same authority, by the name of *Eria ?* See
page 68 of present volume.

† This explains what Hecatæus records, as to the ancient attachment
between the Hyperboreans and the Grecians—" deducing their friend-
ship from remote times." And the offerings which the latter are said to
have brought to the former were precisely of that nature (ανθηματα) which
comports with the spirit of our Budhist pentalogue.—See page 112.

the *Argonauts* to our shores many ages previously *,
but actually with a view to gratify their predilections
by philosophical inquiry.

When the *meteors met*, it is difficult now to decide
which orb it was that emitted the greater light. But
without being too much biassed by the links of pa-
triotism, I think we may very fairly aver that our
countryman communicated, *depressed even as was his
order at that day*, as much information as he had
received †.

Who then can any longer doubt but that this was
the island of the Hyperboreans? Even the *pecu-
liarity* of our language mingles in the chain of
proof; as Diodorus states, that " the Hyperboreans
use *their own* natural tongue." But were all other
arguments wanting, I would undertake to prove the
identity by an admission from this transcriber him-
self. " The sovereignty of this city," says he, " and
the care of the temple, belong to the *Boreades* ‡."

* As to the actuality of the visit, it is past anything like doubt, from
Orpheus, or if you prefer Onomacretus' poem, called " Argonautica ;" and
his conviction of this it was which made Adrianus Junius, quoted by Sir
John Ware, to characterize Ireland as an " insula *Jasoniæ* puppis bene
cognita nautis."

† Abaris ex Hyperboreis, *ipse quoque theologus fuit ; scripsit oracula
regionibus quas peragravit, quæ hodie extant ; prædixit is quoque terræ
motus, pestes, et similia ac cætera. Ferunt eum cum Spartam advenisset,
Lacones monuisse de sacris mala avertentibus, quibus peractis nulla
postmodum Lacedæmone pestis fuerit.*—Apollonius, Histor. Mirab.

> They thought them gods and not of mortal race,
> And gave them cities and adored their learning,
> And begged them to communicate their art.
> KEATING, from an old Irish poem.

Turn back also to page 328, 67, and 66, and see what is there stated !

> " An hundred and ninety-seven years complete
> The Tuath-de-danaans, a famous colony,
> The Irish sceptre swayed."

‡ A spiritual supremacy of this kind prevailed in several cities of Asia
Minor, as, for instance, at Pessinus, in Phrygia. The origin of such

Now, nothing ever has puzzled etymologists so much to explore as the origin of the Irish term *Bards* *. The *guesses* which they have made thereat are so exceedingly amusing, that I will take leave to *refresh* myself, exhausted and languid as I now well nigh am, with the outline of a few.

First, Bochart would derive it from *parat,* to speak!!! Wilford from the Sanscrit, *varta!!!* But " some learned friends of his are of opinion that it comes from *bhardanan,* to burthen!!! because burthened with the internal management of the royal household!!!"

I shall spare my readers any more of those *caricatures,* and submit to his own candour to adjudicate, whether *Bards* could, by possibility, be anything else than the modern Englification for our ancient *Boreades?*

Doubtless, Professor Müller, your astonishment has now subsided, as to Hecatæus's credulity in the existence of the Hyperboreans. Diodorus Siculus, who,

constitutions is uncertain; but, according to tradition, was of very ancient date. The same cities were also great resorts of commerce, lying on the highway from Armenia to Asia Minor. The bond between commerce and religion was very intimate. The festivals of their worship were also those of their great fairs, frequented by a multitude of foreigners; all of whom (certain classes of females not excepted), as well as everything which had a reference to trade, were considered as under the immediate protection of the temple and the divinity. The same fact may be remarked here, which has obtained in several parts of central Africa, namely, that the union of commerce with some particular mode of worship, gave occasion, at a very early period, to certain political associations, and introduced a sacerdotal government.—HEEREN, vol. i. p. 121.

* This word is of uncertain etymology—their early history is uncertain. Diodorus (lib. v. 31), tells us, that the Celts had bards, who sung to musical instruments; and Strabo (lib. iv.) testifies, that they were treated with respect, approaching to veneration. The passage of Tacitus (Germ. 7.) is a doubtful reading.—*American Encyclopædia.*

though, as Granville Penn has affirmed, he " has transmitted to us many *scattered* and important truths," yet does the same judicious commentator add, that it was in a condition " intermixed with much idle fiction, *equivocation*, and anachronism*," was herein your guide! But the *manes* of the Hyperboreans now speak from the tomb, and vindicate their *existence* as well as their *locality !*

I come now to prove this by another mode.

Plato, in his Cratylus, represents Hermogenes as proposing several terms to Socrates for solution, when the following acknowledgment transpires :—

" I think," says the philosopher, " that the Greeks, especially such of them as lived subject to the dominion of foreigners, adopted *many foreign words ;* so that, if any one should endeavour to resolve those words by reference to the *Greek language,* or to any other *than that from which the word* was received, he must needs be involved in error !"

The *foreign* extraction then, of *many* of the Greek words being admitted, it devolves upon me to establish this extraction to be purely *Irish*.

To begin with Dodona—" In Eustathius and Steph. Byzantius," says Vallancey, " we meet with three different conjectures in regard to the derivation of the name Dodona, which, they say, owes its origin either to a daughter of Jupiter and Europa, or one of the nymphs, the daughter of Oceanus ; or, lastly, to a river in Epirus, called Dodon. But, as Mr. Potter observes, we find the Greek authors all differ, both as to the etymology of the name and the site of this oracle. In my humble opinion, Homer and Hesiod

* See Oriental Collections.

have not only agreed that it was not in Greece, but in Ireland, or some island, at least, as far westward."

The passages to which the General refers in those ancient poets, are—

Ζευ ανα Δωδωναις Πελασγικε τηλοθι ναιων
Δωδωνης μιδιων δυσχειμερου *.

that is,—

Pelasgian Jove, who *far from Greece* resid'st
In cold Dodona.

Δωδωνην Φηγον τε Πελασγων εδρανων ηκεν †.

that is,—

To Dodona he came, and the hallowed oak, the seat of the Pelasgi.

Valuable as are those authorities, the General needed not to have had recourse to them at all, had he but been apprised of the origin of the word *Dodona*.

One of the religious names of Ireland, which I have purposely left unexplained till now, was *Tot-dana* ‡. This it derived immediately from the *Tuath-de-danaans*, as indeed it did all its ancient names, with the exception of Scotia. *Tuath-de-danaans* I have shown to mean the *Magic-god-almoners* § and *Tot-dana*, by consequence, must denote the *Magic-almonry* ‖.

Now, the Greeks, having been initiated in all their religious mysteries by the Irish, did not only enrich their language with the vocabulary of our ceremonial, but adopted the several epithets of our island,

* Homer's Iliad, π. v. 233.　　　　† Hesiod, apud Strabo, l. 7.
‡ See Miege's "Present State of Ireland."　　§ See page 257.
‖ On the pillar at Buddall, before alluded to, are these words, viz., " He had a womb, but it obstinately bore him no fruit. One like him can have no relish for the enjoyments of life. He never was blessed with that giver of delight, by obtaining which a man goes to *another Almoner.*" Upon which the learned translator (Sir Charles Wiggins) very correctly comments, that " he had no issue to perform *Sradh* for the release of his soul from the bonds of sin. (See page 113 of this work.) By *another Almoner* is meant the *Deity*.

as the distinctive names for their various localities, so that our *Muc-inis** became their *Myc-ene*, our *Tot-dana* their Do-dona, &c. &c. And even the names of our lakes, with all their legends of *hydras* and *enchantments*, found their way to them also, so that from our Lough-Erne was formed, by a crasis, their L-Erna.

The change from *Tot-dana* to *Do-dona* is much more obvious than may seem at first sight. *T* and *D* being commutable, *Tot*-dana was at once made *Dot*-dana; the intermediate *t* was then left out for sound sake, making it Do-dana; and, lastly, the penultimate *a* was transformed into *o* for the " ore rotundo †," completing the *Grecism* of Do-dona.

You see, therefore, from this, that the origin of *Dodona* was exclusively Irish! that *Dodona* and *Ireland* were, in fact, one and the same!—a circumstance of which Homer was perfectly well assured, when he styled it Δωδωνη δυσχειμερος, or the *Hyperborean Tot-dana* ‡.

Neither was it in *name* only, but in *sanctity* also, that the Greek *Myc-ene* strove to imitate our *Muc-inis*. To this hour is to be found one of the ancient Pelasgian temples, vulgarly termed the *Treasury* of *Atreus,* from the mere circumstance, as Dr. Clarke well remarks, " of there being found a few *brass nails* within it, and evidently for the purpose of fastening on *something* wherewith the *interior surface was formerly lined,* and that many a long year before

* See page 327.

† Graiis, ingenium Graiis: dedit *ore rotundo.*—HORACE.

‡ This is still more evident by his making use of the word τηλοθι, that is, *far off,* meaning *from* Greece ! And Hesiod applies this identical topography to the *British Islands,* which he styles *sacred,* describing them as μαλα τηλι, an immeasurable distance off, towards the northern point of the ancient continent !

Atreus or Agamemnon!" The Doctor, however, was perfectly astray in supposing it a *sepulchre!* In form it is a hollow cone, fifty feet in diameter, and as many in height, composed of enormous masses of a very hard *breccia,* a sort of pudding-stone, the very material whereof most of our Round Towers are constructed, and the property of which is to indurate by time. The *Dune* of *Dornadella* in Scotland is *identically* the *same kind of structure,* built by our Tuathde-danaans, and for the solemn purpose of *religion* alone. This is so accurately described in an article in the Edinburgh Magazine, copied into " Pennant's Tour," that I too will make free to transcribe it.

" It is," says the Reviewer, " of a circular form, and now nearly resembling the frustum of a cone : whether, when perfect, it terminated in a point, I cannot pretend to guess : but it seems to have been higher, by the rubbish which lies round it. It is built of stone, without cement, and I take it to be between twenty and thirty feet still. The entrance is by a low and narrow door, to pass through which, one is obliged to stoop much ; but perhaps the ground may have been raised since the first erection. When one is got in, and placed in the centre, it is open overhead. *All round the sides of the walls are ranged stone shelves, one above another, like a circular beaufait, reaching from near the bottom to the top.* The stones which compose these shelves are supported chiefly by the stones which form the walls, and which project all round, just in that place where the shelves are, and in no others ; each of the shelves is separated into several divisions, as in a bookcase. There are some remains of an awkward staircase. *What use the shelves could be applied to I cannot conceive.* It could not be of any military use, from its situation

at the bottom of a sloping hill, which wholly com-
mands it. The most learned amongst the inhabitants,
such as the gentry and clergy, who all speak the *Irish*
language, could give no information or tradition con-
cerning its use, or the origin of its name."

Now, our *Round Towers* have similar *shelves*, or
recesses in the wall, and " reaching, like a circular
beaufait, from near the bottom to the top !" Where-
ever these do not appear, their place is supplied
by *projecting stones*, for the evident purpose of act-
ing as supporters *. And as the *Mycenian*, the *Cale-
donian*, and the *Hibernian* edifices thus far correspond,
the only thing that remains is *to explain to what pur-
pose could those recesses* serve.

I thus solve the question—*They were as so many
cupboards for containing the idols of Budha*, as the
structures themselves for *temples* of his worship, &c.
Nor is this, their use, yet forgotten, in the buildings
of the like description in Upper India, as appears
from the following statement by Archer. " In the
afternoon," says he, " I went to look at a *Jain
temple*. It was a neat building, with an upper story.
The idol is Boadh. There is a lattice verandah of brick
and mortar round the shrine, and there are *small
cupboards, in which numerous figures of the idol are
ranged on shelves*."

Arguments crowd upon me to establish these par-
ticulars ; the only difficulty is in the compression. I
shall, however, continue to prove this from another
source, even by showing that when Ezekiel declared,
in allusion to Tyre, that " the men of *Dedan* were
thy *merchants* †," he meant the men of *Ireland*.

First, let me refer you to page 4, by which you

* See page 71. † Chapter xvii. 15.

will be reminded of our ancient possession of a *naval equipment*. Secondly, let me quote to you an extract from Vallancey, when directing the result to a different application. His words are—" Another proof of the ancient Irish being skilled in the art of navigation, I draw from a fragment of the Brehon laws in my possession, where the payment, or the reward, for the education of children, whilst under the care of fosterers, is thus stipulated to be paid to the ollamhs, or professors, distinguishing private tuition from that of public schools. The law says, ' If youth be instructed in the knowledge of cattle, the payment shall be three eneaclann and a seventh; if in husbandry and farming, three eneaclann and three-sevenths; if in milrach, i. e. *glais-argneadh as tear*, that is, *superior navigation*, or the best kind of knowledge, the payment shall be five eneaclann and the fifth of an eanmaide; if in *glais-argneadhistein*, that is, second, or inferior (branch of) navigation, two eneaclann and a seventh.' And this law is ordained, because the pupils must have been previously instructed in *letters*, which is the lowest education of all."

Thus you see, at all events, that we were *qualified* for the duties required. Now, I will *demonstrate*, and that too by the aid, or rather at the expense, of Mons. Heeren, that we were the actual persons pointed to by the prophet.

" Deden," says the professor, " is one of the Bahrein, or rather more northerly one of Cathema. The proofs, which to detail here would be out of place, may be found in Assemani, Bib. Orient., tom. ii., par. ii., p. 160, 564, 604, and 744. Difficulties arise here, not merely from want of maps, but also from the variation and confusion of names. *Daden*, or *Deden*,

is also frequently called *Dirin ;* and it may be con-
jectured, that from hence arose the name of Dehroon;
which is given to one of the Bahrein islands in the
map of Delisle. If that were the case, then Dedan
would not be Cathema, as Assemani asserts, but the
island mentioned above; and this is rendered pro-
bable by the *resemblance of names, which is a certain
guide.*"

If the "*resemblance* of names" be "¦ a certain
guide," *identity* of names must be still more certain ;
and then must my *proofs* already prevail, and the
Professor's *conjectures* fall to the ground! Surely, he
cannot say that there is any even resemblance between
D-Irin and *Dehroon!* But he admits, that the place
alluded to is called indifferently *Dedan* * and *D-Irin ;*
and have I not shown that each of those names, iden-
tical and unadulterated, belonged *properly* to Ire-
land? Ireland, therefore, *alone* can be the country
alluded to by the inspired penman.

In denying, however, a *Dodona* to the Greeks, and
an oracle also, General Vallancey was quite incor-
rect. What he should have maintained was, that
both *name* and *oracle* had their *prototypes* in Ireland :
but that, so remote was the date at which the transfer
occurred, all insight into the mysteries had long since
perished.

Indeed, their priests very frankly acknowledged
the fact to Herodotus, when, in his thirst for informa-
tion, he waited upon them at Dodona—" We do
not," said they, " know even the *names* of the deities
to whom we make our offerings—we distinguish
them, it is true, by titles and designations ; but these

* For *Dedan* see last two pages; and for *D-Irin,* see page 128.
The prefixing of *D* to the last word arose from confounding it with the
former name; and thus it was embodied with it, as seen before in *L-Erne.*

are all adventitious and modern in comparison of the
worship, which is of great antiquity." Upon which
the historian very truly concludes, " that their *nature*
and *origin had been always a secret ;* and that even the
Pelasgi, who first introduced them and their rites,
had been equally unacquainted with their history."

Like a true Greek, however, he must set about
coining an origin for them ; and so he tells us a *cock-
and-a-bull* story of two *pigeons* (Peleiai) having taken
flight from Thebes in Upper Egypt, and never stopped
until they perched, one upon the top of Dodona,
and the other God knows where ; and then he flatters
himself he has the allegory solved, by *imagining* that
those *pigeons* were *priestesses,* or *old women,* carried
off by Phœnician pirates, and sold into the land of
Greece!

In this he has been followed by thousands of
imitators, and quoted miraculously at all the public
schools. Nay, his disciples would fain even *improve*
upon the *thing ;* and Servius has gone so far as to say
that the *old woman's* name was *Pelias !*

Now, here is the whole mystery unravelled for
you.

When the Greeks established an oracle of *their*
Dodona, subordinate to our master one, they adopted,
at the same time, one of the orders of our priesthood.
This was that of the *Pheeleas,* the meaning of which
being to them an enigma, they *bent it,* as usual, to
some similar sound in their own language*. This
was that of *Peleiai,* in the accusative *Peleias,* which,
in the dialect of Attica, signifies *pigeons,* and in that

* Or as the Rev. Cæsar Otway would say, in a similar embarrass-
ment,—" I will *give* (i. e. invent) you a motto and a motive for it."—
Ha, ha, ha!—See Dublin Penny Journal, July 8, 1832.

of Epirus, *old women;* and so the whole metamor-
phosis was forthwith adjusted !

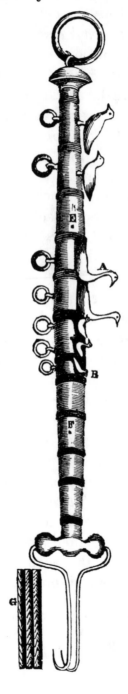

" The very extraordinary piece of antiquity, represented in the annexed wood-cut, was found," says Mr. Petrie, " in a bog at Ballymoney, county of Antrim, and exhibited to the Royal Irish Academy, by the Lord Bishop of Down, in March, 1829. Its material is that description of *bronze* of which all the ancient Irish weapons, &c., are composed, and its actual size is four times that of the representation. It is a tube, divided by joints at A and B into three parts, which, on separating, were found to contain brass wire, in a zigzag form, a piece of which is represented in *fig.* G. This wire appears to have been originally elastic, but when found was in a state of considerable decomposition. At E and F are two holes, about one-eighth of an inch in diameter, and seem intended for rivets or pins to hold the instrument together. The birds move on loose pins, which pass through the tube, and on the other end are rings. The material and style of workmanship of this singular instrument leave no doubt of its high antiquity. But we *confess ourselves totally unable to form even a rational conjecture as to its probable use,* and should feel obliged to any antiquary who would throw light upon it *."

Had the antiquarian *high-priest* to this *magnanimous* assemblage been equally modest in former cases, and courted *instruction,* instead of erecting *himself* into a *Pheelea,* he would not cut the figure which he now does. Ignorance is no fault : it is only its vagaries that are so ridiculous !

However, he has said—I beg pardon, he is in the *plural* number—well then *they* have said, that they

* Dublin Penny Journal, April 6, 1833.

would feel obliged to any *antiquary* who would throw light upon the subject."

To be sure, I am no *antiquary*. The Royal Irish Academy have made *that* as clear as the sun at noon-day. Nay, they have even strove to make their *brethren* at this side of the water to think so also!— But their brethren at this side of the water are too *honest* a people, and too *noble* in their purpose, to make history a trade, and to stifle *truth* at the unhallowed dictates of interest or partiality.

No matter; I will tell all what this piece of anti-quity was. *It was the actual instrument through which the oracle of Dodona was announced!* You see upon it the *swans* by which Apollo was brought to the Hyperboreans! The *bulbul of Iran* also attends in the train; and the affinity of this latter bird to the species of *pigeons*, convinced the Greeks that they had really hit off the interpretation of the word *Pheelea!* and that *pigeons* were, in truth, the *deliverers* of the oracle.

This was the block upon which Abbé Bannier was stumbling. Having learned from some quarter, I be-lieve from Aristotle, that there were some *brass* ap-pendages contiguous to Dodona, he converts those appendages into *kettles*—a worthy friend of mine would add, *of fish*—" which," says he, " being lashed with a whip, clattered against one another until the oracle fulminated!!!"

As to those oracles themselves, with the registries of which antiquity is so replete, I will here articulate my individual belief. No one who knows me can sup-pose that I am superstitious; and, for those who know me not, the sentiments herein delivered will scarcely foster the imputation. Yet am I as thoroughly per-

suaded as I am of my personal consciousness, that some prescience they did possess, conducted partly by human fraud, and partly by spiritual co-operation *.

There is no question but that there must have been some *supernatural* agency in the business; for *human* skill and human sagacity could never penetrate the deep *intricacies* of doubt, and the important *pregnancies* of time which they have *foreshown* †.

Porphyry, in his book " De Dæmonibus " and Iamblichus in his " De Mysteriis," expressly mention that *demons* were in every case the authors of oracles. Without going all this length we may readily allow that they had perhaps a great share in them ; neither will the ambiguity, in which their answers were sometimes couched, detract anything from this admission, because the spirits themselves, when ignorant of any contingency, would, of course, try to skreen their defect by the vagueness of conjectures, in order that if the issue did not correspond with their advice, it may be supposed owing to misinterpretation. The instance of Crœsus and the Delphian oracle was an interesting event. He sent to all the oracles on the same day this question for solution,

* Elementorum omnium spiritus, utpote perennium corporum motu semper, et ubique vigens, ex his quæ per disciplinas varias affectamus, participat nobiscum munera divinandi, et substantiales potestates ritu diversa placatæ, velut ex perpetuis fontium venis vaticina mortalitati suppeditant verba.—Ammianus Marcellinus, lib. 21.

" They then took wives, each choosing for himself; whom they began to approach, and with whom they cohabited ; teaching them sorcery, incantations, and the dividing of roots and trees."—Book of Enoch.

I have collected fifty words in the Irish language relating to augury and divination : every one of them are oriental, expressing the mode of producing these abominable arts; they are, in fact, the very identical oriental words written in Irish characters.—VALLANCEY.

viz., " What is Crœsus, the son of Alyattes, king of
Lydia, now doing ?" That of Delphi answered thus :
" I know the number of the sand of Libya, the measure
of the ocean—the secrets of the silent and dumb lie
open to me—*I smell the odor of a lamb and tortoise
boiling together in a brazen cauldron; brass is under
and brass above the flesh.*"

Having heard this reply, Crœsus adored the god of
Delphi, and owned the oracle had spoken truth ; for
he was on that day employed in *boiling together a lamb
and a tortoise,* in a *cauldron of brass,* which had a
cover of the same metal. He next sent, enjoining his
ambassadors to inquire whether he should undertake
a war against the Persians ? The oracle returned
answer, " If Crœsus passes the Halys, he will put an
end to a vast empire."

Not failing to interpret this as favourable to his
project, he again sent to inquire, " If he should long
enjoy the kingdom ?" The answer was, " That he
should till a mule reigned over the Medes." Deeming
this impossible, he concluded that he and his posterity
should hold the kingdom *for ever.* But the oracle
afterwards declared that by " a *mule* " was meant
Cyrus, whose parents were of different nations—his
father a Persian, and mother a Mede. By which
mule, says a facetious writer, the good man Crœsus
was thus made an *ass !*

That the priests, however, used much deception in
the business, and that this deception did not escape
the notice of the learned men of the time, is evident
from the charge which Demosthenes had brought
against the *Pythia,* of her being accustomed to *Philip-
pise,* or conform her notes to the tune of the Mace-
donian emperor. The knowledge of this circumstance

made the prudent at all times distrust their sugges-
tions, whilst the rabble, without gainsay, acquiesced
as blindly in the belief of their infallibility.

But it was not only as to the meaning of the word
Pheelea that the Greeks were unapprized, they knew
not the' import of their own name *Pelargi*!* It is
compounded of this same term *pheelea,* an *augur* or a
diviner ; and *argh,* the symbolical *boat,* or yoni ! And,
mind you, that this was the great difference between
the Pelargi—which is but another name for Pish-de-
danaans—and the Tuath-de-danaans, that the latter
venerated the *male* organ of energy, and the former
the *female ;* therefore in no country occupied by the
former do you meet with *Round Towers,* though
you invariably encounter those *traces* of *art,* which
prove their descent from *one common origin.*

As presiding over the *diviners* of the *symbolical
boat,* Jupiter was called *Pelargicus* †.

Agyeus was another term in their religious vocabu-
lary, as applied to Apollo, of which the Greeks knew
not the source. They could not, indeed, well mis-
take, that it was derived immediately from αγυια, *via ;*
but that did not expound the fact, and they were still
in ignorance of its proper import. It is merely a
translation of our *Budh-a-vohir,* that is, *Apollo-of-the
high-roads,* not, what the Greeks understood it, as
stationary thereon, but, on the contrary, as *itinerant ;*

* Danaus, the sire of fifty daughters, leaving those fruitful regions
watered by the Nile, came to Argos, and through Greece, ordained that
those who erst were called Pelasgi, should by the name of Danai be
distinguished.—EURIPIDES.

† You will find in Bruce, the Abyssinian traveller's writings, that
those boats are still called, in that country, *arghs,* as they were in ours,
and the people who man them are styled *Phut,* corresponding to our
Fo-morians.

and to whom *Venus the stranger* corresponded on the
other side; the especial province of both being to
ensure the comforts of *hospitality*, of *protection*, and of
love, to all emigrants and all travellers.

Grunie was another epithet applied to *Apollo*, as
we may read in a hymn composed by Orpheus, which
they could not comprehend.—It is derived from *Grian*,
one of our names for the *Sun*.

' But, beyond comparison, the most inexplicable of
all the epithets applied to this divinity is *Lycæus;*
which, though—as has been the case, you perceive, in
every subject yet discussed—it can be explained only in
the *Irish!*—yet, even *there*, it opposes some difficul-
ties to discourage, but not more than what give way
to sagacity and to perseverance.

At Glendalough, in the county Wicklow, one of
the proudest abodes of Budhism, are found, amongst
other sculptures, upon the dilapidated ruins, those
which you see opposite.

The *wolf* is the most frequent in the multitude of
those hieroglyphics. His character is exhibited in
more attitudes than one—and all mysteriously signi-
ficant of natural designs.

In one place you observe his tail gracefully inter-
woven with the long hair of a young man's head.
That represents the youth Apollo, controlling by his
efficacy,—alias, the sun's genial rays—the most
hardened hearts, and so revolutionising the tendency
of the inborn system, as from antipathy often to
produce affection and love!

Of this illustration, the practical proof is afforded
in " Bakewell's Travels in the Tarentaise," to the
following purpose, viz.—

" By way of enlivening the description of the

structure of animals, he (M. de Candolle, Lecturer
on Natural History at Geneva) introduced many inte-
resting particulars respecting what he called *leur
morale*, or their natural dispositions, and the changes
they underwent when under the dominion of man.
Among other instances of the affection which wolves
had sometimes shown to their masters, he mentioned
one which took place in the vicinity of Geneva. A
lady, Madame M——, had a tame wolf, which
seemed to have as much attachment to its mistress as
a spaniel. She had occasion to leave home for some
weeks ; the wolf evinced the greatest distress after
her departure, and at first refused to take food. Dur-
ing the whole time she was absent, he remained much
dejected : on her return, as soon as the animal heard
her footsteps, he bounded into the room in an ecstacy
of delight ; springing up, he placed one paw on each
of her shoulders, but the next moment he fell back-
wards, and instantly expired."

Elsewhere you discern two wolves unmercifully
tearing at a human head ! And this is symbolical of
a species of disease, of which there is published an
account, in a work, called " The Hospitall of In-
curable Fooles," translated from the Italian by Todd,
to the following effect, viz. :—

" Amongst these humours of Melancholy, the phi-
sitions place a kinde of madnes, by the Greeks called
Lycanthropia, termed by the Latines *Insania Lupina*,
or *Wolves furie :* which bringeth a man to this point,
(as Attomare affirmeth) that in Februarie he will goe
out of the house in the night *like a wolfe*, hunting
about the graves of the dead with great howling :
*and plucke the dead mens bones out of the sepulchres,
carrying them about the streets*, to the great feare and

astonishment of all them that meete him: And the foresaide author affirmeth, that melancholike persons of this kinde have pale faces, soaked and hollow eies, with a weak sight, never shedding one tear to the view of the world, &c."

And that this was epidemic amongst the Irish is proved by *Spenser's* testimony, when, drawing a parallel between the Scythians and the Irish of his day, he says—" Also, the Scythians said, that they were once a year turned into wolves; and so it is written of the Irish: though Martin Camden, in a better sense, doth suppose it was a disease, called lycanthropia, so named of the wolf: and yet some of the *Irish doe use to make the wolf their gossip.*"

Thus it appears, that the Irish were not only acquainted with the *nature* of this *sickness*, but also with the knack of *taming* that *animal* of which it bore the name. All this was connected with the worship of Apollo, and with eastern mythology. Nay, the very *dogs*, for which our country was once famous *, and which were destined as protectors against the ravages of the *wolf*, are clear, from Ctesias, to have had their correspondents in India.

The epithet *Lyceus*, I conceive, now elucidated; and so leave to yourself to *penetrate* the rest of those devices. But I shall not, at the same time, take leave of the " *Valley of the Two Lakes* †."

On one of the loose stones, which remain after

* " I thank you," says Symmachus to his brother Flavianus, " for the present you made me of some *Irish dogs (canes Scotici)*, which were there exhibited at the Circensian Games, to the great astonishment of the people, who could not judge it possible to bring them to Rome otherwise than in iron cages."

† This is the meaning of the name *Glen-da-lough*, and a faithful porraiture it is of the situation.

this wreck of magnificence, you will see a full deli-
neation of " The history of Dahamsonda, King of
Baranes (*modern Benares*), who, as his name implies,
was a zealous lover of religious knowledge : and was
incarnated, in order to be tried between his *attachment
to religion* and his zeal for the *salvation of the world*
on the one side, and his love to *his own life*, and his
attachment to his kingdom and wealth, as well as his
kindred and friends, on the other ; for which purpose
the gods had gradually and completely *withdrawn the
light of religious knowledge* from the world by the
time of his accession to the throne *."

This king, in his anxiety to regain the *lost* condi-
tion of mankind—to recover their literature and their
ancient knowledge of religion, instructs his courtiers
to proclaim the offer of a casket of gold, " as a
reward to any person" who would instruct his majesty
in the mysteries of the *Bana* †, that is, the Budhist
Gospel, with a view to its salutary re-propagation.

The officers proceeded in quest of such a pheno-
menon ; but, *in the extent of their own realms he was
not to* be found !

This excites the uneasiness of the king, who " hav-
ing by degrees *increased his offers* to thousands and
millions of money, high titles, possessions of land
and great privileges ; and, at last, offering his own
throne and kingdom, but still finding no instructor,
*leaves his court, resolved to become a private traveller,
and not to rest till he has found one who could commu-
nicate to him the desired knowledge. Having for a length
of time travelled* through many *kingdoms*, towns, and vil-

* Miniature of Budhism.
† " The *secret*, it was *lost*, but surely it was found."—*Freemason
song*.

lages, enduring hardships, he is, at last, by providential interference, led through *a delightful valley* (which affords him subjects for consideration and recreation of mind) into a dismal forest, the habitation of frightful demons, *venomous reptiles*, and beasts of prey.

" *Sekkraia* having on the occasion come down from heaven, in the disguise of a *Raksha*, meets *Bodhesat* (the king) in the wilderness, who fearlessly enters into conversation with him, and informs him of the object of his wanderings. The disguised deity undertaking to satisfy the king, if he will sacrifice to him his flesh and blood in exchange for the sacred knowledge, *Bodhesat* cheerfully ascends a steep rock, shown him by the apparition, and throws himself headlong to the mouth of the *Raksha*. The king's zeal being thus proved, *Sekkraia,* in his own heavenly form, receives him in his arms, as he is precipitating himself from the rock," and has him initiated in the desired information *.

Now, waiving for a moment the latter part of this legend,—every word of which, however, is still chronicled in our country, though transferred by the *moderns* to *St. Kevin* and the *monks,*—I return to add, that, on the above-mentioned stone, you will see a representation of the *ambassadors offering this caske of riches to a professor of letters seated in his* " *doctor's chair ! ! !*"

This stone itself is engraved in " Ledwich's Antiquities," where in his ignorance of its meaning, as well as of everything else which formed the subject

* This account is found in *Satdharmalankare,* a very popular Bhuddist book, being a collection of histories, &c., from the writings of the *Rahats,* in which the original *Paly* (*Pahlavi*) texts are preserved with the Singhalese.—*Miniature of Budhism.*

of his libellous farrago, he perverts it into the *bribing of a Roman Catholic priest!*—as if the priests would so emblazon themselves!—and quotes Chaucer to *prove* the fact, when he says of one of them, that—

> " He would suffer, for a quart of wine,
> A good fellow to have his concubine !"

How inconsistent is error! Elsewhere this Reverend Doctor has asserted, and, accidentally, *with truth,* that there was no such thing at all to be met with at this place, as " Christian symbols." I wonder was he one of those who consider *Roman Catholics* not to be *Christians?*

However, again from *this* he diverges! And, when called upon to decipher the *hieroglyphics upon a stone-roofed Tuath-de-danaan chapel, of the same character as that at Knockmoy,* and discovered here a few years ago, beneath the Christian piles which the early missionaries had built over it, by way of *supersedence,* he throws himself, in his embarrassment, into the arms of *St. Kevin!* associates *him* with the whole! and that, too, after he had fatigued himself, *until half choked with spleen,* in bellowing out the *ideality* and utter *nonexistence* of such a personage!

On the front of the cathedral erected out of the fragments of the Tuath-de-danaan dilapidations, you will find *Budha* embracing the *sacred tree,* known *in our registries,* by the name of *Aithair Faodha,* which signifies literally the *tree* of *Budha* *.

* *Buddu,* the god of souls, is represented by several little images made of silver, brass, stone, or white clay, and these are set up in almost every corner, even in caverns and on rocks, to all which piles, the devotees carry a variety of provisions, every new and full moon throughout the year; but it is in March they celebrate the grand festival of *Buddu,* at which time they imagine the new year begins. At this festival they go to worship in two different places, which have been made famous by

The *pomegranate* of *Astarte*—the medicinal apple of *affection* * —presents itself, also, in the foliage! The *mouldings* upon the arch of the western window refer likewise to *her.* And, to complete the union of Sabian symbolization, the *serpent* mingles in the general tale! while the traditional story of the adjoining *lake* having been infested by the presence of that reptile, has a faithful parallel in one of the lakes of Syria!

Will it not be believed, therefore, that the *valley* at which Dohamsonda had alighted, *after he had traversed many realms far away from his own,* was that of Glendalough? And where, I ask, would he be more likely to obtain the object of his peregrination, viz., initiation into *gospel* truth, than in that country which, from its pre-eminent effulgence in its

their legendary stories concerning them. One of them is the highest mountain in the island, and called by the Christians *Adam's Peak;* the other is in a place where *Buddu* reposed himself under a *tree,* which planted itself there for the more commodious reception of the deity, who, *when he was on earth, frequently amused himself under its agreeable shade,* and *under that tree* the pagans in Ceylon *adore* their *Buddu,* whom they really believe to be a god.—Dr. Hurd.

Bodhesat receives a few handfuls of grass presented to him by Soithia, (a Brahmin,) which grass, when strewed on the ground under the *Bo tree,* there arise from the earth miraculously a throne of diamond, fourteen cubits high, covered externally with grass; on which Bodhesat takes his seat, reclining his back against the *tree,* in order to accomplish his last act of meditations. Buddha having ascended into the air, and displayed his glory to all the worlds in rays of six different colours, in order to afford the gods a proof of his perfection, stands seven days with his eyes fixed on the *Bo tree,* enjoying the *Dhyanes.*—*Miniature,* &c.

* " Yes, love indeed is light from heaven,
 A spark of that immortal fire,
With angels shared, by Alla given,
 To lift from earth our low desire.
Devotion wafts the mind above,
But heaven itself descends in love,
A feeling from the godhead caught,
To wean from self each sordid thought."—Byron.

beatitudes, was exclusively denominated the *Gospel-land*?

This, Sir, is no *rhetoric*—no *declamatory exaggeration*. I will reduce it for you, in its simple elements, to the perspicuity of vision.

Bana-ba is one of the names of our *sacred island*, which, like all the rest of our *history*, has been heretofore a *mystery* to literary inquirers!

The light bursts upon you!—does it not already? Need I proceed to separate for you the constituent parts of this word?

It is compounded then, be it known, of *Bana*, which indicates good tidings, or gospel, and *aba*, land—meaning, in the aggregate, the *Gospel-land!* And accordingly the pilgrim, when he set out upon his journey in quest of the *Bana*, very naturally, betook himself to *Bana-ba*, or the *land of the Bana*, where alone it was to be found!

And you presume to say that *Christianity* is a thing which only commenced last week?

> " Great God! I'd rather be
> A *Pagan* suckled in a creed outworn ;
> So might I, standing on this pleasant lea,
> Have *glimpses* that would make me *less forlorn ;*
> Have sight of Proteus rising from the sea ;
> Or hear old Triton blow his wreathed horn."—WORDSWORTH.

CHAPTER XXXI.

" THEY shall be astonished, and shall humble their countenances: and trouble shall seize them, when they shall behold the Son of *Woman* sitting upon the throne of his glory. Then shall the kings, the princes, and all who possess the earth glorify him who has dominion over all things—him who was *concealed*: for, from the beginning, the Son of Man existed *in secret*, whom the Most High preserved in the presence of his power, and *revealed to the elect* *."

So speaks one of the most extraordinary productions that has ever appeared in England, in the shape of literature! And the commentary of its translator † is as follows :—

" In both these passages," says he, " the *pre-existence* of the Messiah is asserted in language which admits not the slightest shade of ambiguity—nor is it such a pre-existence as the philosophical cabalists attributed to him, who believed the souls of all men, and, consequently, that of the Messiah, to have been originally created together, when the world itself was formed; but an *existence antecedent* to all creation, an existence previous to the formation of the luminaries of heaven; an existence prior to all things visible

* Book of Enoch, lxi. 8—10.
† Dr. Lawrence, present Archbishop of Cashel.

and invisible, before everything concealed.—It should likewise be remarked, that the pre-existence ascribed to him is a divine pre-existence *."

As to the *pre-existence* of the Messiah, in the only way in which the Archbishop affirms, I did not think that the doctrine was so obscure as to require so much stress! Every body acquiesces, who acquiesces in Christianity—that its Founder had existence and dominion with his Father before all worlds. And, therefore, when his Grace offers this as an *illustration* of our opening extract, he either *unconsciously contradicts himself*, or, else, by dealing *in generalities, evades* an *exposition, which he was not at liberty to communicate!*

I am quite ignorant as to whether or not Dr. Lawrence belongs to the order of *Free-masons*, but I confess, that when first I glanced at the above remarks, I fancied he did. The care with which the two words " *secret*" and " *concealed*" were distinguished by him in *italics*, led me to this conjecture. But the *indefinite unsubstantiality* into which he afterward wandered, made the fact of his *initiation* become, itself, a *secret*.

Let me, however, prove the above *dilemma*.

His Lordship has asserted, that the *uninspiration* of " the author" will admit of no dispute †: and yet

* Preface to Translation of the Book of Enoch.

† " If this singular book be censured as abounding in some parts with fable and fiction, still should we recollect that fable and fiction may, occasionally, prove both amusing and instructive; and can then only be deemed injurious when pressed into the service of vice and infidelity. Nor should we forget that much, perhaps most, of what we censure, was grounded upon a rational tradition, the antiquity of which alone, independent of other considerations, had rendered it respectable. *That the author was uninspired will be scarcely now questioned.* But, although his production was apocryphal, it ought not therefore to be necessarily

that "author," whom the Archbishop himself acknowledges to have written, at the very lowest, *antecedently* to the *Advent*, speaks of the *Messiah* as the " *Son of Man*," and the " Son of *Woman**."

Either, therefore, the author was *inspired*, speaking *prospectively* of an occurrence *not then consummated!* or else, *uninspired*, he historically transmits the record of an *incarnation vouchsafed before his time.*

I feel perfectly indifferent as to which horn of this alternative you may patronise. They both equally make for *me*. Nor do I want *either*, otherwise than to show, that else the Archbishop is already *of my way of thinking*, and *restrained* from *avowing* it; or *unwillingly* involved in a *contradictory nodus*, from a partial succumbing to education!

With this I leave Enoch! I have hitherto done without him! I shall continue still to do so! But while bidding *adieu*, I must disburthen myself of the

stigmatized as necessarily replete with error; although it be on that account incapable of becoming a rule of faith, it may nevertheless contain much moral as well as religious truth, and may be justly regarded as a correct standard of the doctrine of the times in which it was composed. *Non omnia esse concedenda antiquitati*, is, it is true, a maxim founded upon reason and experience; but, in perusing the present relic of a remote age and country, should the reader discover much to eondemn, still, unless he be too fastidious, he will find more to approve; if he sometimes frown, he may oftener smile; nor seldom will he be disposed to admire the vivid imagination of a writer, who transports him far beyond the flaming boundaries of the world—

——————————————— ' Extra

Processit longe flammantia mœnia mundi;

displaying to him every secret of creation; the splendours of heaven, and the terrors of hell; the mansions of departed souls, and the myriads of the celestial hosts, the seraphim, cherubim, and ophanim, which surround the blazing throne, and magnify the holy name of the great Lord of Spirits, the Almighty Father of men and of angels."— *Archbishop of Cashel.*

* See page 475.

sentiments which his merits have inspired, and that
after a *very short personal familiarity*.

Thou art then, a GOODLY and a WISE book, Enoch,
stored with *many* and *recondite truths*, but " *few*
they be who *find*" them. Better for thee it were,
however, that thou hadst slept a little longer in thy
tranquil retirement, than obtrude thyself, *unappre-
ciated*, upon an *ungenial* world,—a cold, a calculating,
an adamantine world—who fancy they know *every-
thing*, but who, in truth, know *nothing*—to meet with
nothing but their *scorn !* It is true, Enoch, that thy
face hath been tarnished by many a blemish ! And
that the hand of time hath dealt with thee, as it doth
with the other works of man! Yet, despite of the *cur-
tailments* thus sustained, and the *exotics* incorporated,
thy magnificent ruin still holds within it some *gleams*,
which to the *initiated* and the *sympathetic* afford delight
and gratification.

> ———" Sweet as the *ecstatic* bliss
> Of *souls* that by *intelligence* converse !"

Doubtless, reader, you are acquainted with the
Gospel of St. John?—and you have a heart?—and
you have emotions?—and you have sensibilities?—
and you have intellect? Well, then, tell me frankly,
have not these all been brought into requisition, at
the metaphysical *sublimity* and the oriental *pathos* of
the opening part of that production?

" He was in the world, and the world was made
by him ; and the world *knew him not*.—He came unto
his own, and *his own* received him not *."

You surely cannot suppose this said in reference to
the *late incarnation !* Were it so, why should the

* John i. 10-11,

Evangelist deliver himself in terms so pointedly allu-
sive to *distant times?* The interval between Christ's
disappearance and St. John's registration was but as
yesterday, and, therefore, the latter, when inculcating
the *divinity* of the *former*, upon the belief of his
countrymen, who were all cotemporaries, as well of
one as of the other, need not advertise them of an
addition, of which they were themselves cognisant.

But to illustrate to you as *light*, that it was not the
recent manifestation that was meant by the above
texts, he tells us in the sequel, when expressly nar-
rating *this* latter fact, that " the *logos* was made flesh
and dwelt *among us**." Where you perceive that
" *dwelling among us*" is made a *distinct thing from*, and
posterior in eventuation to " *coming unto his own*," as
before recorded † !

Indeed, in the delineation, it is not only the *order*
of *time*, but the *precision* of *words*, that we see most
rigidly characteristic. The *Jews*, it is certain, could
not be called " *his own*," except by *adoption ;* and, I
am free to allow, that from them, " as concerning the
flesh, Christ came ;" but by " *his own*," are meant his
*real relations !—emanations from the Godhead, such as
he was himself! beings altogether separate from flesh
and blood !* and whose *mysteriousness* was perceptible
most clearly to St. John, as you will perceive by the
Greek words from which this is rendered, viz., τα
ιδια, having been put in the neuter gender !

But suppose them, for an instant, to have been the
Jews !—Then we are told that, " to as many as
received him, gave he power to become sons of
God ‡." Now, the apostles were they who did *impli-*

* John i. 14. † Page 478.
‡ John i. 12.

citly receive him : and why does not St. John refer to those, whether living or dead, as admitted to the privilege of becoming " sons of God ?" I will tell you :—it was because that they did not answer to that order of beings " which were born not of blood, nor of the will of the flesh, nor of the will of man, but of God *."

These were the persons to whom *Christ came before* —these were " his own," because that, *like him,* they also were *of God* †. These were they, who having lapsed into sin ‡, and vitiated their nature, drew down the vengeance of heaven upon them—and to the descendants of these it was that " the elect" and " the concealed one," in mercy was made manifest, with proposals of redemption to regain their lost state !!!

Oh! the depth of the riches both of the wisdom and knowledge of God! how unsearchable are his judgments, and how inscrutable his ways §!

Seest thou not now, therefore, the propriety of St. John's expression, when he says, " and I knew him not, but that he should *be made manifest* to Israel ‖;" for when before " he was in the world," it was in *secret* and *concealed,*—as *still and always repre-sented* in the *mysteries!* The latter, he *asserts,* as a matter of *revelation*—for the former he *appeals to the experience* of his auditors, as a subject of *history:* and *both epochs are confirmed* by the " voice from heaven," which replied to Christ's own prayer, as thus, " I have both glorified it," viz., *at thy former manifestation* —and will glorify it again ¶," *at this thy present !!!*

I was myself twelve years of age before ever I

* John i. 13.

‡ See page 243.

‖ John i. 31.

† See page 242.

§ Romans xi. 33.

¶ John xii. 28.

saw a Testament in any language. The first I was
then introduced to was the Greek. Being in favour
with my tutor, he took an interest in my progress,
and the consequence was, to my gratitude and his
praise, that no deviation from the exactness of gram-
matical technicality could possibly escape my obser-
vation. Soon as I arrived at the text wherein τα ιδια
occurs, its irregularity, at once, flashed across my
mind. I sought for an explanation, but it was in
vain ; my imagination set to work, but it was equally
abortive. At length, in despair, I relinquished the
pursuit, and never again troubled myself with it, or
its solution, until recalled by its connexion with the
present inquiry.

But it was not alone the peculiarity of gender that
excited my circumspection, the phraseology, when
translated, sounded so familiar to my ear, as to
appear an old acquaintance under a new form. For,
though I could then tolerably well express myself in
English, the train of my reflections always ran in
Irish. From infancy I spoke that tongue : it was to
me vernacular. I thought in Irish,—I understood
in Irish,—and I compared in Irish. My sentiments
and my conceptions were *filtrated* therein !

As to dialectal idioms or lingual peculiarities, I
had not, of course, the most remote idea. Whether,
therefore, the expression coming to " his own "
were properly a *Greek* or an *English* elocution, I
did not, then, know either sufficiently well to deter-
mine ; but that it was *Irish* I was perfectly satisfied ;
my ear and my heart, at once, told me so.

I now positively affirm, that the *phrase is neither
Hebrew, Greek,* nor *English!* And if you are not dis-

posed to admit the information which it conveys *,
to be an immediate communication from the Omni-
potent, I have another very adequate mode of account-
ing for St. John's having acquired it, and expressed
it too in a phraseology so *essentially oriental*.

The three wise men—who came from the East to

* Viz., the *secret* of an Antediluvian Incarnation.

Jerusalem, saying, " Where is he that is born King of the Jews ? for we have seen his star in the east, and are come to worship him*"—to a mortal certainty imparted to him the intelligence !

Here you see them with *crosses* upon their crowns†, the religious counterparts of our *Irish shamrocs*‡ ! And surely, as Jesus was then but an infant, those mysterious devices were commemorative of his crucifixion, when " he came to his own,"—and not to that which occurred while he " dwelt among us," a catastrophe which had not yet taken place !

Nor is it alone this single phrase (τα ιδια) that I claim as oriental—the five first verses of this Gospel, as at present arranged, appertain also thereto. They speak the *doctrine* alike of the *Budhists* and of the *Free-masons ;* but in *diction,* and in *peculiarity,* in *tone,* in *point,* and *essence,* they are irrefragably *Irish*§.

That St. John never wrote them is beyond all question ! but having found them to his hand, existing after the circuit of centuries and ages, the composition seemed so pure, and so consonant with Christianity, nay, its very vitality and soul, he adopted it as the *preface* to his *own production,* which begins only at the sixth verse, opening with, " There was a man sent from God whose name was John !"

Having asserted that the preliminary part was inalienably *Irish,* I now undertake to prove a *radical misconception,* nay, a *derogation* from the *majesty* of

* Matthew ii. 1, 2.

† This wood-cut is copied from one of the early block-books.

‡ See page 440.

§ I need not repeat to the reader, that by *Irish* I mean the primitive *Persic,* indiscriminately common as well to *Iran* as to *Irin.*

the *Messiah*, to have crept into the text, in conse-
quence of its having been translated by persons unac-
quainted with that language!

The term, *logos*, which you render *word*, means to
an iota the *spiritual flame*—*log*, or *logh*, being the
original denomination. The Greeks, who had bor-
rowed all their religion from the Irish, adopted this
also from their vocabulary; but its form not being
suited to the genius of their language, they fashioned
it thereto by adding the termination *os*, as *loghos ;*
and thus did it become identified in sound with the
common *logos*, which they had before, and which
merely expresses a *word* or *term!*

But though thus confounded, their philosophers, for
a long time, kept both expressions distinct. The
former they ever considered a *foreign importation*,
rendering it, as we did, by the *spiritual flame ;* as
is evident from Zeno making use of the expression,
δια του παντος λογος, that is, the spiritual *flame*, which
is diffused through, and vivifies everything.

Pythagoras is so explicit upon this *spiritual flame*,
that you would swear he was paraphrasing the first
five verses of St. John.

" God," says he, " is neither the object of sense,
nor subject to passion, but invisible, only intelligible,
and supremely intelligent. In his body, he is like
the *light*, and in his soul he resembles truth. He is
the universal *spirit* that pervades and diffuseth itself
over all nature. All beings receive their *life* from
him. There is but one only God, who is not, as
some are apt to imagine, seated above the world,
beyond the orb of the universe; but being himself all
in all, he sees all the beings that fill his immensity,
the only principle, the light of Heaven, the Father of

all. He *produces everything*, he orders and disposes *everything ;* he is the reason, the *life*, and the motion of all being."

Even the Latins having borrowed the idea from the Greeks, steered clear of the equivocation of the ridiculous *word ;* and the immortal Maro, when describing the quickening influence of this ethereal *logos* through all the branches of nature, interprets it as above, literally, by the *spiritual flame !*

> Principio cœlum ac terras, camposque liquentes,
> Lucentemque globum Lunæ, Titaniaque Astra,
> *Spiritus intus* alit ; totamque infusa per artus
> Mens agitat molem, et magno se corpore miscet.
> Inde hominum pecudumque genus, vitæque volantum,
> Et quæ marmoreo fert monstra sub æquore pontus*.

Am I, therefore, presumptuous in appealing to the *community* to reject this *word* as applied to the *logos.* A meaning, it is true, has been trumped up for this, as the *communicating vehicle* between God and his creatures ! No doubt, the Saviour is all that : but *logos does not express it ;* and the *duration* of an abuse is no reason why it should be perpetuated after its *exposure.*

I have said, that it degraded the dignity of the Godhead to render this expression by the form of *word.* I do not retract the charge : on the contrary I *add* that, independently altogether of the former arguments, adduced to establish its *inaccuracy*, it it would be *revolting* to *common sense*, were it not even thus *incorrect !*

For example—" In him was *life*," says the text, " and the life was the *light* of men."

Now, how could there be *life* in a *word ?* except by the most unnatural straining of metaphor. Or, ad-

* Virgil's Æneid, vi. 724.

mitting that there was *life*, how could there be *light*, except by the same? Whereas, by substituting the proper term, then all is regular and easy; for what could be more natural, than that there should be *life* in *spirit?* and that *this life* should give *light* to men?

You will observe accordingly, that Jesus himself, when describing his own character, exactly states what I here rectify, saying, "I am the *light* of the world"—not the *word* of the world—or any such nonsense. And he continues the idea by noting further, that " he that followeth me shall not walk in *darkness*, but shall have the *light* of life *." Thus keeping up an *uninterrupted* reference to *logos*, or the *spiritual flame!*

I do, therefore, humbly, but strenuously, implore of the legislature, that they *restore* this epithet to its *divine* interpretation! I entreat of the heads, as well of church as of state, that they cancel the error; for *error* I unhesitatingly pronounce it to be,—a *derogation* from the Godhead—and a *perversion* of the attributes of the Messiah!

I will myself show the way—thus: " In the beginning was the *spiritual flame:* and the *spiritual flame* was with God, and the *spiritual flame* was God †."

How beautiful! may I hope that it will never more be extinguished!

Now, there is another text in the same chapter, which, though not incorrectly translated, yet *loses half its beauty*, as at present understood! It will startle you when I recite it! Yet here it comes. " Behold! the *lamb* of God which taketh away the sin of the world ‡ !"

* John viii. 12. † John i. 1.

‡ John i. 29.—See also page 315 of this volume.

By *lamb,* no doubt, you mean a young sheep : but let me ask you, what connexion can you perceive between a *young sheep* and the *taking away of sin?* That of immolation, you answer, as typifying the *grand offering.* Well then, why add " of God?" Why say, the *young sheep of God,* if it was an ordinary animal of the mere *ovine species* that was intended ?

No, Sir, recollect the " *Lamb* slain from the beginning of the world," recorded in the Revelations, as quoted before *.

A deep mystery is involved in this expression, which the ingenuity of man could not evolve but through the Irish. In that language, *lambh* is a word having *three* significations. The first is a *hand ;* the second a *young sheep ;* and the third a *cross* †.

Let us now, in rendering the text, substitute this latter instead of the intermediate ; and it will be, " Behold the *cross* of God which taketh away the sin of the world!" By which you perceive that when John the Baptist, by inspiration, pointed out Jesus Christ as the universal Saviour of the world, his *very words* establish a previous *crucifixion!*

You now see how it happened that ten, in numerals, came to be represented by a cross X. *This* being the *number* of *fingers* upon each person's *hands :* and a *hand* and a *cross* being both prefigured in the *sacred,*

* See page 288.

‡ In the Tartar language, which is a dialect of the Irish, it still retains this latter import, as appears from the following :—" Ce qu'il y a de remarquable, c'est que le grand prêtre des Tartares port le nom de *lama,* qui en langue Tartare signifie *la croix ;* et les *Bogdoi* qui conquirent la Chine en 1644, et qui sont soûmis au *delae-lama* dans les choses de la religion, ont toujours des *croix* sur eux, qu'ils appellent aussi *lamas.*"—*Voyage de la Chine,* par Avril, lib. iii. p. 194.

that is, in the *Irish* language*, by the same term, *lambh*, it hence occurred that in all reckoning and notation, a *new score* should be commenced therefrom —that its *sanctity* should be still further enhanced, by the epithet of *diag*, or *perfection*, which characterizes it as a *submultiple*, and that the *mysteriousness* of the *whole* should be additionally shrouded under the *comprehensive symbol* of a *pyramid* or *triangle* △ †.

"Our Hibernian Druids," says Vallancey, "always wore a key, like the doctors of law of the Jews, to *show they alone had the key of the sciences*, that is, that they alone could communicate the knowledge of the doctrine they preached. The name of this key was *kire*, or *cire ;* and *eo*, a peg or pin, being compounded with it, forms the modern *eo-cire*, the key of a lock. The figure of this key resembled a *cross ;* those of the Lacedæmonians and Egyptians were of the same form."

Estimable and revered Vallancey, it pains me to say anything against you! but on those subjects you were quite *at bay! It was not* " to show that they alone had the key of the sciences," that " the doctors of law of the Jews always wore *a key*," but because that *they had seen it in the ceremonial of the Egyptians*, from whom, like the Lacedæmonians, they had borrowed its use, without *either of them being able to penetrate its import ‡ !*

The origin, then, of this *badge* appearing amongst

* The words *Irish* and *sacred* are synonymous.—See page 129.

† See pages 267, 268, and 269.

‡ "The peculiar office of the Irumarcalim it is difficult to find out," says Lewis, " only it is agreed that they carried the keys of the seven gates of the court, and one could not open them without the rest. Some add, that there were seven rooms at the seven gates, where the holy vessels were kept, and these seven men kept the keys, and had the charge of them."—*Origines Hebrææ*, vol. i. p. 97.

the *habiliments* of our ancient priests, is developed by
the *name* which those priests themselves bore, viz.,
Luamh, which, being but a direct formative from
lambh, a *cross, unlocks* the *secret* of their being its
ministers *.

The *Idæi-Dactyli,* who superintended the mysteries
of Ceres, obtained their designation from the very same
cause, and corresponded literally with our *Luamhs :*
for the *Iod* of the Chaldeans being equivalent to the
lambh or *hand* of the Irish, the number of fingers
thereon were made religiously significant of the X,
or *cross!* And,—what cannot fail to excite astonish-
ment, as to the *immutability* of a nation's *character,—to
this very hour, the symbolical oath of the Irish peasant
is a transverse placing of the fore-finger of one hand
over that of the other,* and then uttering the words,
" *By the cross !*"

Are not the opposers of my *truths,* then, as yet
satisfied? or will they still persist in saying that it
was the *Pope* that sent over our Tuath-de-danaan
crosses†? in the ship Argho! some thousands of
years before ever Pope was born. I wonder was it
his Holiness that transported emissaries also to that
ancient city in America, lately discovered in ruins,
near Palenque; amongst the sculptures of which we
discover a *cross!* And the *priority* of which to the
times of *Christianity* is borne witness to by the gentle-
man who has published the " Description" of those
ruins ‡, though *glaringly ignorant as to what was com-
memorated thereby.*

" Upon one point, however," he says, " it is deemed
essentially necessary to lay a stress, which is the

* See page 438, with the note thereon also.
† See Dublin Penny Journal, Nov. 10, 1833.
‡ Published by Berthoud, 65, Regent's Quadrant, Piccadilly.

representation of a Greek cross, in the largest plate illus-
trative of the present work, from whence the *casual*
observer might be prompted to infer that the Palen-
cian city flourished at a period *subsequent* to the
Christian era ; whereas it is *perfectly well known to all
those conversant* with the mythology *of the ancients,*
that the figure of a *cross* constituted the leading sym-
bol of their religious worship : for instance, the augu-
ral *staff* or wand of the Romans was an exact re-
semblance of a *cross,* being borne as the ensign of
authority by the community of the augurs of Rome,
where they were held in such high veneration that,
although guilty of flagrant crimes, they could not be
deposed from their offices ; and with the Egyptians the
staff of Bootes or Osiris, is similar to the *crosier* of
Catholic bishops, which terminated at the top with a
cross."

But if the Pope had so great a taste for beautifying
our valleys with those costly specimens of art, whereof
some are at least eighteen feet in height, composed
of a single stone, and chiselled into devices of the
most elaborate mysteries, is it not *marvellous* that he
has not, in the plenitude of his piety, thought proper
to adorn the neighbourhood of the Holy See with any
similar trophies? And why has he not preserved in
the archives of the Vatican any *record* of the bequest,
as he has taken care to do in the case of the four *palls?*

But, transcendently and lastly, why did he deem it
necessary to depict *centaurs* upon those *crosses,* with
snakes, serpents, dogs and other animals, such as this
following one exhibits, which is that at Kells, and
which has been alluded to, by promise, some pages
backwards*.

* See page 361. At Monasterboice there are three very beautiful

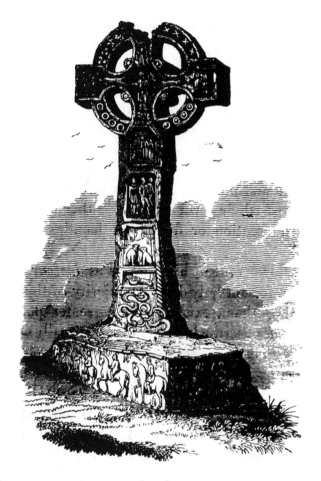

I have now done with the *appropriation* of those columns; and shall just *whisper* into my adversaries' ears—*if they have but recovered from the downcrash of their* fabric—that so far from laying claim to the honour of their erection, the Pope has actually excommunicated all such as revered them! and has otherwise disowned all participation therein, by the fulminating of bulls and of anathemas *!

specimens of those Tuath-de-danaan crosses still remaining, and covered, as usual, with *hieroglyphic sculpture*. " The pillars in the Palencian city," I find, " are also decorated with serpents, lizards, &c."

* See Borlase, p. 162.

Yet did the zealots of party, after the history of those crosses was forgotten, associate them individually with some favourite saint! " This notion," says Mosheim, referring to such *diversions*, " rendered it necessary to multiply prodigiously their number, and to create daily new ones. The clergy set their invention at work, and peopled at discretion the invisible world with imaginary protectors; they invented the names and histories of saints that never existed; many chose their own patrons, either phantoms of their own creation or distracted fanatics whom they sainted."

Here, however, the historian is as *inaccurate* as he is *severe :* for not only did the majority of those *saints,* if not all of them, exist, but the greater part also of those *exploits,* ascribed to them, have actually occurred ! *The imposition consisted in making them the heroes of events and legends belonging to former actors* *.

I shall now give you, from the book of Ballymote, my proof for the assertion before advanced as to the *Goban Saer,* whom they would fain appropriate, having been a member of the Tuath-de-danaans, viz., " Ro gabsat sartain in Eirin Tuatha Dadann is deb ro badar na prem ealadhnaigh : Luchtand saer credne ceard : Dian ceachd liargh etan dan a hingeinsidhe : buime na filedh Goibneadh *Gobha lug* Mac Eithe Occai; ro badar na huile dana Daghadae in Righ : oghma brathair in Righ, is e ar arainic litri no Scot." That is, The Tuath-de-danaans then ruled in Eirin. They were first in all sciences. Credne Ceard was of

* See page 36. I must not omit to mention that the Tuath-de-danaan cross at Armagh, noticed at page 359, was pulled down some time back, to prevent the *squabbles* between the Catholics and the Orangemen, neither of whom had any inheritance therein !

this people; and his daughter *Dean* Ceachd, who presided over physic: she nursed the poet Gohne *Gobha*, the Free-mason (*lug* is the same as *Saer*) son of Occai Esthne. Daghdae the king was skilled in all sciences: his brother Ogmus *taught the Scythians the use of letters.*

Thus you see that he could not, by possibility, be on the same theatre with *St. Abham ;* while the popular tradition is still substantially true which connects his name with the erection of the Round Towers!

The church festivals themselves, in our Christian calendar, are but the direct transfers from the Tuath-de-danaan ritual. Their very *names* in Irish are identically the same as those by which they were distinguished by that earlier race. If, therefore, surprise has heretofore been excited at the conformity observable between our church institutions and those of the East, let it in future subside at the explicit announcement that *Christianity*, with us, was but the *revival* of a religion, imported amongst us, many ages before, by the Tuath-de-danaans from the East, and not from any chimerical inundation of Greek missionaries—a *revival* upon which their hearts were longingly riveted, and which Fiech himself, the pupil of St. Patrick, and bishop of Sletty, unconsciously registers in the following couplet, viz.—

> " *Tuatha* Heren, tarcaintais
> Dos nicfead sith laithaith nua*."

That is,

> " The *Budhists* of Irin prophesied
> That *new* times of *peace* would come."

What kind of *peace*, you ask? Is it of *deliverance*

* Vita prima S. Patricii, Ap. Colgan.

from their *Scythian* oppressors? No, but that spiritual tranquillity, such as they enjoyed before, and at which even the angels of heaven rejoiced, while announcing the tidings to man *.

> " And sweet, and with rapture o'erflowing,
> Was the song from that multitude heard,
> Who their heav'n for a season foregoing,
> To second the Angel appear'd.
> ' All glory,' the anthem resounding,
> ' To God in the highest,' began;
> And the chant was re-echoed, responding,
> ' *Peace* on earth, loving kindness to man +.' "

You will remember that the Scriptures themselves record, how that the *wise men of the East* foresaw this epoch; and " Lo, the star, which they saw in the east, went before them, till it came and stood over where the young child was ‡."

Is it therefore to be wondered at that our Tuath-de-danaans, who were their brethren, should equally anticipate it?

Yes, from the commencement of time, and through all the changes of humanity, God had always witnesses to the *truth* in this nether world.

" And Melchizedec, king of Salem, brought forth bread and wine; and he was the priest of the most high God.

" And he blessed him, and said, Blessed be Abram of the most high God, possessor of heaven and earth:

" And blessed be the most high God, which hath

* " Fear not: for, behold, I bring you good tidings of great joy, which shall be to all people. For unto you is born this day, in the city of David, a Saviour, which is Christ the Lord."—Luke ii. 10, 11.

+ " And suddenly there was with the angel a multitude of the heavenly host, praising God, and saying, Glory to God in the highest, and on earth peace, good will towards men."—Luke ii. 13, 14.

‡ Matthew ii. 9.

delivered thine enemies into thy hand. And he gave him tithes of all *.

" Now consider how great this man was, unto whom even the patriarch Abraham gave the tenth of the spoils.

" For this Melchizedec, king of Salem, priest of the most high God, who met Abraham returning from the slaughter of the kings, and blessed him ;

" To whom also Abraham gave a tenth part of all : first being, by interpretation, king of righteousness, and after that also king of Salem, which is king of *peace.*

" Without father, without mother, without descent, having neither beginning of days nor end of life ; but made like unto the Son of God—abideth a *priest* continually †."

Thus does the apostle proceed, in a strain of the closest argumentation, to point out the superiority of this king of *peace,* over Abraham and his lineage : after which Mr. Brown, in his Commentary upon the Bible, expresses himself as follows, viz.—" Who this Melchizedec was, this priest of God among the Canaanites, greater than Abraham, the friend of God, who were his parents or his successors, is on purpose concealed by the Holy Ghost. And hence he is without father or mother, predecessor or successor, in his historical account, in order that he might typify the incomprehensible dignity, the amazing pedigree and unchangeable duration of Jesus Christ, our great High Priest."

* Genesis xiv. 18, 19, 20.

† Hebrews vii. 4, 1, 2, 3. Rex idem hominum, Phœbique Sacerdos.—VIRGIL.

Nobody can quarrel with the *piety* of this commentator: but *piety* is not the only requisite for a commentator upon the Scriptures; the *absence of stupidity* is an essential condition. It is not, however, as applied to *this particular passage* that I thus express myself: were this the only instance of *accommodating oversight* it should draw forth no critique from me. But the instances are *innumerable,* to verify the expression that " some persons *see* but *perceive* not."

Mr. Brown had no idea of an *emanation!* Mr. Brown did not comprehend the *sons of God!* Mr. Brown did not know the connection which existed between the *peace* of Christ and that which was represented by Melchizedec *.

" How beautiful upon the mountains are the feet of him that bringeth *good tidings,* that publisheth *peace;* that bringeth *good tidings* of good, that publisheth *salvation;* that saith unto Zion, Thy *God* reigneth †."

" These things have I spoken unto you, that in me ye might have *peace.* In the world ye shall have tribulation: but be of good cheer; I have overcome the world ‡."

" If thou hadst known, even thou, at least in this thy day, the things which belong unto thy *peace!* but now they are hid from thine eyes §."

" *Peace* I leave with you; *my peace* I give unto you: not as the world giveth, give I unto you ‖."

* Holy *mysteries* must be studied with this caution, that the mind for its module be dilated to the amplitude of the *mysteries,* and not the mysteries be straitened and girt into the narrow compass of the mind.— BACON.

† Isaiah lii. 7. ‡ John xvi. 33.
§ Luke xix. 42. ‖ John xiv. 27.

" Which hope we have as an anchor of the soul, both sure and steadfast, and which entereth into that within the veil ;"

" Whither the forerunner is for us entered, even Jesus, made an *high priest for ever after the order of Melchisedec* *."

From our fathers to us the good tidings descend,
 From us to our children agen ;
Unrestrain'd as the sun, and as lasting, they blend
 All the nations and ages of men.
Good news of great joy to all people, they speak
 At once to the learn'd and the rude,
To barbarian and Scythian, the Jew and the Greek,
 Nor country nor person exclude.

From the man who goes forth to his labour by day,
 To the woman his help-meet at home ;
From the child that delights in his infantine play,
 To the old on the brink of the tomb ;
From the bridal companions, the youth and the maid,
 To the train on the death-pomp that wait ;
From the rich in fine linen and purple array'd,
 To the beggar that lies at his gate :

To all is the ensign of blessedness shown,
 To the dwellers in vale or on hill,'
Alike to the monarch who sits on his throne,
 And the bond-man who toils at the mill :
High and low, rich and poor, young and old, one and all,
 Earth's sojourners, dead and alive,
Who perish'd by Adam our forefather's fall,
 Shall in Jesus the Saviour revive.

Not an ear, that those tidings of welfare can meet,
 But to *it* doth that welfare belong :
Then those tidings with rapture what ear shall not greet,
 What tongue shall not echo the song ?
All hail to the Saviour ! all hail to the Lord !
 God and man in one person combined !
The Father's Anointed ! by Angels adored !
 The Hope and Delight of mankind † !

* Hebrews vi. 19, 20. † Christmas Carols.

CHAPTER XXXIII.

YET once I was blind, and could not see the light,
And straight to Jeru-*salem* I then took my flight;
They led me through a wilderness, with a multitude of care,
You may know me by the system, or badge I wear.

Twelve dazzling lights I saw, which did me surprise;
I stood in amaze where I heard a great noise;
A *serpent* came by me,—I fell unto the ground,
With joy, peace, and comfort the *secret* I found *.

THE *principle* of all mysteries having been already elucidated, it only remains, that, in this concluding chapter, I point out a few more instances of their practical application.

In the Gospel, then, according to St. Matthew, I find the words, " *O generation of vipers*, who hath warned you to flee from the wrath to come† ?"—And in that according to St. John, the following, " We be not *born* of *fornication;* we have one Father, even God‡."

The juxtaposition of these texts, one with another, and the comparison of them, mutually, with the explication of the *serpent*, given at page 229, will not only confirm the *truth* of all the foregoing developments, but satisfy you farther, what I am very certain you did not before identify, *viz.*, that the phrases *generation of vipers*, and the being *born of fornication*, are one and the same—the *viper*, or *serpent*,

* Freemasons' song.
† Matthew iii. 7. ‡ John vii. 41.

being the symbol of *lustfulness*, making the former equivalent to *ye offspring of concupiscence ;* that is, in other words, ye *born of fornication* *! And the very stress laid upon this mode of *geniture*, implies not only the *possibility* of a different sort, but its *frequency*, also!

" In the Purana prophecies concerning the expected Saviour," say the Asiatic Researches, " it is said, that he was the son, or rather the incarnation, of the great serpent : and his mother was also of that tribe, and incarnate in the house of a pot-maker. She conceived at the age of one year and a half, the great serpent gliding over her while she was asleep in the cradle : and his mother, accordingly, is represented as saying to the child, once that she brought him to a place full of serpents—' Go, and play with them, *they are your relations.*' "

Here it will be seen that, under the form of a serpent, is personified the *Deity*, or the *generative power*.

Nunez de la Vega, Bishop of Chiapa, in Mexico, when describing Nagualism, in his " Constitutions," as observed in that country, says, " The Nagualists practise it by superstitious calendars, wherein are inserted the proper names of all the Naguals, of stars, the elements, birds, beasts, fishes, and reptiles ; with observations upon the months and days; in order that the children, as soon as they are born, may be dedicated to that which, in the calendar, corresponds with the day of their birth : this is preceded by some frantic ceremonies, and the express consent of parents, which is an explicit part between the infants and the Naguals that are to be given to

* See page 229.

them. They then appoint the *melpa*, or place, where, after the completion of seven years, they are brought into the presence of the Nagual to ratify the engagement; for this purpose they make them renounce God and his blessed Mother, instructing them beforehand not to be alarmed, or sign themselves with the cross: they are afterwards to embrace the Nagual affectionately, which, by *some diabolical art or another, appears very tame, and fondly attached to them, although it may be a beast of a ferocious nature, as a lion, a tiger,* &c. They persuade the children, by their *infernal cunning,* that this Nagual is *an angel, sent by God* to watch over their fortunes, to protect, assist, and accompany them; and that it must be invoked upon all occasions, business, or occurrences, in which they may require its aid!"

It is very clear, that the *Nagualism* above notified, is but a degenerate offshoot of that *serpent* worship, which is co-eval with the *fall:* yet, degenerate as it is, it is equally indisputable, that this good man's zeal outsteps far his judgment, the exaggerations of his fancy even committing him so far, as to make him imperceptibly contradict himself!

Surely, were it a principle of action with those unfortunate beings to make their children, on their entrance upon active life, to *renounce God,* they would not teach them, at the same time, to *reverence* a brute creature, merely as being a *subordinate servant of that God!*

To reconcile the Bishop, therefore, to something like truth, I will suppose him to mean by the word *God,* where it first occurs, *Christ,* which is evident from the context, of "his blessed Mother:" and then the prohibition against the sign of "the cross," must

be understood, exclusively, as in reference to *him ;* a
conclusion which is confirmed by an additional refer-
ence to that *oath,* which I have before mentioned, as
still prevalent amongst the Irish.

By the cross is the oath, accompanied by a trans-
verse location of the fore-finger of one hand upon
that of the other : and the addition alluded to is
of Christ: which is never volunteered except when
equivocation is suspected ; and then it is exacted as
a matter of *distinction* between *his* cross and the *more
antecedent* one !

But no further proof is requisite, to prove the
Bishop's want of candour, than his *withholding* docu-
ments from the public eye, which would appear to
illustrate the subject.—" Although in these tracts and
papers there are," says he, " many other things
touching primitive paganism, they are not mentioned
in this epitome, lest in being brought into notice,
they should be the means of confirming more strongly
an idolatrous superstition." He should have had
more confidence in his own cause, and feel that—" If
anything, in consequence of this scrutiny, totter and
fall, it can only be the *error* which has attached itself
to truth, encumbering and deforming it. *Truth* itself
will remain *unshaken, unsullied, fair, immortal !*"

Now, in the description of the ancient city, near
Palenque, quoted before, I find some words, which
prove an affinity between the worship of the ancient
inhabitants of America and those of Ireland, and
which rescue both from the imputations of bigotry.
" I am *Culebra,*" says *Votan,* one of the early princes,
I believe, of Mexico, who wrote an historical tract in
the Indian idiom, " because I am Chivim."

The man's name, you perceive, was *Votan,* but his

ambition was to be considered *Culebra,* or the *snake,*
that is, the deity so personified : the mode whereby
he sought to establish it is foreign from my inquiry.

The *Gadelglas* of the ancient Irish was precisely
similar to this *Culebra* of the Americans : *gad* signifying
a snake, or tortuosity : *el,* god ; and *glas,* green—in all,
the *green snake-god!* And conformably with this
import, we are assured by a man, who knew very
little as to the *reason why,* but whose testimony is
here valuable in a matter of *record,* not of *opinion ;*
viz., that the " Milesians, from the time they first con-
quered Ireland, down to the reign of Ollamh Fodhla,
made use of no other *arms of distinction in their ban-
ners* than a *serpent twisted round a rod,* after the ex-
ample of their Gadelian ancestors *."

You have now the *proof* of " *who put the snakes*
upon our *ancient crosses ?"* And, independently of
such proof, the antiquity itself of all the traditions
associating the *serpent* with the early memoirs of our
ancestors was so great, as to appal even the *monks !*
And as they could not, in their system of *transferring*
our history, *bring down* this serpent to the era of the
saints, they resolved, at all events, to have him in
their dispensation, and so made *Moses* the hero !

This they contrived by inventing the name of
Gadel for one of our forefathers, and then trans-
planting him to the coast of the Red Sea, just as the
Legislator of the Jews was conducting them out of
Egypt ! They then very unsacerdotally make a ser-
pent bite him, in some part of the heel, but very gra-
ciously afterwards restore him to sanity by Moses's
interposition ! with a stipulation, however, that the

* Keating's History of Ireland, 'folio, p. 143.

former *sore* should ever appear *glass* or *green!* And thus was he called *Gadelglas,* or *Gadel the Green!!!*

In truth, it was from this *green* snake-god, above explained, that the island obtained the designation of *Emerald;* and not from the *verdure* of its soil, which is not greater than that of other countries.

The Arabians have a tradition, that Enoch was the first who, after Enos, son of Seth, son of Adam, wrote with a pen, in the use of which he instructed his children, saying to them additionally, " O, my sons, know that ye are *Sabians!*"

Although the substance of the *religion,* couched under this designation, has been already explained, yet the origin of the name itself remains yet to be unfolded.

Then be it known, that in the *sacred,* i. e., *Irish* language, the word *Sabh* * has three significations— firstly, *voluptuousness,* or the *yoni;* secondly, a *snake,* or sinuosity; and thirdly, *death,* or life! And in accordance with this triple import, if you roll back the leaves as far as page 229, you will find in the plate inserted there, and which has been transcribed from the sculptures of the ancient Palencian city before alluded to, those three symbols, viz., the *yoni,* the *serpent,* and *death,* all united in design, and illustrating my development of that mysterious scene wherein—

" Eve *tempting* Adam by a *serpent* was stung †."

The sculpture itself is intended to portray the

* Pronounced *Sauv.* This was the Seva of the Hindoos, by which, although they understood, indeed, as well *generation* as *destruction* to be symbolised; yet, is it clear that they must have long lost the method of accounting for the *reason why,* otherwise than saying, that *death* and *life* meant the same thing ; that is, that the cessation of existence in one form was but the commencement of existence in another.

† Freemasons' song.

situation of those progenitors of the human species in
the Garden of Eden. And yet, striking as it is,
would its tendency remain ever a *secret*, were it not
for the instrumentality of the *Irish* language!

" That the society of free and accepted Masons
possess a grand *secret* among themselves is an un-
doubted fact. What this grand secret is, or of what
unknown materials it consists, mankind in general,
not dignified with the order, have made the most
ridiculous suppositions. The ignorant form inco-
herencies, such as conferring with the devil, and
many other contemptible surmises, too tedious to
mention, and too dull to laugh at. While the better
sort, and more polished part of mankind, puzzle them-
selves with reflections more refined, though equally
absurd. To dispel the opinionative mist from the eye
of general error is the author's intention; and however
rash the step may be thought, that he, a mere atom
in the grand system, should attempt so difficult, so
nice a task, yet he flatters himself that he shall not
only get clear over it, but meet with the united
plaudits both of the public and of his brethren. And
he must beg leave to whisper to the ignorant, as well
as the judicious, who thus unwarrantably give their
judgment, that the truth of this grand secret is as
delicately nice as the element of air; though the phe-
nomenon continually surrounds us, yet human sensa-
tion can never feelingly touch it, till constituted to
the impression by the masonic art. The *principal*,
similar to the orb of light, universally warms and
enlightens the *principles*, the first of which, virtue,
like the moon, is heavenly chaste, attended by ten
thousand star-bright qualifications. The masonic
system is perfectly the emblem of the astronomic;

it springs from the same God, partakes of the same originality, still flourishes in immortal youth, and but with nature will expire *."

The *contortions* of the snake were easily transferred to the revolutions of the heavenly bodies. " When the ancients," says Boulanger, " found out the true cycle of the sun, they coined names by a *jeu de mots*, or words, signifying its heat, or its course, that made up the number 365, as they had done before to make up 360. The name Sabasins, that has so much perplexed antiqnaries and etymologists, is no more than a *numerical name*, which was given to Jupiter and to Bacchus as *periodical* deities. When the suppliant was initiated into the mysteries of Sabasins, a *serpent*, the symbol of revolution, was thrown upon his breast. To ΣABOE, which the Greeks repeated so often in the feasts of Bacchus *without understanding the meaning of the words,* meant no more than the cycle of the year, from the Chaldean *Sabb circuire, vertere,* &c. The ancient religion, which applied entirely to the motions of the heavens and *periodical return* of the stars, was for that reason named *Sabianism,* all derived from the Chaldee *Seba,* a *revolution;*" and this, though Boulanger knew it not, from the Irish Sabh, *serpent,* or *pith.*

Sabaism, therefore, and Ophiolatreia were all one with Gadelianism; and while, apparently, purporting to be the worship of the *serpent* and the *stars*, were, in reality the worship of the *Sabh* or *Yoni*—so that the dialogue, in Genesis, between Eve and the *serpent,* was, in truth, a parley between Eve and the *Yoni :* and the materials for the allegory were afforded by the

* Ashe's Masonic Manual.

fact of *serpent* and *yoni* being both expressed in the
sacred, *i. e.*, Irish language, by one and the same name,
just as the Lingam and the Tree of Knowledge have
been before identified.

The mystery, then, of our ancient escutcheon, viz.,
a *serpent* twisted *round a rod*, resolves itself into the
Yoni embracing the *Lingam.*

Hence, too, it was that the portals of all the Egyp-
tian temples were decorated with the impress of the
circle and the serpent. You see also, why the *seasons*,
at the equinoxes and solstices should have been
marked upon the circle at page 225; and you further
see the mysterious tendency of the Prophet's injunc-
tion to his children, when he said, " Remember that
ye are *Sabians*," to have been equivalent with—Keep
constantly in view, that you are the offspring of *con-
cupiscence*, and, by the suggestion of the *serpent*,
begotten in *sin*, the penalty of which, as a breach of
the Creator's commandments, is inevitable *death*,
from which you are only extricated through the pro-
mised Redeemer, emanating from the same source
which was before instrumental in entailing your
sorrow !

Every syllable of this is hieroglyphically expressed
upon the plate inserted at page 223, where you
observe the *cockatrice*, or snake-god, placed at the
bottom; over him the *crescent*, or mysterious *boot*,
i. e., yoni, the object seduced ; and, finally, the *cross*
in triumph over both, intimating emancipation by the
vicarious passion of God's own Son.

This then is my answer to V. W.'s question,
at page 225, where he asks, " What relation had this
with the Nehustan, or brazen serpent, to which the
Israelites paid divine honours in the time of Heze-
kiah ?"

From this *Sabaism*, or *serpent worship*, Ireland obtained the name of *Tibholas*, or *Tivolas ;* S and T being commutable letters, *Tibholas* is the same as *Sibholas*, and this being derived from *sibal*, a circle, shows the name to have been equivalent with the *land of circles, or revolutions*, otherwise, both to the serpent and the planets.

Those prophetic women of Etruria, designated *Sybils*, were named from the same cause, being priestesses of the *serpent,* i. e., the *Sabh,* or *Yoni*— allegorically represented as married to Apollo, and gifted with a longevity of a thousand years. Here again the same conversion of letters occurred, for the place which *they* inhabited was ca lled from themselves, *Tivola*, corresponding to our Tivolas, the S and T being, as before explained, commutable, and *b* or *bh* being equivalent to *v*.

Pythia is exactly synonymous with *Sybil*, meaning the priestess who presided over the *Pith*, which, like Sabhus, means as well *serpent* as *yoni:* and the oracle which she attended was called *Delphi*, from *de*, divine, and *phith*, yoni—it being but a *cave* in the shape of that symbol*, over the orifice of which the priestess used to take her seat upon a sacred *tripod*, or the religiously emblematic pyramid †, while the inspiring vapour issued from beneath through a tube, similar to that exhibited at page 460, and one end of which passing through the aperture, held fast the tripod, to which the priestess had been secured, so that she should not, in her delirium, relinquish the position.

The great Samian philosopher, known as Pyth-

* See page 282, note. † See page 268.

agoras, only assumed this name in deference to those rites: for *Pyth-agoras* means one who *expounds* the mysteries of the *pith*—viz., *death* from its weakness, and *redemption* from its virtue.

" Behold a virgin shall conceive and bear a son, and shall call his name Immanuel *," was the spiritual substance of those *expositions:* the only difference being in that *Isaiah* spoke prospectively towards a lately verified issue, whereas the *initiated* took the promise from the moment of the *fall:* and of its *partial* accomplishment prior to our era, there can be no doubt, even from the writings of this prophet.

On the opposite plate are three profile likenesses of Christ, as he appeared upon earth in human form—the first is a fac-simile from a *brass* medal, found at Brein Owyn, in the Isle of Anglesey, and published in Rowland's " Mona Antiqua." The inscription upon it has been translated, as meaning, " Jesus the Mighty, this is the Christ and the man together."

The second, likewise of brass, and found at Friar's Walk, near Cork, is now in the possession of a Mr. Corlett. — Inscription upon one side, " The Lord Jesus."—Upon the other, " Christ the King came in *peace,* and the light from the heaven was made life."

You will please observe here, that he does not say the *word* was made life, but the *light* was made life.

The third is of silver, and the inscription means, " Jesus of Nazareth, the Christ—the Lord and the Man together."

The originals of these inscriptions are all in

* Isaiah vii. 14.

Hebrew, and the likenesses which accompany them, although on different metals, appear almost copies one of another: whereas the cruciform figures herein already inserted, have no one feature of correspondence whatsoever with them, but prove themselves, on the contrary, in every particular, an antecedent generation .

—As everything else appertaining to the history of the Round Towers has already been explained, I

* " The countenance of Christ was placid, handsome, and ruddy, so formed, however, as to inspire the beholders, not so much with love and reverence as with terror; his locks were like the colour of a full ripe filbert nut (auburn), straight, and entire down to the ears, from thence somewhat curled down to the shoulders, but parted on the crown of the head after the manner of the Nazarites; his forehead was smooth and shining, his eyes blue and sparkling, his nose and mouth decorous, and absolutely faultless, his beard, in colour like his locks, was forked, and not long."—WASERUS, page 63.

" At this time appeared a man, who is still living, a man endowed with great power, his name Jesus Christ. The people say that he is a mighty prophet; his disciples call him the Son of God. He quickens the dead, and heals the sick of all manner of diseases and disorders. He is a man of tall stature, well proportioned, and the aspect of his countenance engaging, with serenity, and full of expression, so as to induce the beholders to love and then to fear him. The locks of his hair are of the colour of a vine-leaf, without curl, and straight to the bottom of his ears, but from thence, down to his shoulders, curled and glossy, and hanging below his shoulders. His hair on the crown of the head disposed after the manner of the Nazarites. His forehead smooth and fair. His face without spot, and adorned with a certain tempered ruddiness. His aspect ingenuous and agreeable. His nose and his mouth in no wise reprehensible. His beard thick and forked, of the same colour as the locks of his head. His eyes blue and extremely bright. In reprehending and reproving, awful; in teaching and exhorting, courteous and engaging; a wonderful grace and gravity of countenance; none saw him laugh, even once, but rather weep. In speaking, accurate and impressive, but sparing of speech. In countenance, the fairest among the children of men."—(Attributed to Lentulus, predecessor of Pilate in the government of Judea, recorded by Fabricius in his " Codex Apocryphus Novi Testamenti.")

shall now account for the difference of appropriation noticed at page 6. Having been all erected in honour of the *Budh,* they all partook of the Phallic form; but as several enthusiasts personified this abstract, which, in consequence of the *mysteries* involved in the thought and the impenetrable veil which shrouded it from the vulgar, became synonymous with *wisdom* or *wise man,* it was necessary, of course, that the Towers constructed in honour of each should portray the distinctive attributes of the individuals specified. Hence the difference of apertures towards the præputial apex, the crucifixions over the doors, and the absence or presence of internal compartments *.

Those venerable piles vary in their elevation from fifty to one hundred and fifty feet. At some distance from the summit there springs out a sort of covering, which, accompanied as it sometimes is with a cornice, richly sculptured in foliage, in imitation, if you must have it, *præputii humani,* but such also was the pattern of the " nets of checker-work and wreaths of chain-work," which graced " the chapiters which were upon the top of the two pillars belonging to Solomon's temple"—terminates above in a sort of sugar-loaf crown, concave on the inside and convex on the outside.

Their diameter at the base is generally about four-

* The principal one I conceive to have been at the hill of *Tara,* which means the hill of the *Saviour,* and synonymous with mount *Ida,* which means the mount of the cross.—See page 453.

" The predominant style and character of the Pillar Tower," says Montmorency, " in a great measure discloses the *secret* of its origin." It is astonishing how, after this, he and his pupils of the academy should labour to assimilate that secret to a dungeon.

" L'obélisque que les Phéniciens dédierent au Soleil dont le *sommet sphérique* et la matière étoient fort différens des obélisques d'Egypte."— AMMIAN. MARCEL.

teen feet through, that inside measuring about eight, which decreases gradually, but imperceptibly, to the top, where it may be considered as about six feet in the interior.

The distance of the door from the level of the ground varies from four to twenty-four feet. The higher the door the more irrefragable is the evidence of the appropriation of the structure to the purposes specified. The object was two-fold, at once to keep off profane curiosity and allow the votaries the undisturbed exercise of their *devotions ;* and to save the *relics* deposited underneath from the irreverent gaze of the casual itinerant.

Analogous to these would appear to have been the edifices which the Lord had in view when he said, " Neither shalt thou go up by steps unto mine altar, that thy nakedness be not discovered thereon*," which additionally proves the antiquity of the Irish *philebeg ;* for, as with any other costume, such a prohibition would be needless, it follows that the prevailing fashion, in the eastern habiliments, must have been diffuse and open in the nether extremes.

I beg the reader will now be pleased to look back at the Tuath-de-danaan cross at page 358, and he

* Exodus xx. 26.—The word *altar* does not mean what it is generally taken to express, a *platform,* but a *high place,* or standing column, what the Septuagint renders by the Greek word στηλη, a pillar. And this was what the Israelites were forbid erecting to Jehovah, lest that their nakedness should be discovered while ascending by steps or ladders to the entrance overhead.

The Gaurs have *round towers* erected of stone, and thither they carry their dead on biers ; within the tower is a staircase with deep steps made in a winding form, and when the bearers are got within, the priests scale the walls by the help of ladders ; when they have dragged the corpse gently up with ropes, they then let it slide down the staircase.—Dr. Hurd's *Rites and Ceremonies, &c.*

will at once see how it happened that the *Goban Saer,* who is there represented, has been imposed upon the Royal Irish Academy, or rather promulgated by them, as a *woman!* viz., from the peculiarity of his *dress!* being the distinctive badge of his sacerdotal order.

Nor is it only the character of those sculptures, but the existence of any sculptures upon those relics, as well crosses as towers, that proves them to have been Tuath-de-danaan; for the reason why Jehovah forbade the Israelites from using any *tools* upon the stones used in their religious edifices, was, that other nations had loaded theirs with sculptured images of different gods, which made Him say, " If thou wilt make me an altar of stone, thou shalt not build it of *hewn* stone, for if thou *lift up thy tool upon it,* thou hast polluted it."

In their masonic construction there is nothing in the Irish Towers appertaining to any of the four orders of architecture prescribed by the moderns. It is so also with those in the East. They approach nearest, however, to the Tuscan, and the reason of that similarity may be imagined from what I have already stated as to the Etrurians.

Prepared stone is the material of which they are generally composed, and evidently, in some instances, brought from afar. Sometimes also they appear constructed of an *artificial* substance, resembling a reddish brick, squared, and corresponding to the composition of the Round Towers of Mazunderan. Now if the monks possessed this secret, why were not the monasteries, the more important edifices, according to our would-be antiquarians, composed of the same elements? And is it not strange that all *elegance* and *extravagance* should have been lavished upon the

appendages, while *uncouthness, inelegance,* want of du-
rability, or other architectural recommendation are
the characteristics of what they tell us were the prin-
cipals.? Yet neither in the monasteries, nor in any
other Christian building, do we meet with those ma-
terials above described, either *generally* or *partially,*
except where the ruins of a neighbouring Round
Tower have made them available, which, in itself, is
sufficient to overthrow, for ever, the anachronisms of
those who would deny the existence of those temples
anterior to the present era.

But Christian edifices, they say, are generally
found in their vicinity. Yes, and as I have already
explained the reason why *, I forbear now rehearsing
the fact. But even *this stronghold* of the *moderns* I
cut away from them, by stating that at the " Giant's
Ring," in the county Down, the indisputable scene of
primordial veneration, we have an instance of a Round
Tower, *without any church hard by !* And while re-
called by this circumstance, I must observe that the
vitrification manifest within the walls of that struc-
ture, arose from the *burning of the dead bodies* therein,
and not from the indications of the *sacred fire.*

With three exceptions, all have a row of apertures
towards the top, just under the projecting roof, made
completely after the fashion of those which Solomon
had built, being windows of narrow lights †. In
general the number is four, and then they correspond
to the cardinal points. In three instances there is
one aperture towards the summit, in one instance
there occurs five, in one six, in one seven, in one
eight.

Inside they are perfectly empty from the door

* See pages 7 and 8. † 1 Kings vi. 4.

upwards, but most of them divided, either by *rests* or *projecting* stones, into lofts or stories, varying in number from three to eight. In the temple of Solomon we find the same, for " within, in the wall of the house, he made narrowed *rests round about,* that the beams should not be fastened in the walls of the house *." And the images which I have shown to have been cupboarded upon these rests, were nothing more than what Solomon himself did, when " he carved all the walls of the house *round about* with carved figures of cherubims, and palm-trees, and open flowers, within and without †."

In a future publication I intend to show a more startling correspondence between our Round Towers and some other parts of Solomon's temple. Meanwhile I wish it to be borne in mind,—as in some degree accounting for the correspondence—that Solomon's architect was a Sidonian.

A striking perfection observable in their construction is the inimitable perpendicular invariably maintained. No architect of the present day, I venture to affirm, could observe such regularity. Nelson's pillar itself has been proved to vary somewhat from the perpendicular line ; but the keenest eye cannot trace a deviation, in a single instance, from amongst the whole of those Sabian monuments. Even the tower of Kilmacdugh, one of the largest in the kingdom, having from some accident, earthquake, or other cause, been forced to lean terrifically to one side ; yet, miraculous to mention, retains its stability as firm as before : such was the accuracy of its original elevation ‡.

* 1 Kings vi. 6. † 1 Kings vi. 29.

‡ The Tower of Pisa bears no comparison to this edifice.

If asked how it was I conceive them to have been constructed? I should answer, by a scaffolding raised gradually from within. The expense in this case would be infinitely less, and the labour also. It would be very easy to let fall a plumb-line at various intervals of height, by which at all times the perpendicular may be ascertained, and the masonry carried on by, what may be called, overhanding, while the cement employed in giving solidity to the whole, and which is the direct counterpart of the Indian chunan, bids defiance to the efforts of man to dissever, except by the exertion of extraordinary power.

That this was the mode in which their erection was effected, is evident in the instance of Devenish Tower, which, from the elegance of its cut-stone exterior, would seem to negative the idea of their being built from within. But a judicious eye cannot but at once discern that near the top, where it is probable that one or two of the artists may have come out, by the help of some contrivance devised for the purpose, the execution and finish which the workmanship displays, is incomparably superior to that of any of the lower parts. In other instances, where the ancient top having been removed, a modern one has been substituted, the case is very different indeed.

The cohesiveness of all these columns will be best estimated by the fact of the Round Tower at Clondalkin having firmly stood its ground when, in the year 1786-7, the powder-mill explosion, which took place within twenty-four feet of its base, shivered to annihilation every other structure within its influence; nay, extended its violence so far as to shatter the windows in some of the streets of Dublin. That at Maghera also lay unbroken after its fall, exhibiting

to the spectator the almost appalling spectacle of a gigantic cannon!

That both Indians and Irish performed circular *dances* around them, typical of the motions of the heavenly bodies, is highly probable, as we have still the name of a particular movement, apparently that practised on the occasion, still amongst us in common use, viz., *Rinke-teumpoil*, or the temple dance : and that they otherwise honoured them by performing *penances* around them, is evident from the name of *Turrish*, which means a *religious circuit round a tower!* applied afterwards by the Catholics to any penitential *round.* And we have the authority of Sanchoniathon, when talking of the creation, for stating that " the next race consecrated *pillars*—that they *prostrated themselves before them*, and made annual libations to them *!"

These, I conceive, were the halcyon days of Ireland's legendary and romantic greatness. In this sequestered isle, aloof from the tumults of a bustling world, this Tuath-de-danaan colony, all of a religious race, and all disposed to the pursuits of literature, united into a circle of international love, and spread the fame of their sanctity throughout the remotest regions of the universe. That its locality was familiar to the Brahmins of India I make no earthly question — that it was that sacred island which they eulogised so fondly, and spoke of with such raptures, I am sanguinely satisfied—and equally

* The holy wells also, with the practice of hanging pieces of cloth upon the branches of an overhanging tree, all belonged to the Tuath-de-danaan ceremonial. The early Christians took possession each of them of one of these wells, and are now, by prescription, recognised as their patron saints, and even supposed to have been their founders !

convinced am I, that it was that beatifying region, whose wide-spread holiness, and far-famed renown, made such an impression on the minds of Orpheus and of Pindar, when those divine bards, speaking of its Hyperborean inhabitants, thus enchantingly sung—

" On sweet and fragrant herbs they feed, amid verdant and grassy pastures, and drink ambrosial dew, divine potation : all resplendent alike in coeval youth; a placid serenity for ever smiles on their brows and lightens in their eyes; the consequence of a just temperament of mind and disposition, both in the parents and in the sons, inclining them to do what is great, and to speak what is wise. Neither disease nor wasting old age infest this holy people, but without labour, without war, they continue to live happy, and to escape the vengeance of the cruel Nemesis *."

Though clothed in the cadence of measured phraseology, and decked in the charms of an imaginative style, this is scarcely more beautiful than the simple summary of the Tuath-de-danaan moral code, as given you at page 112, and of which, in truth, this is but the paraphrase. For instance, they fed, it is stated, " on sweet and fragrant herbs," because they were prevented by their first commandment from eating " anything endowed with life †." They drank " ambrosial dew," because their fifth commandment forbade their touching " any intoxicating liquor." And

* Μοῖσα δ' οἰκ ἀποδαμεῖ τρόποις ἰπι σφιτέροσι, παντα δι χροὶ παρθίνων λυρᾶν τι Βοαὶ καναχαί τ' αυλων δονιογται δαφνᾳ τι χρυτια κομος αναδησαντις ειλακινα ξοινιν ἰν ῃρονως. νοσοι δ'οντι γηρας ουλομενον κίκρατα ἱρᾶ γινιᾶ· πονιν δι καὶ μαχᾶν ἅτιρ οικιοισι φυγοντις υπιρδικον Νίμισιν.—Pyth. x. 59,

† Even among the vegetables, they abstained from beans, as did the Pythagoreans after them, ob similitudinem virilibus genitalibus.

the healthful aspects they exhibited were but the
natural result of temperate habits and virtuous de-
meanour.

> " The simplest flow'ret of the vale,
> The simplest note that swells the gale,
> The common air, the earth, the skies,
> To them were opening Paradise !

Five hundred years after the period of their
dethronement, while the influence of their example
still continued to operate, we are told by the Dinn
Seanchas, that " The people deemed each other's
voices sweeter than the warblings of a melodious
harp, such peace and concord reigned amongst them,
that no music could delight them more than the sound
of each other's voices."

With these compare what Cambrensis, who was no
friend, has said of this island, about two thousand
years after. " Of all climes," says he, " Ireland is
the most temperate ; neither Cancer's violent heat is
felt there in summer, nor Capricorn's cold in winter ;
but in these particulars it is so blessed, that it seems
as if Nature looked upon this zephyric realm with its
most benignant eye. It is so temperate," he adds,
"that neither infectious fogs, nor pestilential winds, are
felt there, so that the aid of doctors is seldom looked
for, and sickness rarely appears except among the
dying."

The repose of this happy people being at length
disturbed by the ungenial inundation of the Scythian
intruders, the ritual of the temple worship was pre-
cipitated apace ; and this, if I mistake not, " satis-
factorily removes the uncertainty in which the origin
and uses of those ancient buildings has been hereto-

fore involved *." For the Scythians being warriors †
rather than students, and looking with distrust upon
the emblematic images of their temple-serving prede-
cessors, which they considered to be idolatry, did all
in their power by legislative, as well as military
enactments, to efface every trace thereof; so that
in a few years the temple, or tower, worship be-
came utterly extinct, and—more than annihilated—
forgotten.

Instead thereof, they substituted the worship of
fire ‡, which, though their predecessors were far from
recognising as a deity, yet they always showed to it
some reverential respect: and this approximation of
sentiment, on both parts, contributed to, what may be
called, a passive reconciliation : the victors assuming
the mastery of the soil; and the vanquished, in
deference to their high literary repute, being conti-
nued as superintendents of the national education, as
well as the practical followers of all trades and pro-
fessions.

It was so also at Rome, when Romulus dislodged
the Pelasgi, who, we are told by Festus, had them-
selves some time previously, under the name of
" Sacrani," that is, the religious caste, corresponding

* See conditions of advertisement in Preface.

† " You may read in Lucian, in that sweet dialogue, which is entitled
' Toxaris; or, of Friendship,' that the common oath of the Scythians
was by the *sword*, and by the *fire*, for that they accounted those two
speciall divine powers, which should worke vengeance on the perjurers.
So doe the Irish at this day, when they goe to battaile, say certaine
prayers or charmes to their swords, making a crosse therewith upon the
earth, and thrusting the points of their blades into the ground, thinking
thereby to have the better successe here in fight. Also they use com-
monly to swear by their swords."—SPENSER.

‡ See pages 81, 82.

to " Irish," which signifies the same thing, drove the
Ligures and Siculi from Septimontio, *i. e.*, Rome.

The only use now made of those Sabian edifices,
after stifling the religion for which they were de-
signed, was, we may suppose, to promote the study
of astronomical science, for which they were admi-
rably adapted, and with which their *original* destina-
tion was inseparably interwoven *. But as the sti-
mulus of religion was wanting for the prosecution of
those researches, we cannot be surprised that *this*
part of their purpose too, sharing the fate of its col-
lateral helpmate, insensibly repined under the altered
aspect of the scene ; for, to apply to it what has been
said of the great scheme of the creation itself, *viz.*,
that—

> ————" if each system in gradation roll
> Alike essential to the amazing whole,
> The least confusion—but in one—not all,
> That system only, but the whole must fall."

The knowledge of this delightful study, however,
did not yet completely die away; it formed still
an essential in the education of every Irish youth ;
and the remnant of our language, at this very mo-
ment, shows how piously attentive were its framers
to that divine precept which told them, that the
" lights of the firmament of heaven were for signs
and for seasons, and for days and for years."

The profligate degeneracy of the Druids, however,
tended to bring *this* also into disesteem.

This order of priests got so overbearing here,
grasping at not only high ecclesiastical power, but

* They were *afterwards* degraded to every possible purpose they could
be made to subserve ; but I speak above of the time *immediately* after
their overthrow.

also intermeddling in secular transactions, that they made themselves obnoxious to the great body of the people, and a disregard both to the literature and the religion which they inculcated was the inevitable result. To this I ascribe the plebeian war of Ireland, A.D. 47, that deplorable state of a country, when faction and rage usurp the place of counsel and discretion! when commerce stagnates! confidence decays! when lust stalks abroad to desecrate everything holy! and all is doubt, suspicion, melancholy, and death!

How beautifully and how aptly, but yet, for himself, how unwisely, did the philosophic Callisthenes apply the sentiment of Euripedes to Philip of Macedon, at Alexander's Feast?—viz.,

> When civil broils declining states surprise,
> There the worst men to highest honours rise.

Many virtuous persons, we are told, opposed themselves to the encroachments of this degenerate hierarchy. When Conlah, in his retreat from the glitter of life, betook himself to an humble cottage, and devoted the faculties of his comprehensive mind to philosophical pursuits and the improvement of his species, the greatest praise which the annalist, in recording such worth, could bestow, was, "She do rinni an choin bhliocht-ris inna Druwdh;" that is, It is he that disputed against the Druids!

The Books, however, of their predecessors, the Boreades, still remained, and the knowledge of astronomy was kept alive by their perusal. But of these we were despoiled, very shortly after, by that mistaken piety elsewhere deplored. Some few treatises even then must have escaped, and their effect was

best illustrated, as shown before, by the unprecedented success with which the Gospel dispensation was hailed in this island.

I have before shown the instance of Fergil or Virgil, who, in the eighth century, maintained the rotund and true form of the earth, when the rest of Europe were ignorant on the subject. " He was," says Sir James Ware, " the author of a Discourse on the Antipodes, which he most truly held, though against the received opinion of the ancients, who imagined the earth to be a plain."

In this sweeping ban upon the ancients, however, Sir James must not include the ancient Irish, whose hereditary doctrine upon the subject it is evident that Fergil did here only give utterance to; and dearly did he suffer for it; his life, like that of Galileo, having been forfeited thereby, at the hands of the same enlightened tribunal. This was enough to put the *last* extinguisher upon the cultivation, or at least avowal, of the Irish notions of astronomy. It is astonishing, notwithstanding, what an instinctive thirst still lurked in the Irish mind for the sublimities of this pursuit *.

* " I had not been a week landed in Ireland from Gibraltar, where I had studied Hebrew and Chaldaic, under Jews of various countries and denominations, when I heard a peasant girl say to a boor standing by her, *Féach an maddin nag*, (Behold the morning star,) pointing to the planet Venus, the *maddina nag* of the Chaldean. Shortly after, being benighted with a party in the mountains of the western parts of the county of Cork, we lost the path, when an aged cottager undertook to be our guide. It was a fine starry night. In our way, the peasant pointing to the constellation *Orion*, he said that was *Caomai*, or the armed king; and he described the three upright stars to be his spear or sceptre, and the three horizontal stars, he said, were his sword-belt. I could not doubt of this being the *Cimah* of Job, which the learned Costard asserts to be the constellation *Orion*."—VALLANCEY.

Smith mentions an instance of a "poor man near Blackstones, in the county Kerry, who had a tolerable notion of calculating the epacts, golden number, dominical letter, the moon's phases, and even eclipses, although he had never been taught to read English." The author of this Essay has known many such characters;—one in particular who, from his great proficiency in the art, had obtained for himself the honourable designation of the *Kerry Star*.

ERRORS AND OMISSIONS.

Page 28, Fourteen lines from bottom, insert "the fourth century of" between the words "before" and "the Christian light."

90, Three lines from bottom, instead of "Wells'' read "Kells."

106, End of note ‡, instead of "and meaning sprung from" read "O'meaning sprung from."

207, Sixteen lines from top, insert "among" between the words "the persons," for Herodotus gives the credit there alluded to, to Melampus.

229, Eleven lines from top, instead of "its second" read "its first."

238, Nine lines from bottom, instead of "this day" read "Christmas day."

240, Eight lines from top, instead of "impregnable" read "impracticable."

252, Seven lines from top, instead of "inadvertently" read "inadvertedly."

297, Note ‡, erase "See Appendix."

406, Five lines from top, instead of "Tenan" read "Conan."

406, Four lines from bottom, instead "demonstrative" read "demonstrable."

418, Append the name "Mackenzie" after note †.

ATLANTIS REPRINT SERIES

ATLANTIS: MOTHER OF EMPIRES
Atlantis Reprint Series
by Robert Stacy-Judd
Robert Stacy-Judd's classic 1939 book on Atlantis is back in print in this large-format paperback edition. Stacy-Judd was a California architect and an expert on the Mayas and their relationship to Atlantis. He was an excellent artist and his work is lavishly illustrated. The eighteen comprehensive chapters in the book are: The Mayas and the Lost Atlantis; Conjectures and Opinions; The Atlantean Theory; Cro-Magnon Man; East is West; And West is East; The Mormons and the Mayas; Astrology in Two Hemispheres; The Language of Architecture; The American Indian; Pre-Panamanians and Pre-Incas; Columns and City Planning; Comparisons and Mayan Art; The Iberian Link; The Maya Tongue; Quetzalcoatl; Summing Up the Evidence; The Mayas in Yucatan.
340 PAGES. 8x11 PAPERBACK. ILLUSTRATED. INDEX. $19.95. CODE: AMOE

MYSTERIES OF ANCIENT SOUTH AMERICA
Atlantis Reprint Series
by Harold T. Wilkins

The reprint of Wilkins' classic book on the megaliths and mysteries of South America. This book predates Wilkin's book *Secret Cities of Old South America* published in 1952. *Mysteries of Ancient South America* was first published in 1947 and is considered a classic book of its kind. With diagrams, photos and maps, Wilkins digs into old manuscripts and books to bring us some truly amazing stories of South America: a bizarre subterranean tunnel system; lost cities in the remote border jungles of Brazil; legends of Atlantis in South America; cataclysmic changes that shaped South America; and other strange stories from one of the world's great researchers. Chapters include: Our Earth's Greatest Disaster, Dead Cities of Ancient Brazil, The Jungle Light that Shines by Itself, The Missionary Men in Black: Forerunners of the Great Catastrophe, The Sign of the Sun: The World's Oldest Alphabet, Sign-Posts to the Shadow of Atlantis, The Atlanean "Subterraneans" of the Incas, Tiahuanaco and the Giants, more.
236 PAGES. 6x9 PAPERBACK. ILLUSTRATED. INDEX. $14.95. CODE: MASA

SECRET CITIES OF OLD SOUTH AMERICA
Atlantis Reprint Series
by Harold T. Wilkins
The reprint of Wilkins' classic book, first published in 1952, claiming that South America was Atlantis. Chapters include Mysteries of a Lost World; Atlantis Unveiled; Red Riddles on the Rocks; South America's Amazons Existed!; The Mystery of El Dorado and Gran Payatiti—the Final Refuge of the Incas; Monstrous Beasts of the Unexplored Swamps & Wilds; Weird Denizens of Antediluvian Forests; New Light on Atlantis from the World's Oldest Book; The Mystery of Old Man Noah and the Arks; and more.
438 PAGES. 6x9 PAPERBACK. ILLUSTRATED. BIBLIOGRAPHY & INDEX. $16.95. CODE: SCOS

THE SHADOW OF ATLANTIS
The Echoes of Atlantean Civilization Tracked through Space & Time
by Colonel Alexander Braghine

First published in 1940, *The Shadow of Atlantis* is one of the great classics of Atlantis research. The book amasses a great deal of archaeological, anthropological, historical and scientific evidence in support of a lost continent in the Atlantic Ocean. Braghine covers such diverse topics as Egyptians in Central America, the myth of Quetzalcoatl, the Basque language and its connection with Atlantis, the connections with the ancient pyramids of Mexico, Egypt and Atlantis, the sudden demise of mammoths, legends of giants and much more. Braghine was a linguist and spends part of the book tracing ancient languages to Atlantis and studying little-known inscriptions in Brazil, deluge myths and the connections between ancient languages. Braghine takes us on a fascinating journey through space and time in search of the lost continent.
288 PAGES. 6x9 PAPERBACK. ILLUSTRATED. $16.95. CODE: SOA

RIDDLE OF THE PACIFIC
by John Macmillan Brown
Oxford scholar Brown's classic work on lost civilizations of the Pacific is now back in print! John Macmillan Brown was an historian and New Zealand's premier scientist when he wrote about the origins of the Maoris. After many years of travel throughout the Pacific studying the people and customs of the south seas islands, he wrote *Riddle of the Pacific* in 1924. The book is packed with rare turn-of-the-century illustrations. Don't miss Brown's classic study of Easter Island, ancient scripts, megalithic roads and cities, more. Brown was an early believer in a lost continent in the Pacific.
460 PAGES. 6x9 PAPERBACK. ILLUSTRATED. $16.95. CODE: ROP

THE HISTORY OF ATLANTIS
by Lewis Spence
Lewis Spence's classic book on Atlantis is now back in print! Spence was a Scottish historian (1874-1955) who is best known for his volumes on world mythology and his five Atlantis books. *The History of Atlantis* (1926) is considered his finest. Spence does his scholarly best in chapters on the Sources of Atlantean History, the Geography of Atlantis, the Races of Atlantis, the Kings of Atlantis, the Religion of Atlantis, the Colonies of Atlantis, more. Sixteen chapters in all.
240 PAGES. 6x9 PAPERBACK. ILLUSTRATED WITH MAPS, PHOTOS & DIAGRAMS. $16.95. CODE: HOA

ATLANTIS IN SPAIN
A Study of the Ancient Sun Kingdoms of Spain
by E.M. Whishaw
First published by Rider & Co. of London in 1928, this classic book is a study of the megaliths of Spain, ancient writing, cyclopean walls, sun worshipping empires, hydraulic engineering, and sunken cities. An extremely rare book, it was out of print for 60 years. Learn about the Biblical Tartessus; an Atlantean city at Niebla; the Temple of Hercules and the Sun Temple of Seville; Libyans and the Copper Age; more. Profusely illustrated with photos, maps and drawings.
284 PAGES. 6x9 PAPERBACK. ILLUSTRATED. TABLES OF ANCIENT SCRIPTS. $15.95. CODE: AIS

THE SHADOW OF ATLANTIS

ALEXANDER BRAGHINE

THIS 1940 CLASSIC ON ATLANTIS, MEXICO AND ANCIENT EGYPT IS BACK IN PRINT

ATLANTIS REPRINT SERIES

THE RIDDLE OF THE PACIFIC

JOHN MACMILLAN BROWN

This rare 1924 book is back in print!

MYSTIC TRAVELLER SERIES

THE MYSTERY OF EASTER ISLAND
by Katherine Routledge
The reprint of Katherine Routledge's classic archaeology book which was first published in London in 1919. The book details her journey by yacht from England to South America, around Patagonia to Chile and on to Easter Island. Routledge explored the amazing island and produced one of the first-ever accounts of the life, history and legends of this strange and remote place. Routledge discusses the statues, pyramid-platforms, Rongo Rongo script, the Bird Cult, the war between the Short Ears and the Long Ears, the secret caves, ancient roads on the island, and more. This rare book serves as a sourcebook on the early discoveries and theories on Easter Island.
432 PAGES. 6x9 PAPERBACK. ILLUSTRATED. $16.95. CODE: MEI

MYSTERY CITIES OF THE MAYA
Exploration and Adventure in Lubaantun & Belize
by Thomas Gann
First published in 1925, *Mystery Cities of the Maya* is a classic in Central American archaeology-adventure. Gann was close friends with Mike Mitchell-Hedges, the British adventurer who discovered the famous crystal skull with his adopted daughter Sammy and Lady Richmond Brown, their benefactress. Gann battles pirates along Belize's coast and goes upriver with Mitchell-Hedges to the site of Lubaantun where they excavate a strange lost city where the crystal skull was discovered. Lubaantun is a unique city in the Mayan world as it is built out of precisely carved blocks of stone without the usual plaster-cement facing. Lubaantun contained several large pyramids partially destroyed by earthquakes and a large amount of artifacts. Gann shared Mitchell-Hedges belief in Atlantis and lost civilizations (pre-Mayan) in Central America and the Caribbean. Lots of good photos, maps and diagrams.
252 PAGES. 6x9 PAPERBACK. ILLUSTRATED. $16.95. CODE: MCOM

IN SECRET TIBET
by Theodore Illion
Reprint of a rare 30s adventure travel book. Illion was a German wayfarer who not only spoke fluent Tibetan, but travelled in disguise as a native through forbidden Tibet when it was off-limits to all outsiders. His incredible adventures make this one of the most exciting travel books ever published. Includes illustrations of Tibetan monks levitating stones by acoustics.
210 PAGES. 6x9 PAPERBACK. ILLUSTRATED. $15.95. CODE: IST

DARKNESS OVER TIBET
by Theodore Illion
In this second reprint of Illion's rare books, the German traveller continues his journey through Tibet and is given directions to a strange underground city. As the original publisher's remarks said, "this is a rare account of an underground city in Tibet by the only Westerner ever to enter it and escape alive! "
210 PAGES. 6x9 PAPERBACK. ILLUSTRATED. $15.95. CODE: DOT

DANGER MY ALLY
The Amazing Life Story of the Discoverer of the Crystal Skull
by "Mike" Mitchell-Hedges
The incredible life story of "Mike" Mitchell-Hedges, the British adventurer who discovered the Crystal Skull in the lost Mayan city of Lubaantun in Belize. Mitchell-Hedges has lived an exciting life: gambling everything on a trip to the Americas as a young man, riding with Pancho Villa, questing for Atlantis, fighting bandits in the Caribbean and discovering the famous Crystal Skull.
374 PAGES. 6x9 PAPERBACK. ILLUSTRATED. BIBLIOGRAPHY & INDEX. $16.95. CODE: DMA

IN SECRET MONGOLIA
by Henning Haslund
First published by Kegan Paul of London in 1934, Haslund takes us into the barely known world of Mongolia of 1921, a land of god-kings, bandits, vast mountain wilderness and a Russian army running amok. Starting in Peking, Haslund journeys to Mongolia as part of the Krebs Expedition—a mission to establish a Danish butter farm in a remote corner of northern Mongolia. Along the way, he smuggles guns and nitroglycerin, is thrown into a prison by the new Communist regime, battles the Robber Princess and more. With Haslund we meet the "Mad Baron" Ungern-Sternberg and his renegade Russian army, the many characters of Urga's fledgling foreign community, and the last god-king of Mongolia, Seng Chen Gegen, the fifth reincarnation of the Tiger god and the "ruler of all Torguts." Aside from the esoteric and mystical material, there is plenty of just plain adventure: Haslund encounters a Mongolian werewolf; is ambushed along the trail; escapes from prison and fights terrifying blizzards; more.
374 PAGES. 6x9 PAPERBACK. ILLUSTRATED. BIBLIOGRAPHY & INDEX. $16.95. CODE: ISM

MEN & GODS IN MONGOLIA
by Henning Haslund
First published in 1935 by Kegan Paul of London, Haslund takes us to the lost city of Karakota in the Gobi desert. We meet the Bodgo Gegen, a god-king in Mongolia similar to the Dalai Lama of Tibet. We meet Dambin Jansang, the dreaded warlord of the "Black Gobi." There is even material in this incredible book on the Hi-mori, an "airhorse" that flies through the sky (similar to a Vimana) and carries with it the sacred stone of Chintamani. Aside from the esoteric and mystical material, there is plenty of just plain adventure: Haslund and companions journey across the Gobi desert by camel caravan; are kidnapped and held for ransom; witness initiation into Shamanic societies; meet reincarnated warlords; and experience the violent birth of "modern" Mongolia.
358 PAGES. 6X9 PAPERBACK. ILLUSTRATED. INDEX. $15.95. CODE: MGM

24 hour credit card orders—call: 815-253-6390 fax: 815-253-6300

email: auphq@frontiernet.net www.adventuresunlimitedpress.com www.wexclub.com

LOST CITIES

TECHNOLOGY OF THE GODS
The Incredible Sciences of the Ancients
by David Hatcher Childress

Popular *Lost Cities* author David Hatcher Childress takes us into the amazing world of ancient technology, from computers in antiquity to the "flying machines of the gods." Childress looks at the technology that was allegedly used in Atlantis and the theory that the Great Pyramid of Egypt was originally a gigantic power station. He examines tales of ancient flight and the technology that it involved; how the ancients used electricity; megalithic building techniques; the use of crystal lenses and the fire from the gods; evidence of various high tech weapons in the past, including atomic weapons; ancient metallurgy and heavy machinery; the role of modern inventors such as Nikola Tesla in bringing ancient technology back into modern use; impossible artifacts; and more.

356 PAGES. 6X9 PAPERBACK. ILLUSTRATED. BIBLIOGRAPHY. $16.95. CODE: TGOD

VIMANA AIRCRAFT OF ANCIENT INDIA & ATLANTIS
by David Hatcher Childress, introduction by Ivan T. Sanderson

Did the ancients have the technology of flight? In this incredible volume on ancient India, authentic Indian texts such as the *Ramayana* and the *Mahabharata* are used to prove that ancient aircraft were in use more than four thousand years ago. Included in this book is the entire Fourth Century BC manuscript *Vimaanika Shastra* by the ancient author Maharishi Bharadwaaja, translated into English by the Mysore Sanskrit professor G.R. Josyer. Also included are chapters on Atlantean technology, the incredible Rama Empire of India and the devastating wars that destroyed it. Also an entire chapter on mercury vortex propulsion and mercury gyros, the power source described in the ancient Indian texts. Not to be missed by those interested in ancient civilizations or the UFO enigma.

334 PAGES. 6X9 PAPERBACK. RARE PHOTOGRAPHS, MAPS AND DRAWINGS. $15.95. CODE: VAA

LOST CONTINENTS & THE HOLLOW EARTH
I Remember Lemuria and the Shaver Mystery
by David Hatcher Childress & Richard Shaver

Lost Continents & the Hollow Earth is Childress' thorough examination of the early hollow earth stories of Richard Shaver and the fascination that fringe fantasy subjects such as lost continents and the hollow earth have had for the American public. Shaver's rare 1948 book *I Remember Lemuria* is reprinted in its entirety, and the book is packed with illustrations from Ray Palmer's *Amazing Stories* magazine of the 1940s. Palmer and Shaver told of tunnels running through the earth—tunnels inhabited by the Deros and Teros, humanoids from an ancient spacefaring race that had inhabited the earth, eventually going underground, hundreds of thousands of years ago. Childress discusses the famous hollow earth books and delves deep into whatever reality may be behind the stories of tunnels in the earth. Operation High Jump to Antarctica in 1947 and Admiral Byrd's bizarre statements, tunnel systems in South America and Tibet, the underground world of Agartha, the belief of UFOs coming from the South Pole, more.

344 PAGES. 6X9 PAPERBACK. ILLUSTRATED. $16.95. CODE: LCHE

LOST CITIES OF NORTH & CENTRAL AMERICA
by David Hatcher Childress

Down the back roads from coast to coast, maverick archaeologist and adventurer David Hatcher Childress goes deep into unknown America. With this incredible book, you will search for lost Mayan cities and books of gold, discover an ancient canal system in Arizona, climb gigantic pyramids in the Midwest, explore megalithic monuments in New England, and join the astonishing quest for lost cities throughout North America. From the war-torn jungles of Guatemala, Nicaragua and Honduras to the deserts, mountains and fields of Mexico, Canada, and the U.S.A., Childress takes the reader in search of sunken ruins, Viking forts, strange tunnel systems, living dinosaurs, early Chinese explorers, and fantastic lost treasure. Packed with both early and current maps, photos and illustrations.

590 PAGES. 6X9 PAPERBACK. ILLUSTRATED. FOOTNOTES & BIBLIOGRAPHY. $14.95. CODE: NCA

LOST CITIES & ANCIENT MYSTERIES OF SOUTH AMERICA
by David Hatcher Childress

Rogue adventurer and maverick archaeologist David Hatcher Childress takes the reader on unforgettable journeys deep into deadly jungles, high up on windswept mountains and across scorching deserts in search of lost civilizations and ancient mysteries. Travel with David and explore stone cities high in mountain forests and hear fantastic tales of Inca treasure, living dinosaurs, and a mysterious tunnel system. Whether he is hopping freight trains, searching for secret cities, or just dealing with the daily problems of food, money, and romance, the author keeps the reader spellbound. Includes both early and current maps, photos, and illustrations, and plenty of advice for the explorer planning his or her own journey of discovery.

381 PAGES. 6X9 PAPERBACK. ILLUSTRATED. FOOTNOTES & BIBLIOGRAPHY. $14.95. CODE: SAM

LOST CITIES & ANCIENT MYSTERIES OF AFRICA & ARABIA
by David Hatcher Childress

Across ancient deserts, dusty plains and steaming jungles, maverick archaeologist David Childress continues his world-wide quest for lost cities and ancient mysteries. Join him as he discovers forbidden cities in the Empty Quarter of Arabia; "Atlantean" ruins in Egypt and the Kalahari desert; a mysterious, ancient empire in the Sahara; and more. This is the tale of an extraordinary life on the road: across war-torn countries, Childress searches for King Solomon's Mines, living dinosaurs, the Ark of the Covenant and the solutions to some of the fantastic mysteries of the past.

423 PAGES. 6X9 PAPERBACK. ILLUSTRATED. FOOTNOTES & BIBLIOGRAPHY. $14.95. CODE: AFA

24 hour credit card orders—call: 815-253-6390 fax: 815-253-6300
email: auphq@frontiernet.net www.adventuresunlimitedpress.com www.wexclub.com

LOST CITIES

LOST CITIES OF ATLANTIS, ANCIENT EUROPE & THE MEDITERRANEAN
by David Hatcher Childress

Atlantis! The legendary lost continent comes under the close scrutiny of maverick archaeologist David Hatcher Childress in this sixth book in the internationally popular *Lost Cities* series. Childress takes the reader in search of sunken cities in the Mediterranean; across the Atlas Mountains in search of Atlantean ruins; to remote islands in search of megalithic ruins; to meet living legends and secret societies. From Ireland to Turkey, Morocco to Eastern Europe, and around the remote islands of the Mediterranean and Atlantic, Childress takes the reader on an astonishing quest for mankind's past. Ancient technology, cataclysms, megalithic construction, lost civilizations and devastating wars of the past are all explored in this book. Childress challenges the skeptics and proves that great civilizations not only existed in the past, but the modern world and its problems are reflections of the ancient world of Atlantis.
524 PAGES. 6x9 PAPERBACK. ILLUSTRATED WITH 100S OF MAPS, PHOTOS AND DIAGRAMS. BIBLIOGRAPHY & INDEX. $16.95. CODE: MED

LOST CITIES OF CHINA, CENTRAL INDIA & ASIA
by David Hatcher Childress

Like a real life "Indiana Jones," maverick archaeologist David Childress takes the reader on an incredible adventure across some of the world's oldest and most remote countries in search of lost cities and ancient mysteries. Discover ancient cities in the Gobi Desert; hear fantastic tales of lost continents, vanished civilizations and secret societies bent on ruling the world; visit forgotten monasteries in forbidding snow-capped mountains with strange tunnels to mysterious subterranean cities! A unique combination of far-out exploration and practical travel advice, it will astound and delight the experienced traveler or the armchair voyager.
429 PAGES. 6x9 PAPERBACK. ILLUSTRATED. FOOTNOTES & BIBLIOGRAPHY. $14.95. CODE: CHI

LOST CITIES OF ANCIENT LEMURIA & THE PACIFIC
by David Hatcher Childress

Was there once a continent in the Pacific? Called Lemuria or Pacifica by geologists, Mu or Pan by the mystics, there is now ample mythological, geological and archaeological evidence to "prove" that an advanced and ancient civilization once lived in the central Pacific. Maverick archaeologist and explorer David Hatcher Childress combs the Indian Ocean, Australia and the Pacific in search of the surprising truth about mankind's past. Contains photos of the underwater city on Pohnpei; explanations on how the statues were levitated around Easter Island in a clockwise vortex movement; tales of disappearing islands; Egyptians in Australia; and more.
379 PAGES. 6x9 PAPERBACK. ILLUSTRATED. FOOTNOTES & BIBLIOGRAPHY. $14.95. CODE: LEM

ANCIENT TONGA
& the Lost City of Mu'a
by David Hatcher Childress

Lost Cities series author Childress takes us to the south sea islands of Tonga, Rarotonga, Samoa and Fiji to investigate the megalithic ruins on these beautiful islands. The great empire of the Polynesians, centered on Tonga and the ancient city of Mu'a, is revealed with old photos, drawings and maps. Chapters in this book are on the Lost City of Mu'a and its many megalithic pyramids, the Ha'amonga Trilithon and ancient Polynesian astronomy, Samoa and the search for the lost land of Havai'iki, Fiji and its wars with Tonga, Rarotonga's megalithic road, and Polynesian cosmology. Material on Egyptians in the Pacific, earth changes, the fortified moat around Mu'a, lost roads, more.
218 PAGES. 6x9 PAPERBACK. ILLUSTRATED. COLOR PHOTOS. BIBLIOGRAPHY. $15.95. CODE: TONG

ANCIENT MICRONESIA
& the Lost City of Nan Madol
by David Hatcher Childress

Micronesia, a vast archipelago of islands west of Hawaii and south of Japan, contains some of the most amazing megalithic ruins in the world. Part of our *Lost Cities* series, this volume explores the incredible conformations on various Micronesian islands, especially the fantastic and little-known ruins of Nan Madol on Pohnpei Island. The huge canal city of Nan Madol contains over 250 million tons of basalt columns over an 11 square-mile area of artificial islands. Much of the huge city is submerged, and underwater structures can be found to an estimated 80 feet. Islanders' legends claim that the basalt rocks, weighing up to 50 tons, were magically levitated into place by the powerful forefathers. Other ruins in Micronesia that are profiled include the Latte Stones of the Marianas, the menhirs of Palau, the megalithic canal city on Kosrae Island, megaliths on Guam, and more.
256 PAGES. 6x9 PAPERBACK. ILLUSTRATED. INCLUDES A COLOR PHOTO SECTION. BIBLIOGRAPHY. $16.95. CODE: AMIC

ANCIENT SCIENCE

THE LAND OF OSIRIS
An Introduction to Khemitology
by Stephen S. Mehler

Was there an advanced prehistoric civilization in ancient Egypt? Were they the people who built the great pyramids and carved the Great Sphinx? Did the pyramids serve as energy devices and not as tombs for kings? Independent Egyptologist Stephen S. Mehler has spent over 30 years researching the answers to these questions and believes the answers are yes! Mehler has uncovered an indigenous oral tradition that still exists in Egypt, and has been fortunate to have studied with a living master of this tradition, Abd'El Hakim Awyan. Mehler has also been given permission to present these teachings to the Western world, teachings that unfold a whole new understanding of ancient Egypt and have only been presented heretofore in fragments by other researchers. Chapters include: Egyptology and Its Paradigms; Khemitology—New Paradigms; Asgat Nefer—The Harmony of Water; Khemit and the Myth of Atlantis; The Extraterrestrial Question; 17 chapters in all.
272 PAGES. 6x9 PAPERBACK. ILLUSTRATED. COLOR SECTION. BIB. $18.95. CODE: LOOS

THE GIZA DEATH STAR
The Paleophysics of the Great Pyramid & the Military Complex at Giza
by Joseph P. Farrell

Physicist Joseph Farrell's amazing book on the secrets of Great Pyramid of Giza. The Giza Death Star starts where British engineer Christopher Dunn leaves off in his 1998 book, The Giza Power Plant. Was the Giza complex part of a military installation over 10,000 years ago? Chapters include: An Archaeology of Mass Destruction, Thoth and Theories; The Machine Hypothesis; Pythagoras, Plato, Planck, and the Pyramid; The Weapon Hypothesis; Encoded Harmonics of the Planck Units in the Great Pyramid; High Freqquency Direct Current "Impulse" Technology; The Grand Gallery and its Crystals: Gravito-acoustic Resonators; The Other Two Large Pyramids; the "Causeways," and the "Temples"; A Phase Conjugate Howitzer; Evidence of the Use of Weapons of Mass Destruction in Ancient Times; more.
290 PAGES. 6x9 PAPERBACK. ILLUSTRATED. $16.95. CODE: GDS

ATLANTIS & THE POWER SYSTEM OF THE GODS
Mercury Vortex Generators & the Power System of Atlantis
by David Hatcher Childress and Bill Clendenon

Atlantis and the Power System of the Gods starts with a reprinting of the rare 1990 book Mercury: UFO Messenger of the Gods by Bill Clendenon. Clendenon takes on an unusual voyage into the world of ancient flying vehicles, strange personal UFO sightings, a meeting with a "Man In Black" and then to a centuries-old library in India where he got his ideas for the diagrams of mercury vortex engines. The second part of the book is Childress's fascinating analysis of Nikola Tesla's broadcast system in light of Edgar Cayce's "Terrible Crystal" and the obelisks of ancient Egypt and Ethiopia. Includes: Atlantis and its crystal power towers that broadcast energy; how these incredible power stations may still exist today; inventor Nikola Tesla's nearly identical system of power transmission; Mercury Proton Gyros and mercury vortex propulsion; more. Richly illustrated, and packed with evidence that Atlantis not only existed—it had a world-wide energy system more sophisticated than ours today.
246 PAGES. 6x9 PAPERBACK. ILLUSTRATED. $15.95. CODE: APSG

MAYAN GENESIS
South Asian Myths, Migrations and Iconography In Mesoamerica
by Graeme R. Kearsley

India in the Americas? Did the ancient Buddhists, Hindus and Jains transfer cultural influences into Mesoamerica? Were the Maya also in India? Who were the Mandaeans and were they among the enablers and traders who influenced the Maya? Packed with over 1200 illustrations, this book is an instant classic that will rock the academic world. Chapters include Climatic Causes of Early Migrations; Myths and Legends of the Kwakiutl; Mariners, Missions, Traders and Sea Voyages; Myths and Legends of Migration; Tula—Bearded Gods and Monoliths; The Mysterious Zapotecs of Oaxaca; The Maya and the Pacific; Mayan Collapse? or a Return to the Land of the Ancestors; Indonesia and Cultural Diffusion; Architectural and Iconographical References Originating from India Found Among the Maya; Calendrical Rounds; Spider Deities and Star Demons; Sky Pillars; The Cosmic Tree-Megaliths and Monoliths to Planted Pillars; Pauahtuns—"Sons of the Wind" Sacred Symbols of the Mariner Gods; The Turban—The Mariner's Crown; Symbol of Authority—the Vajra/Dorje/Trident; Giants and Wind Gods; The Mandaeans; Reed Bundles of the Mayan, Aztec and in Asia; The Realm of the Peacock Angel and the Red-Haired Mandaeans; tons more. Imported from Britain.
1098 PAGES. 7x9 PAPERBACK. ILLUSTRATED. INDEX. $39.95. CODE: MGEN

THE ORION PROPHECY
Egyptian & Mayan Prophecies on the Cataclysm of 2012
by Patrick Geryl and Gino Ratinckx

In the year 2012 the Earth awaits a super catastrophe: its magnetic field reverse in one go. Phenomenal earthquakes and tidal waves will completely destroy our civilization. Europe and North America will shift thousands of kilometers northwards into polar climes. Nearly everyone will perish in the apocalyptic happenings. These dire predictions stem from the Mayans and Egyptians—descendants of the legendary Atlantis. The Atlanteans had highly evolved astronomical knowledge and were able to exactly predict the previous world-wide flood in 9792 BC. They built tens of thousands of boats and escaped to South America and Egypt. In the year 2012 Venus, Orion and several others stars will take the same 'code-positions' as in 9792 BC! For thousands of years historical sources have told of a forgotten time capsule of ancient wisdom located in a mythical labyrinth of secret chambers filled with artifacts and documents from the previous flood. We desperately need this information now—and this book gives one possible location.
324 PAGES. 6x9 PAPERBACK. ILLUSTRATED. BIBLIOGRAPHY. $16.95. CODE: ORP

One Adventure Place
P.O. Box 74
Kempton, Illinois 60946
United States of America
Tel.: 815-253-6390 • Fax: 815-253-6300
Email: auphq@frontiernet.net
http://www.adventuresunlimitedpress.com
or www.adventuresunlimited.nl

ORDERING INSTRUCTIONS

✓ Remit by USD$ Check, Money Order or Credit Card
✓ Visa, Master Card, Discover & AmEx Accepted
✓ Prices May Change Without Notice
✓ 10% Discount for 3 or more Items

SHIPPING CHARGES

United States

✓ Postal Book Rate { $3.00 First Item
50¢ Each Additional Item
✓ Priority Mail { $4.50 First Item
$2.00 Each Additional Item
✓ UPS { $5.00 First Item
$1.50 Each Additional Item

NOTE: UPS Delivery Available to Mainland USA Only

Canada

✓ Postal Book Rate { $6.00 First Item
$2.00 Each Additional Item
✓ Postal Air Mail { $8.00 First Item
$2.50 Each Additional Item
✓ Personal Checks or Bank Drafts MUST BE
USD$ and Drawn on a US Bank
✓ Canadian Postal Money Orders OK
✓ Payment MUST BE USD$

All Other Countries

✓ Surface Delivery { $10.00 First Item
$4.00 Each Additional Item
✓ Postal Air Mail { $14.00 First Item
$5.00 Each Additional Item
✓ Payment MUST BE USD$
✓ Checks and Money Orders MUST BE USD$
and Drawn on a US Bank or branch.
✓ Payment by credit card preferred!

SPECIAL NOTES

✓ RETAILERS: Standard Discounts Available
✓ BACKORDERS: We Backorder all Out-of-
Stock Items Unless Otherwise Requested
✓ PRO FORMA INVOICES: Available on Request
✓ VIDEOS: NTSC Mode Only. Replacement only.
✓ For PAL mode videos contact our other offices:

European Office:
Adventures Unlimited, Pannewal 22,
Enkhuizen, 1602 KS, The Netherlands
http: www.adventuresunlimited.nl
Check Us Out Online at:
www.adventuresunlimitedpress.com

Please check: ☑

☐ This is my first order ☐ I have ordered before ☐ This is a new address

Name					
Address					
City					
State/Province		Postal Code			
Country					
Phone day		Evening			
Fax		Email			

Item Code	Item Description	Price	Qty	Total

Please check: ☑

☐ Postal-Surface
☐ Postal-Air Mail
(Priority in USA)
☐ UPS
(Mainland USA only)
☐ Visa/MasterCard/Discover/Amex

Subtotal ➠	
Less Discount-10% for 3 or more items ➠	
Balance ➠	
Illinois Residents 6.25% Sales Tax ➠	
Previous Credit ➠	
Shipping ➠	
Total (check/MO in USD$ only) ➠	

Card Number

Expiration Date

10% Discount When You Order 3 or More Items!

Comments & Suggestions	Share Our Catalog with a Friend